THE WALLACE COLLECTION

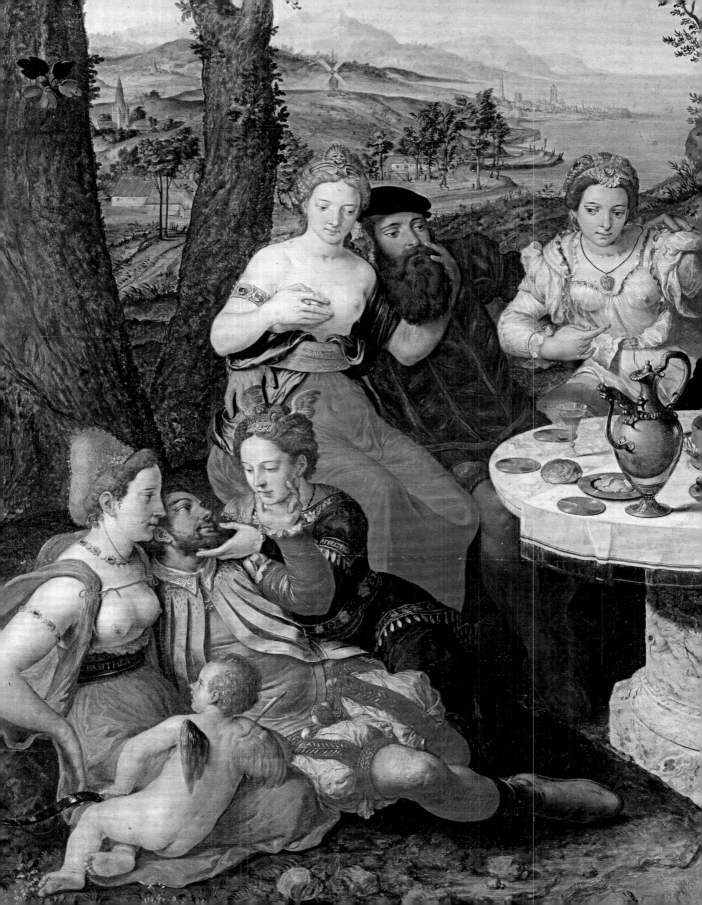

THE
WALLACE
COLLECTION

SCALA

© Scala Publishers Ltd, 2006
© Text The Wallace Collection, 2006

First published in hardback in 2005 by
Scala Publishers Ltd
Northburgh House
10 Northburgh Street
London ECIV OAT

ISBN 1 85759 412 6 (hardback)
ISBN 1 85759 422 3 (paperback)

Text by Stephen Duffy (introduction, nineteenth-century paintings);
David Edge (arms and armour); Jo Hedley (paintings pre-1800);
Suzanne Higgott (medieval and Renaissance works of art);
Rosalind Savill (introduction, gold boxes and Sèvres porcelain);
Eleanor Tollfree (furniture); Jeremy Warren (sculpture, medieval
and Renaissance works of art)
Photography by Roy Fox, Gordon Roberton, Andrew Smart
(A. C. Cooper Ltd) and Martin Spillane
Image editing by Melanie Oelgeschläger
Edited by Esme West
Designed by Yvonne Dedman
Printed and bound by Sirivatana Interprint PCL in Thailand

10 9 8 7 6 5 4 3 2 1

Half-title (detail):
Tray ('grand plateau carré'), 1757–8
Sèvres porcelain manufactory
See page 167

Frontispiece (detail):
An Allegory of True Love, c.1547
Pieter Pourbus (1523/4–84)
See page 46

Right (detail):
The Rising of the Sun, 1753
François Boucher (1703–70)
See page 157

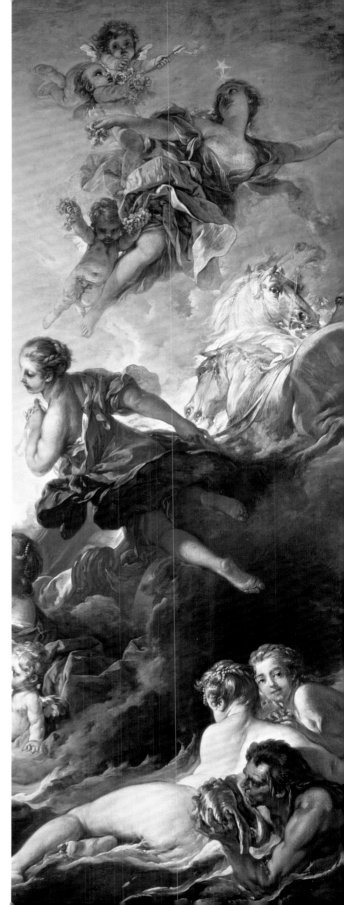

Contents

Introduction

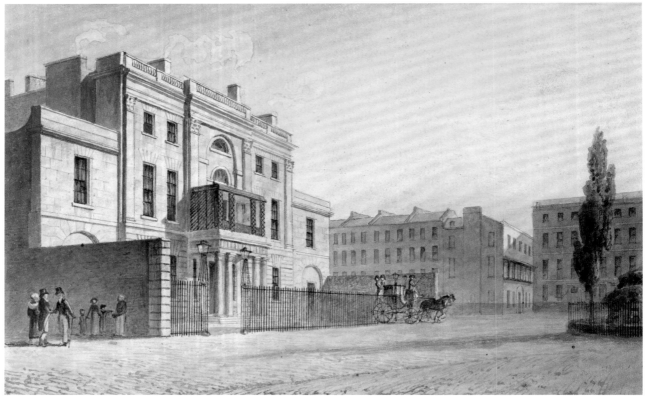

Manchester, later Hertford, House, *c.*1813

For many people the Wallace Collection is their favourite place in London. Although it is a national museum like some of London's grandest institutions, its particular charm lies in its intimacy, its wonderful works of art displayed in a sumptuous, but unintimidating house, the principal London residence of its former owners. 'This palace of genius, fancy and taste', a phrase of Benjamin Disraeli's, written in the visitors' book in 1878, captures its magic perfectly. To walk into the Wallace Collection is like stepping back into a leisured, more graceful age than our own, one where time seems to have moved at a gentler pace and where beauty was enjoyed without the slightest trace of shame or embarrassment.

The Collection was assembled in the eighteenth and nineteenth centuries by five generations of one remarkable family: the first four marquesses of Hertford and Sir Richard Wallace, the illegitimate son of the 4th Marquess. It was Sir Richard's widow, Lady Wallace, who bequeathed it to the nation in 1897. Its main strength, much to the chagrin of patriotic Frenchmen at the time of the bequest, is probably its extraordinary array of eighteenth-century French art: furniture, porcelain and gold snuffboxes of the finest quality, often with illustrious provenances from royal collections, together with French painting at its most elegant and

sensuous in the works of Watteau, Boucher and Fragonard. Complementing these are masterpieces by some of the greatest names of European art, such as Titian, Rembrandt, Hals and Velázquez, the finest collection of princely arms and armour in Britain and superb medieval and Renaissance objects, including Limoges enamels, maiolica, glass and bronzes. In all the galleries of the Wallace Collection there are works of the highest international importance.

Of the objects now in the Collection, the first to be acquired by the family were bought by the 1st Marquess of Hertford in the mid-eighteenth century and the last by Sir Richard Wallace in the 1880s. The Collection was not assembled in a steady or continuous manner over those years. On the contrary, it was only with the 3rd Marquess in the early nineteenth century that the family included a collector in any committed sense, and it was to be his son, the 4th Marquess, who bought on an enormous scale between 1843 and his death in 1870, who set the tone of the Collection we see today. His son, Richard Wallace, greatly extended its chronological range with his purchases of medieval and Renaissance works of art, but, as we shall see, nearly all these were acquired in an exceptional spell of buying in the two years after his father's death. Although some outstanding objects were

acquired before and afterwards, well over 90 per cent of the 5,500 works of art in the Collection today were bought by the 4th Marquess and Sir Richard Wallace during the years between 1843 and 1872.

The 1st Marquess of Hertford was Francis Seymour-Conway (1719–94), a descendant of the Edward Seymour who, in 1547, became Lord Protector of England during the minority of his nephew Edward VI. Although he was not aware of it at the time, the 1st Marquess began what was to become the Wallace Collection when he bought six paintings by Canaletto (and Canaletto's studio) and two portraits by Reynolds, all of which passed down the family line and were eventually inherited by Richard Wallace. His son, the 2nd Marquess (1743–1822), added three further English portraits, by Reynolds (*Miss Nelly O'Brien*), Romney and Gainsborough, the last two being portraits of his friend Mrs Mary Robinson ('Perdita'), an actress who, towards the end of her life, became a notable literary figure through her novels and poems. In her youth she had entranced the young Prince of Wales (later George IV), becoming his first mistress in 1779 when he was seventeen years old. It was George who, in 1818 (when he was Prince Regent), presented Gainsborough's portrait of her to the 2nd Marquess. The Prince was a close friend of the Marquess's wife, the 2nd Marchioness. Although she was probably never George's mistress, even if cruel caricatures of the time alleged otherwise, the 2nd Marquess complacently accepted the intense friendship between the Prince and his wife, and there was certainly some irony, as well as a characteristic tactlessness, in the Prince's gift of this portrait just as his close association with the Marchioness was ending.

It was the 2nd Marquess who began the family's occupation of Hertford House, now the home of the Wallace Collection, when he leased the building (then called Manchester House) as his main London residence in 1797. (His country seat was Ragley Hall in Warwickshire, which is still owned by the Hertford family.) The Prince of Wales was to be a frequent visitor to the house when his friendship with the 2nd Marchioness was at its height between about 1806 and 1819. A watercolour (opposite) of the house from Manchester Square, painted around 1813, shows the Prince's yellow carriage leaving through the front gates. It was after the death of the 2nd Marchioness in 1834 that the first of a series of inventories, which give invaluable insight into the development of the Wallace Collection, was taken.

The most charismatic member of the family, the 3rd Marquess (1777–1842), son of the 2nd Marquess and Marchioness, was also a friend of the Prince, the most flamboyant and influential art collector of his age. The Marquess (when Earl of Yarmouth) helped the Prince to build up his extensive collections, buying, for example, forty splendid Dutch and Flemish pictures on his behalf in the decade before the Prince became king in 1820. He also fully shared the Prince's taste for opulence and luxury, furnishing his London residences (St Dunstan's Villa in Regent's Park and Dorchester House on the edge of Hyde Park) with rich fabrics, gilt bronzes and furniture with Boulle marquetry (of turtleshell with brass or pewter), in a style comparable to that of the Prince's Carlton House, the last word in Regency extravagance.

Like the Prince (and the eighteenth-century French collectors on whom they partly modelled themselves), the 3rd Marquess also had a great fondness for seventeenth-century Dutch paintings and Sèvres porcelain. It is to the 3rd Marquess that the Collection owes, among other things, many of its finest Italianate bronzes, more than thirty pieces of Sèvres porcelain (including at least two pairs of vases formerly owned by the 2nd Marquess) and twenty-seven seventeenth-century Dutch and Flemish paintings, including Caspar Netscher's exquisite *The Lace Maker*. He also bought Titian's *Perseus and Andromeda*, the Collection's most important Renaissance picture, painted for Titian's greatest patron, Philip II of Spain, in 1554–6.

The 3rd Marquess was a rather disreputable character, whose appreciation of art was not always purely disinterested. He gained social kudos from his friendship and shared artistic tastes with the Prince Regent, and, like many others of his time, he was often tempted by the financial opportunities that the burgeoning art market in England could offer. Even Netscher's *The Lace Maker*, bought in 1804, was sent twice to auction less than five years later, and is only in the Collection today because it failed to sell on both occasions. Greedy and clever, the Marquess's importance to the history of the Collection resides not only in the objects he acquired but also in the extra wealth that he brought to the family from his marriage in 1798 to Maria Fagnani, the illegitimate

The 3rd Marquess of Hertford, c.1823
Thomas Lawrence
Washington, National Gallery of Art, Gift of G. Grant Mason, Jr.
© Washington, National Gallery of Art

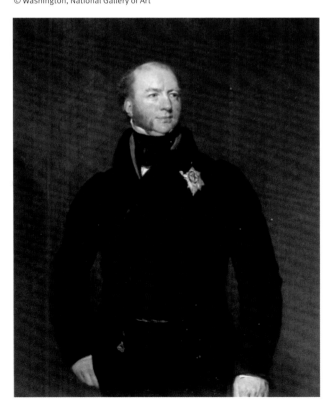

daughter of a former dancer. The family already owned extensive property in England, Ireland and Wales, but Maria made it even richer. This was because she enjoyed an unusual financial advantage: two extremely wealthy men, the 4th Duke of Queensberry (known as 'Old Q') and his associate George Selwyn, both believed that they were her father, and when they died, after lives replete with wit and debauchery, they both bequeathed her substantial fortunes. It was this marriage that elevated the family to one of the very richest in England and ultimately ensured the wealth that enabled the 4th Marquess and his son to build and maintain their collections.

In 1800 the future 4th Marquess was born, but two years later his parents separated, the 3rd Marquess to live in London, as we have heard, and Maria to live in Paris where she brought up her son (plus a further (illegitimate) son, Lord Henry Seymour, born in 1805). The 3rd Marquess devoted his last years to travel on the Continent and to sensual indulgence on an apparently epic scale. He had the distinction of becoming the model for unsavoury characters in novels by William Makepeace Thackeray and Benjamin Disraeli (Lord Steyne in *Vanity Fair* and Lord Monmouth in *Coningsby*), and 'No man lived more despised, or died less regretted' was his acid epitaph from the diarist Charles Greville when he finally died in 1842. The miniatures in the Collection today include several mistresses of the 3rd Marquess, no doubt bought or commissioned by the Marquess himself.

The 3rd Marquess's son, Richard Seymour-Conway, 4th Marquess of Hertford (1800–70), was as much French as English, at least in his taste and sympathies. Although he returned briefly to England after the end of the Napoleonic Wars, after spending most of his early youth in Paris, it was France that he made his home from his late twenties until the end of his life. He owned two splendid Paris properties, a huge apartment on the corner of the fashionable boulevard des Italiens and the rue Laffitte, and a beautiful château called Bagatelle, on the outskirts of the city

in the bois de Boulogne. These, together with Hertford House, which he used largely as a storeroom and seldom visited, he eventually filled with works of art, having acquired a passionate taste for collecting at the comparatively late age of forty-three. Long before he died, he was acknowledged as the greatest collector in Paris, if not Europe, a man who bought on such a lavish scale that accumulation was clearly of as much importance to him as display and private enjoyment. A demonstration of this was his treatment of Rubens's *The Rainbow Landscape*, perhaps his greatest acquisition, bought for the huge sum of 4,550 guineas in 1856. After its purchase at Christie's in London it was sent to Hertford House and never seen by the 4th Marquess, who remained rooted to his homes in Paris for the last fourteen years of his life.

He seems to have been a private man who could be stirred to enthusiasm only by his devotion to his mother (who died in 1856) and by the pursuit of art for his collection. It was perhaps characteristic of his withdrawn nature that he apparently never had his portrait painted. He certainly took little interest in the estates, particularly in Ireland, from which he derived most of his wealth. Yet, for all his studied insouciance, he could be witty and charming when required, and Sir Robert Peel is said to have remarked that the 4th Marquess could have been prime minister 'if he had lived in London, instead of frittering away his time in Paris'. He never married, although he had several mistresses, one of whom, Madame Oger, he cruelly deceived by arranging a mock marriage ceremony, in which his valet was dressed as a clergyman. He is also reputed to have paid the beautiful Countess de Castiglione, former mistress of Emperor Napoleon III, a million francs for one night of unrestrained pleasure.

Although he was never entirely predictable, the 4th Marquess was generally conservative in his artistic tastes, preferring to buy works by artists with established reputations. He also preferred to buy at auctions rather than from dealers, whom he seems to have distrusted, more so over paintings than the decorative arts.

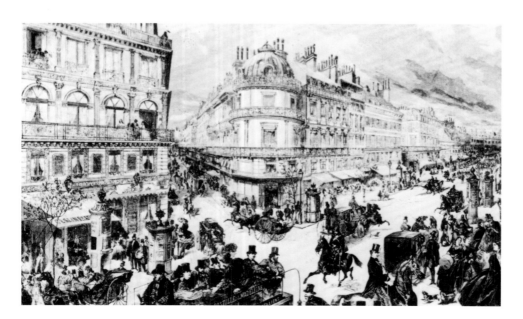

The Paris residence
The corner of the rue Laffitte and the boulevard des Italiens, Paris, showing the rotunda of the 4th Marquess of Hertford's apartment at no. 2 rue Laffitte

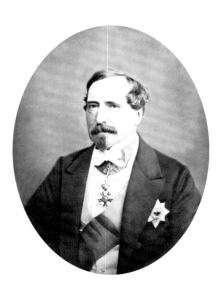

The 4th Marquess of Hertford
Photograph by Etienne Carjat, *c.*1860

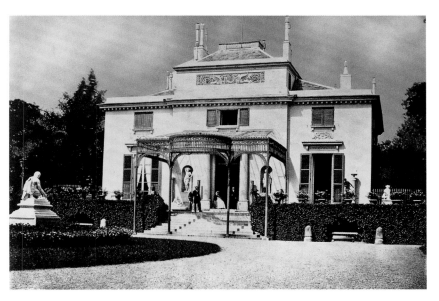

Above:
The château of Bagatelle, *c.*1855

Below:
The 4th Marquess of Hertford (left) with his mistress, Madame Oger, and his son, Richard Wallace, at Bagatelle, *c.*1860

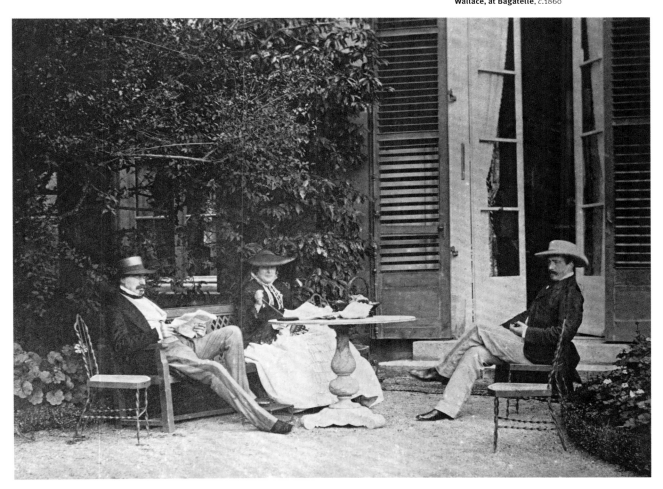

Seldom, however, was he put off by high prices, buying, for instance, *The Laughing Cavalier* for more than six times the saleroom estimate in competition with one of his keenest rivals, James de Rothschild. He was confident in his own taste, although he could on occasions be influenced by his main London agent, Samuel Mawson, and by his son, Richard Wallace, to buy something he had not seen in person. To Mawson he expressed his dislike of the early Renaissance paintings that were becoming fashionable in the 1850s, and he frequently referred to his preference for 'pleasing' pictures, such as those of Murillo with their 'rich, mellow quality'. Unpleasant subjects, including old men and martyrdoms, were to be avoided, and he once described a painting by Landseer as unacceptable because it had 'blood on all the animals'. With few exceptions, he remained consistent in his preference for paintings in good condition and with subjects that pleased the eye rather than troubled the soul. In all, he acquired more than 600 of the 775 paintings, drawings and watercolours now in the Wallace Collection. If any single factor has been responsible for defining the character of the Collection we see today, then it must be the Marquess's taste for pictures with a strong decorative appeal, combined with the almost limitless opportunities for buying them that he enjoyed as a wealthy Englishman living in Paris in the mid-nineteenth century.

Like his father, the 4th Marquess was particularly fond of Dutch paintings, but he bought far more and collected a much wider range of styles and subject matter. He added many more Dutch and Flemish domestic scenes by artists like Metsu, Ter Borch and De Hooch to those he inherited from his father, while also buying grander gallery pictures and portraits such as Rubens's *The Rainbow Landscape*, Rembrandt's *Titus* and Hals's *The Laughing Cavalier*. He also acquired paintings by other great seventeenth-century artists such as Poussin (*A Dance to the Music of Time*), Van Dyck, Velázquez (*The Lady with a Fan*) and Philippe de Champaigne. Venetian views by Canaletto and Guardi were bought in number to add to the Canalettos he had inherited from his great-grandfather, the 1st Marquess, enabling a Canaletto Room to be created especially for them at Hertford House. He also sought out paintings by artists of his own century, including Delaroche, Horace Vernet and Meissonier, thereby founding a collection of works by these once highly fashionable painters that is now unique in Europe because they fell out of favour soon after their deaths and other collections were dispersed. In the 1860s the Marquess also bought many examples of Oriental arms and armour, a fashionable taste at the time in Paris that was followed by Napoleon III among others. These objects complemented the extensive range of Orientalist paintings that was already in his collection, and, although many were bought mainly for their use in decorative displays, they included some of the most exquisite works of art now in the Wallace Collection, such as the jewelled and gold-hilted Mughal dagger dating from the early seventeenth century.

More than those of any other era or country, the arts of eighteenth-century France were most in harmony with the 4th Marquess's distinct sensibility. No other period could offer him such a perfect combination of refinement, sensuality and craftsmanship, all of which he esteemed highly and was prepared to buy at the highest prices. When he began collecting in the 1840s, the arts of this era, for ever associated with the Bourbon monarchy of the *ancien régime*, were already recovering from the neglect that they had suffered in France after the outbreak of the Revolution. Outside France, furniture and Sèvres porcelain had continued to be enjoyed and collected (not least, as we have seen, by the Prince Regent and the 3rd Marquess of Hertford), and even in France itself the *ancien régime* had never been without its admirers. It was to be in the 1840s, however, thanks principally to the enthusiasm of the 4th Marquess and other rich men such as James de Rothschild, that the decorative arts and the paintings of Watteau, Boucher and Fragonard gained that close association with millionaires' taste that they have retained ever since. No art was more teasingly sensuous, more elegant or more essentially aristocratic, and therefore none had a more profound appeal for the 4th Marquess of Hertford.

As early as 1843, the first year in which he began collecting in earnest, he bought two of Boucher's most important early works, *The Rape of Europa* and *Mercury confiding the Infant Bacchus to the Nymphs*. A superb Sèvres porcelain inkstand that had belonged to Louis XV's daughter, Madame Adélaïde, was acquired in the same year. By the end of the decade he had already established himself as an outstanding collector of furniture through purchases such as the great astronomical clock that had belonged to Madame de Pompadour's godfather, Jean Paris de Monmartel, and an imposing Boulle wardrobe (one of two he was to own) bought in 1848. For the next two decades, to within weeks of his death in 1870, he continued to buy hundreds of eighteenth-century French objects of superb quality, including not only paintings, porcelain and furniture but also many miniatures, gold boxes, tapestries and sculptures. Only silver, apparently of little interest and which has rarely survived from eighteenth-century France, escaped his relentless pursuit.

His paintings by Watteau, Greuze and the landscape painter Claude-Joseph Vernet conformed to established English taste, as these masters had been much admired and collected in England even in their own lifetimes. In all, he acquired at least twenty pictures by Greuze and eight by Watteau, as well as twenty-six by Watteau's followers Pater and Lancret, and although he only bought two Vernets they included one of the artist's most splendid marine paintings, *A Storm with a Shipwreck*. Only the Marquess's French domicile, however, can help explain his devotion to Boucher and Fragonard; no other English collector before or since, except perhaps Richard Wallace, has shown a similar enthusiasm for these quintessentially Gallic painters. The 4th Marquess bought at least thirty paintings by Boucher, including his finest rustic scenes, *A Summer Pastoral* and *An Autumn Pastoral*, and his greatest mythological pictures, *The Setting of the Sun* and *The Rising of the Sun*. His six Fragonards included *The Swing*, the painting that more than any other epitomises that light-hearted, exuberant sensuality ever since associated with eighteenth-century France.

Like his Dutch pictures, his eighteenth-century French furniture and Sèvres porcelain, so complementary to his French

paintings of the same era, were bought on a scale that far exceeded that of the 3rd Marquess. Not only did he buy grand and opulent pieces of furniture of the kind that had appealed to his father, much of it decorated with Boulle marquetry of the time of Boulle himself and of the Boulle revival that began in the 1750s, he also acquired many rococo pieces in a more elegant, sometimes extravagant style as well as neoclassical works of great importance. Among his finest treasures were the splendid commode made in 1739 by Gaudreaus and Caffiéri for Louis XV's bedchamber at Versailles, the roll-top desk by Riesener supplied to the comte d'Orsay around 1770 and no less than three secretaires made in the early 1780s by Riesener for Marie-Antoinette's use at Versailles. Ironically, he was actually unaware of the early history of all these pieces, as it was only in the twentieth century that archival research accurately established their early provenance, but we can be sure that he would have been thrilled to learn that they had once been in these pre-eminent royal collections. The 4th Marquess so loved the finest French furniture that he had copies made of some of the greatest pieces that he knew he would never own, such as Louis XV's desk at Versailles and the writing table made in Paris for the Elector of Bavaria in 1715. His finest examples of the cabinet-maker's art were complemented by a superb collection of furnishing bronzes: candelabra, candlesticks,

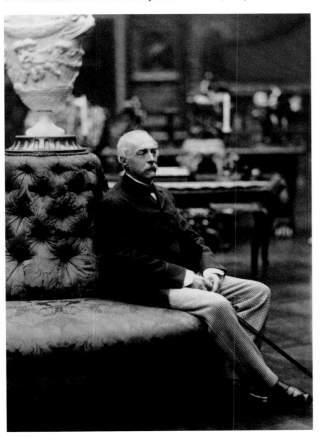

Sir Richard Wallace in the Great Gallery of Hertford House, *c.*1887

clocks, firedogs and two magnificent chandeliers made by Jacques Caffiéri and given by Louis XV to his eldest daughter, Louise-Elizabeth, Duchess of Parma.

The 4th Marquess combined his interest in furniture with his fondness for porcelain by buying tables and secretaires decorated with Sèvres plaques. These were complemented by a huge array of Sèvres vases and useful wares in a wide variety of ground colours, many painted with figure subjects reflecting his interest in French paintings of the same era. It is overwhelmingly due to him that today the Collection has an outstanding collection of Sèvres that contains, among much else, 137 vases, 80 tea wares and 67 useful wares. Pieces of the highest quality attracted him, but those with royal connections he found particularly irresistible. No doubt the fictional sale-catalogue description of Madame Adélaïde's inkstand as having been used by Marie-Antoinette to write her last farewells before her execution added greatly to its appeal. He also believed that the splendid pieces from the Catherine II service, bought from Lord Lonsdale in 1856, had been presented to the Empress by Louis XV. When, in 1860, he paid 63,000 francs (about £2,520) for three vases presented by Louis XVI to Prince Henry of Prussia, a contemporary magazine asked 'Where will such follies stop?'

Although the 4th Marquess allowed very few people into his Paris and London properties to see his collections, and was usually keen to maintain his anonymity whenever he bought in the auction rooms, he was nevertheless willing to lend to some of the great exhibitions that took place in the 1850s and 1860s. He was persuaded to send forty-four paintings, including Rembrandt's *Titus*, Hals's *The Laughing Cavalier*, five Murillos and Velázquez's *Lady with a Fan*, to the magnificent Art Treasures of Great Britain exhibition at Manchester in 1857; in 1865 it was the turn of Parisian audiences to see some of his eighteenth-century French furniture and decorative objects as well as his Oriental armour at the Musée Rétrospectif. It says much for the renown of his collections that on both occasions he was, at his own insistence, given a separate room for the display of his objects.

When the 4th Marquess died in 1870 he left all his unentailed property to Richard Wallace (1818–90). These assets, of which the Marquess could dispose as he wished, included his great art collection and his Paris residences. The entailed property, which had to pass down the legitimate family line and included the family seat at Ragley Hall, was inherited by a second cousin who became 5th Marquess of Hertford. In this way Wallace, the Marquess's illegitimate son by a Mrs Agnes Jackson, became a very rich man. Brought up in Paris from the age of six by his grandmother, the 2nd Marchioness, he had served his father well for many years as his agent and secretary, but, by his own account, was unaware until the Marquess's death that the Marquess was his father. Until the age of twenty-four he was known as Richard Jackson, but in 1842, for reasons that are rather obscure, he changed his surname to Wallace, his mother's maiden name.

Immediately after his father's death Paris was devastated by the Commune, a revolutionary uprising that followed France's defeat in the Franco-Prussian War. At this time Wallace gave large sums of money to charitable causes as well as, most famously, fifty

drinking fountains known still to this day in Paris as *wallaces*. Despite the award of a baronetcy, this troubled period seems to have unsettled him, and in 1872, by now Sir Richard Wallace, he began moving his residence to London after buying the lease of Hertford House, which had passed as entailed property to the 5th Marquess. With him he brought many of his finest works of art inherited from his father. He was also accompanied by his wife, Julie-Amélie-Charlotte Castelnau (1819–97), whom he had only been able to marry in 1871 because of opposition from the 4th Marquess, although she was the mother of their son, Edmond Richard, who by then was thirty-one years old.

Wallace, who was often complimented for his poise and charm, had a more attractive personality than his father. He took a real interest in the Irish estates that his father had neglected and conscientiously represented Lisburn in parliament. He also became a Trustee of the National Gallery and the National Portrait Gallery. It was characteristic of his philanthropic nature that he lent many of his works of art to the Bethnal Green Museum in one of the poorest parts of London while Hertford House was being enlarged to accommodate his collection. The exhibition, which opened in June 1872 and lasted almost three years, drew huge crowds and helped make Wallace famous in England. One artist, then totally unknown, who was deeply impressed by his visit to the exhibition was Vincent van Gogh.

As a young man Wallace had made his own collection of decorative objects and small-scale modern pictures, which he had been forced to sell in 1857 after some unfortunate speculation on the Paris stock exchange. Shortly after his father's death he began a short but vigorous campaign of buying works of art, which transformed the character of the collection he now owned by adding a much wider range of objects. In 1871 he bought *en bloc* for 400,000 francs (about £16,000) the collection of the comte de Nieuwerkerke, who had been Napoleon III's minister for the fine arts. This contained much of the European armour now in the Collection, including an important German fifteenth-century 'Gothic' armour for man and horse. There were also Renaissance sculptures, bronze portrait medals, wax reliefs and Italian maiolica. He did not, however, stop there. Shortly after this purchase he acquired from the Paris dealer Frédéric Spitzer much of the collection of arms and armour that had been formed in England by Sir Samuel Rush Meyrick (1783–1848), the founder of the scientific study of arms and armour. The Meyrick Collection contained much richly decorated armour by the great sixteenth-century armourers of southern Germany and northern Italy. With these and a few single purchases Wallace not only added objects like Limoges enamels, rock crystal and carvings of boxwood and ivory to the collection he inherited from his father but also extended its chronological range back to the medieval and early Renaissance periods, which had little interested the 4th Marquess. As if to emphasise this new direction, in 1872, Wallace also bought from the vicomte Both de Tauzia, a curator at the Louvre, more than twenty Italian and Netherlandish 'Primitive' paintings, together with a few Old Master drawings and manuscript illuminations. The 4th Marquess had once written that the new fashion for 'Primitives', the artists of the late Middle Ages and the early

Renaissance, was one 'I have not yet adopted & that I don't think I ever will'.

This intense period of collecting in the early 1870s was not sustained by Wallace in his later years, probably because Hertford House was full to bursting. He did, however, acquire a number of other works of art, both in the early 1870s and even in the last decade of his life, that complemented his father's collection. For example, he bought some splendid miniatures and gold boxes, such as the Van Blarenberghe *Fair of Saint-Germain* and the gold box with miniature portraits of Voltaire and Madame du Châtelet formerly owned by the Empress Eugénie. In 1871 he bought the fine pair of tables of painted steel and bronze gilt made for the dealer Dominique Daguerre between 1785 and 1787, and in the following year he bought a Sèvres porcelain toilet service that may once have been intended for Madame de Pompadour. Among his most sensitive purchases of paintings was Thomas Lawrence's *George IV*, an iconic image of an important figure in the history of the Collection, bought in 1883 and perhaps the last major work of art Wallace ever bought.

During the Wallaces' residence at Hertford House it was possible to see its fabulous treasures one day a week on application. A privately printed list of the principal pictures was even produced, a common practice in the great London town houses of the time. Fortunately, photographs taken in about 1890 (opposite) show what some of the interiors looked like. They reveal that Wallace liked to live with his works of art (in his Billiard Room, for instance, he displayed Dutch paintings, Boulle furniture and bronze statuettes), but they also show that some of his rooms, such as the European Armoury and the Great Gallery, were exhibition galleries, intended to display his collections in the dense, even cluttered way that was characteristic of the time.

Wallace died at Bagatelle on 20 July 1890. He had hoped to establish a dynasty of titled art lovers, but sadly his son Edmond Richard had died in 1887 leaving no legitimate children. Although, like his father, Wallace had had some discussions with British government officials about his collection coming to the nation, these had been fruitless, and in his will he bequeathed all his property to his wife, Lady Wallace. A former perfume seller on the boulevard des Italiens, she appears to have had little or no interest in art, but she had a strong sense of responsibility towards her husband's memory. When she died in 1897, after spending her last years at Hertford House isolated from society by her shyness and her uncertain grasp of the English language, she bequeathed to the nation the works of art 'placed on the ground and first floors and in the galleries at Hertford House', thereby almost certainly fulfilling her husband's wishes. She also stipulated that the resulting museum must be called 'The Wallace Collection' and that the Collection should 'be kept together, unmixed with other objects of art'. Almost all the rest of her estate passed to her late husband's secretary, John Murray Scott (1847–1912), who had helped her in her widowhood and who became the first chairman of the Wallace Collection's trustees, responsible for establishing the Collection as a public museum. The properties he received included the two residences in Paris, Bagatelle and the apartment on the rue Laffitte, which still contained many works of art,

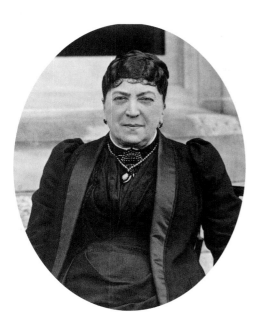

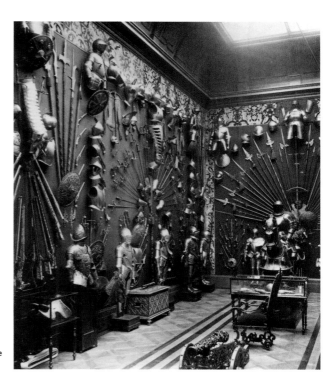

Above:
Lady Wallace, *c.*1890

Right:
The European Armoury, Hertford House
Photograph by J. J. Thomson, *c.*1890

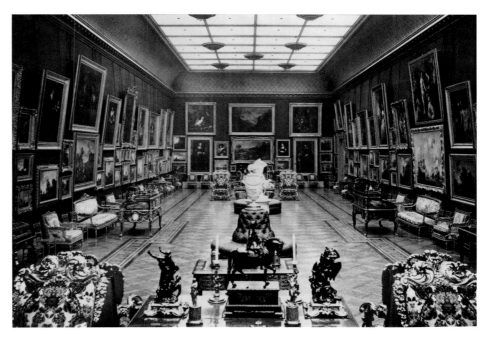

Right:
The Great Gallery, Hertford House
Photograph by J. J. Thomson, *c.*1890

particularly French paintings, sculpture, furniture and tapestries. Murray Scott was to sell Bagatelle and many of its objects, and on his death he left the contents of the rue Laffitte apartment to Lady Sackville of Knole, who sold them *en bloc* to a Parisian dealer, Jacques Seligmann. These and other dispersals of Murray Scott's property thus ensured that works of art from this part of the fabulous collection once owned by Sir Richard and then Lady Wallace are now to be found in museums and private collections throughout the world.

The Wallace Collection was opened formally as a national museum by the Prince of Wales (later Edward VII) on 22 June 1900. It has remained open ever since, apart from during the two

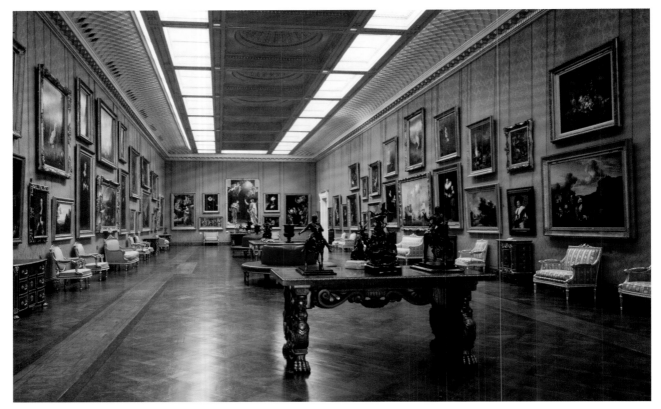

The Great Gallery, 2005

World Wars; its objects were sent for safekeeping to the Post Office Underground Station at Paddington in the first war, and to a country house, Hall Barn, near Beaconsfield, Buckinghamshire, in the second. Although the terms of Lady Wallace's bequest have restricted additions to the Collection to just a handful of minor works added to complete existing works of art, there have been few constraints on the display of its objects or the appearance of the galleries. As a series of photographs of the Front State Room clearly show, not only have the rooms been refurbished frequently but the displays and even the architectural features have also undergone many alterations (see pages 16–17).

A major refurbishment completed in 1982 added air conditioning and involved a conscious effort to separate the rooms from the galleries by introducing a patterned carpet (since removed) to the areas that were once part of the original house. This also resulted in John Ingamells's magnificent re-hang of the Great Gallery, where there is now a breathtaking display of European masterpieces, chiefly from the mid-seventeenth century. Since 1994 four rooms on the ground floor have been redecorated, and each has been treated individually, with a specific theme running through the displays of paintings and the decorative arts. They now have walls hung with French silks, improved lighting and modern environmental monitoring, and are a deliberate evocation of the opulence of the display in Richard Wallace's day. These refurbishments have been made possible by generous

donations from individuals and charitable trusts, and work on four more rooms on the first floor is hoped for.

By far the most dramatic alterations to Hertford House since the nineteenth century took place between 1997 and 2000, and were unveiled by the Prince of Wales on 22 June 2000, one hundred years to the day since his ancestor inaugurated the museum in 1900. This development, involving a wide range of new facilities essential to a modern museum, entailed the creation in the basement of a new Lecture Theatre, Education Studio and Meeting Room, a Conservation Gallery to explain modern conservation techniques, a Reserve Gallery (for the 5 per cent of objects not previously on display) and two Exhibition Galleries for temporary displays of objects, either from the Collection itself or borrowed from public and private collections. As a final flourish the central courtyard, topped by a spectacular glass roof, now has a restaurant where visitors can enjoy a cup of tea or a three-course meal. Funded almost entirely by Mr Joe Lewis and the Heritage Lottery Fund, the Centenary Project, while leaving the great rooms and galleries untouched, has helped enormously to implement the Collection's far-reaching educational and family-activity programmes, which range from lectures and study days to art classes and costumed entertainments. The Wallace Collection is now not only one of the most attractive museums anyone can visit but also one of the most exciting. ↔

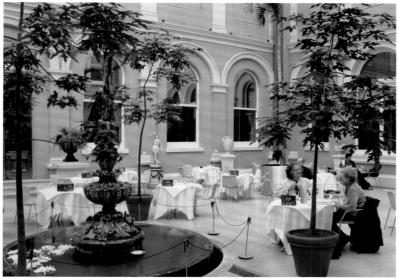

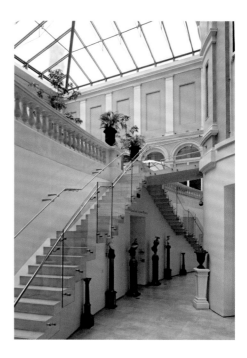

Below:
Hertford House, home of the Wallace Collection

Above and right:
The courtyard and restaurant; the courtyard and glass roof seen from the Porphyry Court

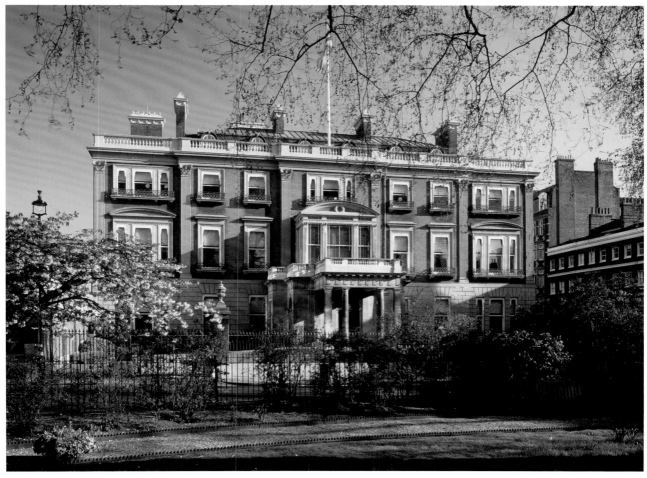

The Front State Room

Sir Richard and Lady Wallace moved into Hertford House in 1875 after a massive rebuilding and refurbishment programme. The first room their visitors encountered (as do ours today) was the Front State Room. From a photograph of around 1890 and the 1890 inventory of Hertford House, it is known that they decorated it richly, with crimson silk-damask wall panels framed in gilded wood, silk and velvet curtains and even additional gilded mouldings on the ceiling, and that it was filled with treasured works of art.

As these photographs show, from the moment the house was converted into a museum, the glories were gradually stripped away. By 1901 the back wall was knocked through to lighten the room behind, the fabric and its gilded frames were removed and so was the overmantel. In 1919 the chair rail and gilded ceiling mouldings went, and in 1936 the room became one large gallery with the Back State Room behind. Then, in 1977, the rooms were divided once more, and in the 1980s the chandelier was removed. By 1994 the room looked forsaken and sparsely hung with works of art, and it was decided to refurbish it to its former glory. Luckily, being a State Room, most of its furniture in Wallace's day (except a table and a cabinet) was not of a personal nature and so had been retained when the museum was established. It was therefore almost the only room that could be restored to how it once had been.

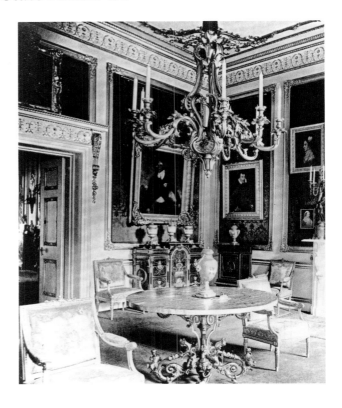

Above:
The Front State Room, *c*.1890, showing the sumptuous display introduced in the 1870s when the Wallaces were in residence

Left:
The Front State Room, *c*.1901, after the first alterations for the opening of the Wallace Collection as a museum

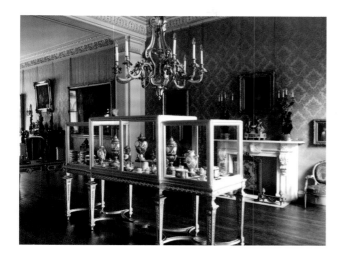

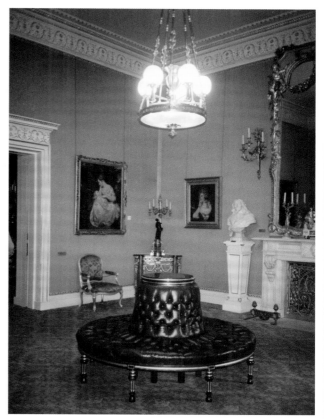

Today all the decorative features have been re-created and the overmantel and chandelier returned from other galleries. Once again the room demonstrates the incomparable opulence of English portraits in combination with bronzes, Boulle furniture and Sèvres porcelain. Once again visitors can enter this room and experience the splendour of a great London town house of the late nineteenth century. ❧

Above left:
The Front State Room, 1958, showing the removal of the wall separating the Back State Room, which had taken place in 1936

Above right:
The Front State Room, 1994, after the major re-hang and refurbishment completed in 1982 had introduced carpeting and removed the Caffiéri chandelier to another gallery

Right:
The Front State Room, 2005, with the room restored largely to its appearance in the Wallaces' day. The table and larger Boulle cabinet shown in the photograph of c.1890 were not part of Lady Wallace's bequest to the nation

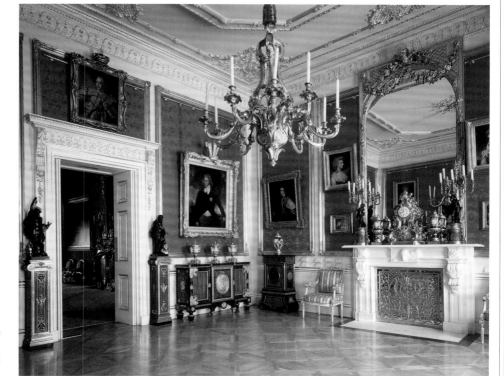

Medieval and Renaissance Art

The 4th Marquess of Hertford's notorious comment to his agent Samuel Mawson concerning a group of early European paintings offered for sale – 'Primitive Masters … I have not yet adopted and … I don't think I ever will' – encapsulates his generally lukewarm attitude towards medieval and Renaissance art. The fact that the Wallace Collection today owns one of the richest and most interesting collections in Britain of art from this period is therefore due almost entirely to Sir Richard Wallace. Various factors contributed to an explosion of interest in medieval and Renaissance art during the nineteenth century, including the upheavals of the French Revolution and the Napoleonic Wars, which brought vast quantities of material on to the market, the pre-occupation of Romantic writers and artists with early history and, later in the century, the growth of nationalist movements in several European countries. By mid-century it was almost *de rigueur* for any serious collection to include Renaissance bronzes or maiolica. The 4th Marquess's refusal to go with this fashion contrasted with the determined pursuit of such material by his greatest rivals, such as the Rothschilds. He did, however, acquire two of the most important pieces of Renaissance sculpture in the collection, Giovanni Fonduli da Crema's *Seated Nymph* and Germain Pilon's great bust of King Charles IX.

Sir Richard Wallace's tastes were more in tune with the period. After inheriting from his father, he moved very quickly to make good this gap in the Wallace Collection, buying in 1871 the whole of the comte de Nieuwerkerke's remarkable collection of sculpture, maiolica, enamels and arms and armour. Wallace went on to make other smaller *en bloc* purchases but also continued to add important individual pieces, such as the great maiolica wine cistern made for Cosimo I de'Medici, for which he paid a record price (£4,500) in 1875, and the Bell of St Mura. The very last work of art that he bought, in 1888, was a Renaissance bronze. The medieval and Renaissance works of art in the Wallace Collection are remarkable for their wide range and for the very high quality of many individual works. As such, they are a worthy testament to Sir Richard Wallace's keen eye and sensibility. ✍

Opposite (detail):
Platter: *Apollo and the Muses, *c.*1580
Martial Courteys (dates unknown)
See page 53

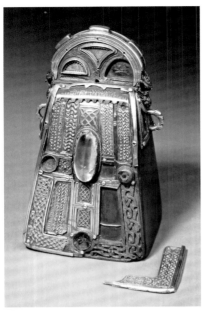

The Bell of St Mura, 11th century and later
Irish

◀ This hand bell is reputed to have come from the abbey of Fahan in County Donegal, Ireland, founded in the seventh century by St Mura (Muranus). The bronze body of the bell was probably made at Kells, County Meath, the great centre of art and monastic life in Ireland, with further layers of decoration applied in successive stages. The earliest is an Irish style of Viking ornament, visible in the bottom-right corner, where a later piece has become detached. The silver filigree and cast plaques, rock crystal and amber stones were added at various times from the eleventh to the sixteenth century. Several legends are connected with the bell, which is said to have descended from heaven ringing loudly.

Bronze, brass, gold and silver with rock crystal and amber; h 15 cm, w 8.95 cm, d 7.7 cm
Acquired by Sir Richard Wallace in 1879
IIIJ498

Burial of a Bishop, early 13th century
French

▼ During the Middle Ages the city of Limoges was the one of the most important centres in western Europe for the large-scale production of metalwork in copper. Objects were cast in moulds, then chased, engraved and sometimes enamelled. Limoges copper-gilt metalwork was widely exported throughout Europe. This relief, which is notable for the exceptionally elaborate chasing of the garments of the six figures, was probably originally attached either to the front of an altar or, possibly, to the side of a reliquary casket or *châsse*.

Copper gilt; h 30.5 cm, w 36.8 cm
Probably acquired by Sir Richard Wallace in 1871
IIIN286

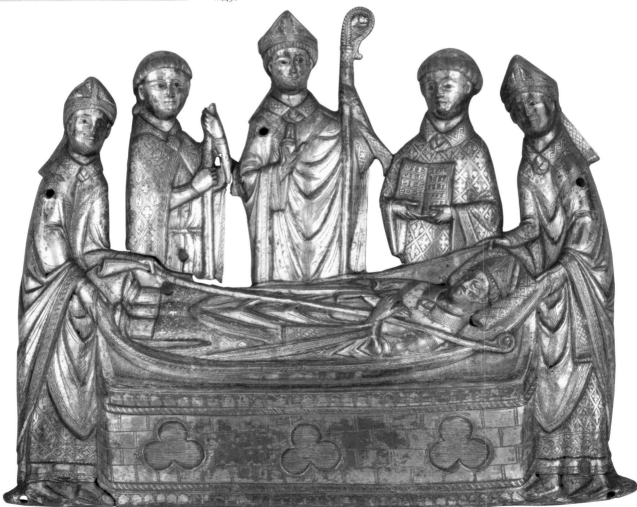

St John the Baptist, c.1270–90
French

▶ The tall, slim figure of St John, characteristic of Gothic art, comes from a *châsse* adorned with *champlevé* enamel plaques that forms part of the treasury of Rouen Cathedral. (*Champlevé* is a technique that involves pouring liquid enamel into grooves engraved on a metal surface.) The St John was once one of twelve figures of Apostles set under arches on the sides of the *châsse*, which is in the form of the nave of a church. The *châsse* was altered in 1776 to receive the relics of St Romanus, at which point this statuette may have been replaced by a cast.

Chased and gilt bronze; h 21.8 cm, w 7.7 cm
Acquired by Sir Richard Wallace in 1871
S152

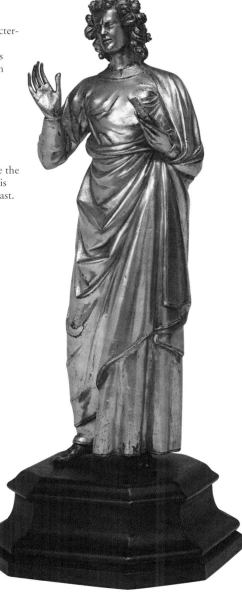

Morse, probably 19th century (perhaps incorporating 15th-century elements)
German(?)

◀ A morse is a clasp for a bishop's cope. This piece, showing the Virgin and Child between angels, may include some fifteenth-century elements, but was probably created largely in the nineteenth century, when renewed interest among collectors in the art of the Middle Ages encouraged a strong market in forgeries. Like every collection formed in the nineteenth century, the Wallace Collection contains its share of forgeries. Some are now regarded as fine works of art in their own right, while others have value as documents for the history of collecting. This morse has a distinguished provenance, having been owned by Augustus Charles Pugin and subsequently by his famous son, Augustus Welby Northmore Pugin (1812–52), the architect, writer and designer who was the leading figure in the Gothic Revival in Britain.

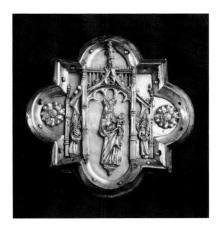

Gilt copper; h 14.5 cm, w 14.5 cm
Probably acquired by Sir Richard Wallace at an unknown date
IIIG293

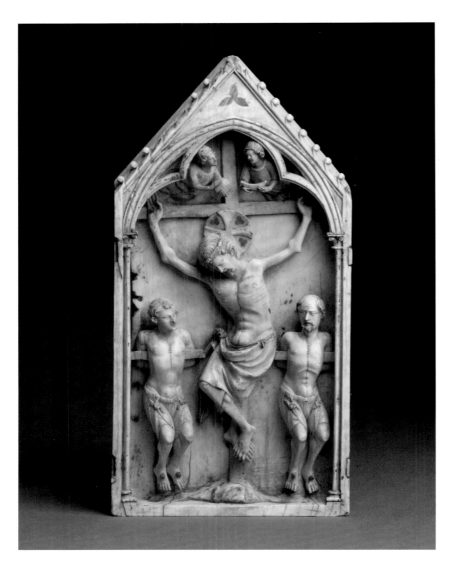

Christl crucified between two Thieves,
early 14th century
French

◀ Christ is shown crucified between two thieves: the good thief on Christ's right, youthful and clean shaven, who asked Christ to remember him, and the bad thief, bearded and bald, who abused Christ (Luke 23:39–43). This ivory, which was once partly pigmented, is remarkable for the expressive naturalism and sculptural depth of the main figures. One of the greatest Gothic ivories to survive, it was probably made in Paris in the early fourteenth century.

Ivory; h 26.6 cm, w 13.4 cm
Probably acquired by Sir Richard Wallace
at an unknown date
S247

The Nativity, late 14th century
Italian, Umbria

▶ Objects in *verre églomisé* (gilded glass) were a speciality of the Italian region of Umbria in the Middle Ages, and were particularly popular with the Franciscan order. The technique involves the etching of gold leaf that has been applied to glass. This panel was probably once the wing of a diptych (a painting or carving on two separate panels, usually hinged like a book). It has decorative details added in red and green glazes as well as blank spaces that once held pieces of parchment and relics. The composition of the Nativity scene suggests the influence of the frescoes in the Lower Church of San Francesco at Assisi and of Duccio's *Maestà* (now in the Uffizi, Florence).

Gilded glass; 8.5 x 6 cm
Probably acquired by Sir Richard Wallace
at an unknown date
IIIG307

The Descent from the Cross and ***The Death
of the Virgin***, *c.*1400
French

▶ With its well-preserved, jewel-like
pigmentation, this tiny ivory resembles
contemporary manuscript illuminations.
Made in the form of a diptych, it is part of
a small group of ivories made in Parisian
workshops around 1400 (other ivories from
this group are in Berlin and in the church of
San Lorenzo, Portovenere). The diptych has
been mounted, probably in the nineteenth
century, in a hinged silver locket, with each
wing set under a square of convex glass.

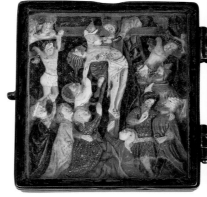

Ivory; h 6.4 cm, w 5.7 cm
Probably acquired by Sir Richard Wallace
at an unknown date
S252

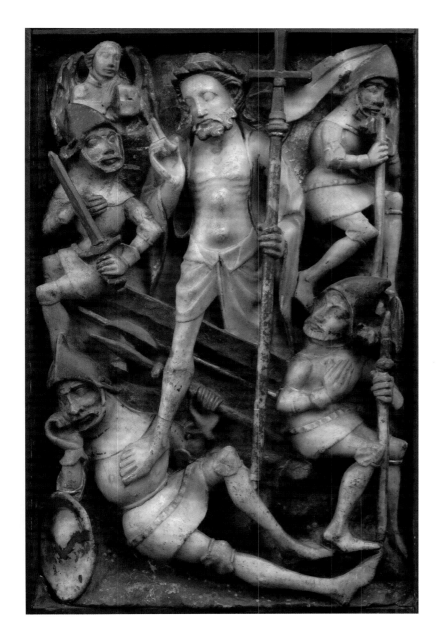

The Resurrection, 15th century
English, Nottingham School

◀ Production of sculpted panels in gypsum
alabaster (sulphate of lime) flourished in
Nottingham and surrounding areas in the
fifteenth century. Most depict scenes from
the Passion of Christ, the Life of the Virgin
or saints and martyrdoms. They were
painted, gilded and usually set within a
wooden framework, either singly or in a
series, to form altarpieces. The subject of
the Resurrection of Christ (Matthew 28:3)
is one of the more common subjects for
Nottingham alabasters. This particular
example is notable for the fine state of pre-
servation of its painted and gilded surface.

Alabaster, partially painted and gilt; h 44.5 cm,
w 27.9 cm
Probably acquired by Sir Richard Wallace
at an unknown date
S3

Dish with the Arms of Philip the Good, Duke of Burgundy, *c*.1428
Spanish, Manises

▶ The technical and decorative mastery of the Moorish potters in medieval Spain was unrivalled in early fifteenth-century Europe. Their exotic wares, with pale tin-glazed grounds and bold decoration inspired by Islamic ornament, usually combining cobalt blue with glistening, metallic golden lustre, which necessitated an additional firing in a reducing atmosphere, were coveted by the nobility of France and Italy. This beautiful dish is particularly important, both for its armorial shield and for its decoration. The shield bears the arms of Philip the Good, Duke of Burgundy, in the form used between 1419 and 1429, providing early evidence of the export market for these luxury goods. The decoration shows the influence of the Gothic style, and is exceptional in incorporating a wreath of vine shoots encircling the shield.

Tin-glazed and painted earthenware (maiolica); diam. 38.1 cm
Probably acquired by Sir Richard Wallace at an unknown date
C1

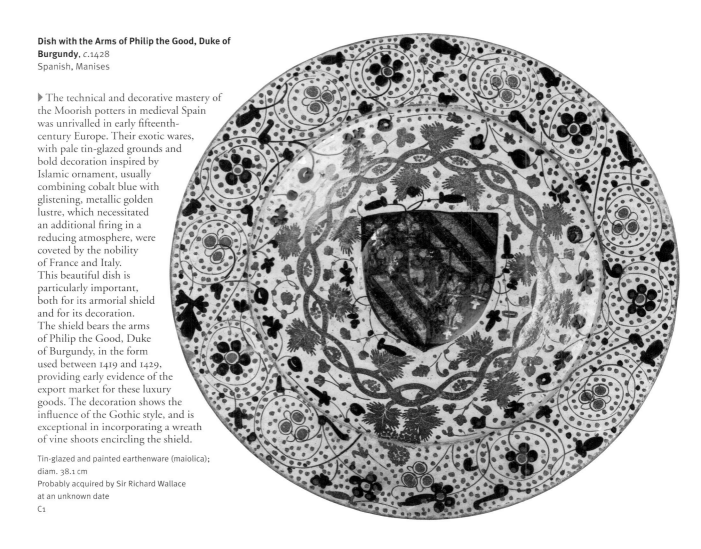

Serving Knife of Philip the Good, Duke of Burgundy, *c*.1430–40
French or Burgundian

▼ Philip the Good (1396–1467) ruled as Duke of Burgundy from 1419 until 1467. The coat of arms enamelled upon the silver-gilt pommel of this knife are those he assumed upon his marriage with Isabella of Portugal in 1430. It was in her honour that he founded the Order of the Golden Fleece in the same year. During this period, the Burgundian court became a brilliant cultural centre, admired and emulated throughout western Europe. Philip himself became one of the Duchy's most famous and successful rulers; by the end of his reign he had virtually doubled the Burgundian lands, and ensured that Burgundy itself had become a byword for all that was noble and powerful. This serving or carving knife was as much a visible symbol of the Duke of Burgundy's wealth and taste as a mere item of cutlery; it would have been used as part of a set of such knives, conspicuously and with great ceremony during important state occasions and banquets.

Steel, silver, wood, enamel and gold; l (overall) 41.1 cm, wt 130 g
Acquired by Sir Richard Wallace in 1871
A881

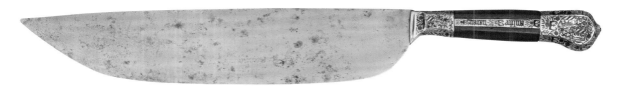

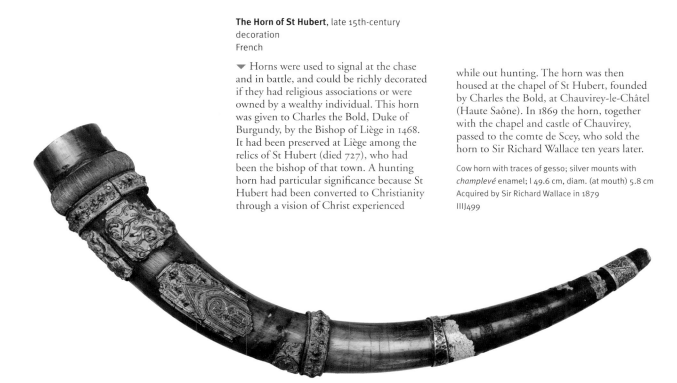

The Horn of St Hubert, late 15th-century decoration
French

▼ Horns were used to signal at the chase and in battle, and could be richly decorated if they had religious associations or were owned by a wealthy individual. This horn was given to Charles the Bold, Duke of Burgundy, by the Bishop of Liège in 1468. It had been preserved at Liège among the relics of St Hubert (died 727), who had been the bishop of that town. A hunting horn had particular significance because St Hubert had been converted to Christianity through a vision of Christ experienced while out hunting. The horn was then housed at the chapel of St Hubert, founded by Charles the Bold, at Chauvirey-le-Châtel (Haute Saône). In 1869 the horn, together with the chapel and castle of Chauvirey, passed to the comte de Scey, who sold the horn to Sir Richard Wallace ten years later.

Cow horn with traces of gesso; silver mounts with *champlevé* enamel; l 49.6 cm, diam. (at mouth) 5.8 cm
Acquired by Sir Richard Wallace in 1879
IIIJ499

Collar of the Gorcum Civic Guild Guards,
late 15th century
Netherlands

▶ The civic guards, like the guilds, were important social institutions in the Netherlands. They often had elaborate rituals and celebrations, at which the masters wore badges or collars. This spectacular collar belonged to the Guild of St George in Gorcum (Gorinchem), an important centre of silversmithing. Each year an archery competition would be held by the Guild, after which this collar was worn by the winner, the 'Guild King' or constable, on official occasions. There are thirty shields on the chain with the names and coats of arms of constables dating from 1499 to 1826. The parrots within the chain refer to the fact that popinjays or stuffed birds were traditionally used as targets for the competitions.

Silver with traces of gilding and enamelling; diam. (chain without shields) 34 cm
Acquired by Sir Richard Wallace in 1871
IIIJ508

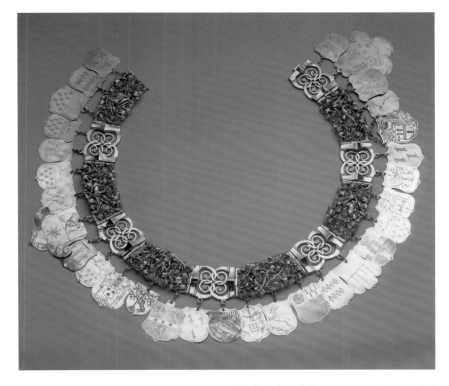

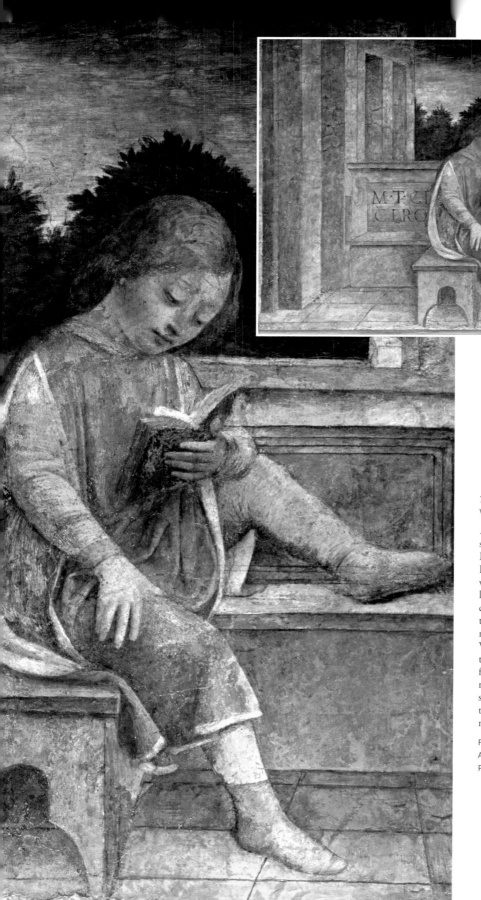

The Young Cicero Reading, *c.*1464
Vincenzo Foppa (1427/30–1515/6)

▲ *The Young Cicero Reading* is the only
surviving fresco from the Banco Mediceo,
Milan. In 1455, Francesco Sforza gave the
Palazzo to Cosimo I de'Medici (1389–1464),
who had it lavishly restyled. Foppa, the
leading Lombard master of the Quattro-
cento period, was commissioned to fresco
the courtyard. *The Young Cicero Reading*
may have been intended to accompany the
Virtues as an emblem of Rhetoric, one of
the Liberal Arts. Set in the open courtyard
for four hundred years, the fresco was
removed around 1863, framed and exten-
sively retouched, which explains some of
the compositional inconsistencies that are
now apparent.

Fresco; 101.6 x 143.7 cm
Acquired by Sir Richard Wallace in 1872
P538

Angel with a Sword, 1479–80
Hans Memling (1430/40–94)

▶ The right wing of a triptych, probably
that described in the 1516 and 1524 inven-
tories of Margaret of Austria as having a
central panel depicting a small Pietà by
'Rogier' (van der Weyden), side panels by
'Master Hans', each showing an angel, and
an Annunciation in grisaille on the exterior.
It exhibits Memling's smooth, analytical
naturalism, with the figure placed like a
living column against an uncharacteristically
archaic gold background. The angularity
and asceticism of the figure betray the
influence of Van der Weyden, while its
elegance recalls German painting and
Memling's early training in the Rhine area.

Oil on oak panel; 40.7 x 16.4 cm
Acquired by Sir Richard Wallace in 1872
P528

Initial 'O' with St Apollonia, late 15th century
Italian, Lombard

▶ This is a cutting from an illuminated manuscript – the first letter of a text that is now lost. In the eighteenth and nineteenth centuries illuminated medieval manuscripts were frequently cut up and their illuminations framed or stuck into albums. This illumination was painted in Lombardy, northern Italy, probably around 1480. St Apollonia of Alexandria (died 249) was a virgin martyr who refused to sacrifice to pagan gods. She is said to have had her teeth pulled out before being burned at the stake. In the illumination she is shown holding a pair of pincers, in which is a tooth – the symbol of her martyrdom. In her right hand she holds an orange book bag.

Gouache on vellum; diam. 7.8 cm
Probably acquired by Sir Richard Wallace
at an unknown date
M322

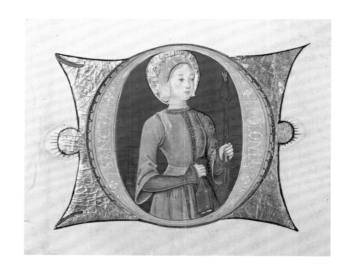

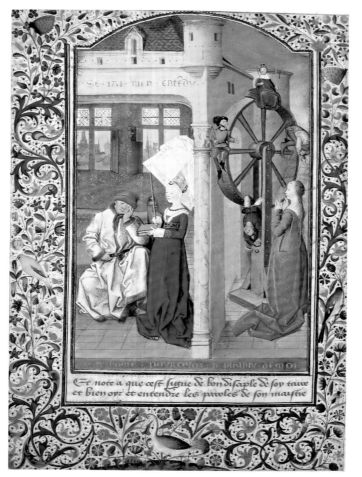

Miniature from Boethius, 'De Consolatione Philosophiae', late 15th century
French

◀ A cutting from an illuminated manuscript of the late Roman consul Boethius's celebrated work *On the Consolations of Philosophy*. The frontispiece to Book II, the illustration shows Boethius in a pink robe listening to instruction from the female figure of Philosophy. To the right, Fortune turns a wheel, on which are four figures, including a king with a crown. This miniature and another in the Wallace Collection, the frontispiece to Book III, are attributed to the Maître de Coëtivy, named after a Book of Hours made between 1458 and 1473 for Olivier de Coëtivy and his wife, Marie Marguerite de Valois (now in the Österreichische Nationalbibliothek, Vienna).

Gouache on vellum; 24.1 x 16.5 cm
Probably acquired by Sir Richard Wallace
at an unknown date
M320

Initial 'A' with Galeazzo Maria Sforza in prayer, 1477(?)

Cristoforo de Predis (active 1470s)

▲ The initial, perhaps cut from a choir book, shows Galeazzo Maria Sforza, Duke of Milan (1444–76), a famously martial figure, kneeling in prayer to God (the half-length figure, upper right), presumably asking for victory in the battle taking place in the middle distance. The arms of the dukes of Milan are also enclosed in a wreath in the border. The battle depicted probably took place during the campaigns of 1476, during which Galeazzo fought against the armies sent into northern Italy by Charles the Bold of Burgundy. Below the initial is

the artist's signature, partly rubbed: *Opus Xpstofori de Predis VII die Aprilis 147*[-]. Cristoforo, brother of the better known Ambrogio, signed various manuscripts in the 1470s.

Gouache on vellum; initial: h 22.4 cm; w 18.9 cm; border: h 9.7 cm, w 22.8 cm
Probably acquired by Sir Richard Wallace at an unknown date
M342

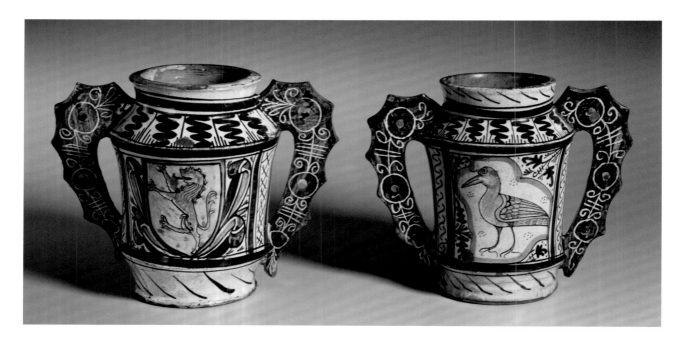

Drug Jars (*albarelli*), *c.*1460–1500
Italian, Deruta

 These drug jars show the early influence of Spanish tin-glazed and painted ceramics on potters in the small Umbrian town of Deruta, before the influence of classical antiquity came to dominate the decoration of Italian maiolica, the tin-glazed and painted earthenware associated most closely with late fifteenth- and sixteenth-century Italy. The Spanish influence is evident in the vessel form itself, and in the bold white, cobalt blue and manganese palette, the simple, compartmentalised patterns, the armorial shield and the flat, cusped handles with their incised decoration. Non-porous and relatively inexpensive, maiolica *albarelli* were used in pharmacies to store dry or semi-solid ingredients, covered with a piece of paper or parchment secured below the rim.

Tin-glazed and painted earthenware (maiolica)
Left: h 21.8 cm, w 27.3 cm; right: h 21 cm, w 25.5 cm
Acquired by Sir Richard Wallace in 1871
C80 and C81

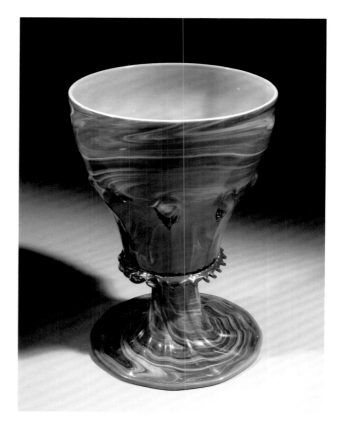

Goblet, *c.*1500
Italian, Venice

▶ This masterpiece from the 'golden age' of Venetian glassmaking is an exceptional example of the glassmakers' ability to simulate hardstones. The external striated decoration imitates chalcedony in contrasting warm and cold palettes, while the inside of the bowl may simulate jade. A writer of the period provides us with a sense of the awe in which this kind of work was held, proclaiming: 'There is no kind of precious stone that cannot be imitated by the industry of the glassworkers, a sweet contest of nature and man.' The goblet's shape is inspired by contemporary metalwork, and it may originally have had a lid. Prestigious glass goblets of similar form were made in imitation of rock crystal and turquoise.

Glass; h 17.8 cm, diam. 12.2 cm
Probably acquired by Sir Richard Wallace at an unknown date
XXVB92

Dish, *c.*1500–10
Italian, Deruta

▲ Deruta is renowned for producing glorious, large maiolica dishes, glowing with metallic-golden lustre. The young woman depicted on this early example epitomises the ideal of feminine beauty as immortalised by such artists as Perugino and Pinturicchio, who were working locally to great acclaim around the turn of the century. Perhaps the dish was a betrothal gift: the inscription on the scroll means 'My heart has only hope', and the pendant on a chain round her neck may house a portrait of the young woman's lover or a mirror showing his reflection.

Tin-glazed and painted earthenware (maiolica); diam. 38.9 cm
Acquired by Sir Richard Wallace in 1871
C27

❧ Alfred-Émilien O'Hara, comte de Nieuwerkerke ❧

The wonderfully rich and eclectic nature of the collections of medieval and Renaissance works of art and arms and armour in the Wallace Collection is largely due to Richard Wallace's purchase, in August 1871, of the extensive art collection formed in Paris by Alfred-Émilien, comte de Nieuwerkerke (1811–92).

Nieuwerkerke's extraordinarily successful career as an arts administrator in Second Empire France reached its apogee in 1863, with his appointment as surintendant des Beaux-Arts. He was also a highly successful sculptor, specialising in portraits and exhibiting at the Salon. Although he was able, ambitious and charming, his meteoric rise to prominence in both these fields was undoubtedly due in part to the influence of princesse Mathilde Bonaparte (1820–1904), cousin of Emperor Napoleon III (1808–73). Nieuwerkerke had a long-lasting liaison with the princess; when they met in 1845 she was already married to the Russian art collector Prince Anatole Demidoff.

Nieuwerkerke, who was ideally placed to keep abreast of the Parisian art market, assembled much of his collection between 1864 and 1868. Contemporaries were astounded by the quality and scale of his collection, densely arranged in carefully orchestrated displays in his apartment in the Louvre.

The spectacular German 'Gothic' suit of armour for horse and rider (see page 70) was the highlight of his arms and armour collection, which incorporated many outstanding examples from the great production centres in Germany and Italy. Decorative-arts objects from France, Germany and Italy abounded, including sculpture, furniture, ceramics, glass, enamels, goldsmiths' work, jewellery and watches. The collection featured in prestigious art books and was painted several times. It was the subject of Antoine Vollon's *Curiosités*, completed in 1868, which illustrates many works of art now in the Wallace Collection. ❧

Right:
Alfred-Émilien O'Hara, comte de Nieuwerkerke,
1868 (detail)
Édouard Dubufe
Gattaiola, Duranti Collection

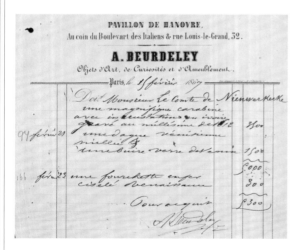

Above:
Invoice from Alfred Beurdeley to Nieuwerkerke,
15 February 1867
Hertford House Archives

Right:
Plaque: *Marguerite de France as Minerva*
Enamel: Jean de Court, 1555;
frame: Northern Italian, *c.*1500 and
French, *c.*1850
Acquired by Sir Richard Wallace in 1871
Enamel: IIIF253; frame: F502

For the plaque see page 50

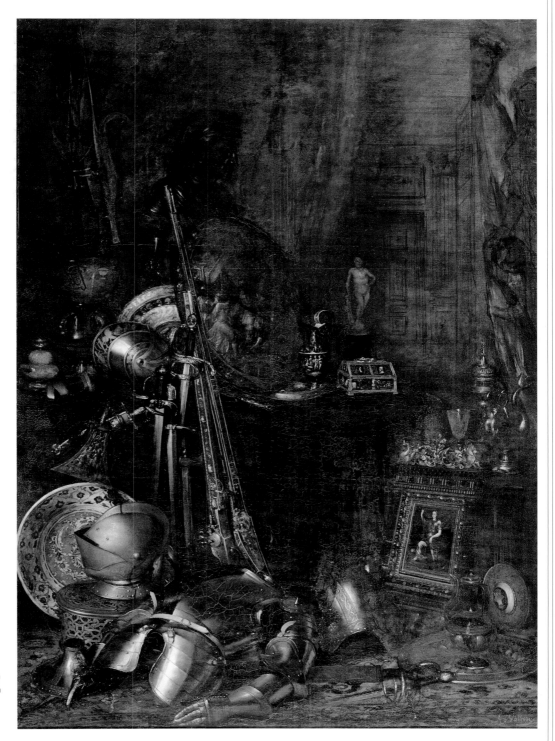

Curiosités, 1868
Antoine Vollon (1833–1900)
Oil on canvas; 264 x 192 cm
Paris, musée d'Orsay
© Photo RMN/ © Hervé
Lewandowski

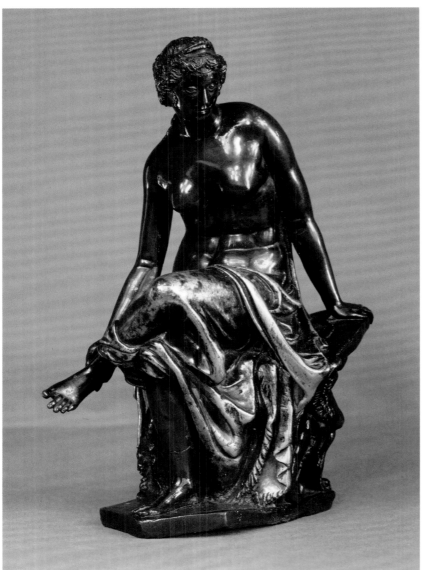

Seated Nymph, late 15th century
Giovanni Fonduli da Crema (active c.1480)

◀ This statuette is signed on the back of the throne in a cartouche OPUS IO CRE, which has been taken as the signature of da Crema. Almost nothing is known of this sculptor, though he is known to have worked in Padua, a great centre for bronze casting in the late fifteenth and early sixteenth centuries. Surprisingly, given that the *Seated Nymph* has long been regarded as one of the finest small bronzes to survive from the Renaissance, no other bronzes by Giovanni Fonduli have been identified. Details such as the coiffure and the grotesque creatures round the seat are similar to the work of Andrea Riccio (1470–1532), while the subtle gilding of the drapery recalls the statuettes of the Mantuan sculptor Antico (c.1460–1528).

Bronze, partially gilt; h 20.4 cm
Acquired by the 4th Marquess of Hertford by 1865
S72

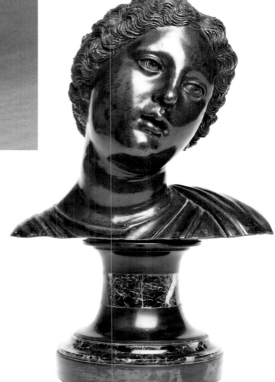

Ideal Head, c.1500–10
Antonio Lombardo (c.1458–1516)

▶ Rather than a portrait, this is a representation of ideal beauty based on classical prototypes: the lady's elaborate hairstyle, for example, derives directly from Roman female portraits. Although designed by Antonio Lombardo, a member of the most successful family of sculptors in Venice around 1500, it was probably cast by Severo da Ravenna (c.1465/75–after 1538). The bust might originally have stood on a desk or high up on a shelf in a scholar's study.

Bronze; h 17.8 cm
Acquired by Sir Richard Wallace in 1871
S62

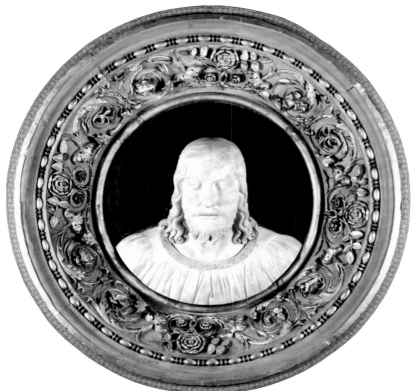

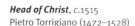

Head of Christ, c.1515
Pietro Torrigiano (1472–1528)

◀ Pietro Torrigiano, Michelangelo's bitter rival when they were students together in the Florentine Academy and the man who famously broke Michelangelo's nose in a fight, had come to England by 1511, the year he began a number of sculptures for Westminster Abbey. In 1512 he was commissioned by Henry VIII to design and execute the tomb of Henry VII and Elizabeth of York in the newly built Chapel of Henry VII. This bust was also sculpted for the Abbey, and was originally mounted on a wall between the Islip and Esteney chapels in the north transept. It was probably removed from there in the eighteenth century. It is said that Sir Richard Wallace discovered the sculpture in the servants' hall of his country seat, Sudbourne Hall in Suffolk.

Marble; h (bust) 45.8 cm, diam. 96.5 cm
Probably acquired by Sir Richard Wallace
at an unknown date
S7

Hat Badge (enseigne): Judith with the Head of Holofernes, c.1535–40
English

▼ Hat badges were a common adornment at many sixteenth-century European courts. Although they were not as popular at the Tudor court, a few very richly ornamented examples were made in England. Scenes from the Old Testament appear to have been especially popular. This badge shows the Jewish heroine Judith dropping the head of the Assyrian general Holofernes into a bag held by her servant. He had been besieging Bethulia and had hoped to seduce her, but she decapitated him while he was overcome with liquor (Apocrypha: Judith 13). The simplicity and directness of the design are comparable to contemporary woodcut illustrations.

Chased and enamelled
gold; diam. 5.3 cm
Acquired by Sir Richard
Wallace in 1871
XIIA62

St John the Baptist in the Desert, c.1500–25
Italian, Florence

▶ The saint, the forerunner or 'messenger' of Christ, is shown at the time he retired to the desert (Luke 1:80). He wears a shirt of camel's hair. Other versions of this model indicate that when complete the saint would have held a cup in his left hand and his right hand to his heart. The Wallace Collection's statuette is one of a large number of similar works, products of an unidentified studio working in Florence in the first quarter of the sixteenth century. It has recently been suggested that they may be early works by the sculptor Jacopo Sansovino (1486–1570).

Terracotta; h 66 cm
Probably acquired by Sir Richard Wallace
at an unknown date
S55

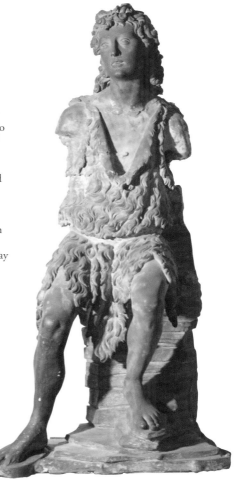

Shrine: *The Virgin and Child Enthroned*, c.1510–20
Italian, probably Gubbio

▶ Apparently serene, this image of the Virgin and Child enthroned under a canopy in fact alludes to Christ's Crucifixion, for the Child holds a bird, symbol of the soul's flight after death. Small devotional reliefs, displayed in homes and on street corners, were popular in Italy until quite recently. This shrine is one of only four devotional reliefs set within Gothic niches to survive in maiolica. The small Umbrian town of Gubbio was renowned for its lustrewares at this period, especially the distinctive red used here in conjunction with a golden-brown lustre. Maiolica reliefs decorated with lustre are extremely rare.

Tin-glazed and painted earthenware (maiolica); h 45.8 cm, w 25.8 cm, d 9.5 cm
Acquired by Sir Richard Wallace at an unknown date
C25

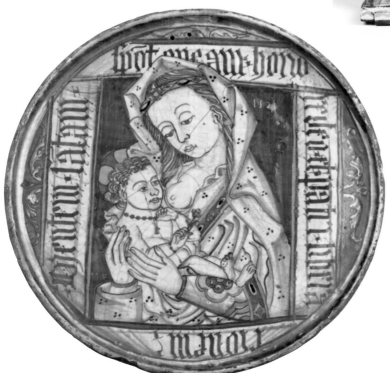

Wall Plaque: *The Virgin and Child*, 1521
Italian

◀ This unusual wall plaque is surprisingly archaic for 1521, the date inscribed beside the Virgin's head. The depiction of the Virgin nursing the infant Christ is taken from an anonymous fifteenth-century German woodcut. The maiolica painter has embellished the figures and added a taut scroll inscribed in Gothic script with a phrase that was used in the Middle Ages to protect against fire and lightning. Mother and child are posed reflectively within the white scroll, which is arranged to represent a window. The Virgin leans forwards out of the frame, suggesting, perhaps, engagement with the wider world even during this moment of intimacy.

Tin-glazed and painted earthenware (maiolica); diam. 34.8 cm
Acquired by Sir Richard Wallace in 1871/2
C79

The Virgin and Child with the Infant Baptist, c.1517–19
Andrea del Sarto (1486–1530)

▼ The Virgin holds the standing Christ who, with outstretched hand, blesses the infant St John the Baptist. St John is already dressed in animal skins of the kind he will wear when preaching in the desert. Behind him stand two angels, and in the landscape to the right an episode from the *Fioretti* (*Little Flowers*) of St Francis is illustrated, with St Francis kneeling before an angel playing a viol. The picture demonstrates del Sarto's increasingly mannerist elegance in its colouring, complex artificial composition and elegantly refined poses, which nevertheless convey emotion with great immediacy. Numerous related versions and copies attest to the popularity of the composition.

Oil on poplar panel; 106.5 x 81.3 cm
Acquired by the 4th Marquess of Hertford in 1850
P9

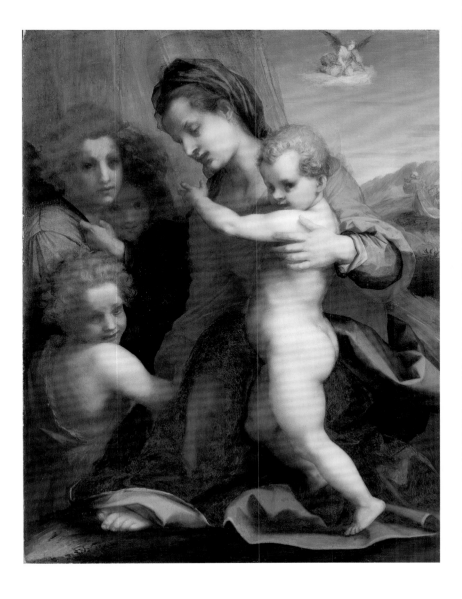

The Lure of the Antique

A fascination with antiquity, the fabulous worlds of ancient Greece and Rome, is a theme that runs through and links many works of art in the Wallace Collection. Although the ancient world had not been forgotten completely during the so-called Dark Ages, the advent of the European Renaissance created an explosion of new interest in the Antique that was to last for centuries to come. This enthusiasm could be expressed in different ways, but at its most obvious level can be seen in the appropriation of the mythology of Greece and Rome for the subject matter of countless paintings, sculptures and other works of art. Educated people in Renaissance Italy or in eighteenth-century France, for whom such works of art were made, would have recognised instantly the subject matter as well as the moral context of a story such as Venus taking leave of her doomed lover Adonis. People also genuinely identified with and even had themselves depicted as gods or as heroic characters from ancient Greek and Roman history. This strong sense of continuity with the distant past, difficult for us to appreciate today, is charmingly caught in a tiny plaque depicting the Roman god of medicine, Aesculapius, dressed as a sixteenth-century physician.

Roman and Greek sculptures, the most tangible surviving evidence of the artistic achievement of the ancients, became during the Renaissance more sought after than any contemporary works of art. From the Renaissance onwards, copies after the Antique were produced in huge numbers and in all materials and sizes. Some, for example the *Hermaphrodite*, are close, often very beautiful, copies of the ancient prototype. For others, such as the *Niobid*, artists would use an ancient sculpture as the starting point for their own new interpretation of the antique spirit. These and many other works of art in the Wallace Collection bear eloquent witness to the continuing and potent spell woven by ancient Greece and Rome.

Above:
Aesculapius, 16th century
German
Gilt bronze; h 5.4 cm, w 3.8 cm
Acquired by Sir Richard Wallace in 1878
S318

Left:
Niobid, 16th century
Italian
Bronze; h 32.4 cm
Acquired by Sir Richard Wallace in 1871
S73

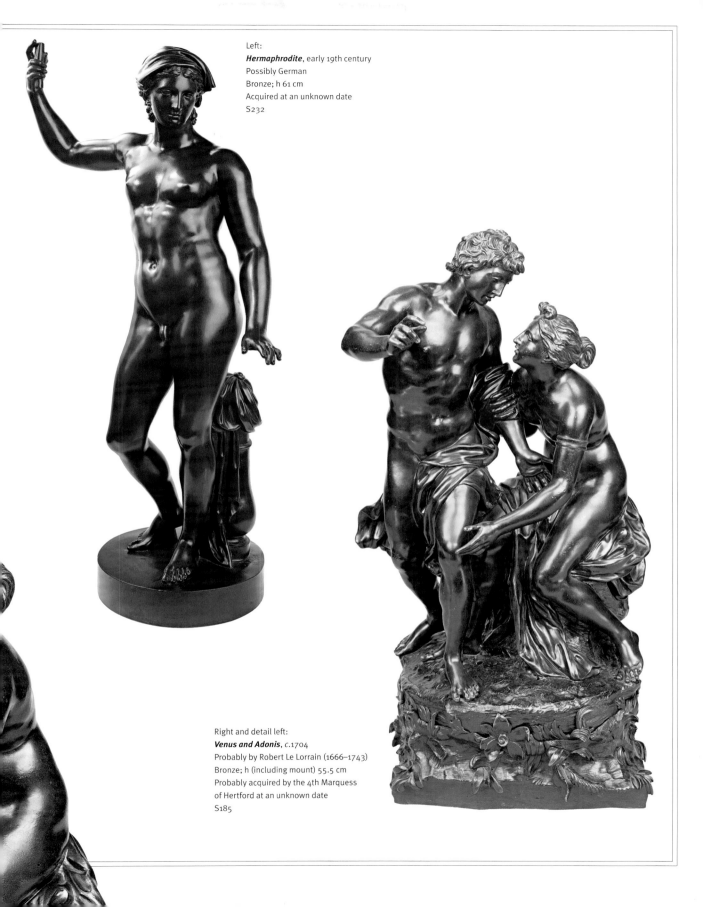

Left:
Hermaphrodite, early 19th century
Possibly German
Bronze; h 61 cm
Acquired at an unknown date
S232

Right and detail left:
Venus and Adonis, c.1704
Probably by Robert Le Lorrain (1666–1743)
Bronze; h (including mount) 55.5 cm
Probably acquired by the 4th Marquess
of Hertford at an unknown date
S185

Ewer and Basin, early 16th century
Italian, Venice

▼ Ewers and basins were very common domestic objects during
the Renaissance and would have been found in every well-to-do
household. While undecorated sets in plainer materials were made
for daily use, grander sets such as this were generally made for
ceremonial purposes and would not necessarily have been used.
The basin bears a pair of coats of arms, one of which has been
identified as that of the Ciacchi family of Florence, suggesting that
this set was made as a gift for a marriage involving a member of this
family. The ewer and basin are characteristic examples of Venetian
enamelled copperwork from the period around 1500. The gadroon-
ing in the lower section of the ewer and on the dish also occurs in
Venetian glass of the late fifteenth and early sixteenth centuries and
is derived from contemporary metalwork.

Enamelled copper; ewer: h 29.5 cm, w 19.4 cm;
basin: diam. 46.7 cm
Acquired by Sir Richard Wallace in 1871
IIIF279 and IIIF280

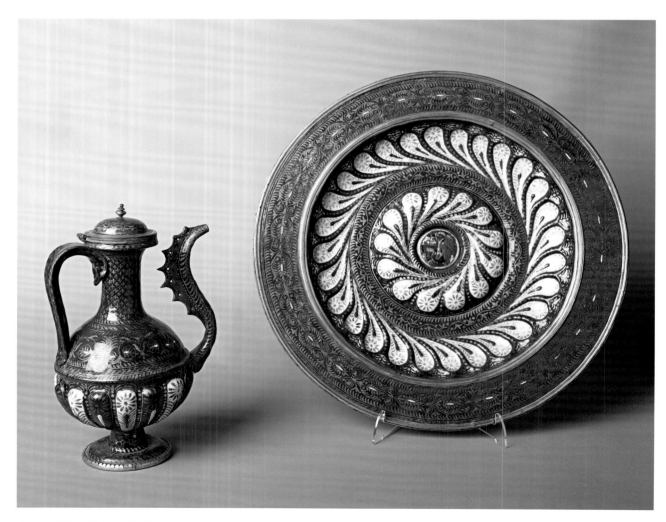

Niccolò di Pietro de' Boni, 1528
Giovanni Francesco Rustici (1474–1554)

▼ Niccolò Boni was the housekeeper of the Florentine sculptor and painter Giovanni Francesco Rustici. In 1528, Rustici, who was of noble birth and more of a dilettante than a professional artist, left for France, leaving his property in Florence under the supervision of Boni. It has been suggested that he made this medal as a farewell gift. Boni's dress as an emperor *all'antica* may relate to his appearance in the masquerades that were popular in Florentine aristocratic society.

Bronze; diam. 6.3 cm
Probably acquired by Sir Richard Wallace
at an unknown date
S349

The Rape of Ganymede, 16th century
Italian

▲ Struck by his beauty, Jupiter chose the shepherd Ganymede to be his cupbearer and came to earth in the guise of an eagle in order to carry him up to Olympus. This oval relief, remarkable for the vivacity of its modelling, is closely based on a celebrated drawing by Michelangelo Buonarroti (1475–1564). The drawing was reproduced in various media, including a now lost rock-crystal carving by Giovanni Bernardi (1496–1553), in turn used to produce a series of smaller bronze plaquettes. A version of Michelangelo's drawing that is now in the Fogg Art Museum, Cambridge, Massachusetts, may be the original.

Bronze; h 23.8 cm, w 32.7 cm
Probably acquired by Sir Richard Wallace
at an unknown date
S316

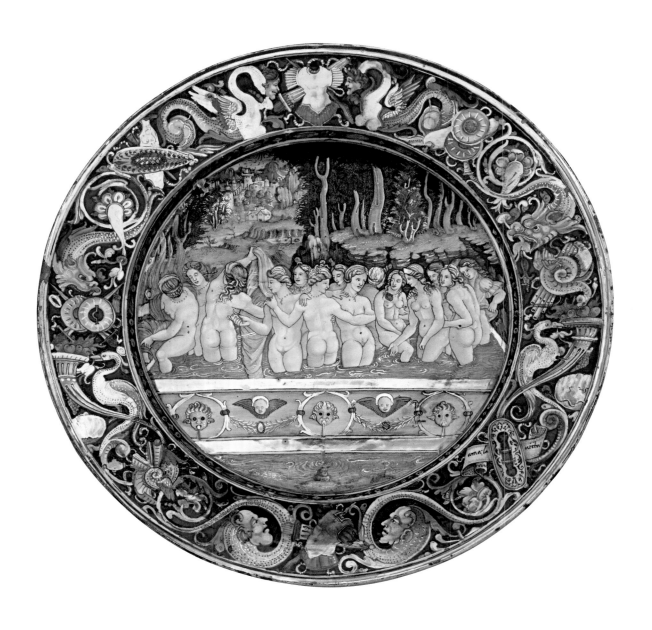

Dish: *The Bathing Maidens*, 1525
Workshop of Giorgio Andreoli (*c.*1470–1555)

▲ This exquisite, monumental dish is an outstanding example of the virtuosity achieved by Maestro Giorgio Andreoli's acclaimed maiolica workshop in Gubbio, Italy. The inscription in lustre on the back, dated 6 April 1525, proclaims proudly that it was made in this workshop, which was celebrated for the beauty of its lustre, especially the distinctive red. Silver, gold and red lustre all shine from the surface of this beautiful dish. The contemporary fascination with classical antiquity is demonstrated by the pool in which the young

ladies bathe, with its Roman-inspired marble front, and by the flamboyant rim, decorated extravagantly with grotesques. The bathing women are taken from three Italian prints depicting subjects from classical mythology.

Tin-glazed and painted earthenware (maiolica); diam. 44.6 cm
Acquired by Sir Richard Wallace in 1872
C66

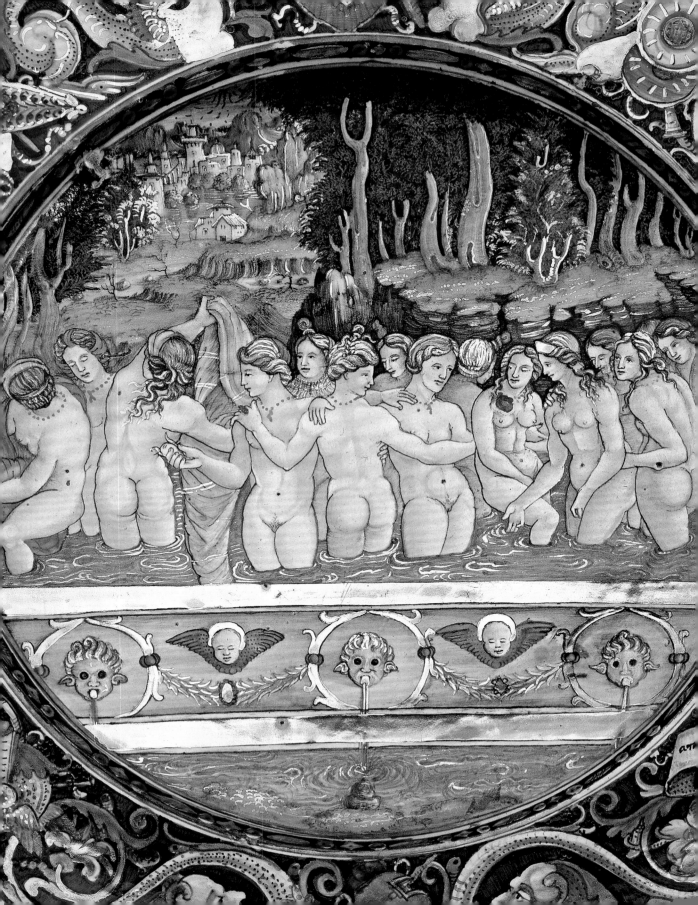

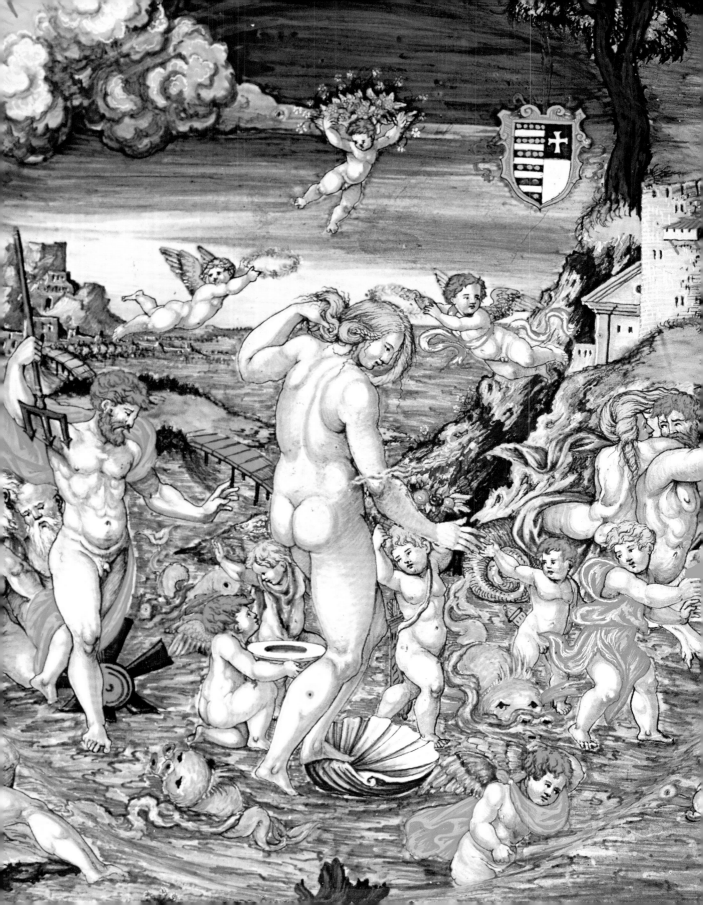

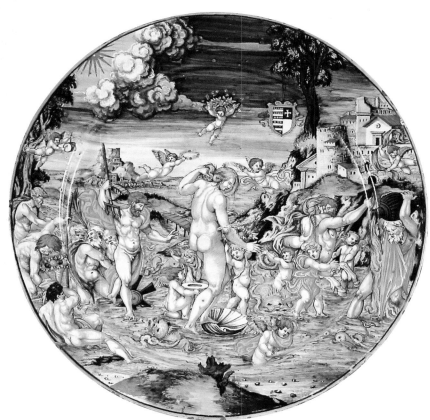

Dish: *The Triumph of Neptune*, 1533
Francesco Xanto Avelli da Rovigo (1500?–45)

◀ Two Venetian families, Michiel and Gritti, are represented by the coat of arms on this spectacular dish, probably made for Giacomo Michiel and his wife, Laura Gritti, the Doge's niece. It was painted by Xanto, who signed and inscribed more works than any other maiolica painter. The inscription on the back includes the verse 'Neptune triumphs here in the salt waves on which rejoices the amorous naked Star between her sons, and fair and lovely comes crowned with flowers and leaves'. The complex allegory probably celebrates Venice as a victorious maritime power. As was his usual practice, Xanto extracted figures from various print sources and incorporated them into his composition.

Tin-glazed and painted earthenware (maiolica); diam. 48 cm
Probably acquired by Sir Richard Wallace at an unknown date
C89

Adam and Eve in Paradise, *c.*1535–50
'Adam D'

▶ Almost nothing is known about the sculptor 'Adam D', beyond his tantalisingly cryptic signature and a handful of works. He was one of the leading members of a group of wood-carvers in the so-called Danube School, who worked in an area bounded by Salzburg, Passau and Prague, and often evoked the lush forests and mountains of the region in their art. Although the human figures in this refined relief are placed in the foreground, the composition is determined by the almost overpoweringly luscious forest landscape, in which animals abound.

Rosary Bead: *St George and the Dragon* and ***St Hubert and the Stag*,** early 16th century
Flemish

▶ This wood-carving, a work of astonishing skill on a minute scale, comes from a rosary, a string of beads used to assist the memory when reciting prayers. It contains images of St George slaying the Dragon and St Hubert being converted to Christianity by the sight of a stag bearing a crucifix between its antlers. The carving has been attributed to the workshop of Adam Dirksz (working 1500–30).

Boxwood; h (open) 8.9 cm, w 4.5 cm
Acquired by Sir Richard Wallace in 1871
S281

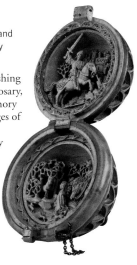

Right:
Wood, probably pear; h 11.6 cm, w 8.4 cm
Probably acquired by Sir Richard Wallace at an unknown date
S291

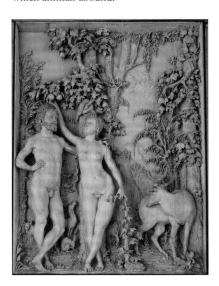

Medieval and Renaissance Art ❧ 45

An Allegory of True Love, c.1547
Pieter Pourbus (1523/4–84)

▶ Pourbus's masterpiece depicts a group of mythological and allegorical characters. The viewer's gaze is met in the centre of the picture by an older man, Sapiens (Wisdom), who embraces Fidutia (Fidelity). She offers the wise man spiritual love sanctified by Christian matrimony, while the other figures warn the viewer of the folly of carnal love. The complex subject reflects Pourbus's involvement with the erudite circles of the Bruges Chambers of Rhetoric, while the elegant figures reveal his debt to Italian mannerism. The lively landscape background and naturalistic detail also clearly demonstrate the development of naturalism in painting in the Southern Netherlands.

Oil on oak panel; 132.8 x 205.7 cm
Acquired by Sir Richard Wallace in 1872
P531

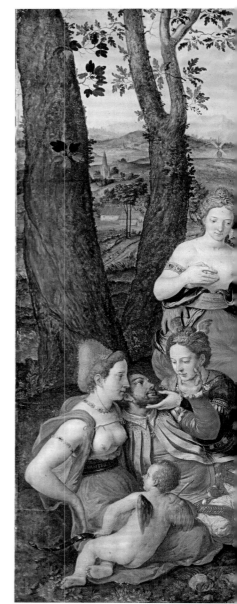

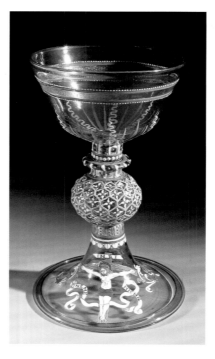

Chalice-shaped Goblet, c.1540–50
French

◀ The demand for fine Venetian-style glass in sixteenth-century Europe induced some Italian glassmakers to work abroad. This goblet is one of a small group of surviving enamelled-glass vessels that were made in France, probably by immigrant Italian glassmakers, in the mid-sixteenth century. The Crucifixion on the foot and the snakes and rays emanating from the base of the bowl perhaps allude to St John's Gospel (3:14–15): 'And as Moses lifted up the serpent in the wilderness, even so must the Son of Man be lifted up: That whosoever

believeth in him should not perish, but have
everlasting life.' The image of Christ would
literally have been lifted when the goblet was
raised. Glass chalices were prohibited for the
Eucharist, so it would be fascinating to know
the circumstances of its commissioning.

Glass with enamels and gilding; h 22.4 cm,
diam. 14 cm
Acquired by Sir Richard Wallace in 1871
XXVB96

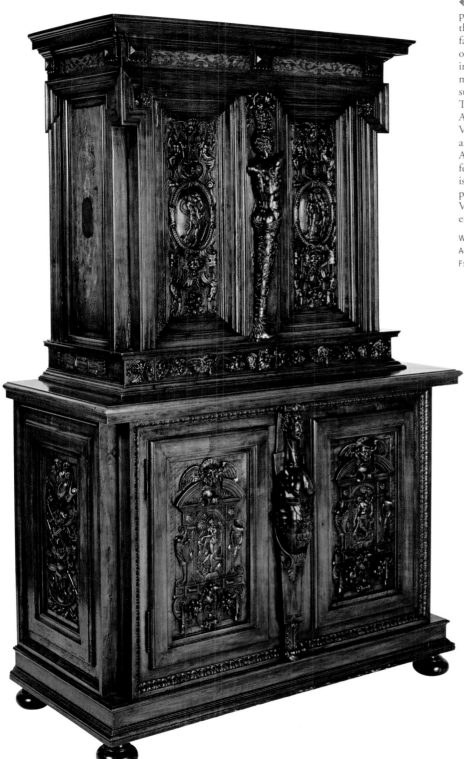

Cabinet, *c.*1550 and *c.*1865
French

◀ This cabinet is characteristic of the many pieces of furniture that were put together in the nineteenth century in response to the fashion for medieval and early Renaissance objects. The doors of the upper stage include oval medallions dating from the mid-sixteenth century, with mythological subjects derived from classical gems. The one on the left shows Hercules and Antaeus, the one on the right Mars and Venus. The male term is of the same period and based on an engraving by Jacques Androuet du Cerceau (*c.*1510–*c.*1584). The female term in the centre of the lower stage is reminiscent of grotesques in Roman wall paintings and at Raphael's Loggia at the Vatican and might also derive from an engraving by du Cerceau.

Walnut and oak; h 217.5 cm, w 135.8 cm, d 61.9 cm
Acquired by Sir Richard Wallace in 1871
F11

Footed Bowl: *The Death of Cleopatra, Queen of Egypt*, *c*.1550–75
Martial Ydeux, 'dit le Pape' (dates unknown)

▼ ▶ The fate of Cleopatra, who killed herself following the suicide of her lover Antony and her defeat by the Romans under Octavian, inspired many sixteenth-century French writers and artists. The interior of this bowl shows the moment when the reclining Cleopatra applied two poisonous asps (venomous snakes) to her breasts, watched by her horrified attendants. The decoration in the bowl is based on an engraving by Jean Mignon, probably after a design of around 1544 by Luca Penni. Mignon and Penni were employed by François I at Fontainebleau. The fashionable style of decoration associated with the château is reflected in the Queen's elongated body and the elaborate, fruit-filled border.

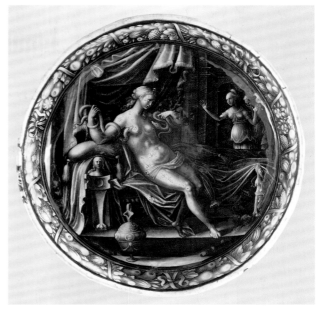

Enamel with gilding on copper; h 7.3 cm, diam. 23.6 cm
Probably acquired by Sir Richard Wallace *c*.1871–3
IIIF243

Table, *c*.1550 and *c*.1830
North Italian and English

▼ One of a pair, this table has mid-sixteenth-century north Italian supports, which are dramatic examples of Renaissance Italian carving, featuring winged female terms flanking masks. The tabletops were probably added in about 1830, making the tables also important

examples of the nineteenth-century revival of interest in Renaissance styles. The tables appear to have been put together in their current form for Bentley Priory, home of the 2nd Marquess of Abercorn, at whose sale in 1853 they were bought by the 4th Marquess of Hertford.

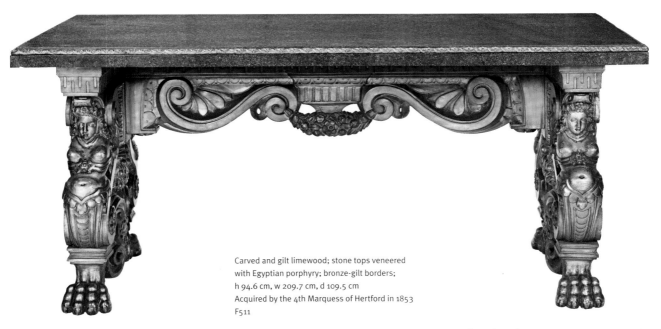

Carved and gilt limewood; stone tops veneered
with Egyptian porphyry; bronze-gilt borders;
h 94.6 cm, w 209.7 cm, d 109.5 cm
Acquired by the 4th Marquess of Hertford in 1853
F511

Medieval and Renaissance Art ❧ 49

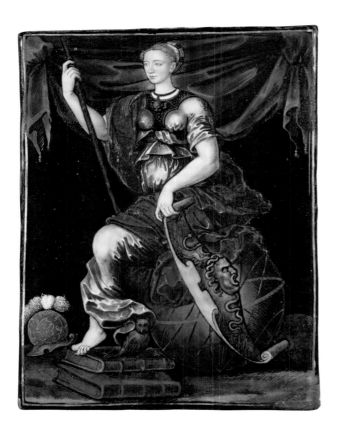

Plaque: *Marguerite de France as Minerva*, 1555
Jean de Court (?–c.1585)

◀ This plaque is the only fully signed and dated enamel by Jean de Court. It depicts Marguerite de France (1523–74), daughter of François I and sister to Henri II, as Minerva/Pallas, the classical goddess of war and wisdom. She has the goddess's attributes: a shield, breastplate, helmet and spear as goddess of war, and an owl and books as goddess of wisdom. Marguerite's learning was widely respected. Writers and poets, Pierre Ronsard among them, regarded her as their protectress and champion in the fight against ignorance. The globe, symbol of fame, also illustrates Marguerite's motto, *Rerum sapientia custos* (Wisdom, guardian of the world).

Enamel with foil and gilding on copper; h 20.9 cm, w 15.8 cm
Acquired by Sir Richard Wallace in 1871
IIIF253

For the frame, see page 32

***The Holy Family*, c.1560–70**
Pompeo Cesura (?–1571)

▶ Cesura was associated with the school of Raphael early in his career. This composition is clearly influenced by Raphael's *Madonna of the Rose* (now in the Prado, Madrid) and Perino del Vaga's *Holy Family*. Its sweet facial expressions, bright colours and elegant, elongated forms, however, also recall the Italian mannerists, Correggio and Parmigianino. The painting must have enjoyed some popularity in its day, for it was etched by Orazio de Sanctis in 1573 and again by an anonymous engraver in a print published by Giacomo Rossi.

Oil on walnut panel; 26.4 x 18.7 cm (including arched top);
21.2 x 13.8 cm (painted surface)
Acquired by the 4th Marquess of Hertford at an unknown date
P552

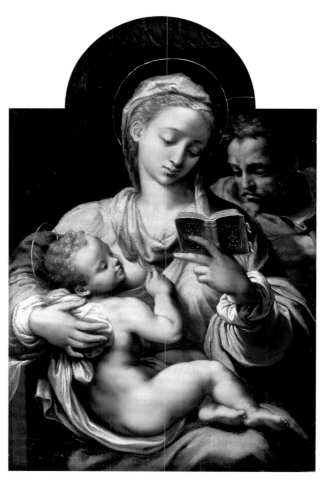

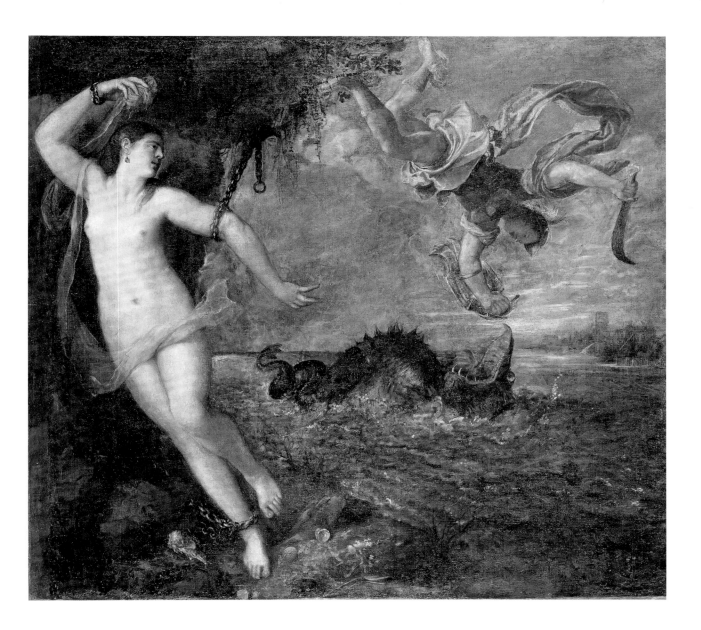

Perseus and Andromeda, 1554–6
Titian (*c*.1485/90–1576)

▲ The story of Perseus and Andromeda is told in Ovid's
Metamorphoses. Queen Cassiopeia, wife of Cepheus, King of Joppa,
boasted that she and her daughter, Andromeda, were more beautiful
than the sea nymphs, the Nereides. Neptune, god of the sea, angry
at this insult, sent a sea monster to destroy Cepheus's kingdom.
Andromeda was chained to a rock as a sacrifice to appease the
monster, but was rescued by Perseus, whom she later married. The
picture was one of six poesies (visual poems) devised for Philip II,
King of Spain. It later belonged to the sculptor Pompeo Leoni

(1533–1608), Van Dyck, the Regent, Philippe, duc d'Orléans, Philippe
'Egalité', duc d'Orléans, the Duke of Bridgewater, the Earl of Carlisle
and the Earl of Gower. The condition of the painting has suffered
greatly since the sixteenth century, although the grandeur of Titian's
original conception still has the power to impress.

Oil on canvas; 175/173 x 189.5/186.8 cm roughly cut
Acquired by the 3rd Marquess of Hertford in 1815
P11

Dish, *c.*1560–70
Turkish, Iznik

▶ This beautiful dish is wonderfully evocative of the sixteenth-century Ottoman court culture in which Iznik ceramics flourished. At its centre, the glorious turquoise background, suggesting perhaps a brilliant summer sky, is a perfect foil for the fantastical, stylised peacock among flowers and foliage. The delightful decoration in the border, comprising split palmettes interwoven with flowers and leaves, both frames and extends the peacock's flower-bedecked domain. The distinctive red, standing out in relief, was a recent addition to the Iznik palette, which became more vivid from around mid-century. A key element in the popularity of Iznik ceramics was the strong, clean white ground. The inclusion of a bird at the centre of an Iznik dish is very unusual at this early date.

Underglaze-painted fritware; diam. 47.4 cm
Acquired by Sir Richard Wallace in 1871
C199

Cabinet, *c.*1580 and *c.*1860
French, Burgundy and Paris

◀ This late sixteenth-century Burgundian cabinet was restored in the mid-nineteenth century. The cornice, carved panels and standing figures are probably old, but the plinth, the bun feet, and the panelled backs and side panels of both stages are nineteenth century. The upper stage is decorated with three standing female figures, all supporting baskets of fruit. In the centre is Hecate, a goddess of the Underworld, crowned with a crescent moon and encircled by a serpent. The drawer fronts of the lower stage are carved with trophies of arms and the doors with grinning masks and pairs of harpies (bird-like female monsters). The keyholes for the upper and lower sections are both concealed, the upper one by a sliding section of Hecate's drapery, the lower one by the tongue of the grotesque mask on the plinth of the central term.

Walnut and pine; h 199.5 cm, w 180.6 cm, d 71 cm
Acquired by Sir Richard Wallace in 1871
F10

Charles IX, *c.*1570–79
Germain Pilon (*c.*1525–90)

▶ Charles IX (1550–74) acceded to the throne of France at the age of ten. Weak in health and character, he was dominated by his mother, Catherine de'Medici, and by the duc de Guise, the leader of the Catholic faction at a time of intense religious strife in France. For all the splendour of Charles's costume, with his laurel crown and military armour, the thin lips and suspicious eyes of this masterful portrait brilliantly suggest the young King's brittle and nervous character. It is one of the finest surviving works of Germain Pilon who was *sculpteur du roi* under both Charles IX and his successor, Henri III.

Bronze; h (excluding socle) 62.2 cm, w 60.5 cm
Acquired by the 4th Marquess of Hertford in 1865
S154

Platter: *Apollo and the Muses*, *c.*1580
Martial Courteys (dates unknown)

▼ The viol-playing god Apollo presides over the nine music-making Muses, while behind them two poets crowned with laurel wreathes converse. The winged horse Pegasus stamps to prevent the mountain from rising in response to the music. His stamping creates the Hippocrene stream, personified by the young woman below Apollo who pours water from a vase. The composition derives ultimately from Raphael's *Parnassus* fresco in the Vatican, but its direct source is an engraving after a drawing by Luca Penni. Penni's modifications to Raphael's composition include the addition of Pegasus and the Hippocrene stream, both of which are associated in classical mythology with Apollo and the Muses on Mount Helicon, rather than Parnassus. The coat of arms suspended from the tree has not been identified.

Enamel with gilding on copper;
h 41.7 cm, w 56.3 cm
Probably acquired by
Sir Richard Wallace *c.*1871–3
IIIF268

See details on pages 18–19

Wine Cooler, 1574
Workshop of Flaminio Fontana

▼ Probably made for Cosimo I de'Medici, Grand Duke of Tuscany, this monumental wine cooler bears his device of a turtle with a mast on its back, illustrating his motto, *Festina lente* (Hasten slowly). The inscription on its base indicates that it was made in Fontana's maiolica workshop in Urbino in 1574; Cosimo died in April 1574. Wine coolers were kept on or below a buffet, filled with ice, snow or cold water, to keep wine cool during meals. The decoration of this exceptionally large cooler combines white-ground grotesques, vigorously sculpted monsters and a Roman naval battle scene derived, unusually, from a drawing. The water-based theme was appropriate to a wine cooler.

Tin-glazed and painted earthenware (maiolica);
h 40 cm, l 71 cm
Acquired by Sir Richard Wallace in 1875
C107

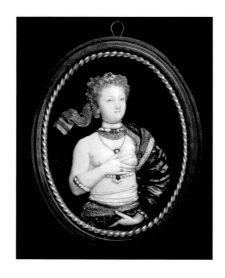

Youth, late 16th century
Italian

◀ Due to its malleability wax has been widely used for the production of sculptures, and it emerged as an art form in its own right in the fifteenth and sixteenth centuries, particularly in Italy. This example has a companion piece also in the Wallace Collection, of *Old Age*, showing a wrinkled old woman holding a crutch. A similar pair of waxes is in the Victoria and Albert Museum, London. Such images, emphasising the brevity of human life and the vanity of human ambitions, were commonplace in medieval and Renaissance art.

Wax; h 10 cm, w 7.5 cm
Acquired by Sir Richard Wallace in 1871
S457

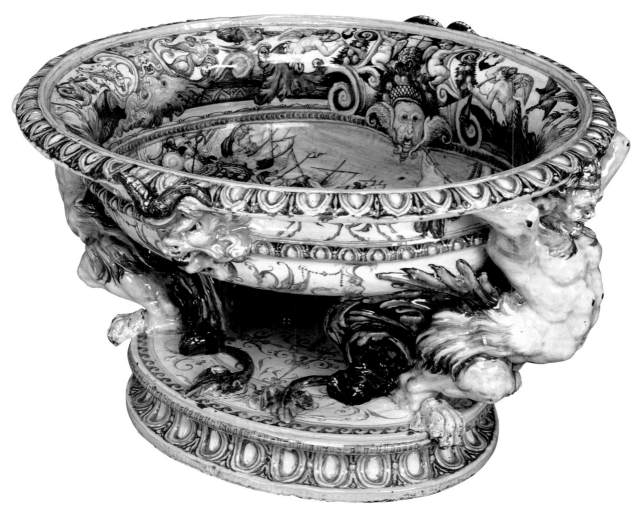

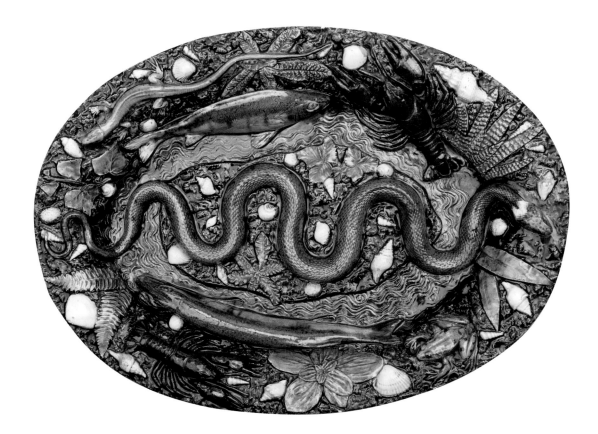

Basin, late 16th century
Bernard Palissy (1510–90) or a follower

▲ Bernard Palissy, a highly innovative self-taught potter, pioneered the production of lead-glazed earthenwares incorporating life-cast reptiles, water creatures and plants. His interest in the imitation of nature through art was shared by many artists of the period. This basin is an excellent example of the rustic-style pottery, or *figulines rustiques*, for which Palissy is best known. He sold his first rustic basin to Henri II in 1556. This basin has been transformed into a pond or stream supporting an abundance of animal and plant life, including a snake, fish and crayfish. Perhaps it accompanied a ewer for hand washing during meals or simply served as a table ornament.

Painted and lead-glazed earthenware;
l 49.3 cm, w 37.1 cm
Probably acquired by Sir Richard Wallace
at an unknown date
C174

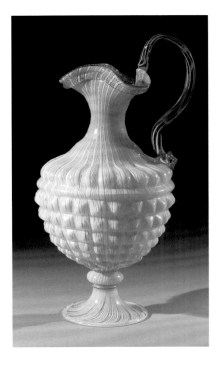

Ewer, late 16th century
Italian, Venice

◀ Surely the slender handle of this elegant ewer could not have supported its weight while the contents were being poured? If it were used at all, the ewer must have been held with two hands. Perhaps it simply adorned the sideboard during a meal, demonstrating the discerning taste of its owner in prizing the fabulous technical feats of the Venetian glassmakers. While this classic ewer shape had enduring appeal in sixteenth-century Italy, the elaborate decoration, combining a complex network of white canes incorporated into the glass (*vetro a retorti*) with the mould-blown pineapple form of the body, is typical of the more flamboyant productions of the latter part of the century.

Glass with *vetro a retorti* decoration and gilding;
h 27.1 cm, diam. 13 cm
Probably acquired by Sir Richard Wallace in 1871
IIIE174

Hans Holbein, 1543
Lucas Horenbout (1490/5–1544)

▶ Horenbout's exquisitely detailed manner of painting on vellum established the main characteristics of miniature painting in England in the sixteenth century. This style is represented superbly in the Wallace Collection by Horenbout's miniature of the German-born artist, Hans Holbein the Younger (1497/8–1543). The inscription in gold identifies the sitter by his initials (H. H.), his age (forty-five years old) and the date (1543). This was the year of Holbein's death from plague. The Wallace Collection's miniature was probably painted posthumously to commemorate the deceased artist.

Gouache on vellum; diam. 4.2 cm
Bequeathed to Sir Richard Wallace by Lord Henry Seymour in 1859
M203

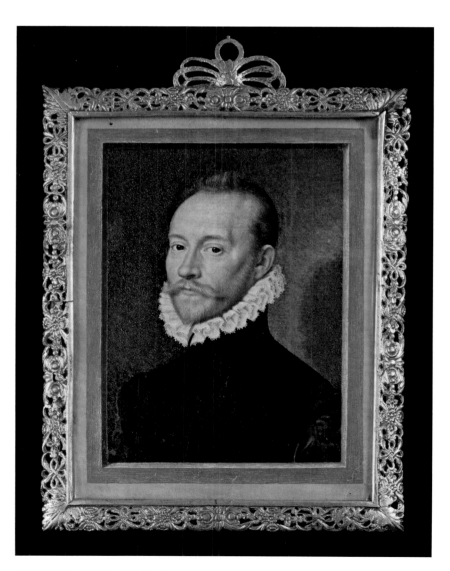

Jean de Thou, c.1570
François Clouet (c.1515/20–72)

◀ François Clouet succeeded his father, Jean, as court painter to François I in 1541. He specialised in portraiture, producing exquisitely detailed paintings, drawings and miniatures of the sixteenth-century French élite. Jean de Thou (died 1579), seigneur de Bonneuil, was a minor governmental official whose father became first president of the Paris Parlement in 1562. The pendant portrait of his wife, Renée Baillet, is also in the Wallace Collection.

Oil on card; 13.8 x 10.7 cm
Acquired at an unknown date
M263

See caption opposite

Pendant: *Rabbit*, late 16th century
Possibly Spanish

▶ One of the hallmarks of the Renaissance princely curiosity cabinet (*Wunderkammer*) was the juxtaposition of marvels from the natural world with masterpieces of human ingenuity. This duality can be seen in the small sculptures or items of jewellery created from large misshapen 'baroque' pearls, which became especially popular at princely courts from the late sixteenth century.

This particularly delightful pendant depicts a rabbit or hare, the flecked white-enamel points suggesting the animal's fur. Baroque-pearl jewellery of this type was made in Spain but also elsewhere in Europe, for example in Florence.

Baroque pearls and enamelled gold;
h (including chain) 6.2 cm
Probably acquired by Sir Richard Wallace
at an unknown date
XIIA78

Statuette of a Soldier, probably late 16th century
German

▶ The body of the soldier is made from two large baroque pearls, and the legs, arms, head and armour from silver, partly gilded. The use of pearls to create the body of the figure is notably successful in this brilliant and fluid figure in the full mannerist style. It appears to be one of the earliest baroque-pearl figures, the fashion for such small sculptures reaching its height in the later seventeenth and early eighteenth century.

Baroque pearls and parcel-gilt silver;
h (with base) 23.7 cm (without base) 16.1 cm
Probably acquired by Sir Richard Wallace
at an unknown date
IA35

Henri IV and Marie de'Medici, 1603
Guillaume Dupré (c.1574–1642)

▼ Dupré was also a sculptor, but his reputation rests mainly on his work as a medallist. He made many portrait medals of Henri IV (1553–1610), the first Bourbon King of France, and his wife Marie de'Medici (1573–1642). On the reverse of the medal the King and Queen are shown as Mars and Minerva, standing with hands joined and the infant dauphin (the future Louis XIII) as Cupid between them, an eagle descending from the skies with a crown in its beak. It was Henri IV who finally brought peace to France after decades of bitter civil war. Countless images celebrating his qualities and achievements were produced in many media.

Gilt bronze; diam. 6.6 cm
Probably acquired by Sir Richard Wallace
at an unknown date
S368

Sir Richard Leveson, c.1595–1600
Isaac Oliver (c.1565–1617)

◀ Isaac Oliver, a prominent member of the artistic community of Elizabethan and Jacobean London, was the most important pupil of the miniaturist Nicholas Hilliard, whose success he threatened towards the end of the sixteenth century. This miniature reveals his refined and cosmopolitan manner in details such as the wavy brown hair and carefully drawn face. The sitter was a naval commander who served on the *Ark Royal* against the Spanish Armada in 1588 and was eventually appointed vice-admiral of England in 1604.

Gouache on vellum; 5.2 x 4.3 cm
Acquired at an unknown date
M287

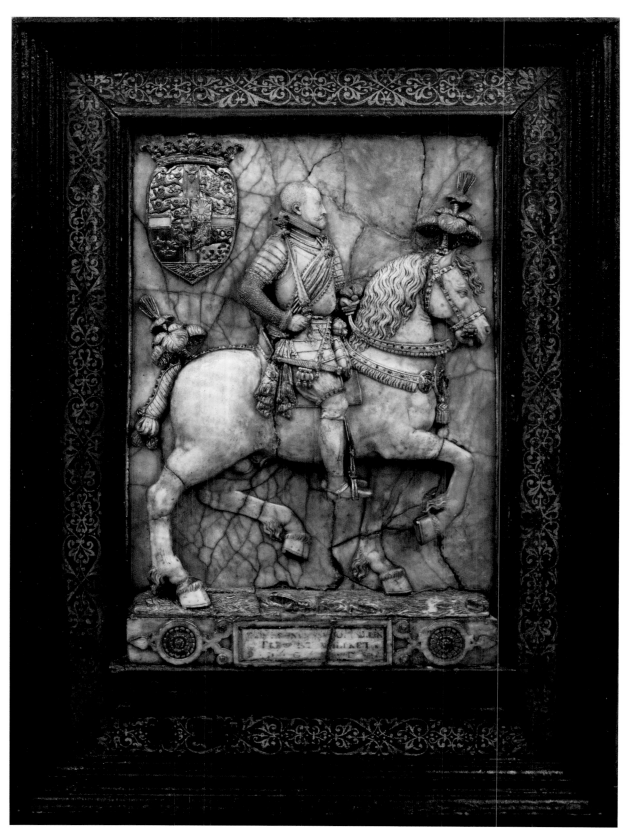

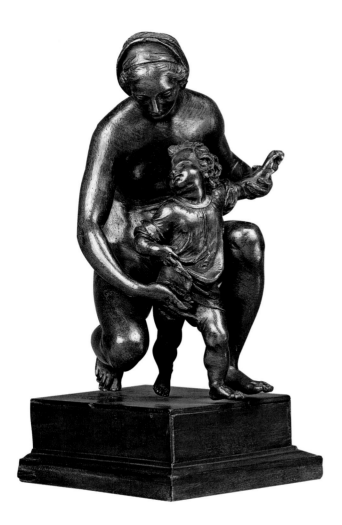

Mother and Child, *c.*1600
French

◀ This bronze has been attributed to Barthélemy Prieur (*c.*1536–1611). Appointed *sculpteur du roi* in 1591, Prieur was the most prolific maker of bronze statuettes working in France at the beginning of the seventeenth century. Many small bronzes attributed to him and his workshop have survived. The Wallace Collection's version of this particular model is the finest known, and is of the highest quality. Its subject, a mother helping her child to urinate, is humble, even unpleasant, but is treated in the most tender manner. As so often in northern European art, the subject matter has not prevented the greatest care from being taken with the details and finishing.

Bronze; h 14.6 cm
Probably acquired by the 4th Marquess of Hertford in 1861
S129

Venus after the Bath, late 16th century
Workshop of Giambologna (1529–1608)

▼ Born in Flanders, Giambologna worked for almost the whole of his career in Italy in the service of the Medici. He became the most influential sculptor of his time, famous for his monumental statues and for his elegant small bronze statuettes, which were made in large numbers and disseminated throughout Europe, often as diplomatic gifts. This small figure is the finest of several smaller bronzes associated with Giambologna now in the Wallace Collection and was probably made under the sculptor's direct supervision.

Bronze; h 13.5 cm
Acquired at an unknown date
S127

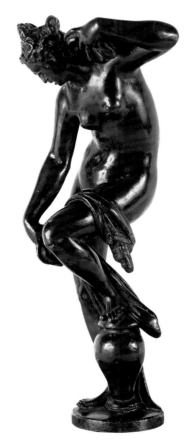

Fredrik II of Denmark, 1591
Netherlandish/Danish

◀ An alabaster equestrian portrait of Fredrik II of Denmark and Norway (1534–88), bearing an eccentric inscription that may be translated as 'My trust is in God alone/Wilpret is true/By God's grace King of the Danes'. Wilpret was Fredrik's favourite dog. The sculpture may be by Geert van Egen (active 1591–1600), one of many sculptors from the Netherlands who worked in Germany and Scandinavia in the sixteenth and seventeenth centuries. He sculpted the tomb of Fredrik II in Roskilde Cathedral (1594–98).

Alabaster, partially gilt; h 41.9 cm, w 26 cm
Acquired by Sir Richard Wallace in 1871
S13

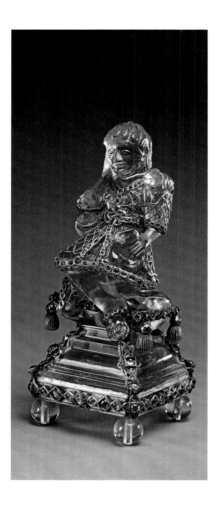

Bowl, 17th century
Indian

▼ Rock crystal is a transparent, colourless quartz, which, although very hard, has from ancient times been carved into decorative and useful objects. The bowl was probably made in the seventeenth century in the Mughal lands of northern India. The Mughals, the Muslim rulers of India, had a long and outstanding artistic tradition, particularly in architecture, textiles and metalwork as well as carving in precious materials such as jade and rock crystal.

The Good Shepherd, *c.*1600
Indo-Portuguese, Goa

◀ The Good Shepherd is a representation of Christ as a shepherd, symbolising his care for and guidance of Christians. The subject was not in the traditional repertoire of Indian carvers and goldsmiths, but was introduced into Goa, the centre of the Portuguese empire in the East. Numerous similar statues in ivory are known, in which the figure of Christ takes on, as here, some of the appearance of a figure of Buddha or Krishna. This is the finest and most elaborate of only four such sculptures in rock crystal to survive. With its sumptuous setting of gold and gemstones, it was almost certainly made for the wealthy Portuguese market.

Bowl (*tazza*), *c.*1610
Giovanni Ambrogio Miseroni (1551/2–1616)

▶ Smoky quartz is a rare variant of rock crystal prized for its dark translucence. This bowl is made in the form of a grotesque mask with open mouth. It is the finest in a group of four bowls in smoky quartz recorded in the 1607–11 inventory of the Habsburg Emperor Rudolf II (1552–1612) as having been 'brought from Milan', where the Miseroni family had its workshop and where most of the finest rock-crystal carving of this period was done. Giovanni Ambrogio was the head of the celebrated Miseroni workshop at this time.

Smoky quartz; h 10.8 cm, l 19 cm, w 13 cm
Acquired by the 4th Marquess of Hertford
or Sir Richard Wallace at an unknown date
IA14

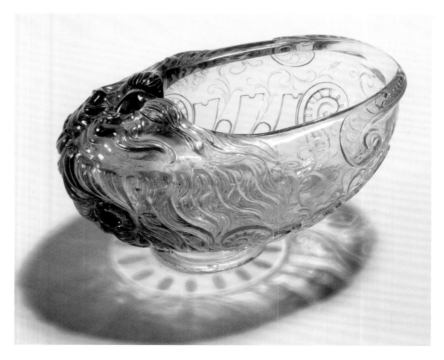

Cup and Cover, late 16th century
German

▲ Probably made in Augsburg, this cup and cover have been attributed to David Altenstetter (master 1573, died 1617), whose distinctive style in a technique using *basse-taille* (low-cut) enamel decoration was nevertheless copied by various other gold-smiths and enamellists.

Parcel-gilt and enamelled silver; h 22.2 cm
Probably acquired by Sir Richard Wallace
at an unknown date
XIIA112B

Steeple Cup and Cover, 1613/14
English, London

▶ The cup and cover bear the marks for London, the date 1613/14 and the maker 'CB'. Other works by this maker are known, but he remains unidentified. 'Steeple cups' take their names from their covers, crowned by an obelisk or steeple-like terminal, and were introduced during the last years of the reign of Elizabeth I (1558–1603). Although very popular in England in the early seventeenth century, they were not made on the Continent and are therefore an exclusively English decorative-art form. The cup bears the crest of the Old Serjeants' Inn, Chancery Lane.

Parcel-gilt silver; h 59.4 cm, w 14.4 cm
Acquired by Sir Richard Wallace in 1879
XIIL195

Medieval and Renaissance Art ❧ 61

Susannah and the Elders, c.1670–80
Daniel Neuberger the Younger (1621–80)

▶ The Biblical story of Susannah and the Elders was frequently taken as an example of innocent virtue triumphing over vice. Falsely accused of adultery by two old men who desired her and spied her bathing, she was saved by the prophet Daniel who proved her innocence. In this relief the sumptuous effect of the coloured wax is augmented by the use of real seed pearls and textiles, especially for the central figure of Susannah. It is one of the finest works of Daniel Neuberger the Younger, the leading member of a family of sculptors in wax in Augsburg. Daniel spent a portion of his career at the Imperial court in Vienna, where he is recorded as having taught Emperor Leopold I to model in wax.

Wax, pearls and textiles; h 15 cm, w 13.5 cm
Probably acquired by Sir Richard Wallace in 1871
S460

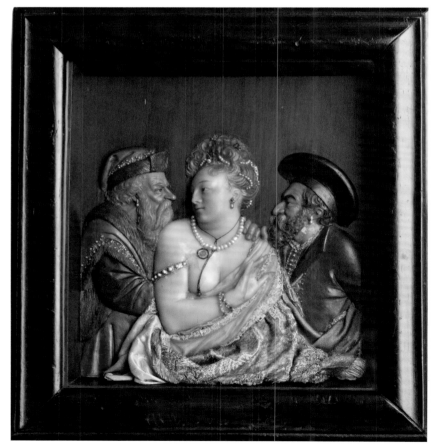

The Borghese Dancers, 1642/3
François Anguier (1604–69)

◀ *The Borghese Dancers* (now in the Louvre, Paris) is a celebrated
Roman marble relief, the name of which derives from the Villa
Borghese in Rome, where it was displayed from the early seventeenth
century. It features five female figures in clinging draperies dancing
to a gentle but measured step. A plaster cast was made of this marble
and other antique sculpture for Louis XIII of France in 1640.
This bronze version, probably intended for the *grande galerie* of the
Louvre, is a reworking by François Anguier of the plaster cast, which
is said to have arrived in Paris as a 'rather formless sketch'. The
casting of this and a pendant in the Louvre, *Maidens adorning a
Candelabrum*, was contracted to Henri Perlan (1597–1656). Anguier
produced many funerary monuments, including the mausoleum of
Henri II, duc de Montmorency, at Moulins.

Bronze; h 66.6 cm, w 200.8 cm
Acquired by the 3rd or 4th Marquess of Hertford
at an unknown date
S155

Flambeau, 1647–50
Ferdinando Tacca (1619–86)

▶ One of a pair of figures, both in the Wallace Collection,
that are the only signed works by Tacca, who eventually
inherited the workshop in Florence established by Giambologna.
They bear the arms of Alberico II Cybo, Duke of Massa,
and in 1662 were inventoried in the palace chapel at Massa, near
Carrara in Tuscany. The figures were used as candlesticks and,
together with another pair, were conceived as part of an elaborate
Calvary group for the chapel.

Patinated bronze; h 104.1 cm
Probably acquired by Sir Richard Wallace at an unknown date
S139

Hercules and the Hydra's Head, 17th century
Possibly German

◀ This statuette may have been made in Augsburg in the mid-seventeenth century. The second of Hercules's twelve labours was to slay the seven-headed hydra, a water snake that was ravaging the countryside of Lerna, near Argos. The statuette shows Hercules resting his foot on one of the hydra's heads. His right hand rests on his club, draped with the skin of the Nemean lion, which Hercules had overcome in his first labour. The design is a distant variant of *The Farnese Hercules*, a late Roman marble discovered around 1546 (now in the Museo Archeologico Nazionale, Naples).

Ivory; h 27.2 cm
Acquired by Sir Richard Wallace in 1871
S258

Baby-linen Basket or Salver, *c*.1670
Lucas Luicksen (Lucassen) (working 1652–77)

▼ In the Netherlands in the seventeenth century baby-linen baskets were presented to expectant parents by the father's mother shortly before the birth of a child. This example bears the marks of the town of Deventer and the silversmith Lucas Luicksen (Lucassen). The relief in the centre derives from a design by the celebrated Utrecht goldsmith Paulus van Vianen (1570–1613). Its subject, the fleeing Daphne being turned into a laurel tree to escape the attentions of Apollo, seems, however, to be a strange choice for a baby-linen basket, and perhaps the object is simply a salver.

Parcel-gilt silver; h 7 cm, l 63.5 cm, w 34.3 cm
Probably acquired by Sir Richard Wallace
at an unknown date
XXIVC99

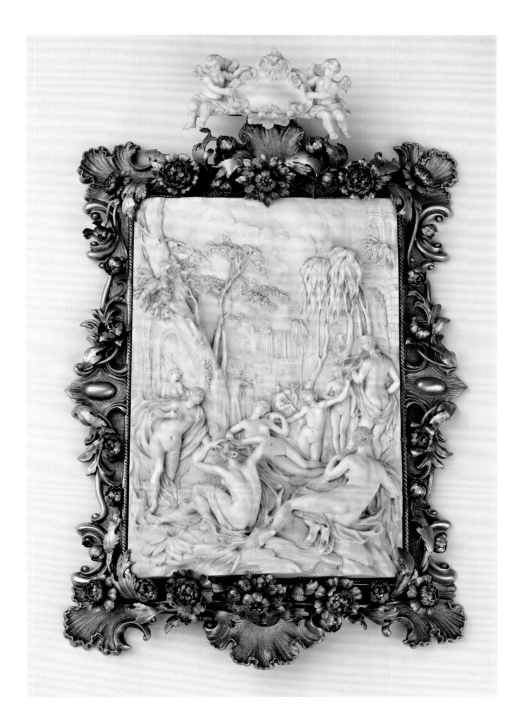

Diana and her Nymphs, c.1700
Domenikus Steinhart (1655–1712)

▲ One of the finest works of Domenikus Steinhart, who, after training in Italy, worked in Munich from 1682 until his death. The sumptuous frame of silver gilt was probably made about twenty years after the central panel, and is an early example of the rococo style that flourished in southern Germany in the eighteenth century.

Ivory; h 24.2 cm, w 14.6 cm
Probably acquired by Sir Richard Wallace at an unknown date
S265

Arms and Armour

The magnificent collection of European arms and armour in the Wallace Collection is among the finest in the world. It is augmented by an equally important collection of Oriental (largely Indian, Middle Eastern and Ottoman) weaponry. The former was acquired almost entirely by Sir Richard Wallace, from two principal sources: the collection of the comte de Nieuwerkerke, sold in 1871, and the best part of Sir Samuel Rush Meyrick's collection, purchased from the dealer Frédéric Spitzer in the same year. Although such sources ensured a high level of quality within the collection, it seems likely that Wallace himself possessed little profound knowledge of European armour; his purchases were more a reflection of his enthusiasm for the medieval and Renaissance periods so neglected by his father. The two main strengths of the European Armoury are the highly decorated armour for parade and tournament and an extensive series of richly ornamented sixteenth- and seventeenth-century daggers, swords and princely sporting guns.

The Oriental arms and armour, on the other hand, were collected by Wallace's father, the 4th Marquess of Hertford, during the twelve years before his death in 1870. They were acquired specifically for their decoration and exotic associations, many pieces being near contemporary in date. The Emperor Napoleon III and his half-brother the duc de Morny were also enthusiastic collectors of such material.

The appeal of the exotic, although not unknown in the eighteenth century, was an aspect of Romanticism stimulated by particular historical events; Napoleon Bonaparte's Egyptian campaigns (1798–1801) and the Greek War of Independence (1821–30) had aroused a general interest in the Ottoman Empire, and the French conquest of Algeria in 1830 had brought the Arab world into even sharper focus in France.

When, in 1875, Sir Richard Wallace finally installed his armoury collection in Hertford House, he arranged it mainly on the walls in decorative 'trophies of arms'. This was fairly typical of the nineteenth-century attitude to arms and armour: an armoury served to evoke a romantic past rather than to stimulate academic study. ✑

Opposite (detail):
Parade Shield made for Henri II, c.1550–60
Northern Italian
See page 73

Cross-hilted Sword of War, mid- to late 14th century
French or English

▶ Although in excavated condition, this archetypal late-medieval fighting sword has survived the centuries extraordinarily well. Given its date, it may well have been carried into battle during the Hundred Years War between England and France, which began shortly before the famous Battle of Crécy in 1346 and closed with the Battle of Castillon in 1453. Formerly in the comte de Nieuwerkerke's collection, its earlier provenance is unknown, but there is a strong likelihood that it was found in France, the distinctive corrosion patterns on the blade indicating perhaps that it was a river find. The grip binding is a later (probably nineteenth-century) restoration.

Steel, wood and textile; l 85.7 cm, wt 1.16 kg
Acquired by Sir Richard Wallace in 1871
A460

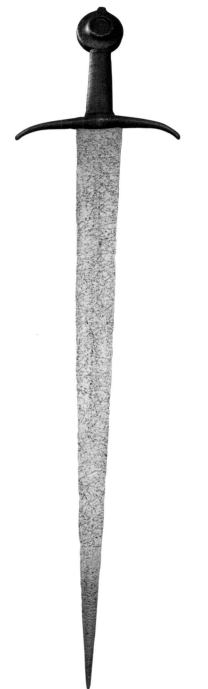

Bascinet Helmet, c.1390–1410
Northern Italian (Milan?)

▲ This superb example of the armourer's art is both beautiful and practical, designed as it is to deflect attack from virtually every direction. It was thus not the weight of metal that protected the wearer (this type of helmet is actually quite light) but its scientific design. Although Milan does seem to have been a major European producer of such helmets, it is now thought that other centres, not just in Italy but elsewhere in Europe too, were producing very similar forms of armour. Besides its great rarity, this is also prized as being one of the world's most romantic and evocative helmets, since it belongs squarely within the era of the Hundred Years War in Europe; helmets of this type almost certainly saw action at the Battle of Agincourt in 1415.

Iron, steel, leather and brass; h 26 cm,
wt (with visor and mail camail) 4.07 kg
Acquired by Sir Richard Wallace in 1871
A69

Jousting Helm, c.1420
English or Flemish

▲ Skilfully wrought in only two pieces, this helm demonstrates considerable crafts-manship on the part of its unknown maker. Helms of this general type have sometimes been found in English churches, used as funerary trophies. It is likely that this one, formerly in the collection of Sir Samuel Rush Meyrick, also came from an English church, in which case it might even have been made in England. There is some evidence, however, that much 'English' armour was being made in Flanders at this time. Made of steel rather than iron, it is likely to have been an expensive and prestigious piece. Helms of this form were never worn in battle, but were only employed in the tournament, where their great weight was less of a hindrance.

Steel; h 34.6 cm, wt 7.4 kg
Acquired by Sir Richard Wallace in 1871
A186

Hunting Crossbow, c.1450–70
Bavarian

▶ A very high-status weapon, used not for war but for hunting and conspicuous display. The stock, or tiller, is entirely overlaid with stag horn carved in imitation of ivory, depicting knights, hunting scenes, St George and the Dragon, courtly lovers and Adam and Eve. The bow-stave is made not of horn, wood and sinew, as was common at this time, but the finest steel, evidence of 'cutting-edge' technology found only on the finest of weapons. A painted coat of arms identifies this remarkable bow as having once belonged to the Völs-Colonna family from the South Tyrol.

Steel, wood, stag horn and parchment; l 72 cm,
bow span 59.6 cm, wt 4.4 kg
Acquired by Sir Richard Wallace in 1871
A1032

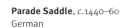

Parade Saddle, c.1440–60
German

◀ The entire surface of this rare fifteenth-century wooden saddle is overlaid with carved stag horn, enriched with infills of hard, coloured wax. The decoration includes a conversation between courtly lovers: for example, a lady asks, 'And if the war should end?', to which her lover responds, 'I will rejoice ever to be thine.' A number of these richly decorated saddles are known; another, slightly plainer in its decoration, is also in the Wallace Collection (A407). Their precise purpose is uncertain; it has been suggested that they were used for horses led in procession on ceremonial occasions, serving as visible evidence of wealth and taste.

Wood, stag horn and coloured waxes;
l (maximum overall) 100 cm, wt 3 kg
Acquired by Sir Richard Wallace in 1871
A408

Tournament Shield (*renntartsche*), late 15th century
German

▶ This impressive shield was intended for use in the joust known as the Rennzeug. Its decoration is so fine, however, that it may well have been made as a tournament prize. It was originally one of the most important pieces in the collection of Sir Samuel Rush Meyrick. He recorded that it came originally from the Imperial Collection in Vienna; if this is true it may well have once belonged to the future Emperor Maximilian I, while still Archduke of Austria. The cut-out in the top left corner of the shield was to accommodate the jouster's lance, while the 'bouched' shape of the shield was intended to facilitate catching an opponent's lance to ensure a clear, clean strike.

Wood, iron, textile and gesso; h 53.7 cm, wt 4.62 kg
Acquired by Sir Richard Wallace in 1871
A309

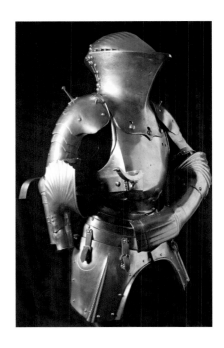

Joust Armour, *c.*1500–20
German (Nuremberg?)

◀ A heavy tournament armour for the joust known in the German lands as the *Stechzeug*. It would never have been used on the field of battle. It was worn for joust courses, in which the lances were invariably fitted with iron coronals (lance-heads having three or four points rather than one single sharpened one), in order to spread the impact and avoid any risk of penetration. This kind of course became known as the 'Joust of Peace'.

Tournaments incorporating such jousts were held regularly in Nuremberg throughout much of the sixteenth century not only for those of knightly rank but also the burgher class.

Steel, leather and brass; wt (overall) 40.91 kg
Acquired by Sir Richard Wallace in 1871
A23

'Gothic' Armour for Man and Horse,
late 15th century
Mainly South German

▶ Though probably assembled and partly restored in the nineteenth century, this impressive display serves to show something of the splendour and elegance of the German 'Gothic' style of armour, with fluted surfaces and boldly cusped borders. This 'field' armour (armour for war) is recorded as having come from the castle of Hohenaschau in the Tyrol, dynastic home of the von Freyberg family, whose armoury was dispersed in the early 1860s. Fifteenth-century plate armour is of the greatest rarity; although in this case that for the man is heavily composite, the barding (horse armour) is relatively homogeneous and is in remarkably good condition.

Iron, steel, brass (latten) and leather;
wt (overall) 27.16 kg (man), 30.07 kg (horse)
Acquired by Sir Richard Wallace in 1871
A21

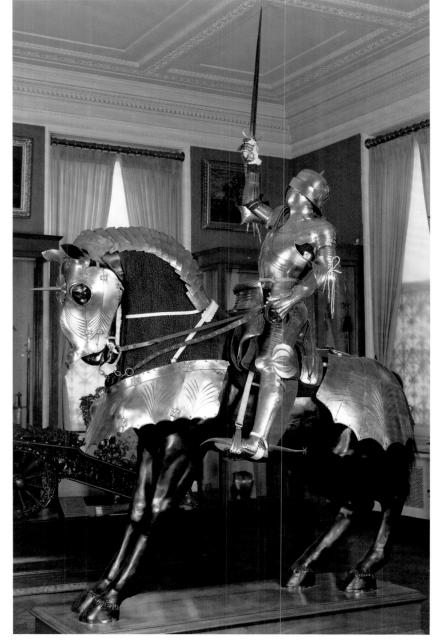

Armour for Horse and Man, *c*.1532–6
German, Nuremberg

▶ A composite armour made up from at least eight different armours bearing the same decoration, all originally made for Elector Otto Heinrich, Count Palatine of the Rhine (1502–59). The entire surface of the armour is painted black, enriched with bands of etched and gilt decoration, the breastplate additionally bearing an etched and gilt depiction of the Virgin and Child. The date 1532 appears on the saddle, while the shaffron (armour for the horse's head) is dated 1536. The armour was taken from the Elector's castle at Neuburg in Bavaria by Napoleon's troops in 1800, and was subsequently removed to England and exhibited in Bond Street, London, from where it entered the collection of Sir Samuel Rush Meyrick. The textile horse caparison is a modern restoration.

Steel, gold, wood, leather, brass and textile; wt (overall) 26.4 kg (man), 28.47 kg (horse)
Acquired by Sir Richard Wallace in 1871
A29

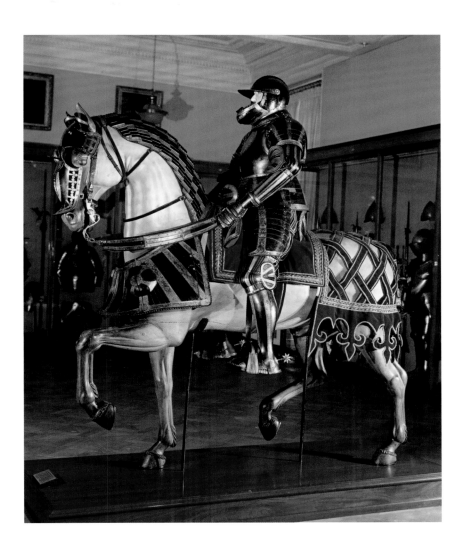

Helmet, *c*.1530
German, Augsburg

◀ This superb helmet, from an Imperial-quality armour, attributed to the master armourer Kolman Helmschmid of Augsburg, was perhaps made just before his death in 1532; alternatively, the armour may be the work of his equally famous son, Desiderius. Both men worked for the Imperial Court and created some of their finest armours for the Emperor Charles V and his son Philip II of Spain. This particular armour bears close structural similarities to the so-called KD (for Karolus Divus) armour (*c*.1526) of Charles V in the Royal Armoury, Madrid, and is certainly of equal quality. The helmet retains part of its original red silk-faced lining, albeit now mostly faded to yellow.

Steel, leather, textile, brass and gold; wt (overall) 16.3 kg
Acquired by Sir Richard Wallace in 1871
A30

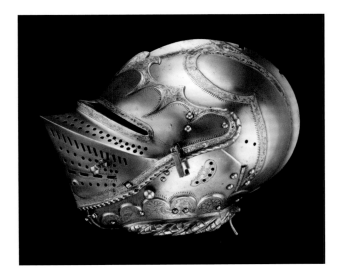

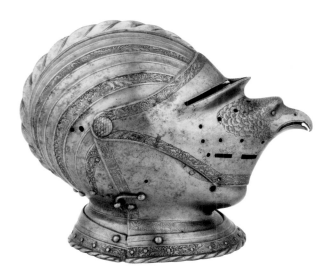

Close-Helmet, *c.*1530
German, Nuremberg

◀ A parade visor, boldly formed as the head of an eagle; in the event that the wearer of the helmet wished to fight in the field or tournament, it could presumably have been exchanged for another (or several) less flamboyant and more practical visors, now lost. The helmet does, however, retain its original quilted arming cap and the remains of its internal leather cross-straps. There appears to be no maker's or town-guild mark, but two closely similar helmets with marks are in the Musée de l'Armée in Paris; both are struck inside the skull with the Nuremberg 'N' set within a dotted-edge circle, which makes it likely that this helmet too was made in that city.

Steel, textile, leather and brass; wt 3.36 kg
Acquired by Sir Richard Wallace in 1871
A158

Parade Helmet, mid-16th century
Italian

◀ This boldly embossed parade helmet, finely wrought from steel (probably heat-blued originally since no traces of gilding can be found), was made by an unknown master craftsman, probably in northern Italy. No other work quite like it has been identified, although in skill and confidence it ranks with the products of the Negroli family of Milan, perhaps the finest craftsmen of their era in Italy. A pair of cheekpieces in the Bargello, Florence, may belong with the helmet; since they are known to have come from the old Medici armoury, it is possible that it too has a Medici provenance.

Steel and brass; wt 1.8 kg
Acquired by Sir Richard Wallace in 1871
A106

Falchion, mid-16th century
Italian

▶ This magnificent short-sword is of a type known as a 'falchion' that was popular in the sixteenth century for both hunting and ceremonial parade use. The sword is listed in an inventory of the old Medici armoury in Florence compiled in 1639, its description matching its present state in all respects except with regard to the grip, which is described as being made of leather-bound wood. The present grip is almost certainly a later (possibly nineteenth-century) replacement. The blade is etched with the arms of Cosimo I de'Medici (1519–74) as used between 1546 and 1569.

Steel, agate hardstone and gold; l 61 cm, wt 1.68 kg
Acquired by Sir Richard Wallace in 1871
A710

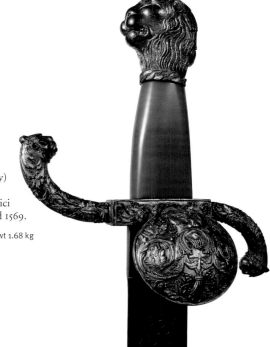

Parade Shield made for Henri II, *c*.1550–60
Northern Italian

▶ A truly magnificent example of the armourer's art, this shield was undoubtedly made for Henri II of France: his initials entwined with those of his mistress, Diane de Poitiers, appear above the central composition. A burgonet helmet in the Musée de l'Armée in Paris was probably made to accompany this shield. Although the maker is unknown, it is likely that he worked in Milan, the main centre for the production of high-quality parade armour of this type. The decoration, richly embossed and damascened with gold, depicts Scipio Africanus receiving the keys of the city of Carthage after the Battle of Zama in 202 BC; by analogy, this subject might have been intended to celebrate the surrender of Calais by the English in 1558.

Steel, brass and gold; h 67.3 cm, wt 4.11 kg
Acquired by Sir Richard Wallace in 1871
A325

See details on pages 66–7

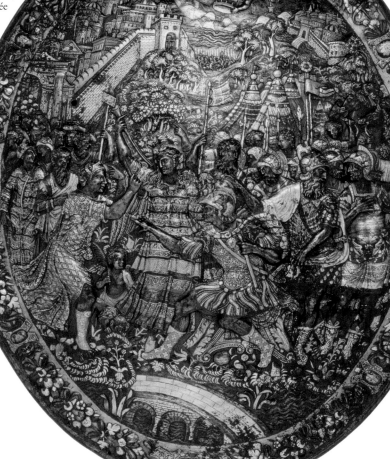

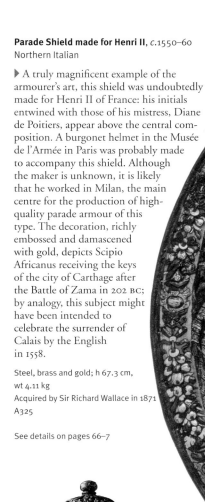

Princely Parade Scimitar, *c*.1550–60
Italian

◀ The hilt of this scimitar sword is richly pierced, chiselled and inlaid with gold, with a highly detailed and complex composition of horsemen and other figures; the strapwork of the pommel is arranged to form the letter H, perhaps for Henri II of France. The equally ornate blade, damascened for almost its entire length with arabesques and scrollwork, is struck with makers' marks, tentatively identified as those of Daniele da Serravalle, as well as an unidentified coat of arms, not that of the French King but perhaps belonging to the unknown nobleman who presented the sword to him.

Steel, gold and wood; l 70.5 cm, wt 1 kg
Acquired by Sir Richard Wallace in 1871
A708

Arms and Armour ☙ 73

Half-Armour for Parade, *c.*1570–90
Italian, Milan

▼ The magnificent half-armour is
embossed, gilt and damascened in gold and
silver in the style of Lucio Piccinino of
Milan. Such splendid ceremonial armour
would have been worn only for parade use
on foot. It is relatively lightweight and the
decoration, raised in high relief rather than
consisting of flat, glancing surfaces, would
have done little to deflect an attack. The
armour's typical high-mannerist decoration
includes such random motifs as Hercules
and the Nemean lion, Roman soldiers and
bound captives, set among a rich and
complex design of strapwork; these themes
all reflect the heroic and militaristic self-
image of many members of the
Renaissance aristocracy.

Iron, leather, textile, gold and silver; wt 10.9 kg
Acquired by Sir Richard Wallace in 1871
A51

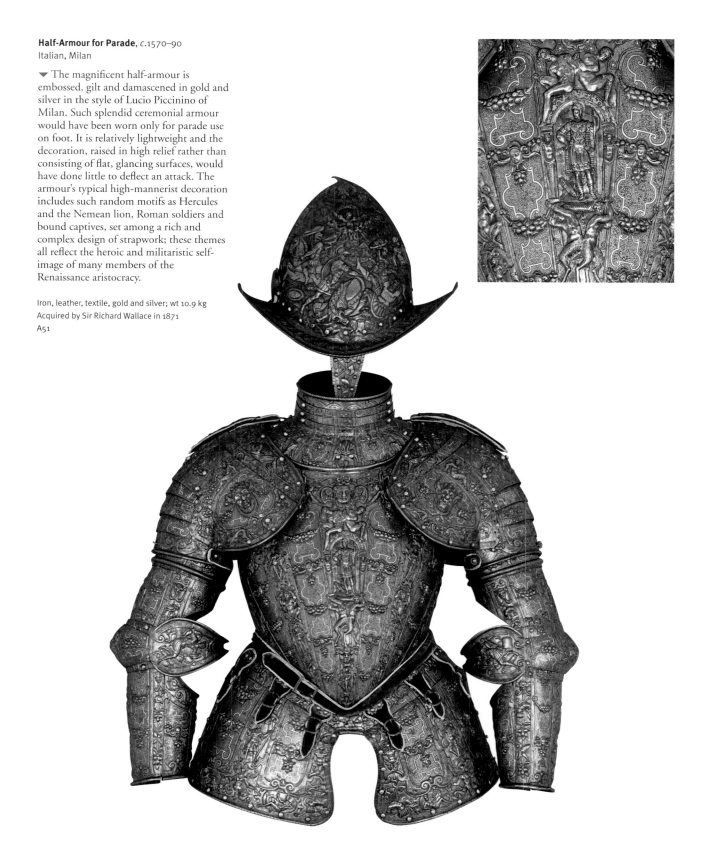

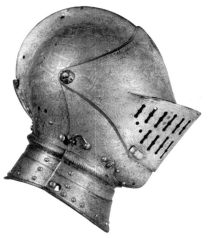

Tournament Helmet of Emperor Ferdinand II,
1555
German, Augsburg

◀ A close-helmet, intended for tournament use, once part of the fabulous 'Golden Garniture' made in 1555 by the master armourer Conrad Richter of Augsburg for the Emperor Ferdinand II and his three sons. An exchange visor for the helmet in the Bargello, Florence, is dated 1555 across the brow. This garniture is now widely scattered; also in the Wallace Collection are a pair of stirrups (A430–31). Signs of sword cuts on the brow indicate that despite its rich decoration this helmet has been used in earnest. Its interior retains a fragment of the original helmet lining faced with red silk.

Steel, leather, brass, textile and gold; wt 5.62 kg
Acquired by Sir Richard Wallace in 1871
A188

Half-Armour of Wolf Dietrich von Raitenau,
c.1590
Italian, Milan

▶ Made as part of a large field and tournament garniture for Wolf Dietrich von Raitenau, who became Prince-Bishop of Salzburg in 1587, this princely armour is fully etched and gilt in the manner of Pompeo della Chiesa, one of the most celebrated Milanese armourers. It has survived in remarkably good condition, even retaining its padded helmet lining, faced in red silk.

Steel, gold, leather, brass and textile; wt 17.56 kg
Acquired by Sir Richard Wallace in 1871
A60

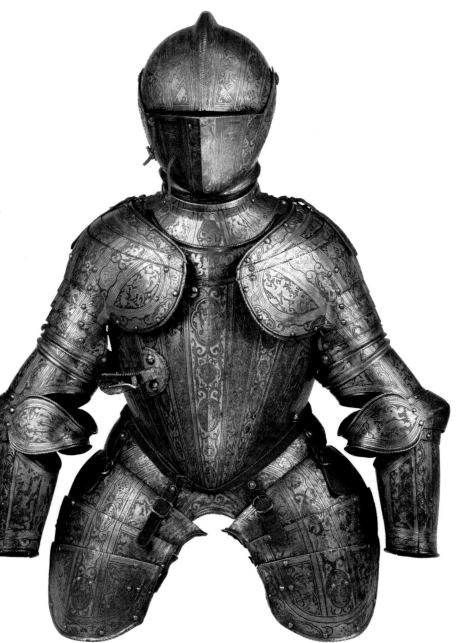

The Greenwich Field Armour of Lord Buckhurst

This field armour (*c.*1587) was produced at the Almain Armourers' workshop at Greenwich, England. It has extra detachable pieces designed to reinforce it, should the wearer so desire. Its design is recorded in a contemporary album preserved in the Victoria and Albert Museum, London, where it is identified as having been made for 'Lord Bucarte', almost certainly Thomas Sackville, Lord Buckhurst, later Earl of Dorset (1536–1608). Jacob Halder, master of the workshop from 1576 until his death in 1608, would certainly have worked on such a prestigious commission himself. This particular armour may have been ordered in early expectation of the arrival of the Spanish Armada in 1588.

English Field Armour, 16th century
Steel, leather, brass and gold; wt 32.03 kg
(36.70 kg with the reinforcing breastplate)
Acquired by Sir Richard Wallace in 1871
A62

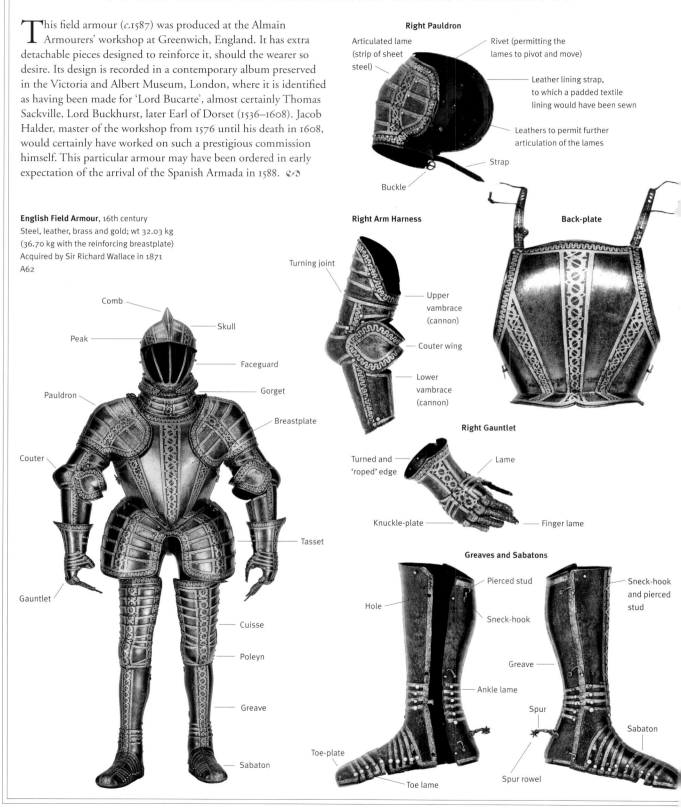

Right Pauldron

Articulated lame (strip of sheet steel)

Rivet (permitting the lames to pivot and move)

Leather lining strap, to which a padded textile lining would have been sewn

Leathers to permit further articulation of the lames

Strap

Buckle

Right Arm Harness

Turning joint

Upper vambrace (cannon)

Couter wing

Lower vambrace (cannon)

Back-plate

Right Gauntlet

Turned and 'roped' edge

Lame

Knuckle-plate

Finger lame

Comb

Skull

Peak

Faceguard

Gorget

Pauldron

Breastplate

Couter

Gauntlet

Tasset

Cuisse

Poleyn

Greave

Sabaton

Greaves and Sabatons

Pierced stud

Sneck-hook and pierced stud

Hole

Sneck-hook

Greave

Ankle lame

Spur

Sabaton

Toe-plate

Spur rowel

Toe lame

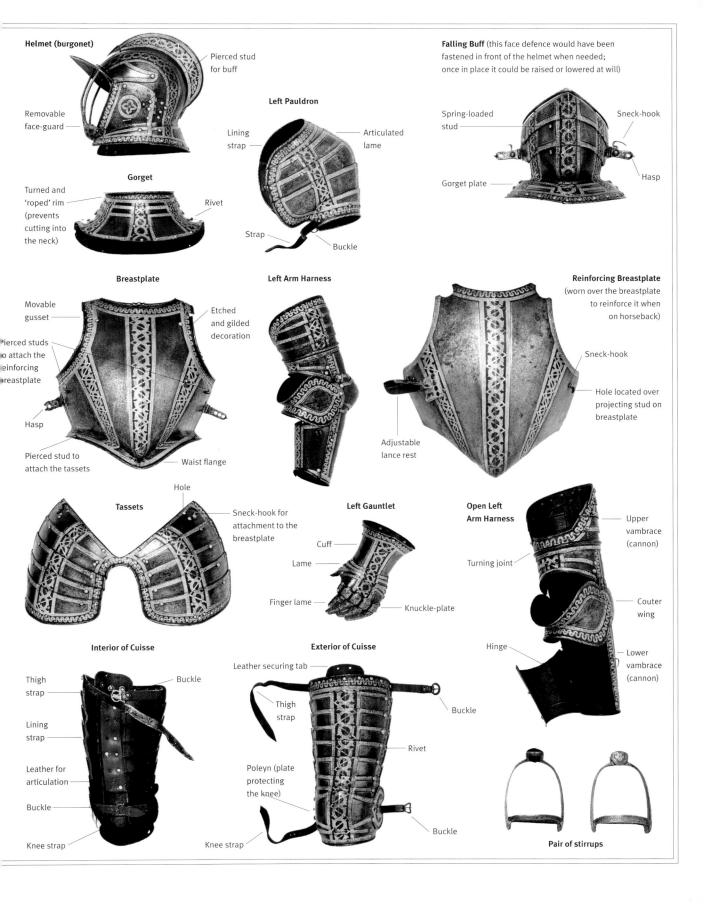

Helmet (burgonet)

Pierced stud for buff

Removable face-guard

Gorget

Turned and 'roped' rim (prevents cutting into the neck)

Rivet

Left Pauldron

Lining strap

Articulated lame

Strap

Buckle

Falling Buff (this face defence would have been fastened in front of the helmet when needed; once in place it could be raised or lowered at will)

Spring-loaded stud

Sneck-hook

Gorget plate

Hasp

Breastplate

Movable gusset

Etched and gilded decoration

Pierced studs to attach the reinforcing breastplate

Hasp

Pierced stud to attach the tassets

Waist flange

Left Arm Harness

Reinforcing Breastplate (worn over the breastplate to reinforce it when on horseback)

Sneck-hook

Hole located over projecting stud on breastplate

Adjustable lance rest

Tassets

Hole

Sneck-hook for attachment to the breastplate

Left Gauntlet

Cuff

Lame

Finger lame

Knuckle-plate

Open Left Arm Harness

Upper vambrace (cannon)

Turning joint

Couter wing

Hinge

Lower vambrace (cannon)

Interior of Cuisse

Thigh strap

Buckle

Lining strap

Leather for articulation

Buckle

Knee strap

Exterior of Cuisse

Leather securing tab

Thigh strap

Buckle

Rivet

Poleyn (plate protecting the knee)

Buckle

Knee strap

Pair of stirrups

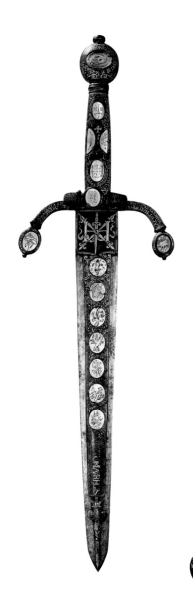

Sword of Henry, Prince of Wales, c.1610–12
English and German

▼ Although the silver-encrusted hilt is almost certainly English (of London manufacture, perhaps by Robert South, Royal Cutler to both James I and Charles I), the blade was made in Solingen, Germany, by the master bladesmith Clemens Horn, whose mark appears on it twice. It was common to mount imported blades in sword-hilts at this time. Henry was the eldest son of James I, but died before he could inherit the throne, resulting in Charles I, his younger brother, becoming king in his place. The Prince of Wales's feathers on the blade indicate a date after 1610, when Henry was granted this title; he died in 1612 at the age of nineteen, probably of typhoid fever.

Steel, wood, silver and gold; l 82cm; wt 1 kg
Acquired by Sir Richard Wallace at an unknown date
A511

Swept-hilt Rapier, c.1605–15
English

▼ The majority of the elegant civilian swept-hilt rapiers in the Wallace Collection are either Italian or German, these being the two principal centres in Europe for the production of such weapons. There is, however, a small group of richly decorated English swords, of which this is a notable example. An 1861 account records that the sword had apparently been 'recently dug up' near the town of Saffron Walden in Essex. The present blade, though genuine, was added at that time (the original presumably being heavily corroded), and the decoration of the hilt has undergone some restoration. The main scheme is, however, original and a rare example of fine-quality English work.

Steel, wood, gold and silver; l 113.4 cm, wt 1.29 kg
Acquired by Sir Richard Wallace in 1871
A596

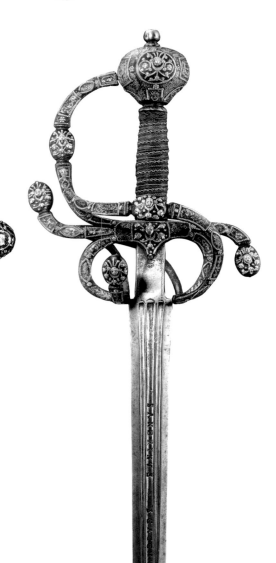

Dagger of Henri IV of France, c.1599–1600
French

▲ Richly damascened in gold and set with a series of mother-of-pearl inlays (many are later replacements), this superb dagger, together with its matching swept-hilt rapier, was presented to Henri IV by the city of Paris in 1600 on the occasion of his marriage to Marie de'Medici; the blade of the dagger bears an inscription to this effect, and their linked initials appear on the hilt. The sword, which Napoleon Bonaparte is said to have carried with him on campaign as a talisman, is now in the Musée de l'Armée, Paris.

Steel, mother-of-pearl and gold; l 24 cm, wt 270 g
Acquired by Sir Richard Wallace in 1877
A790

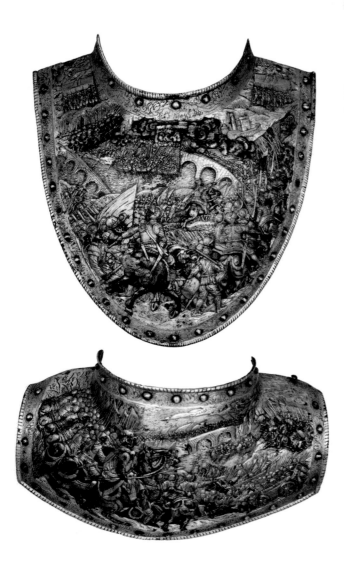

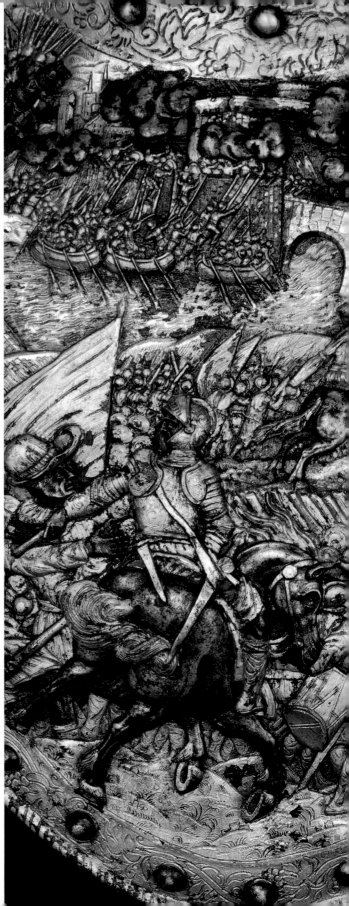

Parade Gorget, *c.*1610–20
French or Flemish

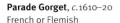 Whereas in the early sixteenth century much fine-quality armour for parade was still made of steel, later examples, such as this gorget, or collar, were frequently made of iron. The material no longer mattered, since by this date richness of decoration was increasingly eclipsing the demands of practical use. Embossed, chased, blued, gilt and plated with silver, the decoration derives from engravings of battle scenes (*c.*1570) by Antonio Tempesta, themselves based upon an engraving by Cornelis Cort (after Frans Floris) that was published in 1563. During the latter part of the sixteenth century, this kind of princely parade armour was produced in ever increasing quantity by the major armour-producing centres of northern Italy, the greatest of which was undoubtedly Milan. By the close of the century, however, other European competitors had caught up; this particular piece is now thought to have been made in France or Flanders.

Iron, brass, silver and gold; wt (front) 830 g, (back) 710 g
Acquired by Sir Richard Wallace at an unknown date
A238

Wheel-lock Sporting Gun, *c.*1620
German, Munich

▶ Outstanding among the group of decorated wheel-lock sporting guns in the Wallace Collection is this princely weapon, almost certainly made for the Bavarian electoral court. The deeply chiselled, blued and gilt barrel is attributed to the Munich workshop of Daniel Sadeler, perhaps the finest steel chiseller of his day. The veneered snakewood stock, inlaid with stag horn and ivory, bears the initials of the equally celebrated Hieronymus Borstorffer. The gun was one of the highlights of the comte de Nieuwerkerke's collection.

Steel, wood, stag horn, ivory and gold;
l (overall) 170 cm, wt 5.25 kg
Acquired by Sir Richard Wallace in 1871
A1090

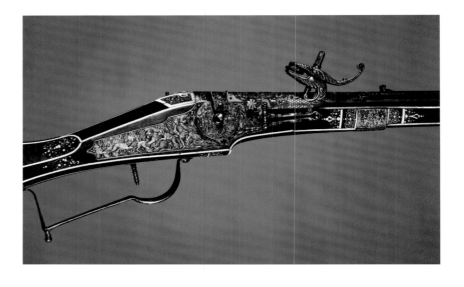

Ceremonial Staff-weapon, *c.*1643–1715
French

▶ This ceremonial staff-weapon was probably designed by Georges Berain and made for the *gardes du corps*, personal bodyguard of Louis XIV (1638–1715, reigning from 1643). The blade is blued and damascened in gold with the arms of France and Navarre surrounded by the collars of the Orders of St Michel and St Esprit (incorporating the royal initial H for Henri III, founder of the latter order) surmounted by a crown. Above this is a trophy of arms, the sun in splendour (an appropriate emblem, Louis XIV being widely known as 'the Sun King') and a scroll with the royal motto NEC PLURIBUS IMPAR (EQUAL TO ANYTHING).

Steel, gold, wood, brass and textile;
l (overall) 240 cm, (head) 53.3 cm, wt 2.91 kg
Acquired by the 4th Marquis of Hertford in 1870
A1008

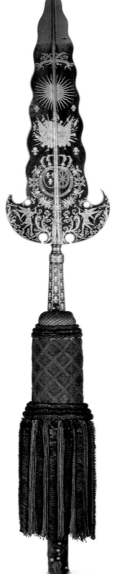

Pair of French Flint-lock Pistols made for Louis XIV, *c.*1655–70
French

▶ More works of art than weapons, this elegant and sumptuously decorated pair of flint-lock pistols were made for the French king Louis XIV. Their precise provenance is unknown. It has been suggested that they might have been made in celebration of the capture of Dunkirk in 1658. Alternatively, they might have formed part of a gift from the city of Lille to mark and celebrate the annexation of that city by French forces in the 1667–8 Spanish Netherlands campaign; the fleur-de-lis with which they are profusely decorated may constitute a pun on the city's name. The quality and craftsmanship are of the highest order: the stocks are of carved walnut stained dark in imitation of ebony, while the gun barrels are engraved, blued and damascened in gold. As was often the case with guns intended for royalty, they do not bear the name of their maker.

Double-barrelled Flint-lock Sporting Gun, *c.*1805–9
French

▶ Nicolas Noël Boutet (1761–1833) was gun maker to the Royal, and then Imperial, Court of France at Versailles and is generally recognised as the finest continental gun maker of his era. Although his factory at Versailles did manufacture high-quality regulation military arms (including edged weapons), it is for his presentation-quality silver- and gold-mounted firearms that he is perhaps best known. The escutcheon on the wrist of the stock of this gun bears a Gothic 'N' monogram similar to that on the case of a rifle also in the Wallace Collection (A1126); both weapons probably belonged to Tsar Nicholas I of Russia. The 3rd Marquess of Hertford was Envoy Extraordinary to Tsar Nicholas in 1827, so it is possible that either or both guns were a gift to him from the Russian Tsar at that time.

Wheel-lock Pistol, 1645
Monaco

▶ This fascinating and very delicately fashioned wheel-lock pistol bears on the lower edge of its lock-plate the inscription *Faict a Mourgues par La Fonteyne Inventeur, 1645*. Mourgues is thought to be an ancient name for Monaco. There are a number of unusual features on this weapon. The octagonal barrel is made of brass rather than steel, engraved throughout its length and gilt. The mainspring for the lock is of coil form rather than the more usual leaf spring. The butt-cap, which is even more unusual, opens to reveal a compass and sundial.

Steel, wood, brass, copper, stag horn, silver and gold; l 36.8 cm, wt 445 g
Acquired by Sir Richard Wallace at an unknown date
A1182

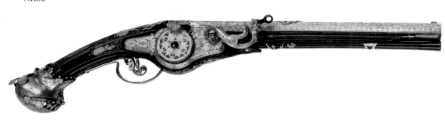

Steel, wood and gold; l (overall) 59.7 cm, (barrel) 41.4 cm, wt 800 g
Acquired by Sir Richard Wallace at an unknown date
A1209–10

Steel, wood, silver and gold;
l 122.4 cm, wt 3.12 kg
Acquired at an unknown date
A1127

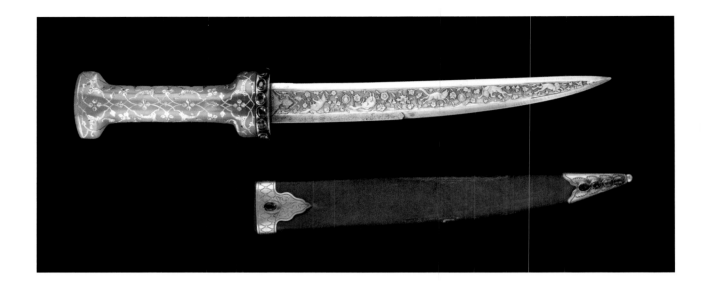

Persian Dagger, c.1496–7
Middle Eastern, Iran

▲ The blade is of 'watered' steel (patterned to give the shimmering appearance of ripples on water) with gold inlay and encrusted gold decoration comprising desert foxes and hares amid arabesques. The hilt is of jade inlaid with gold, and has a silver-gilt band at the base (a later addition) set with green glass stones. The blade is inscribed with the Islamic date 902 (1496–7 in the Christian calendar) together with couplets of poetry and the name of its maker (sadly indecipherable). It is extremely rare to find a weapon of such princely quality bearing a fully attributable inscription.

Steel, jade, gold, silver, wood, brass, textile and glass;
l 34.4 cm, wt (without scabbard) 270 g
Possibly acquired by the 4th Marquess of Hertford in 1867
OA1414

Dagger, late 16th or early 17th century
Turkish

◀ This superb dagger was acquired by the 4th Marquess of Hertford at the Paris sale of Charles Auguste Louis Joseph, duc de Morny. Persian-inspired in form, its hilt is fashioned from dark green agate, the rivet-caps consisting of rubies set in silver gilt, while the blade is skilfully pierced and inlaid throughout its length with gold. The minutely executed decoration incorporates couplets of poetry in Persian script. The scabbard mounts are of silver gilt; like the scabbard itself, they are of Turkish workmanship, but generally much later in date than the rest of the dagger. This weapon is of exceptionally high quality: for example, the decoration of the blade is 'true' inlay, whereby the gold was laid into grooves painstakingly cut into the base metal, instead of being simply 'damascened' (laid on to a cross-hatched surface and burnished in place).

Steel, agate hardstone, wood, silver,
textile, gold and precious stones; l 33 cm,
wt (without scabbard) 260 g
Acquired by the 4th Marquess of Hertford in 1865
OA1430

Mughal Dagger, *c.*1620
Indian

▶ The hilt of pure gold is closely set with table diamonds, rubies and emeralds in a manner characteristic of the Mughal court workshops during the first decades of the seventeenth century. Immediately adjacent to the blade of watered steel, the projecting lower guard features a tiger's head mounted with rubies carved to represent the eyes, nose and whiskers; natural diamond crystals form the teeth. Although the early provenance of this dagger is unknown, it was almost certainly made for a prince of the Mughal court, possibly even for Shah Jahan (builder of the Taj Mahal) himself. Workmanship of this degree of artistry and skill is of the utmost rarity; only one other dagger as fine as this one is known (now in the al Sabah collection, Kuwait).

Steel, gold, wood, textile, precious stones and enamel; l 35.1 cm, wt (without scabbard) 510 g
Acquired by the 4th Marquess of Hertford by 1870
OA1409

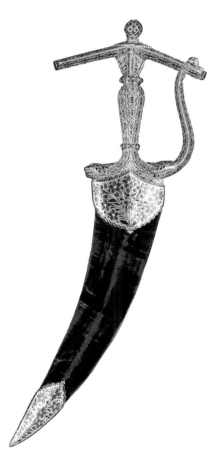

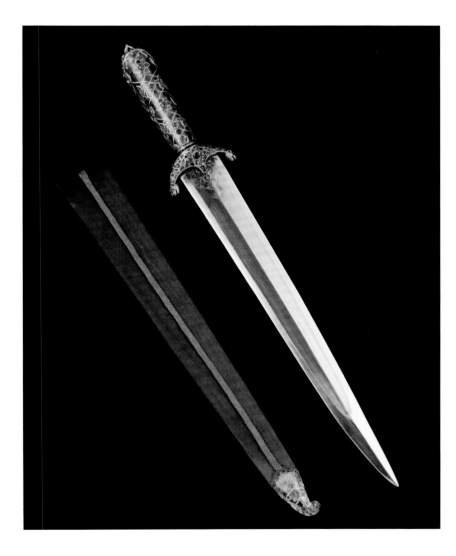

Mughal Dagger, 17th century
Indian

◀ The hilt of this magnificent Mughal dagger is fashioned from rock crystal inlaid with gold and set with rubies, emeralds and diamonds. The name *Claud Martin* is lightly inscribed in tiny letters on one panel of the stone, halfway up the grip; Claude Martin was a Frenchman who fought against the British in India, but changed sides following the siege and fall of Pondicherry in 1760–61. He joined the army of the British East India Company as an ensign, working his way up through the ranks to become major-general in charge of the Lucknow Arsenal. He is recorded as having been an enthusiastic collector of princely Mughal Indian arms and armour, so this dagger was presumably once his.

Steel, gold, wood, rock crystal and textile; l 39 cm, wt (without scabbard) 310 g
Acquired by the 4th Marquess of Hertford at an unknown date
OA1415

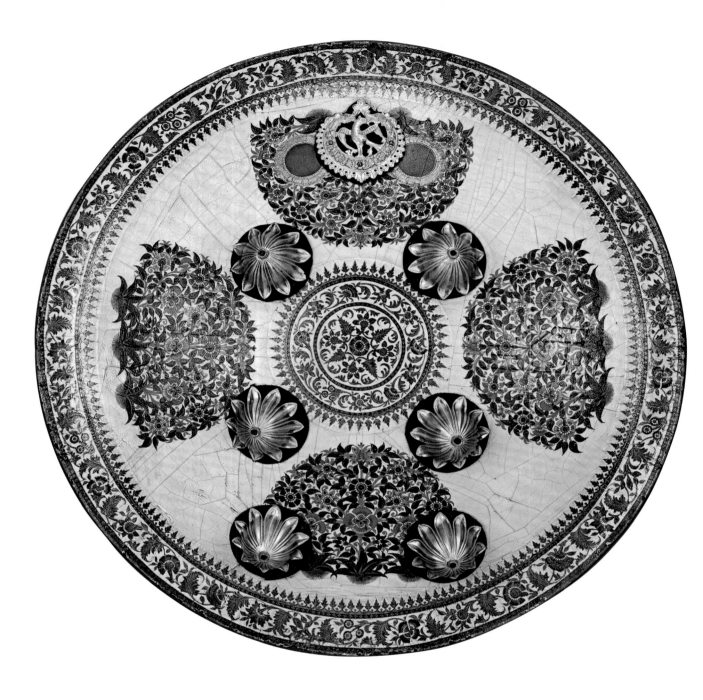

Shield, 18th century
Indian, Kutch or Scinde

▲ An exceptionally decorative example of its type, this fine painted and gilt buffalo-hide shield was made both as a work of art and to be of practical use in the field. There are gilt-metal bosses on the outer surface and a padded textile hand-rest and straps on the inside. It is possible that such ornately decorated Indian shields were made for presentation or as rich gifts. The buffalo hide would have been resistant to arrows and sword cuts but not bullets; nonetheless, as with swords, such items were owned and carried by tradition long after they had ceased to have any practical, martial use.

Leather, brass, textile and gold; diam. 48.2 cm, wt 2.44 kg
Acquired by the 4th Marquess of Hertford in 1869
OA2077

Steel, jade, gold, wood,
textile and precious stones;
l 28.1 cm, wt (without
scabbard) 120 g
Acquired by the 4th Marquess
of Hertford in 1870
OA1387

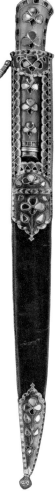

'Knife of Tipu Sultan', late 17th or 18th century
Indian

◀ The hilt of this knife is of jade set with
diamonds, rubies and emeralds, mounted in
gold. The fittings of the sheath are equally
rich, being of gold, enamelled and jewelled
en suite with the hilt. The blade, damascened
in gold, is of the finest watered steel. The
overall concept and design demonstrate
a high degree of taste, artistry and skill;
particularly admirable is the way in which
the locket of the sheath is pierced, revealing
the decoration of the knife-hilt even when
the knife is fully sheathed. It was acquired
from the collection of Anatole Demidoff,
prince of San Donato in Florence. The entry
in his 1870 Paris sale catalogue describes this
piece as having belonged to Tipu Sultan.

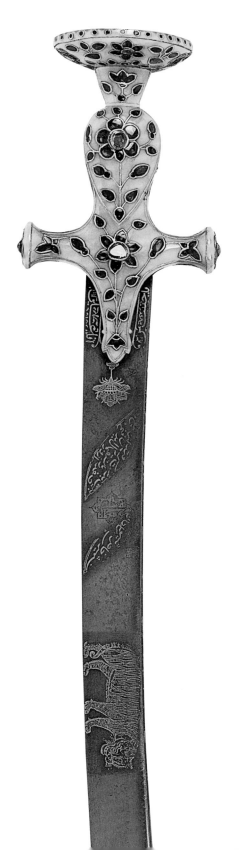

Sword (*tulwar*) of Tipu Sultan,
late 18th century (blade possibly earlier)
Indian (hilt) and Persian (blade)

▶ This sword is one of the most magnificent
in the Collection. Its hilt is of jade decorated
with diamonds, rubies and emeralds set
within mounts of gold, while the watered-
steel blade bears the maker's signature of
Assad Ullah and a series of inscriptions
damascened in gold, including one to the
effect that 'This is the sword of Tipu'. Tipu
Sultan (1753–99) ruled in southern India
from 1782 until his death at Seringapatam
in 1799, at the close of the fourth Mysore
War. He was known as the 'Tiger of
Mysore', and the blade bears his 'badge' of
a tiger damascened in gold. The sword was
purchased by the 4th Marquess of Hertford
at the Paris sale of the art collection of the
comte de Pourtalès-Gorgier in 1865.

Steel, jade, wood, textile, gold and precious stones;
l (overall) 88.5 cm, wt (without scabbard) 940 g
Acquired by the 4th Marquess of Hertford in 1865
OA1402

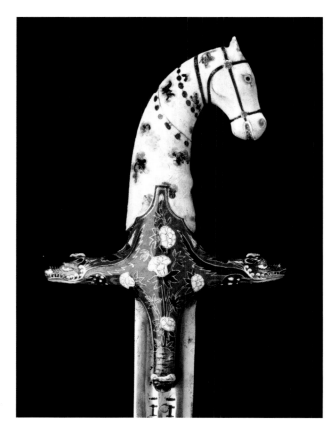

Sword, 18th century
Indian, Jaipur

◀ The hilt is a *tour de force* of the enameller's art. Fashioned entirely in gold, the grip is formed as a horse's head, enamelled in naturalistic colours, while the guard features richly enamelled monsters' and tigers' heads. The blade, although purporting to be of seventeenth-century European origin, is in fact more likely to have been made in India. Straight, multi-fullered, back-edged blades like this one were predominantly a European style, but were highly prized in the East. There was accordingly an active export trade in them from Europe (where by this date they had become relatively unfashionable) to India. Such was the demand that many blades of this type were copied by local bladesmiths, complete with (sometimes garbled) European-style inscriptions and makers' marks.

Steel, gold and enamel; l 93.5 cm, wt (without scabbard) 1 kg
Acquired by the 4th Marquess of Hertford
at an unknown date
OA1432

Ceremonial Mace (*sota*), late 18th century
Indian

▶ This beautifully wrought, silver-gilt, tiger-headed mace, one of a pair, was intended not as a weapon but purely for processional use, being carried by harbingers to herald the imminent approach of a prince, nobleman or important official. The tiger's eyes are made of garnets, and a green stone is mounted in the centre of the forehead. Although appearing to be of massive and deadly weight, such maces were usually hollow, made out of thin sheet silver, embossed, chased, engraved and parcel-gilt. The hollow shell was filled with pitch, or a similar substance, to confer a degree of strength and rigidity. Similar examples bearing different animals' heads (horses, bulls or elephants, for example) are also known.

Silver, pitch(?), gold and precious stones; l 77.3 cm, wt 2.77 kg
Acquired by the 4th Marquess of Hertford in 1870
OA1760

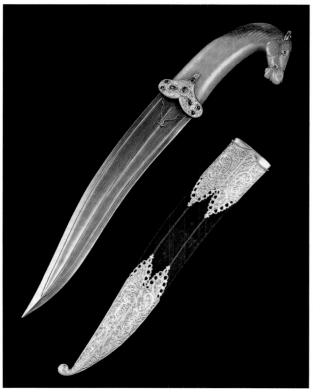

Dagger (*khanjar*), 18th century
Indian, Lahore

◀ This jade-hilted Mughal dagger is carved with a horse's head, a flaw in the stone having been cleverly utilised by the maker to delineate the horse's mane. The grip is further ornamented with inlays of gold set with cabochon rubies and emeralds, while the double-edged blade is of watered steel. The sheath is of wood covered in velvet, with mounts of chased gilt brass. Although supremely decorative, and of great value even when it was first made, this dagger was also capable of use as a deadly weapon.

Steel, brass, wood, textile, gold and precious stones; l 36.4 cm,
wt (without scabbard) 340 g
Acquired by the 4th Marquess of Hertford in 1869
OA1420

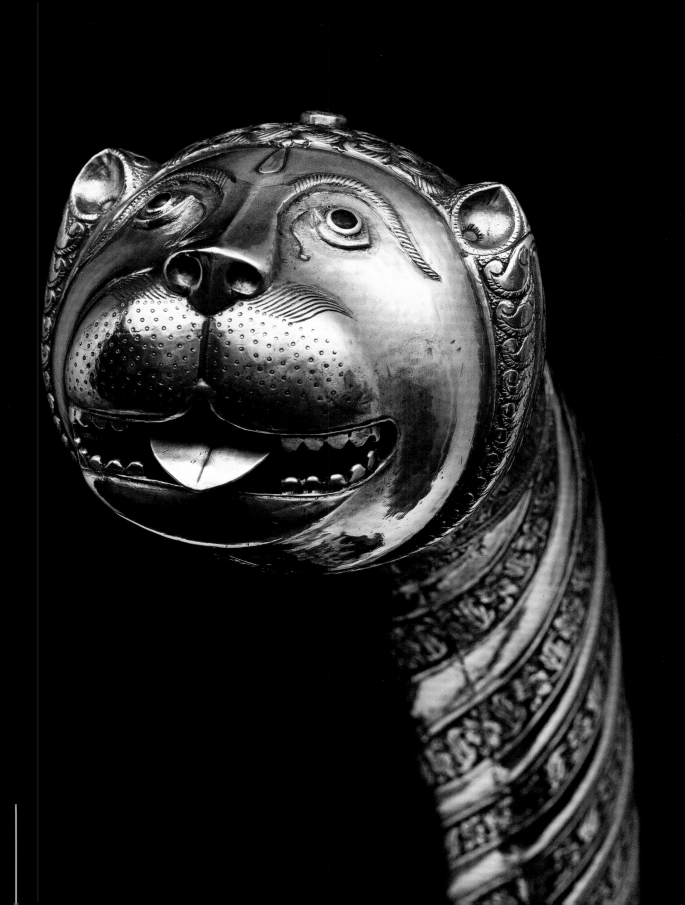

Sikh Helmet, late 18th century
Indian

▼ The richly gold-damascened helmet skull is of burnished steel, shaped to accommodate the topknot of hair that is worn for religious reasons by all devout Sikhs; this type of helmet is therefore always specifically Sikh in origin. It is furnished with a tippet (camail) of fine butt-jointed brass and iron mail worked in a diaper pattern, with a dagged bottom edge. There is in fact a slight flaw in the metal of the helmet skull, just to one side, but it has been cleverly concealed by the maker, who has applied a bird damascened in gold directly over it. Another bird has been applied to the other side, in order to balance the design.

Steel, iron, brass, gold and textile;
h (including the camail) 37.4 cm, wt 1.27 kg
Acquired by the 4th Marquess of Hertford at an unknown date
OA1769

Sword (*shamshir*) of Ranjit Singh,
early 19th century (blade probably earlier)
Indian (blade possibly Persian)

▼ This magnificent gold-mounted sword once belonged to Maharajah Ranjit Singh, the 'Lion of the Punjab' (1780–1839). In terms of the breadth of his vision, his charisma and the extent of his political and military achievements, Ranjit Singh has been compared to Napoleon Bonaparte. Unlike Napoleon, however, he never lost a major battle. Although ravaged by smallpox as a child (the disease permanently blinded him in one eye), by the age of ten Ranjit Singh was accompanying his father on military campaigns, and at twelve he took command of his first battle. In 1799, at the age of just nineteen, he rode at the head of his army into the city of Lahore to found the first Sikh dynasty to control the entire Punjab.

Steel, gold, wood, leather, textile and seed pearls;
l (overall) 91.6 cm, wt (without scabbard) 1.02 kg
Acquired by the 4th Marquess of Hertford by 1865
OA1404

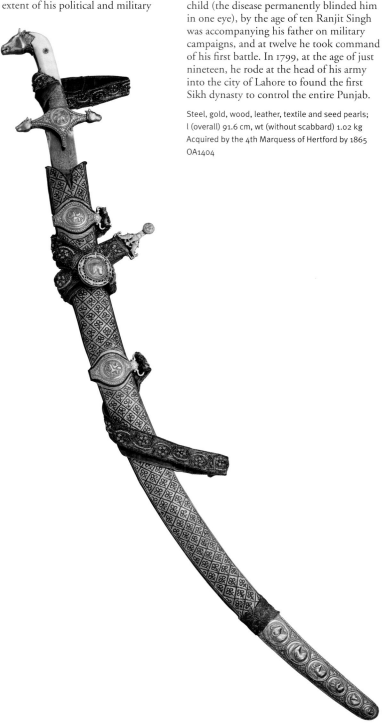

Armour of a Rajput Warrior, late 18th century
Indian

▶ A rare and impressive Rajput armour from central India comprising a helmet (*tóp*), 'Coat of Ten Thousand Nails' with long boots and shoulder guards *en suite*, vambraces (*dastána*), and a sword (*khanda*) with scabbard and tablet-woven textile baldric. The main fabric of the armour is made of layers of textile faced with green velvet, studded with myriad small brass or copper-gilt nails in a wavy diaper pattern, and lined with a woven kincob material. The coat is further reinforced with contoured plates made of watered steel, damascened in gold.

Steel, gold, wood, brass,
leather and textile; h (overall,
robes only) 102.8 cm
Acquired by the 4th
Marquess of Hertford
at an unknown date
OA1828, 1790–94

Ceremonial Helmet, early 19th century
Middle Eastern, Iran

▼ A Persian 'horned devil' helmet almost certainly never intended for battle, but for ceremonial purposes only. Its exotic decorative appearance would have made it particularly attractive to wealthy cultured collectors such as the 4th Marquess of Hertford. The camail, or skirt, attached to the base of the helmet, comprises very fine butt-joined brass and iron links, worked in a diaper pattern. The helmet bowl appears to have been made from watered steel, damascened in gold.

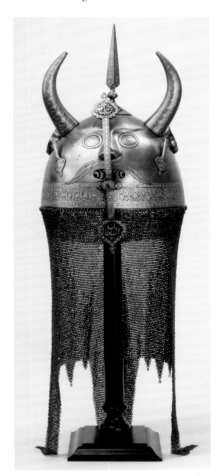

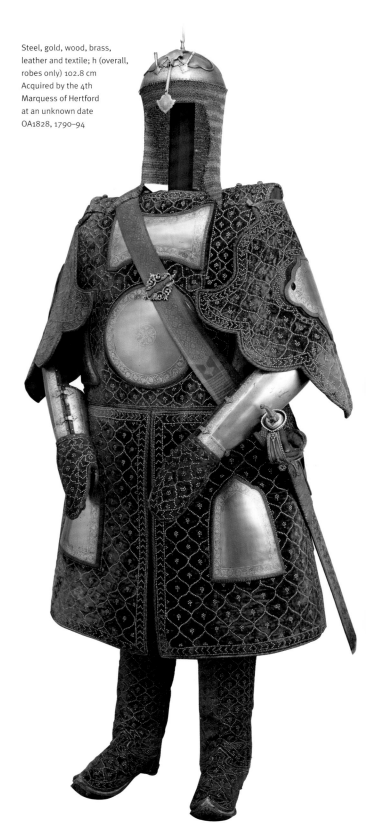

Steel, iron, gold, brass
and textile; h (including
camail) 69.7 cm,
wt 1.94 kg
Acquired by the 4th
Marquess of Hertford
at an unknown date
OA1523

Miquelet-lock Rifle, late 18th or early 19th century
Turkish

▲ The stock, carved from burr maple, is richly inlaid with decorative motifs incorporating stained ivory, brass and ebony. The barrel is of octagonal section, constructed with 'pattern-welded' steel forged in a spiral 'damascus-twist' pattern, and rifled for accurate shooting. Ottoman-made gun barrels of this type were very highly prized throughout Europe and the East. Even at this date the sword was still preferred by many as a more 'honourable' weapon, requiring skill and dedication to master. Kurtbay, a noted Egyptian Mameluke warlord, appealed to the Ottoman sultan to abandon the use of firearms, on the grounds that a rifle or musket could be deadly 'even if a woman were to fire it'.

Steel, gold, wood, ivory, brass, ebony and coral; l 104 cm, wt 2.69 kg
Acquired by the 4th Marquess of Hertford at an unknown date
OA2157

Pair of Flint-lock Pistols, late 18th or early 19th century
Algerian

▶ Full-stocked in silver and profusely inlaid with carved pieces of coral, these muzzle-loading flint-lock pistols are among the most colourful and exotic of their type ever to have been made. A number of similarly decorated pistols, together with matching long-guns decorated *en suite*, were presented to George III by the Algerian ambassador on behalf of the bey of Algiers in 1811 and again in 1819. Some of these remain in the Royal Collection at Windsor Castle.

Steel, wood, silver and coral; l 54 cm, wt (overall, single pistol) 1.08 kg
Acquired by the 4th Marquess of Hertford by 1865
OA2041

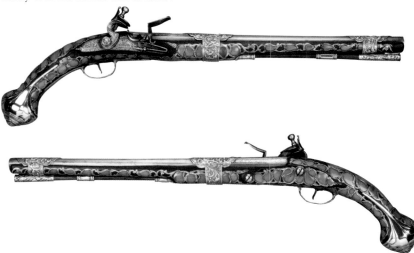

Sword and Scabbard, late 18th or early 19th century
Arabian

▼ This flamboyant sword (*nimcha*), mounted with silver parcel-gilt, is furnished with a blade not unlike that of a British regulation-pattern 1796 Light Cavalry sabre. Whereas many Arabian swords were made of 'crucible-watered' steel (a product well known throughout India and the Middle East, used for the finest weapons and armour), in this case the blade appears to have been made of a 'mechanical-watered' steel, akin to pattern welding. The silver mounts are struck in several places with early nineteenth-century French import marks. The weapon is in such crisp condition that it is unlikely to have seen much practical use before becoming a collector's piece.

Steel, silver, wood, textile and gold; l 100 cm, wt (without scabbard) 1.04 kg
Acquired by the 4th Marquess of Hertford by 1865
OA1787

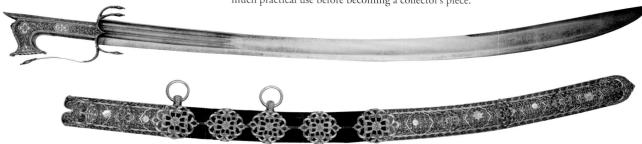

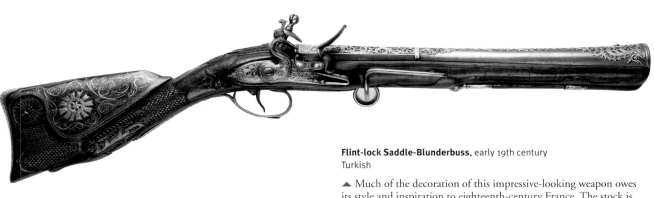

Flint-lock Saddle-Blunderbuss, early 19th century
Turkish

▲ Much of the decoration of this impressive-looking weapon owes its style and inspiration to eighteenth-century France. The stock is deeply carved and inlaid with scrolling silver wire, while the blued steel of the metalwork is heavily encrusted with silver. A saddle-ring and bar have been fitted to enable the gun to be carried and used on horseback, slung from a baldric or from the saddle. Firearms of this type were fired from the thigh or hip and were popular throughout the lands of the Ottoman Empire, but were rarely ever used in this way in western Europe.

Steel, wood and silver; l 63.5 cm, wt 1.6 kg
Acquired by the 4th Marquess of Hertford at an unknown date
OA2066

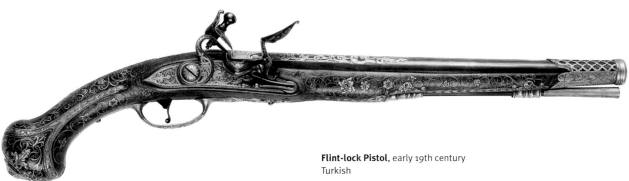

Flint-lock Pistol, early 19th century
Turkish

▲ Pistols made in the style of earlier western European examples (late seventeenth- and early eighteenth-century, for instance) were very popular throughout the Ottoman Empire during the nineteenth century. The workmanship of this example, one of a pair, is extremely fine: the stock is profusely inlaid with scrolling silver wire and the mounts are decorated in both gold and silver. This pistol shows strong French influence in its form and decoration, and indeed was thought at one time to have perhaps been made in Marseilles for export to eastern Europe. At this time there was a flourishing export market in such luxury manufactured goods for a specifically eastern clientele, but this pistol would seem to be an example of the best-quality native Turkish work. The name inscribed on the wrist escutcheon (*Hamdân Ibrâhîm*) is probably that of the pistol's former owner.

Steel, wood, silver and gold; l 51 cm, wt (overall, single pistol) 1.15 kg
Acquired by the 4th Marquess of Hertford by 1865
OA1509/22

Arms and Armour ∽ 91

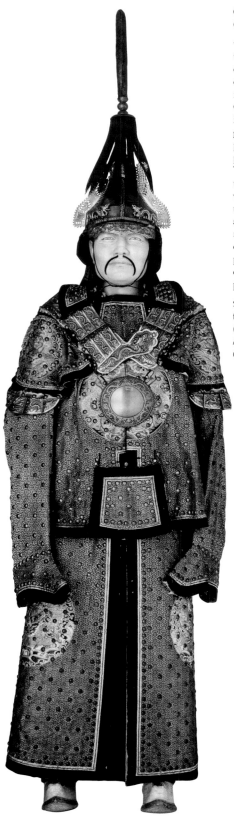

Court Dress of a Military Mandarin, *c.*1821–50
Chinese

◀ Never intended for use on the battlefield, this magnificent panoply was the court dress of a military mandarin. High-ranking officials of the mandarin class were responsible for running the Imperial Chinese government and army. The helmet is of silver with components of pierced and gilt copper, and is surmounted with a tall plume covered with sable fur and accompanied by a cascade of dyed red hair. The robes are of woven metallic-wrapped threads and coloured silks, richly patterned with depictions of storm dragons protecting the Sacred Jewel amid storm-tossed seas, and studded with hemispherical gilt-headed rivets throughout. Two circular silver plates ornament the front, while the shoulders are protected with further plates of silver bordered with elements of silver-gilt, embossed, pierced and decorated with dragons.

Silver, copper, brass, textile (silk brocade), leather, fur, gold and precious stones; h (robes only) 133 cm, (helmet) 90 cm
Acquired by the 4th Marquess of Hertford by 1865
OA1701

Elephant Goad, 19th century
Indian, Jaipur

▼ Fashioned entirely of gold, enamelled and jewel-encrusted throughout, this princely elephant goad was most probably made specifically for exhibition purposes, rather than for actual use when riding on an elephant. The haft is decorated with a spiral pattern of finely worked flowers and foliage in brightly coloured translucent enamel profusely set throughout with table-cut (flat) diamonds. The head is formed as an elephant, richly set with rubies. A similar example is in the Victoria and Albert Museum, London.

Gold, steel, enamel and precious stones; l 54 cm, wt 940 g
Acquired by the 4th Marquess of Hertford by 1865
OA1382

Sabre, first half of the 19th century
Austrian

▶ This exotic silver-mounted sabre belonged to Anatole Demidoff, prince of San Donato in Florence. It is depicted in an unfinished equestrian portrait of him by Karl Briullov (1799–1852), begun in 1828, and now in the Palazzo Pitti, Florence. Although seemingly made of gold in Briullov's portrait, little of the precious metal still remains; most has vanished, perhaps due to over cleaning during its 'working' lifetime. Despite its singularly Ottoman style, the hilt of the sword bears an (unidentified) Austrian silversmith's mark, and all the mounts are struck with the standard Austrian mark for silver, indicating that it is almost certainly of Austrian manufacture. Swords in 'Eastern' style were particularly fashionable throughout Europe at this time, being especially sought after by dashing young cavalry officers and noblemen.

Steel, silver, wood, textile, turquoise stones and gold; l 93.5 cm, wt (without scabbard) 760 g
Acquired by the 4th Marquess of Hertford in 1870
OA1753

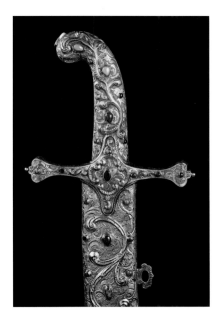

Cannon, 1688 (barrel) and 1853–4 (carriage)
Italian

▼ The cast-bronze barrel, intended for ceremonial use, is decorated in high relief with scenes from classical legend, including Jupiter and the Titans, Hercules and Cacus, and the Rape of the Sabine Women. It is both signed and dated on the muzzle by the maker, Giovanni Mazzaroli (working in Venice 1660–1710). According to legend, the barrel was found in the Venetian lagoon. A similar one, possibly its pair, is in the Hermitage Museum, St Petersburg. The ornate carriage of carved walnut enriched with gilding was commissioned from the craftsman Angiolo Barbetti (1803–80) by Anatole Demidoff, prince of San Donato in Florence. It bears on each side an oval shield painted with the Demidoff arms, and was designed by Demidoff's friend and secretary, Auguste de Sainson, who based it on a miniature cannon once belonging to Cosimo III de'Medici (1642–1723). The ironwork was hand-wrought by G. Ciani (dates unknown).

Bronze, steel and wood; l (overall) 193 cm, (barrel) 139 cm, wt (barrel) 8.3 kg, (bore) 3.8 cm
Acquired by the 4th Marquess of Hertford in 1870
A1245

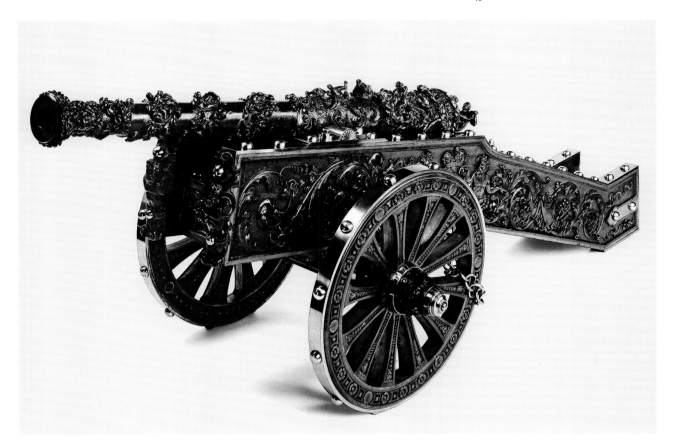

Seventeenth-century Paintings

Many of the greatest Old Master painters are represented in the Wallace Collection. The Collection's Great Gallery is one of the finest rooms of European painting anywhere in the world, displaying an outstanding array of Dutch, Flemish, French and Spanish paintings of the seventeenth century, the great majority acquired by the 4th Marquess of Hertford. These include masterpieces by Rembrandt, Hals, Rubens, Poussin, Claude and Velázquez, often bought by the Marquess at the greatest sales of his time for substantial sums. As early as 1854, little more than ten years after he had begun collecting in earnest, the German art historian Dr Gustav Waagen noted that the 4th Marquess had purchased 'a series of master-works by the greatest painters of the 16th, 17th and 18th centuries … at prices seldom given by Governments, still less by private individuals.'

One reason for the extraordinarily high quality of the 4th Marquess's paintings was his insistence on works in good condition and with an established provenance. In this respect he followed the example of his father, the 3rd Marquess, who began the splendid collection of seventeenth-century Dutch paintings with a number of landscapes and small-scale domestic scenes. The 4th Marquess, however, far outshone his father in the range and number of his purchases, not only in Dutch paintings but also in those of the other major schools. In essence his collection comprised a representative array of almost all the leading seventeenth-century painters as defined by the taste of his time. Only perhaps the Italian school was comparatively weak, which may reflect the declining reputations of the artists of Baroque Italy while he was collecting. No wonder that when the Marquess lent some of his finest paintings to the Art Treasures of Great Britain exhibition at Manchester in 1857 his collection made the greatest impact; one critic wrote, 'No, never in my life, have I seen such fine examples of the great masters.' ❧

Opposite (detail):
Flowers on a Fountain with a Peacock,
*c.*1700–10
Jan Weenix (1642–1719)
See page 125

St John the Evangelist's Vision of Jerusalem, 1635–8
Alonso Cano (1601–67)

◀ The Book of Revelation (21:10–27) ends the Bible with an account of St John's vision of a new heaven and a new earth. The painting shows the moment when an angel carries St John away to a high mountain and shows him the new Jerusalem descending from heaven. Cano was commissioned in 1635 by the Hieronymite nuns of the convent of Santa Paula, Seville, to make a carved retable (screen) with ten paintings illustrating the story of St John the Evangelist. This is one of six paintings and two carvings actually completed by the artist before his departure for Madrid in 1638.

Oil on canvas; 82.6 x 43.8 cm
Acquired by the 4th Marquess of Hertford in 1852
P15

The Lady with a Fan, late 1630s–early 1640s
Diego Velázquez (1599–1660)

▶ The Lady with a Fan is one of Velázquez's most famous paintings, yet the identity of the sitter remains a mystery. It has been suggested that it may portray either the artist's wife, Juana de Miranda, his own daughter, Francisca, or the exiled Marie de Rohan, duchesse de Chevreuse (1600–79). The closely observed features, severe gaze, sober palette and prominently displayed rosary lend the picture an aura of intensity and enigma that has long fascinated viewers. The French art historian Thoré-Bürger claimed that no other painting better represented the art of Velázquez and Spain.

Oil on canvas; 95 x 70 cm
Acquired by the 4th Marquess of Hertford in 1847
P88

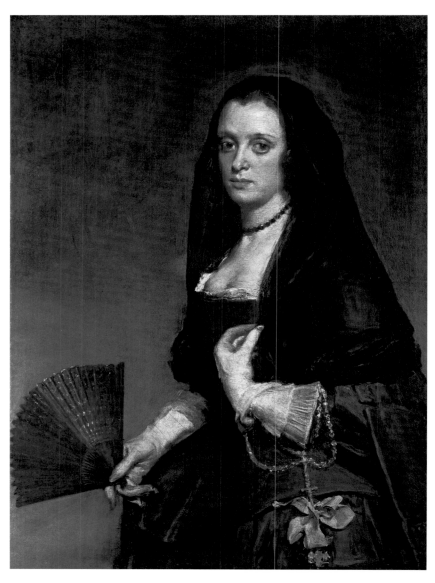

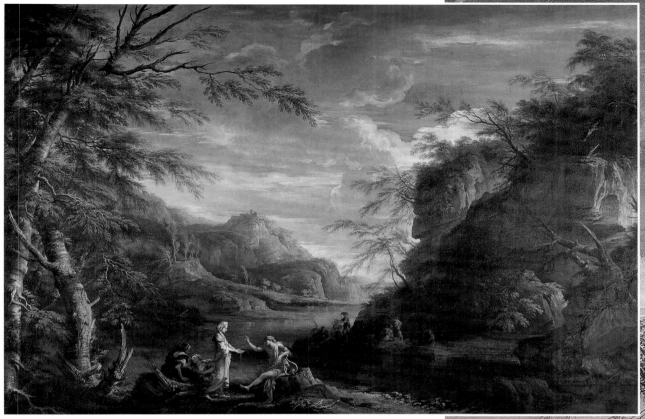

River Landscape with Apollo and the Cumaean Sibyl, 1650s
Salvator Rosa (1615–73)

▲ Ovid's _Metamorphoses_ (XIV, 129–53) tells how the amorous Apollo
offered the Cumaean Sibyl anything she desired. She is shown in the
painting asking for as many years of life as there are grains of dust in
her hands. Although Apollo granted her wish, she still refused him
her favours. In retribution he denied her perpetual youth, and she
lived for a thousand years in increasing misery. Rosa's expressive
brushwork, dark tones and dramatic chiaroscuro, together with his
characterisation of the wild landscape of rocks and splintered trees,
create a sense of foreboding and mystery in keeping with the
melancholy story.

Oil on canvas; 173.7 x 259.5 cm
Acquired by the 4th Marquess of Hertford in 1850
P116

The Adoration of the Shepherds, c.1665
Bartolomé Esteban Murillo (1617–82)

▼ Mary displays the infant Christ, allowing the Shepherds to be the first to recognise the Son of God. They bring doves, the traditional offering for purification after birth, and a bound lamb. The latter symbolises Christ's later sacrifice, which the Child already contemplates in the heavenly vision of a Cross seen at the top of the painting. Realistic details, such as the still life of the cushion and straw hat and the dirty foot of the shepherd in the foreground, lend the picture a feeling of immediacy and intimacy that makes its message all the more convincing.

Oil on canvas; 146.7 x 218.4 cm
Acquired by the 4th Marquess of Hertford in 1846
P34

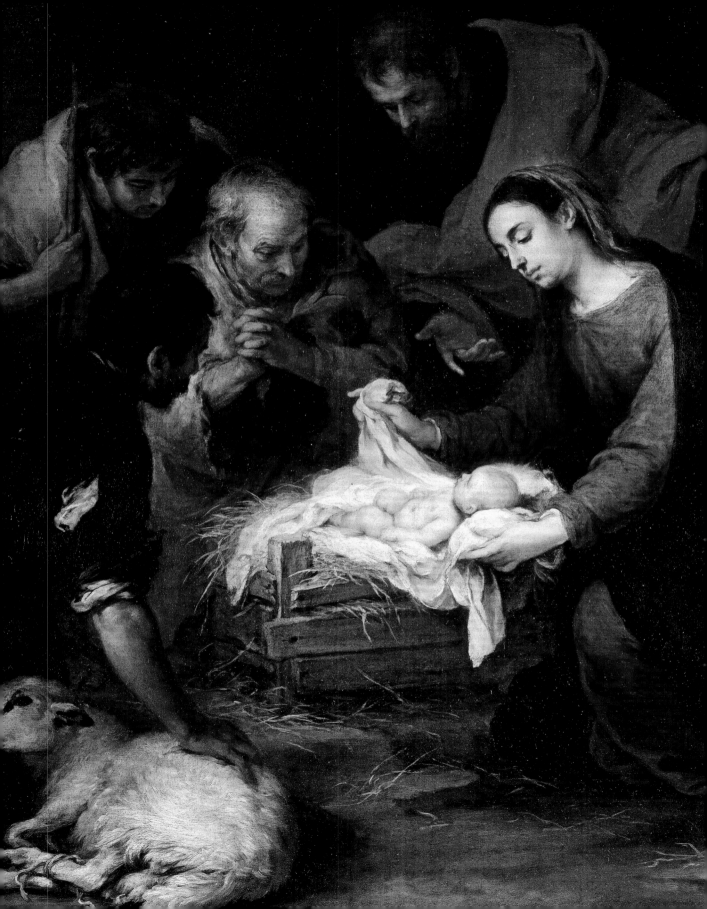

A Dance to the Music of Time, *c.*1634–6
Nicolas Poussin (1594–1665)

◀ One of Poussin's most famous masterpieces, the picture's complex iconography was probably dictated by its patron Giulio Rospigliosi, later Pope Clement IX. Its first meaning is derived from Boitet de Frauville's *Les Dionysiaques*, which describes how, following the complaints of Time and the Seasons, Jupiter gave Bacchus and his gift of wine to the world to alleviate the harsh conditions of human life. The dancing figures represent the Seasons; Autumn, normally shown as a woman, is here represented by the god of wine himself. It is probable that the scene was reinterpreted by Rospigliosi during the process of composition, for the dancing figures came to be more generally identified with the perpetual cycle of the human condition itself: from Poverty, Labour leads to Riches and then to Pleasure, which, if indulged in to excess, reverts to Poverty.

Oil on canvas; 82.5 x 104 cm
Acquired by the 4th Marquess of Hertford in 1845
P108

The Annunciation, *c.*1648
Philippe de Champaigne (1602–74)

▶ *The Annunciation* illustrates the moment in St Luke's Gospel (1:38) when the Archangel Gabriel tells Mary that the Holy Spirit, symbolised by the descending dove, will cause her to bear the Son of God. Mary's abandoned work basket and the prie-dieu in the background refer to apocryphal accounts that she was sewing, praying or reading the Bible. A favourite theme of the artist, this version was painted for the parish church of Sainte-Catherine in the Marais, Paris. The striking austerity of the work may reflect the Jansenist sympathies of the painter.

Oil on canvas; 334 x 214.5 cm
Acquired by the 4th Marquess of Hertford in 1845
P134

Landscape with Apollo and Mercury, 1660
Claude (Claude Gellée) (1604/5(?)–82)

▲ A melancholy Apollo in the foreground plays the pipes in memory of his lost love, the nymph Coronis. In the background Mercury takes advantage of Apollo's self-absorption to steal away his cattle. The subject, which was used several times by Claude between 1645 and 1666, derives from Ovid's *Metamorphoses* (II, 680–710). The true subject of the picture, however, is the luminous morning landscape inspired by the Roman Campagna, which Claude drew and painted throughout his career.

Oil on canvas; 74.5 x 110.4 cm
Acquired by the 4th Marquess of Hertford in 1846
P114

❧ Dutch and Flemish Paintings ❧

Although better known for its French pictures, the Wallace Collection also owns an outstanding array of Dutch and Flemish paintings, surpassed in Britain only by those of the National Gallery and the Royal Collection. Following the dispersal of many continental collections during the French Revolution and the Napoleonic Wars, the 3rd Marquess of Hertford purchased a number of highly finished Dutch and Flemish pictures, often originating from famous collections of the *ancien régime*. Ostade's *Interior with Peasants*, bought by 1829 and formerly in the collection of the eminent French collector Ange-Laurent de la Live de Jully, is typical of his taste for exquisite low-life genre scenes. Many of the 3rd Marquess's purchases were speculative, as seen in his unsuccessful attempts to sell Netscher's *The Lace Maker*, while his friendship with the Prince Regent led to his acquiring forty Dutch and Flemish pictures for the Prince (still in the Royal Collection).

The 4th Marquess of Hertford's collecting of Northern works was on a typically grander scale. His first recorded purchase of Dutch and Flemish paintings took place in 1843, and he continued to collect them with great tenacity until the year of his death. He was attracted to more obviously pleasing subjects, such as Ter Borch's *Lady reading a Letter* (bought in 1848), and was unafraid to pay high prices for trophy pictures, like Rubens's *The Rainbow Landscape* or Rembrandt's *Titus*. Indeed, his paying more than six times the estimate for Hals's *The Laughing Cavalier* initiated the rehabilitation of the painter's artistic reputation. His taste extended to major altarpieces, history paintings, group portraits, still lifes, exquisite oil sketches, landscapes, seascapes, town views and church interiors and, with the exception of Hals, reflects nineteenth-century English taste as canonised in John Smith's catalogue of Dutch and Flemish paintings, published between 1829 and 1842.

As his father's agent and secretary, Sir Richard Wallace had acquired a substantial knowledge of art, and several contemporaries complimented him on his connoisseurial eye. It was he who added the Netherlandish 'Primitives', including Memling's *Angel with a Sword* and Pourbus's *An Allegory of True Love*, to the collection and acquired Steen's *Celebrating the Birth* in 1872. ❧

A Lady reading a Letter,
c.1660–5
Gerard ter Borch (1617–81)
Oil on canvas; 44.2 x 32.2 cm
Acquired by the 4th Marquess
of Hertford in 1848
P236

Right:
Interior with Peasants, 1663
Adriaen van Ostade (1610–85)
Oil on oak panel; 34.1 x 39.7 cm
Acquired by the 3rd Marquess of Hertford by 1829
P169

Below:
Celebrating the Birth, 1664
Jan Steen (1626–79)
Oil on canvas; 87.7 x 107 cm
Acquired by Sir Richard Wallace in 1872
P111

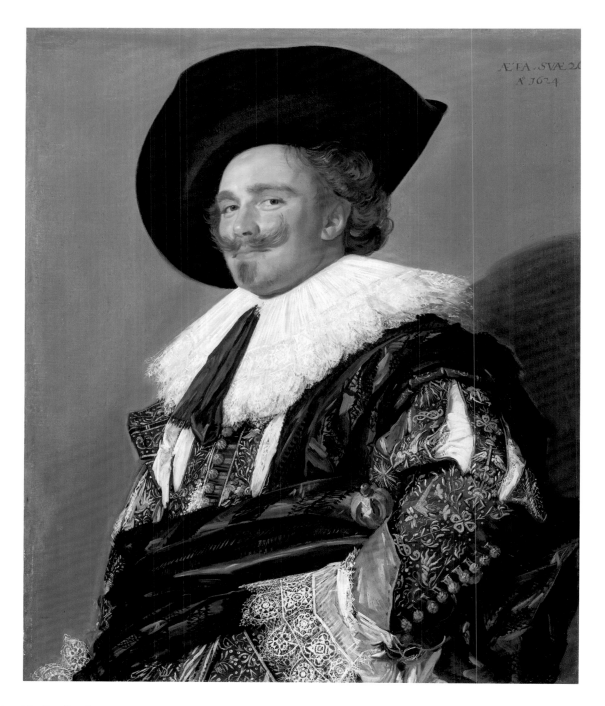

The Laughing Cavalier, 1624
Frans Hals (1582/3–1666)

▲ The title *The Laughing Cavalier* was coined between 1875 and 1888; yet, as has often been pointed out, the sitter is neither laughing nor a cavalier. He wears a rich jacket embroidered with motifs common in emblem books of the time and symbolic of the pains and pleasures of love, including arrows, flaming cornucopias and lovers' knots, which may suggest that the picture is a betrothal portrait. One of the most brilliant of all Baroque portraits, the picture's low viewpoint and swaggering pose contribute to its sense of monumentality. At close hand the painting also astounds with its bravura technique. The vivid colours, differing textures and details of the costume are captured brilliantly by Hals's fluid, expressive brushwork.

Oil on canvas; 83 x 67.3 cm
Acquired by the 4th Marquess of Hertford in 1865
P84

The Holy Family with St Elizabeth and St John the Baptist, 1614–15
Peter Paul Rubens (1577–1640)

◀ The subject is taken from the Franciscan *Meditationes Vitae Christi* (IX). Elizabeth holds the infant John the Baptist, who recognises the infant Christ with hands clasped in prayer. In return, Christ raises his left arm in blessing. The picture demonstrates Rubens's exceptional powers of characterisation and narrative. The picture is remarkable, too, for the highly sculptural, monumental quality of the figures and for its simple but dramatic palette of primary colours. It was painted between 1614 and 1615 for the Archduke Albert, governor of the Spanish Netherlands, and hung in his private oratory at the ducal palace in Brussels.

Oil on oak panel; 136 x 100 cm made up to 138.3 x 102.5 cm
Acquired by the 4th Marquess of Hertford in 1846
P81

The Birth of Henri IV, 1628
Peter Paul Rubens (1577–1640)

▶ Rubens's oil sketches have long been prized for their technical brilliance and originality. This is one of three *modelli* in the Wallace Collection relating to Rubens's intended cycle illustrating the Life of Henri IV. Commissioned in 1622 by the King's widow, Marie de'Medici, the series was intended to complement the famous Medici Cycle, commemorating the 'life and heroic acts' of the Queen, but was never executed, making the surviving sketches all the more precious. Here an allegorical description of the birth of Henri IV (1553–1610) depicts the infant Henri being cradled by a woman symbolising his birthplace, the city of Pau, while Mars, god of war, hands the child a sword, foretelling his future military prowess.

Oil on oak panel; 21.2 x 9.9 cm
Acquired by the 4th Marquess of Hertford in 1859
P523

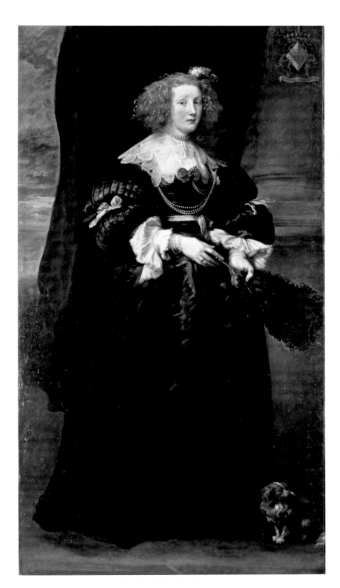

Philippe Le Roy and ***Marie de Raet***, 1630 and 1631
Anthony van Dyck (1599–1641)

▲ Long acknowledged as two of Van Dyck's greatest works and the finest portraits to survive from his second Antwerp period (1627–32), they demonstrate the artist's ability to capture not only his sitters' likenesses but also their aspirations. Philippe Le Roy (1596–1679) was the illegitimate grandson of a successful Antwerp gunpowder manufacturer. As a result of his own financial acumen, Philippe, aged only thirty, was able to acquire the land and feudal rights to the villages of Ravels and Eel and the right to call himself 'Lord of Ravels'. In 1631 he married Marie de Raet (1614–62), the sixteen-year-old daughter of François de Raet, almoner of Antwerp, Lord of Couwenstyn. He marked this union by commissioning the present pair of portraits from Van Dyck. Le Roy's portrait was painted,

probably to celebrate his betrothal, in 1630. By commissioning an expensive full-length portrait, the sitter made clear from the outset his wish to be portrayed in a grand manner. Van Dyck's achievement was to create an image matching Le Roy's ambition, without making him appear *arriviste*. *Marie de Raet* was painted the following year to celebrate the couple's marriage. She is painted in the trappings of nobility, embodying her new husband's taste and wealth, and is made all the more charming by her air of innocence and vulnerability.

Oil on canvas; each 213.3 x 114.5 cm
Acquired by the 4th Marquess of Hertford in 1850
P94 and P79

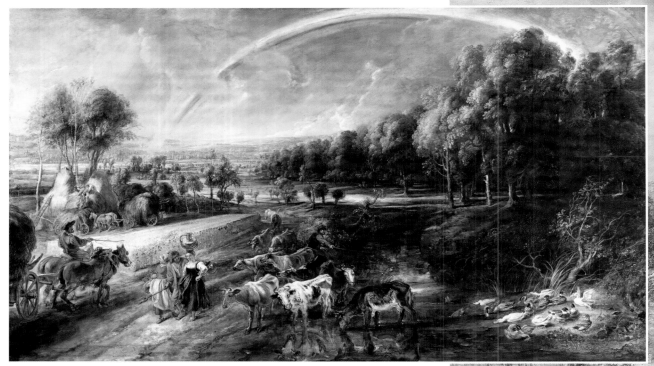

The Rainbow Landscape, *c.*1636
Peter Paul Rubens (1577–1640)

▲ In 1635 the fifty-eight-year-old Rubens bought the château of Het Steen, situated between Brussels and Antwerp. Soon afterwards he painted a view of the château (now in the National Gallery, London) and this companion piece, which shows the surrounding country-side. The two pictures celebrate Rubens's deep love for the landscape of Brabant and are the greatest landscapes he painted. *The Rainbow Landscape*, however, is not a simple naturalistic record. Rather it recreates a vision of his native countryside in order to convey not just what he saw but also what he thought and felt about the land and man's relationship to it. Thus the rainbow recalls the covenant made between God and Man after the Flood, and the harvest can be seen as man's just reward for his labours.

Oil on oak panel; 135.6 x 235 cm
Acquired by the 4th Marquess of Hertford in 1856
P63

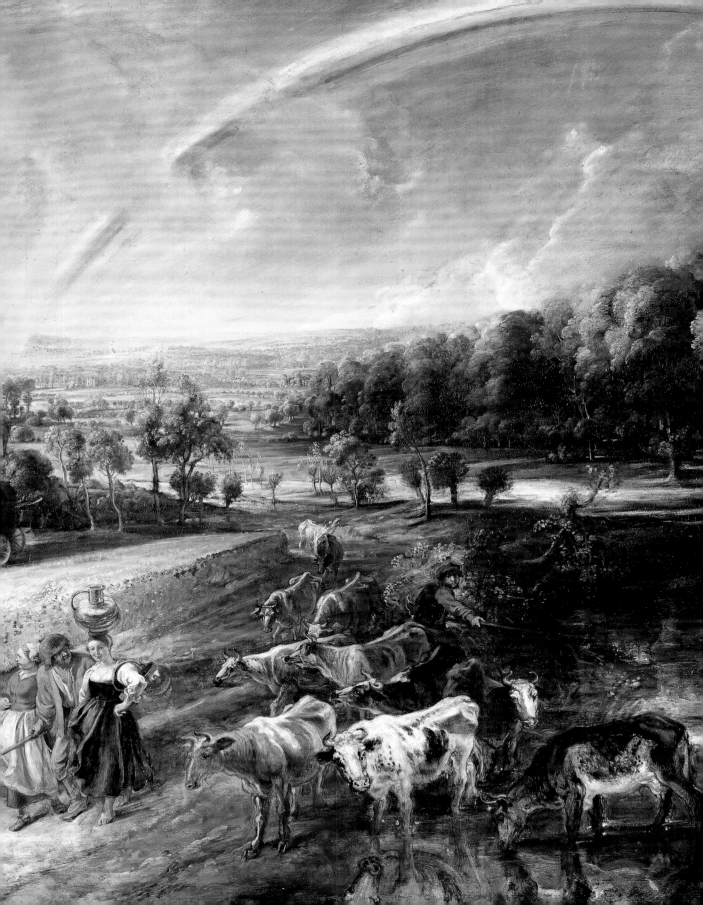

A Boor Asleep, 1630s
Adriaen Brouwer (c.1605/6–38)

◀ The delicate palette and bravura handling of this jewel-like example of Brouwer's art, painted on a beige ground, are typical of the artist's maturity and help explain his appeal to contemporaries such as Rubens and Rembrandt. The composition was popular and frequently copied, Brouwer himself producing a number of closely related compositions. When the art historian Dr Waagen saw *A Boor Asleep* in Manchester House in 1854 he described it as 'by far the finest example of this rare master I know'.

Oil on oak panel; 36.6 x 27.6 cm
Acquired by the 3rd Marquess of Hertford by 1820
P211

The Smokers, 1644
David Teniers the Younger (1610–90)

▼ Three peasants roll tobacco, fill a pipe and inhale, while their friend relieves himself in a corner. The discarded shoe indicates the protagonists' unwillingness to leave such a congenial interior, and the mussel shells warn of the poverty to which such behaviour will lead. The painter's mahlstick and the portrait drawing on the wall may refer to the artist's own fondness for taverns. Painted on copper, the picture is remarkable for its meticulous finish and for the fine execution of details such as the still life of crockery in the right foreground.

Oil on copper; 36.5 x 50.2 cm
Acquired by the 4th Marquess of Hertford in 1858
P227

Still Life with Lobster, 1643(?)
Jan Davidsz. de Heem (1606–83/4)

▲ Typical of De Heem's sumptuous banquet still lifes, this picture is a virtuoso display of his ability to capture texture in paint, from the mouth-watering display of fruit, crustacea and other foodstuffs to the skilfully painted reflective surfaces of pewter plates, glass roemer and silver flagon. Indeed, the image of the artist at work can be seen reflected in the shiny surfaces of the roemer and flagon. The jewel box with key also implies closer attention is needed to unlock all the picture's secrets, thus prompting the viewer to look past the material display to the spiritual world beyond.

Oil on canvas; 79.2 x 102.5 cm made up to 80.2 x 103.7 cm
Acquired by the 4th Marquess of Hertford in 1843
P175

The Avenue at Meerdervoort, early 1650s
Aelbert Cuyp (1620–91)

▲ An evening view looking across the Maas, with the castle of
Meerdervoort on the left and a distant view of Dordrecht on the
right. The composition is an unusual combination of urban view
and rural landscape, bisected by a central avenue that leads the
viewer's gaze into the picture. It is one of Cuyp's earliest seigneurial
subjects and was probably commissioned by Cornelis van Beveren
(1591–1663), who later added the name Meerdervoort to his surname.
The two boys seen in the distance may be identified as Van Beveren's
eldest grandchildren, Michiel and Cornelis, whose father, Pompe
van Meerdervoort, lived in the castle.

Oil on canvas; 69.8 x 99 cm
Acquired by the 4th Marquess of Hertford in 1868
P51

Interior of the Oude Kerk, Delft, 1651
Emanuel de Witte (c.1617–91/2)

▶ De Witte's first dated church interior, this painting depicts the north transept and choir of the Oude Kerk in Delft, seen obliquely from the south aisle of the nave. In accordance with Protestant teaching, the bare white interior of the church focuses attention upon the minister, the only active figure, preaching from the pulpit to a large congregation. The simplicity of the interior emphasises the quality of stillness created by the artist, and the descending daylight suggests the attentive congregation's communication with the heavens. The picture is an excellent example of De Witte's masterly ability to create convincing illusions of space and light.

Oil on oak panel; 60.5 x 44 cm
Acquired by Sir Richard Wallace in 1872
P254

A Southern Harbour Scene, late 1650s
Nicolaes Berchem (1620–83)

▼ Typical of Berchem's decorative and exotic harbour scenes, the harbour was imaginatively identified with the port of Genoa by Jacques Aliamet, who engraved the picture in the eighteenth century. The picture's distinguished provenance demonstrates the artist's appeal to collectors in the eighteenth and nineteenth centuries; its owners included Charles-Ferdinand, duc de Berry, and Anatole Demidoff, prince of San Donato. The 4th Marquess of Hertford paid the considerable price of 42,000 francs (about £1,680) for the painting at the latter's sale in 1868.

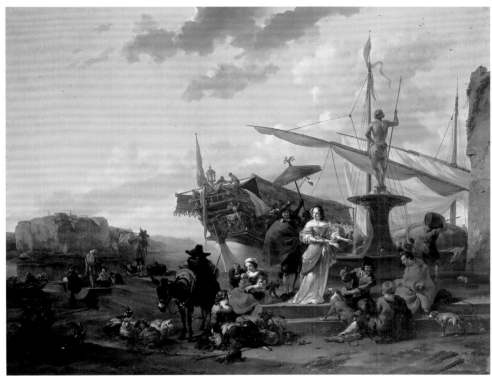

Oil on canvas; 82.9 x 103.7 cm
Acquired by the 4th Marquess of
Hertford in 1868
P25

A Skating Scene, c.1655–60
Aert van der Neer (1603/4(?)–77)

▲ In this highly assured work Van der Neer typically adopts a slightly raised vantage point, from which he depicts a large expanse of sky. The masterly perspective is achieved by motifs such as the receding clouds and above all by the sense of space and light created by the subtle tonal effects: gold pink on the horizon for the setting sun, gradually cooling to blues and greys further away. On the ground recession into depth is conveyed simply by the tapering ribbon of a frozen river, while small figures animate the foreground and middle distance, providing picturesque interest as they chat, skate or play *kolf*.

Oil on canvas; 53.4 x 68 cm
Acquired by the 4th Marquess of Hertford in 1849
P217

Interior with Woman Cooking, 1656
Esaias Boursse (1631–72)

▶ Thought to depict a sickroom, because of its stillness and the prominence of the unmade bed, *Interior with Woman Cooking* may be one of two such subjects listed in the inventory of the artist's brother in 1671. The directness of the image and rough surface of the technique are typical of Boursse's highly individual style, which anticipated nineteenth-century realist painting.

Oil on canvas; 51 x 57.8 cm made up to 51.6 x 58.8 cm
Acquired by Sir Richard Wallace in 1872
P166

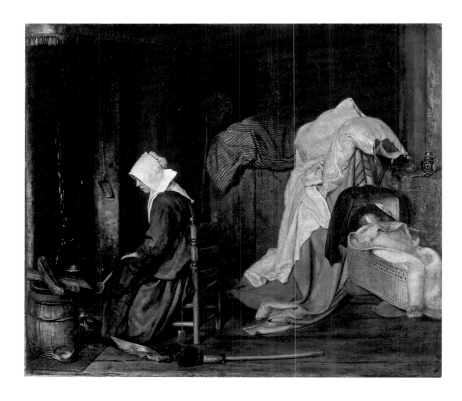

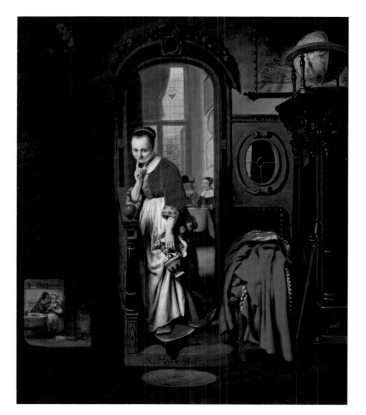

The Listening Housewife, 1656
Nicolaes Maes (1634–93)

◀ Maes's most innovative genre motif was the interior with the eavesdropper who exposes the peccadilloes of other members of the household. Here a housewife invites the viewer to witness the misbehaviour of the servants below stairs, whose dalliance not only allows the cat to lick the plates on the kitchen floor but also leaves the guests unattended and hungry in the dining room above. The theme of admonition, suggested by the picture of Christ, top left, is reinforced by the manipulation of space and light, which contrasts the probity of the dining room with the moral and physical descent towards the heated kitchen.

Oil on canvas; 84.7 x 70.6 cm
Acquired by the 4th Marquess of Hertford after 1857
P224

The Sleeping Sportsman, c.1658–60
Gabriel Metsu (1629–69)

▶ The hunt is often metaphorically interpreted as man's pursuit of woman in seventeenth-century Dutch genre painting. Alcohol, however, has rendered Metsu's hunter incapable of reaping the rewards of his hunting prowess. The lady, standing expectantly in the doorway with an empty glass, looks beyond the sleeping figure to a second man who leans and mocks from a window, arm raised, ready to steal the huntsman's 'bird', or rather his opportunity for dalliance with the mistress of the house. The picture is remarkable for its deft depiction of material textures as well as its vivid colouring.

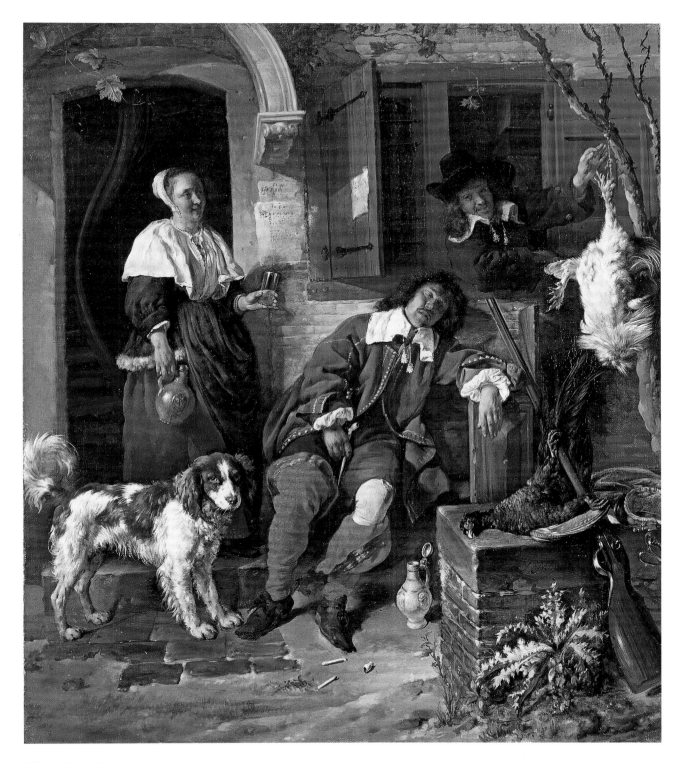

Oil on canvas; 40.3 x 34.9 cm
Acquired by the 4th Marquess of Hertford in 1845
P251

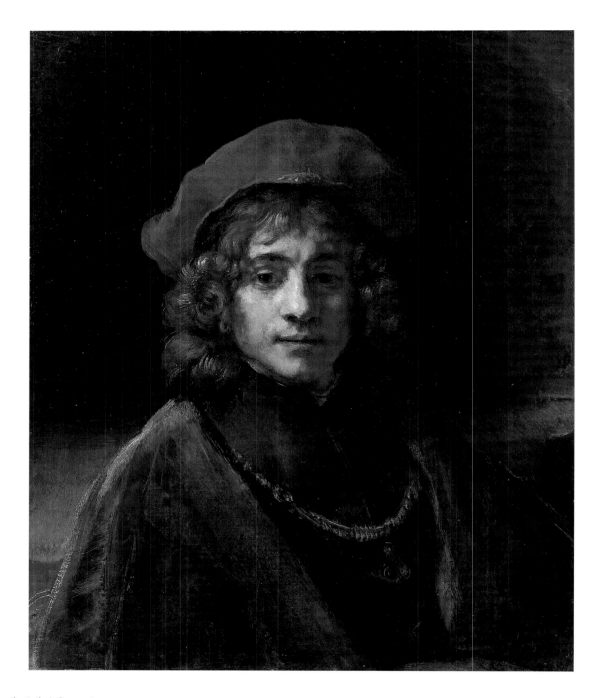

Titus, the Artist's Son, c.1657
Rembrandt (Harmensz.) van Rijn (1606–69)

▲ In 1656, Rembrandt was declared bankrupt, and at about the time this portrait was painted his sixteen-year-old son, Titus van Rijn (1641–68), and Titus's stepmother, Hendrickje Stoffels, were forced to administer the production of his etchings and the sale, in 1658, of his pictures. Rembrandt captures sympathetically the young man's serious gaze, while his bravura handling of the paint lends the image an appearance of spontaneity and immediacy. The restricted palette, dominated by brown and dark red, and the sharp contrasts of light and shade accentuate this feeling of intimacy, adding to

the illusion of psychological connection between viewer and sitter. Of the twelve Rembrandts listed in the Wallace Collection when it was bequeathed to the nation in 1897, this is the only work to retain its full attribution to Rembrandt unchallenged.

Oil on canvas; 68.5 x 57.3 cm
Acquired by the 4th Marquess of Hertford in 1850
P29

A Hermit, c.1661
Gerrit Dou (1613–75)

▶ A hermit in monkish garb in a vaulted interior sits surrounded by *vanitas* symbols, reminders of the transience of worldly possessions and the inevitability of death. A skull acts as a *memento mori*, while the hourglass and candle recall the brevity and fragility of human life. In contrast, the hermit seeks spiritual solace in the everlasting truths of the Bible open before him. The picture's meticulous finish is typical of Dou's mature style, which inspired the formation of the school of Leiden *fijnschilders* ('fine painters'), who continued to paint in a similarly polished manner well into the eighteenth century.

Oil on oak panel; 32.1 x 23.7 cm
Acquired by the 4th Marquess of Hertford in 1843
P170

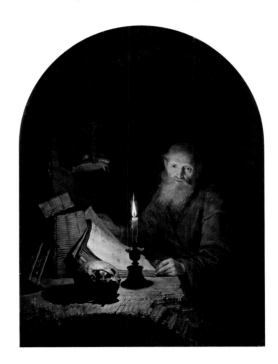

The Horse Fair, 1660s
Philips Wouwermans (1619–68)

▼ *The Horse Fair* is the most famous of the pictures by Wouwermans in the Wallace Collection. The picture demonstrates Wouwermans's strengths as a landscapist in creating subtle evocations of a vaguely Mediterranean or Italianate terrain and atmosphere. The technical virtuosity of the handling and the picture's decorative quality won it great renown in eighteenth-century France. One commentator wrote: 'No picture by Wouwermans surpasses this in its fine touch, fresh colouring and brilliance, which exceed the imagination.' Such elegant subjects, exquisitely executed, and often bearing a distinguished provenance, endeared Wouwermans's works to the 4th Marquess of Hertford, who bought at least seven pictures by the artist.

Oil on mahogany panel; 64.3 x 88.4 cm
Acquired by the 4th Marquess of Hertford in 1854
P65

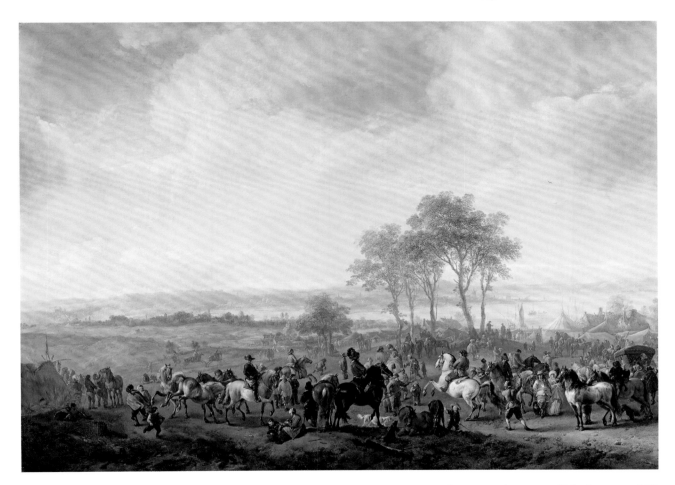

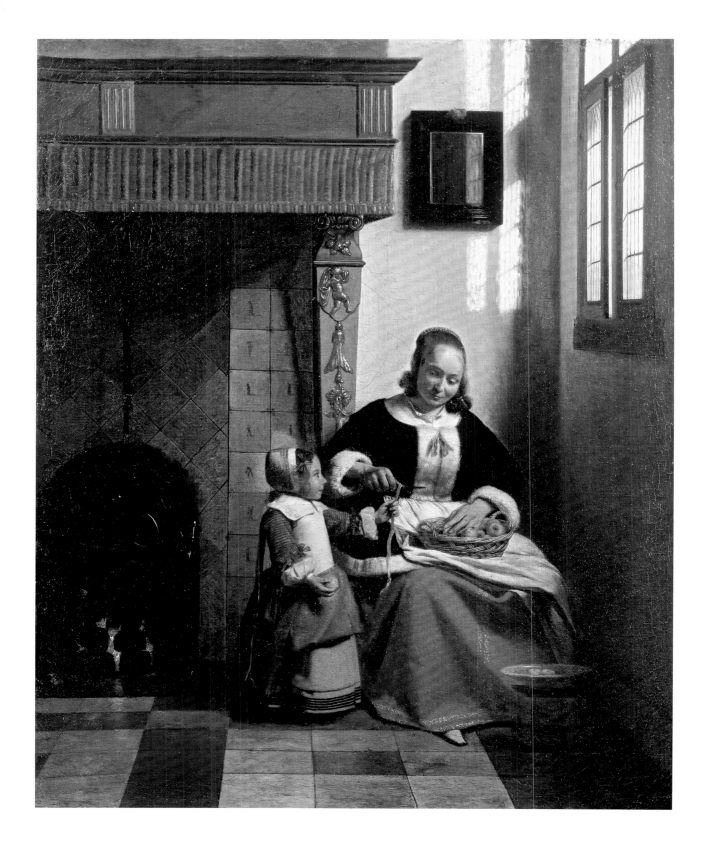

A Woman peeling Apples, c.1658–60
Pieter de Hooch (1629–84)

◀ Typical of his carefully composed, light-filled interiors, the picture is a fine example of De Hooch's innovative contribution to domestic subjects in seventeenth-century Dutch art. Here the mother, teaching her daughter to peel apples, presents a positive female role model, while the complementary theme of marital love is represented by the cupid on the fireplace pillar. De Hooch's attention to contemporary customs is shown by the black opthalmic patch on the woman's temple, a supposed cure for sight disorders. The picture recalls Vermeer's paintings of figures in a light-filled corner of a room and was wrongly attributed to the latter in Thoré-Bürger's pioneering study of Vermeer (1866).

Oil on canvas; 67.1 x 54.7 cm
Acquired by the 4th Marquess of Hertford in 1848
P23

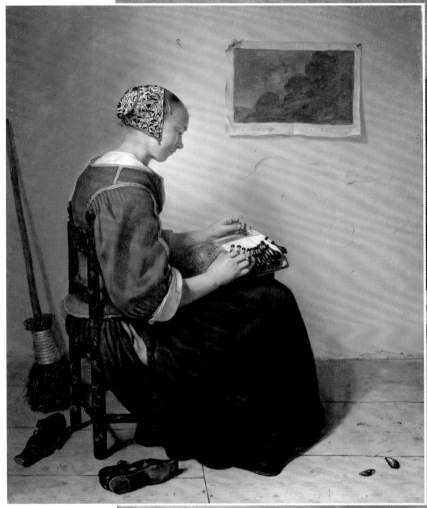

The Lace Maker, 1662
Caspar Netscher (1639–84)

▲ Netscher's undisputed masterpiece, *The Lace Maker* is one of the most successful representations of idealised female virtue in Dutch art. The girl's modest woollen dress implies her lack of vanity, while her absorption in the delicate and difficult task of lace making underlines her seriousness and moral probity. Stylistically, the picture reveals Netscher's sensitivity to the formal experiments of the Delft School, in particular to the understated light-filled interiors of De Hooch and Vermeer. The concentrated subject, bold restricted palette and sculptural quality of the figure, offset against a luminous white wall, lend the picture an aura of monumental gravity, belying its modest dimensions.

Oil on canvas; 33 x 27 cm
Acquired by the 3rd Marquess of Hertford in 1804
P237

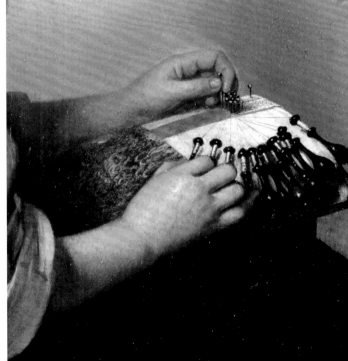

Landscape with a Waterfall, 1660s–70s
Jacob van Ruisdael (1628/9–82)

▼ Ruisdael became so famous for such panoramic waterfall views that plays and poems were written to honour his achievement. Even his name was regarded as synonymous with his subject matter, for *ruis dael* means 'noisy valley' in Dutch. His skill lies in his ability to convey a very real sense of the visual drama of a crashing torrent. This painting belonged to the first director of the Louvre, baron Vivant Denon (1747–1825), and was described at his sale in 1826 as 'a rustic landscape the melancholy of which inspires reverie … Joseph Vernet said that it seemed you could almost hear the murmur of the water'.

Oil on canvas; 101.2 x 142.2 cm
Acquired by the 4th Marquess of Hertford in 1850
P56

A Stormy Landscape, 1663–5
Meindert Hobbema (1638–1709)

▲ Hobbema began painting his characteristic richly textured woodland views around 1662. This painting is an excellent example of this new phase in his art and demonstrates his delight in creating woodland vistas, varied with differing tree forms and patches of light, opening on to illuminated clearings with picturesque cottages. Even with the threat of an impending storm, his vision of nature is one of cheerful domesticity. Described as Hobbema's reception piece for the Middelburg Academy by the dealer Jean-Baptiste-Pierre Le Brun, it was regarded as one of Hobbema's masterpieces by the art historian Hofstede de Groot.

Oil on canvas; 96.7 x 128 cm
Acquired by the 4th Marquess of Hertford in 1845
P75

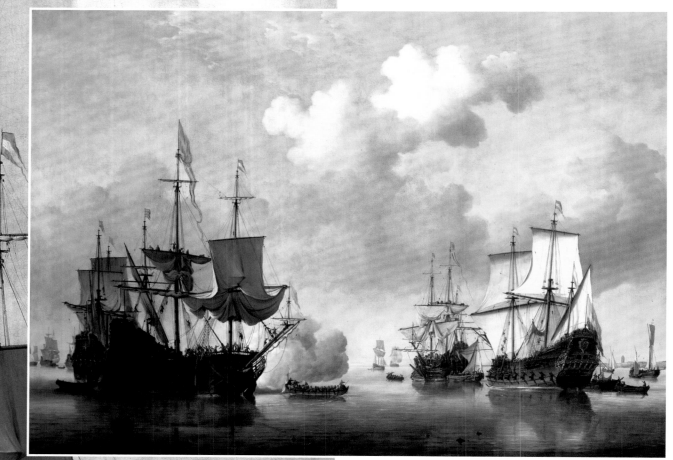

Calm: Dutch Ships coming to Anchor, *c*.1665
Willem van de Velde the Younger (1633–1707)

▲ This stately Dutch seascape, painted when the artist was only thirty-two years old, is regarded by many as his masterpiece. The main subject of the painting is the ship in the left foreground, which flies the flag and pendant of the commander-in-chief of the Dutch fleet. It has been identified as the *Liefde*, the flagship of Admiral Cornelis Tromp (1629–91), who was commander-in-chief in 1665. The painting may have been commissioned by Tromp to commemorate his brief command.

Oil on canvas; 169.9 x 233 cm
Acquired by the 4th Marquess of Hertford in 1846
P137

View of the Westerkerk, Amsterdam,
late 1660s–early 1670s
Jan van der Heyden (1637–1712)

◀ This view is an architectural portrait of
the Westerkerk in Amsterdam, and thus a
notable exception to Van der Heyden's
usual practice of only loosely basing his
townscapes on an actual view. Much of the
picture's fascination derives from the minute
handling, with each element painted with
the same degree of definition. Visual drama
is conveyed by the sharp contrasts of colour,
light and texture: shadows slanting across
the church façade, sharp rooftops etched
against the clear blue sky, bright green trees
and their leafy shadows overlaying warm
red brick or dazzling whitewash and glassy
reflections on the canal.

Oil on oak panel; 41.3 x 59.1 cm
Acquired by the 4th Marquess of Hertford in 1848
P225

Flowers on a Fountain with a Peacock,
c.1700–10
Jan Weenix (1642–1719)

▶ The most spectacular of a group of
thirteen paintings by Weenix in the Wallace
Collection, this picture is a particularly fine
and characteristic example of his late
decorative style. It demonstrates the artist's
skill in combining a theatrical *mise en scène*
with finely observed detail. It also combines
natural and architectural elements, com-
posed in the grand manner, with dramatic
lighting to obtain a monumental effect.
The picture's impressive visual power,
however, derives principally from the artist's
ability to render different textures in paint.
Its scale and quality may indicate that it
once formed part of a larger commission
from a prestigious patron, possibly for a set
of Seasons.

Oil on canvas; 177 x 165 cm
Acquired by the 4th Marquess of Hertford in 1859
P59

See details on pages 94–5

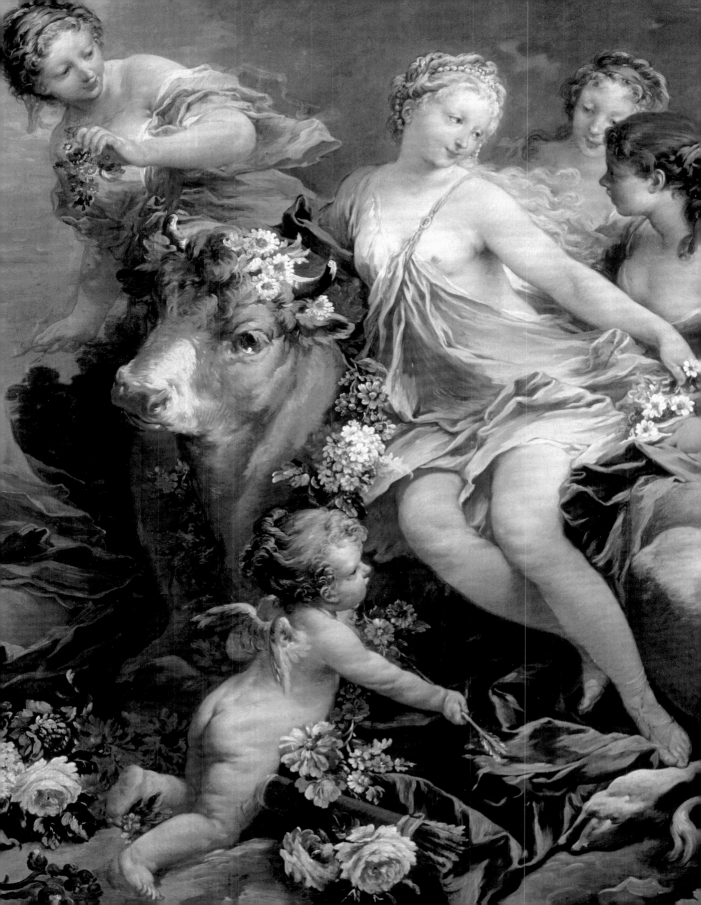

Eighteenth-century France

The superb collections of eighteenth-century French art, including paintings, porcelain, furniture, sculpture, gold boxes and other decorative objects, are probably the most distinctive feature of the Wallace Collection. By far the most important contribution to this sumptuous array was made by the 4th Marquess of Hertford, whose circumstances as a wealthy aristocrat with homes in the most fashionable part of Paris and the Bois de Boulogne encouraged his instinctive sympathy for the *ancien régime* of Louis XIV to Louis XVI. He had a profound love for beauty and craftsmanship, and a marked preference for works of art that celebrate intimacy and pleasure; no one could have satisfied these criteria better than the artists and craftsmen of eighteenth-century France.

It was ironic that the French Revolution of 1789, which overthrew the *ancien régime*, helped create the opportunities for the Marquess to form his enormous collection. Many great French collections were split up and sold as a result of the immense social and economic upheavals of the Revolutionary period. Indeed, such was the glut of eighteenth-century art on the market and so tainted was it by its association with a despised regime that in the first decades of the nineteenth century it was out of fashion and comparatively cheap in France. By the time the 4th Marquess began collecting in the 1840s it was already recovering from this disparagement. When he died in 1870, thanks to his own enthusiasm and that of other wealthy collectors such as the Rothschilds and the duc de Morny, it had acquired an association with millionaires' taste, which it has retained ever since.

When the Wallace Collection was first opened to the public in 1900 it was the eighteenth-century French art that attracted most comment. English audiences may have been used to seeing French furniture and porcelain, but the paintings of Boucher and Fragonard were largely unfamiliar, and their subject matter challenged the conventions of late Victorian taste. To this day the Wallace Collection is the only place in Britain where one can see a truly representative range of eighteenth-century French art at its most refined and sensuous. ❧

Opposite (detail):
The Rape of Europa, c.1732–34
François Boucher (1703–70)
See page 150

Charles Le Brun, c.1667
Antoine Coysevox (1640–1720)

▶ This bust of the artist who dominated the visual arts in France between the 1650s and the 1680s was exhibited before the French Academy in 1676, serving as the model for a marble version (now in the Louvre, Paris) that Coysevox offered to the Academy as his reception piece in 1679. Charles Le Brun (1619–90) was not only First Painter to Louis XIV but also Chancellor of the Academy and, as head of the Gobelins manufactory, the leader of a team producing luxury furnishings (tapestries, furniture and silver) unsurpassed in Europe. Coysevox, the son of a Lyons joiner, rose to become one of the greatest sculptors of his time. He shows Le Brun in his day shirt, with only a miniature of Louis XIV, tucked within his cloak, hinting at his position and status.

Terracotta; h 66 cm
Probably acquired by the 4th Marquess of Hertford at an unknown date
S60

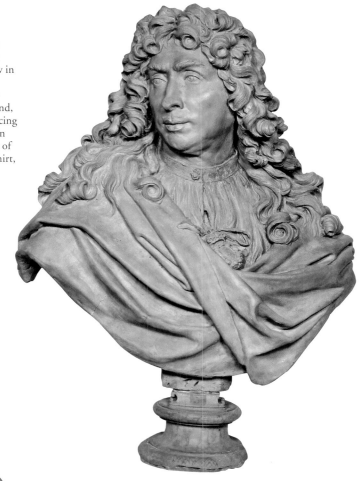

Louis XIV of France, c.1699
Antoine Coysevox (1640–1720)

◀ In gilt bronze (most of the gilding has worn away), this is inevitably a much more formal image than Coysevox's terracotta bust of Le Brun (above). It conveys marvellously the imperious nature of the Sun King, Louis XIV (1638–1715), who with unsurpassed extravagance used the arts to promote himself and his country. Similar to a marble version executed for the Parliament of Burgundy in 1680 (Musée des Beaux-Arts, Dijon), it was almost certainly shown at the Paris Salon of 1699 when the King was aged sixty-one. Although very much a state portrait, the sculptor has not omitted to indicate the ageing King's heavy jowls.

Gilt bronze; h (excluding socle) 74.9 cm
Acquired by the 3rd or the 4th Marquess of Hertford at an unknown date
S165

Jupiter victorious over the Titans: 'Fire',
*c.*1655–80
French

▶ This is one of a pair of superb bronzes,
probably cast in France after models by the
great Italian sculptor Alessandro Algardi
(1598–1654). The other, also in the Wallace
Collection, depicts *Juno controlling the
Winds: 'Air'* (s162). First inventoried in 1689,
they were owned by Louis XIV, XV and
XVI, and in 1796, after the Revolution,
passed as payment in kind from the govern-
ment to a merchant named Jacques de
Chapeaurouge. This bronze shows Jupiter
astride an eagle with a thunderbolt in his
right hand. Cowering below are three of the
giant Titans who challenged the gods but
were crushed by Jupiter under the rocks of
mounts Pelion and Ossa.

Bronze; h (including base) 127 cm
Probably acquired by the 4th Marquess of Hertford
by 1870
S161

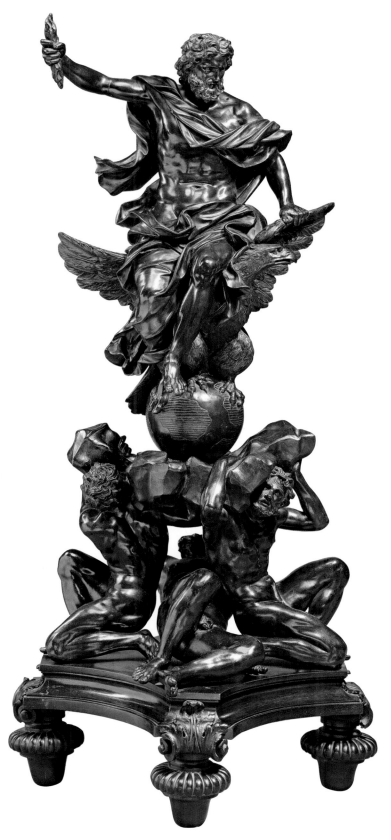

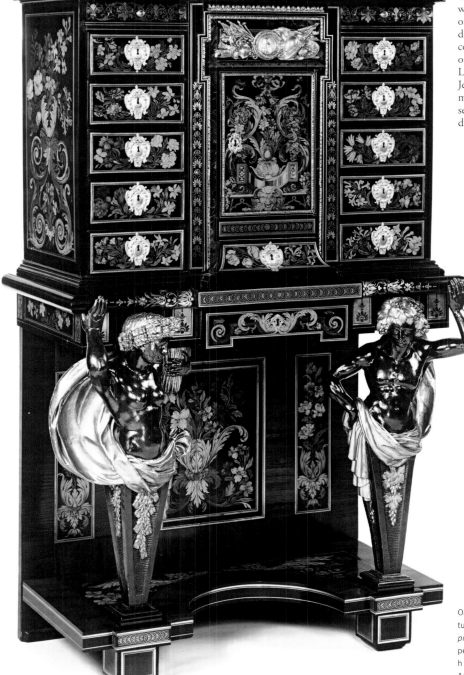

Cabinet on Stand (*cabinet avec son pied*),
*c.*1665–70
Attributed to André-Charles Boulle (1642–1732)

◀ This spectacular cabinet can be dated to the late 1660s, although it probably underwent slight alterations in the nineteenth century. Only four other similar cabinets are known to exist. The naturalistic depiction of flowers and insects in the wood marquetry reflects the popularity of Dutch still-life painting in the last few decades of the seventeenth century. This is combined with more imaginary elements of Baroque architecture. The medal of Louis XIV at the front of the cabinet is by Jean Warin (1606–72). Such cabinets were made largely to impress, but the central section might also have been used for the display of prized works of art.

Oak, walnut and pine veneered with ebony, turtleshell, purple heart, floral marquetry and *première-partie* Boulle marquetry of ebony, brass, pewter and copper; gilding and gilt-bronze mounts; h 186.7 cm, w 123 cm, d 65 cm
Acquired by Sir Richard Wallace in 1872
F16

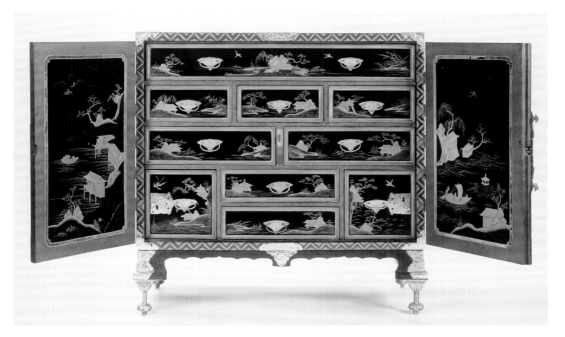

Hiba-wood lacquered in black and gold; gilt-copper hinges, lock-plates, corner mounts and drawer handles; h (excluding feet) 86 cm, w 99 cm, d 54 cm
Acquired by the 4th Marquess of Hertford at an unknown date
F18

Lacquer Cabinet (*cabinet de laque*), c.1680
Japanese, Kyoto(?), and French

▲ Japanese lacquer was enormously prized in Europe in the seventeenth and eighteenth centuries. This cabinet, one of a pair, belongs to a type of Japanese cabinet made for export through the Dutch East India Company, though it is of higher quality than most export lacquer. There are ten drawers inside, each with a lacquer front. Some decorative elements of the exterior, such as the mountains, rocks and roofs of buildings, are raised in low relief, and the summit of Mount Fuji has applied silver leaf to represent snow. The gilt-bronze feet are of late seventeenth-century French manufacture.

Chest of Drawers (*commode*), c.1695
French

▶ Magnificent, sarcophagous-shaped chests of drawers of this kind were characteristic of the grandest furniture of the late seventeenth century. This piece has been attributed tentatively to Alexandre-Jean Oppenordt (c.1639–1715). It was altered in the nineteenth century by the famous London dealer and restorer Edward Holmes Baldock before he sold it to the 12th Earl of Pembroke; he probably, for example, had the original marquetry top replaced with the present marble. It was at Lord Pembroke's sale that the chest of drawers was bought by the 4th Marquess of Hertford.

Oak and walnut veneered with ebony and *première-partie* Boulle marquetry of brass and turtleshell; *lumachella* marble top; gilt-bronze mounts; h 87.5 cm, w 132 cm, d 63.5 cm
Acquired by the 4th Marquess of Hertford in 1851
F405

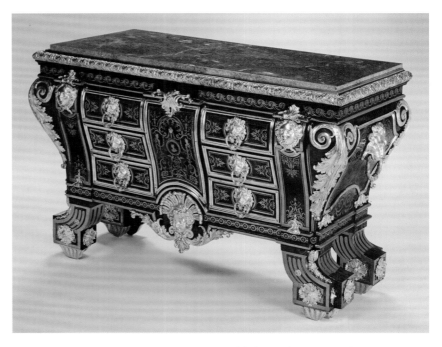

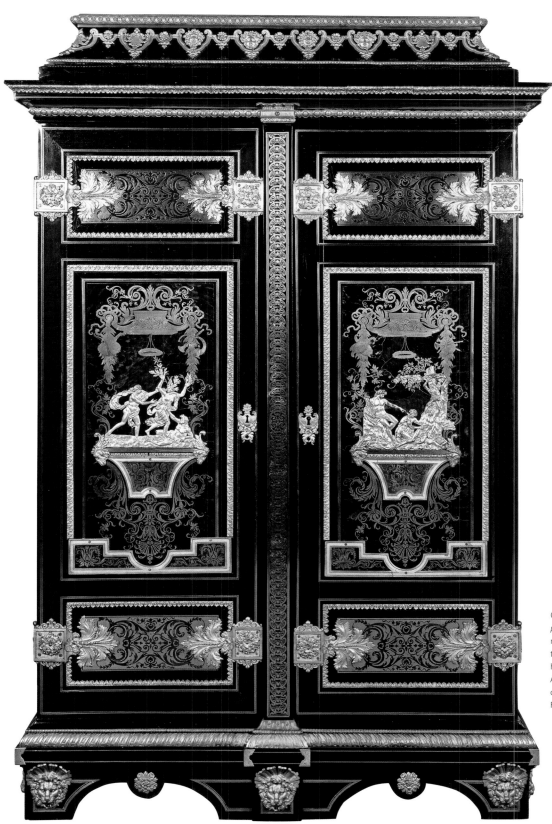

Oak veneered with ebony and
première-partie Boulle
marquetry of brass and
turtleshell; gilt-bronze mounts;
h 255 cm, w 163.5 cm, d 61 cm
Acquired by the 4th Marquess
of Hertford in 1848
F61

Wardrobe (*armoire*), *c*.1700
Attributed to André-Charles Boulle (1642–1732)

◀ This grand wardrobe is one of two in the Wallace Collection. The main purpose of the piece was for display, but it was also fitted with shelves for storing linen or other items. The figurative, gilt-bronze mounts on the centre of the doors represent Apollo and Daphne and Apollo flaying Marsyas, mythological stories derived from Ovid's *Metamorphoses*. Boulle himself was a compulsive collector and owned a series of drawings after the *Metamorphoses* by Raphael, destroyed in his workshop fire of 1720. The wardrobe was once in the collection of the Duke of Buckingham at Stowe House. The interior was lined with peach-blossom silk and fitted with gilt-bronze brackets and hooks to hold the clothes of Queen Victoria when she visited in 1845, three years before the 4th Marquess purchased the wardrobe.

Inkstand (*écritoire*), 1710
French

▲ This superb inkstand was made in 1710 for the Paris Guild of Barber–Surgeons, whose motto and arms are incorporated within the elaborate marquetry design. Around the top edge are the names of twelve senior surgeons, including that of Georges Mareschal, who was surgeon to Louis XIV, the Regent and Louis XV. Phrases and symbols relating to medicine, including the serpents of Aesculapius, ancient god of medicine, appear on the outer edges. The inkstand has been attributed tentatively to Alexandre-Jean Oppenordt.

Oak, pine and walnut veneered with ebony and *première-partie* Boulle marquetry of brass and turtleshell; gilt-bronze mounts and writing fitments; h 10 cm, w 55.8 cm, d 38.6 cm
Acquired by the 3rd or the 4th Marquess of Hertford probably by 1842
F49

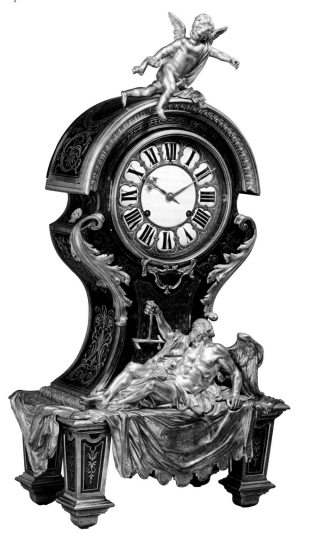

Pedestal Clock (*pendule*), *c*.1712–20
Attributed to André-Charles Boulle (1642–1732)

◀ The allegory of Love triumphing over Time was a popular motif for clocks made in the eighteenth and nineteenth centuries. Here the figure of Love at the top formerly held Time's scythe in his left hand. The recumbent figure of Time derives from a model by the sculptor François Girardon (1628–1715). The movement of the clock is perhaps by Jacques-Augustin Thuret (died 1739), who, like Boulle and Girardon, had lodgings in the Louvre. Boulle produced a group of these clocks, which can be dated between 1708 and 1720.

Oak veneered with turtleshell, ebony, brass and ebonised walnut; gilt bronze; h 100.2 cm, w 52 cm, d 31 cm
Acquired by the 3rd or the 4th Marquess of Hertford by 1870
F43

Knife, Fork and Spoon, 18th century(?)
French

▶ This *couvert* comprising a knife, fork and spoon was bought by Sir Richard Wallace in 1872 as having once belonged to Louis XIV's great minister Cardinal Mazarin. However, although of fine quality, these objects were probably made in the eighteenth century. The practice of having a complementary setting of knife, fork and spoon originated in Renaissance Italy but was established and developed in France under Louis XIV, spreading eventually to the whole of Europe.

Gold and bloodstone; l (knife) 20.1 cm, (fork) 18.3 cm, (spoon) 17.8 cm
Acquired by Sir Richard Wallace in 1872
XXA37–39

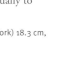

Toilet Mirror (*miroir de toilette*), 1713
Attributed to André-Charles Boulle (1642–1732)

▶ The toilet mirror was supplied to the duchesse de Berry (1695–1719), daughter of Philippe, duc d'Orléans, Regent of France, by the dealer Alexis Delaroue in 1713. Although attributed to Boulle, the sphinx feet and some of the gilt-bronze border were added later in the same year by the goldsmith Pierre Ladoireau. The design of the *première-partie* marquetry on the back of the mirror is after an engraving by Jean Berain (1640–1711), who was appointed *Dessinateur de la Chambre et du Cabinet du Roi* in 1674. At some time in the eighteenth century the arms of the duchesse de Berry were removed, and the present marquess's coronet was added for the 4th Marquess of Hertford in 1868.

Oak veneered with ebony and *première-partie* Boulle marquetry of brass and tortoiseshell; gilt bronze;
h 73 cm, w 56 cm
Acquired by the 4th Marquess of Hertford by 1868
F50

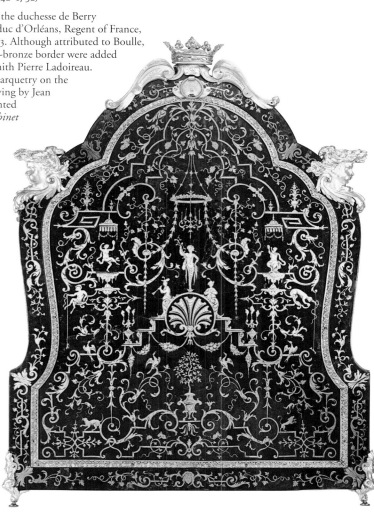

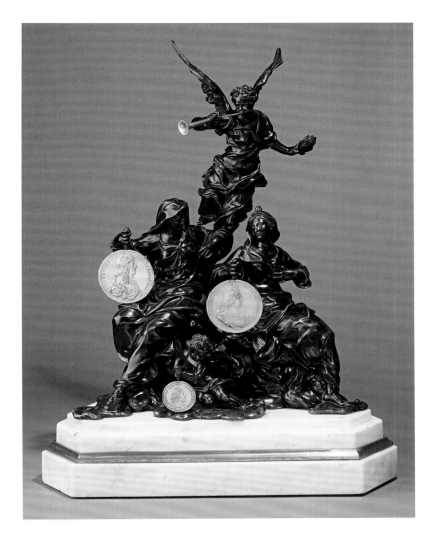

Allegory commemorating the Accomplishment of the Vow of Louis XIII, 1714
Philippe Bertrand (1663–1724)

◀ In 1714 the French Academy offered a poetry prize on the subject of the vow made by Louis XIII in 1638 to re-decorate the choir of Notre-Dame if a son were born to him (as indeed happened that year). The winner of the prize was the now forgotten abbé du Jarry, while the runner-up was the young Voltaire, who subsequently ridiculed du Jarry's work. This sculpture was the prize. It comprises allegorical figures of Religion (left), Piety (right) and Fame (above) with an angel (below). Fame trumpets the achievement, while the other figures hold medals bearing busts of Louis XIII and Louis XIV and images relating to the vow and to the Academy itself.

Bronze and gilt bronze; marble base;
h (excluding base) 46.9 cm
Acquired by the 4th Marquess of Hertford by 1867
S176

Psyche discovering Cupid, c.1715–20
French

▶ Psyche was visited by her lover, the god Cupid, every night, but, as a mortal, was not allowed to look on him. While he was asleep, however, she crept up on him in order to see him and, in doing so, spilt oil from her lamp – the scene shown in this bronze. Cupid grimaces in pain as the oil drips on his forehead. Moments later he will take flight, and Psyche will spend many years looking for him until eventually they are reconciled. There are several surviving examples of this bronze. The identity of the sculptor of the model is uncertain, but Corneille van Clève (1645–1732) has been suggested.

Bronze; h 45.7 cm
Acquired by the 4th Marquess of Hertford
or Sir Richard Wallace at an unknown date
S186

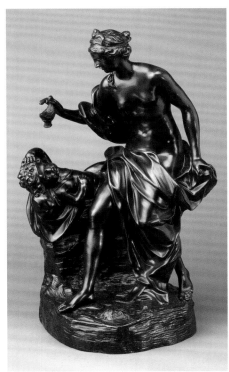

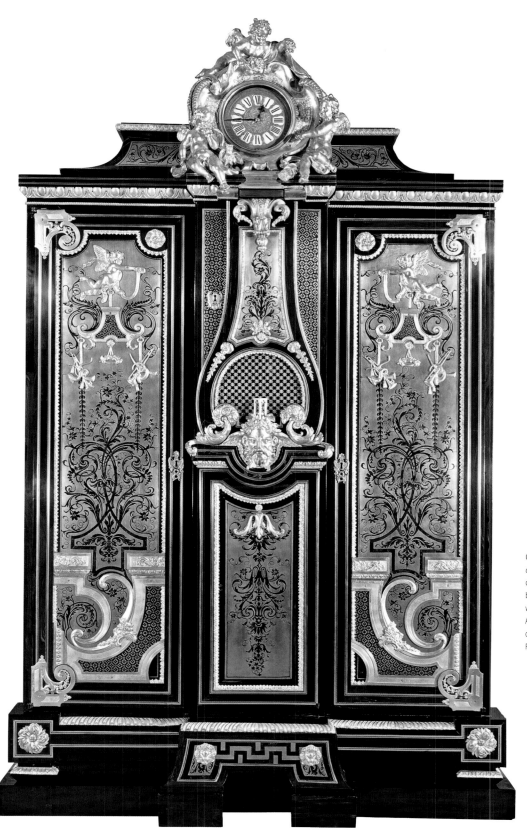

Oak veneered with ebony and
contre-partie Boulle marquetry
of brass and turtleshell; gilt-
bronze mounts; h 311.5 cm,
w 196 cm, d 65.8 cm
Acquired by the 4th Marquess
of Hertford at an unknown date
F429

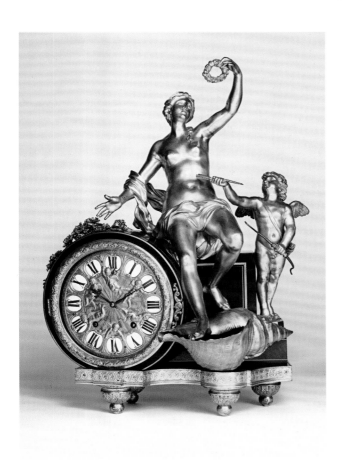

Mantel Clock (*pendule de cheminée*), c.1715
Attributed to André-Charles Boulle (1642–1732)

◀ The model for this clock was listed in the 1715 inventory of Boulle's workshop when, although unfinished, it was valued at the high figure of 2,500 *livres*. The clock movement is by Jean Jolly (master 1698). The gilt-bronze figure of Venus rests her right foot on a spiral shell, which was probably cast from life, while Cupid with his bow and arrow stands beside her. Originally there would have been a garland of gilt-bronze flowers running down from the chaplet held by Venus to the flowers on the left-hand side. The clock face, decorated with flying putti, is of a type often used by Boulle.

Oak veneered with turtleshell, rosewood, ebony and brass; gilt bronze;
h 79 cm, w 53.5 cm, d 42 cm
Acquired by the 4th Marquess of Hertford in 1870
F93

Writing-table (*bureau plat*), c.1715–c.1720
Attributed to Bernard I Van Risenburgh (c.1660–1738)

▼ The writing table is similar to that made around 1715 for the Elector of Bavaria (now in the Louvre, Paris), also attributed to Van Risenburgh. The female heads at the tops of the legs are crowned with laurel and flanked by sprays of palm. The ends of the table are decorated with gilt-bronze female masks, their hair dressed with pearls and crowned with acanthus. Owned by the 3rd Marquess of Hertford, the table was not inherited by his son, the 4th Marquess. Instead, the 4th Marquess bought it at the sale of the contents of his father's property, St Dunstan's Villa in London.

Oak, pine and walnut veneered with ebony and *première-partie* Boulle marquetry of brass and turtleshell; gilt-bronze mounts; h 78 cm, w 181 cm, d 92 cm
Acquired by the 4th Marquess of Hertford in 1855
F59

Wardrobe (*armoire*), 1715
André-Charles Boulle (1642–1732)

◀ Together with its companion piece, this wardrobe was listed in October 1715 in the workshop of the great cabinet-maker André-Charles Boulle. This piece is in *contre-partie* marquetry, with the design laid out in turtleshell against a background of brass. The companion piece (now lost) was in *première-partie* marquetry, with the brass pattern set against a background of turtle-shell. Although he did not invent the technique, Boulle gave his name to this type of marquetry, so often found on eighteenth- and nineteenth-century furniture. Few pieces of furniture can today be definitely associated with his workshop, but this is one of them. It may have been made for Jean Delpech, councillor in the Paris Parlement.

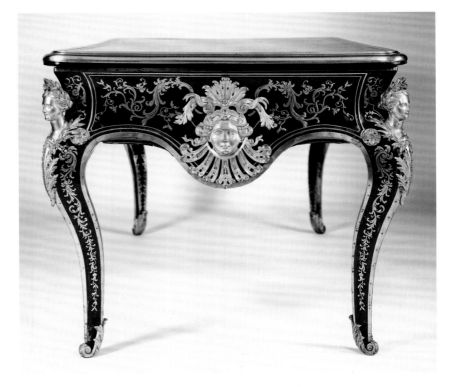

**Madame de Ventadour with Portraits of Louis XIV
and his Heirs**, c.1715–20
French School

▲ This picture was painted to celebrate the role of the duchesse de
Ventadour in ensuring the continuation of the Bourbon dynasty.
She is shown leading the duc d'Anjou, the future Louis XV
(1710–74), whom she saved during the measles epidemic of 1712.
They are surrounded by his forebears: Henri IV (1553–1610) is
represented in a bust on the left; Louis XIII (1601–43) in a bust on
the right; Louis XIV (1638–1715) sits in the centre of the picture;
Louis, the Grand Dauphin (1661–1711), stands leaning against his
father's chair; on the right stands Louis XIV's grandson and the duc
d'Anjou's father, Louis, duc de Bourgogne (1682–1712). The wealth
and power of the dynasty is underlined by the palatial setting, which
evokes Versailles and its Apollonian imagery.

Oil on canvas; 127.6 x 161 cm
Acquired by the 4th Marquess of Hertford by 1867
P122

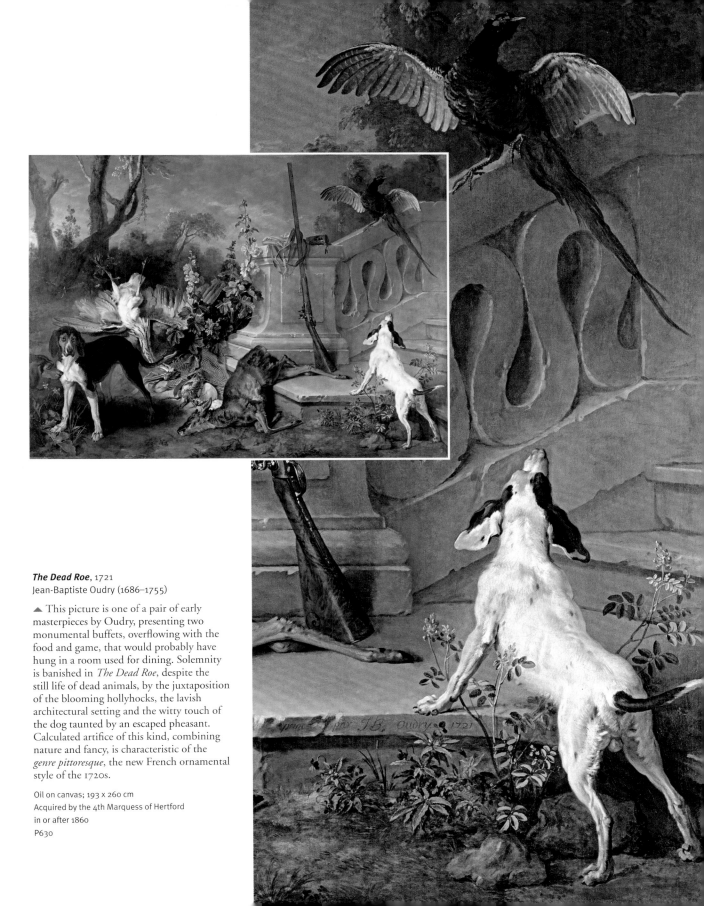

The Dead Roe, 1721
Jean-Baptiste Oudry (1686–1755)

▲ This picture is one of a pair of early masterpieces by Oudry, presenting two monumental buffets, overflowing with the food and game, that would probably have hung in a room used for dining. Solemnity is banished in *The Dead Roe*, despite the still life of dead animals, by the juxtaposition of the blooming hollyhocks, the lavish architectural setting and the witty touch of the dog taunted by an escaped pheasant. Calculated artifice of this kind, combining nature and fancy, is characteristic of the *genre pittoresque*, the new French ornamental style of the 1720s.

Oil on canvas; 193 x 260 cm
Acquired by the 4th Marquess of Hertford
in or after 1860
P630

Gilles and his Family, *c.*1716–18
Jean-Antoine Watteau (1684–1721)

▶ The central figure is dressed as the *commedia dell'arte* character Mezzetin, the rascally valet and musician. The existence of a drawing for his head, inscribed 'Syroie', suggests that it is also a portrait of Watteau's friend the dealer Pierre Sirois (1665–1726). Watteau may thus be making a witty reference to Sirois's own unpredictable nature. The mixture of theatrical and contemporary costumes adds an additional note of ambiguity; like Shakespeare, Watteau saw the illusion of the theatre and the deception of the real world as interchangeable. This picture is one of the few paintings by the artist to retain something of its scintillating surface texture.

Oil on walnut panel; 27.1 x 19 cm made up to 27.7 x 21 cm
Acquired by the 4th Marquess of Hertford in 1846
P381

Les Champs Elisées, *c.*1716–18
Jean-Antoine Watteau (1684–1721)

▼ *Les Champs Elisées* evokes the spirit of an idealised park landscape, and may be read as a progress of love. We move from left to right through child-like innocence, female friendship and conversation between the sexes to the isolation of the observer standing on the right. The sleeping Venus on the dolphin fountain acts as a witty comment on the platonic nature of the foreground scene. This is in direct contrast to the background, where between the trees we glimpse loving couples and boisterous dancers recalling Rubens's earthy kermises.

Oil on mahogany panel; 31 x 41 cm made up to 33.1 x 42.6 cm
Acquired by the 4th Marquess of Hertford in 1848
P389

Harlequin and Columbine, *c.*1716–18
Jean-Antoine Watteau (1684–1721)

▶ A masterful example of Watteau's poetic meditations on manners, courtship and love conveyed via delicate draughtsmanship and exquisite, shimmering brushstrokes. Harlequin's awkward, lunging gesture towards Columbine demonstrates his inability to restrain his physical desire beneath the requisite social grace and is contrasted with the calm of the group in the background, where two lovers sit bathed in light and listening to a guitarist, in harmony with the music and each other, their mutual feeling symbolised by the roses in their hair and those shown growing beside them. The presence of the *commedia dell'arte* characters, Crispin and Pierrot, reinforce the mood of theatrical ambiguity.

Oil on oak panel; 36 x 24.9 cm made up
to 36 x 25.9 cm
Acquired by Sir Richard Wallace in 1859
P387

Pocket Compass and Sundial,
early 18th century
French

▶ A cultured eighteenth-century gentleman would be knowledgeable about the arts and sciences. Many would be enthusiastic scientific observers and carry scientific instruments, such as this combined compass and sundial, in their capacious pockets. Although not signed, this instrument has been attributed to the English maker Michael Butterfield (1635–1724), who worked in Paris, having moved there around 1663. He produced many pocket compasses and sundials such as this, and gave his name to (though he did not invent) this particular type, with its dial plate engraved with different hour scales serving different latitudes, its compass and its adjustable gnomon (the stationary arm of the sundial that indicates the time).

Silver; h 3.1 cm, w 6.5 cm, d 7.7 cm
Acquired by Sir Richard Wallace in 1871
IIIJ512

Chest of Drawers (*commode*), *c.*1720
Attributed to Étienne Doirat (*c.*1670–1732)

▼ This chest of drawers shows similarities to several chests of drawers stamped by, or recently attributed to, the cabinet-maker Doirat. The gilt-bronze corner mounts of Roman generals are of models found on the stands of three medal cabinets by Charles Cressent (1685–1768), although the chasing is not of such high quality. The top is cut in two halves from the same block of Sicilian jasper, joined together so that the pattern of one half mirrors the other. The colour of the jasper has been carefully chosen to reflect that of the marquetry.

Pine veneered with walnut, ebony and *contre-partie*
Boulle marquetry of brass and turtleshell, green-stained horn and mother-of-pearl; Sicilian jasper top; gilt-bronze mounts; h 86.5 cm, w 150.2 cm, d 70 cm
Acquired by the 4th Marquess of Hertford in 1855
F406

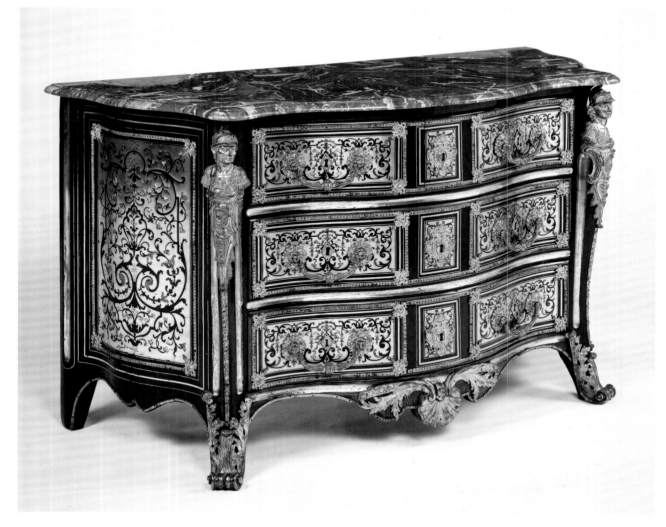

Balustrade (*rampe d'escalier*), 1719–20
French

▲ Installed on the main staircase of Hertford House by Sir Richard Wallace in 1874, this balustrade was originally in the Hôtel de Nevers, Paris, when it was occupied by the Banque Royale – hence the royal emblems of sunflowers and interlaced Ls (for Louis XV). The horns of plenty overflowing with coins and banknotes are suggestive of the new monetary system proposed by John Law, who persuaded the Regent of France to establish in 1716 a national bank capable of issuing notes. The balustrade was much altered for its insertion into Hertford House, but it remains the finest example of French iron and brass work from the Regency period (1715–23) to have survived. It was the only work of art to be mentioned in Lady Wallace's will bequeathing the Collection to the nation. This was because she was concerned that, as a fitting in Hertford House, the balustrade might be overlooked if the Collection were moved from the building.

Wrought and cast iron; gilt brass;
h 0.915 m; l 26.448 m
Acquired by Sir Richard Wallace c.1871
F68

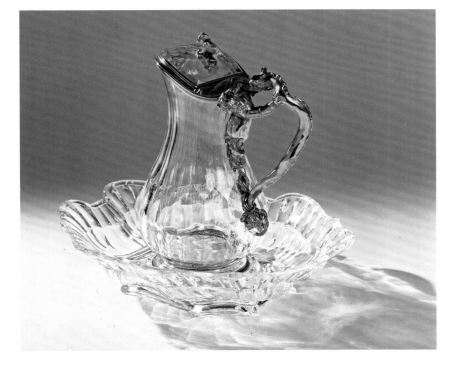

Ewer and Basin, 1728–9
Jean Gaillard (active 1695–1754)

◀ This rare piece is made of precious rock crystal with solid-gold mounts of a young Triton wrestling with a snake-like sea monster on the handle and a small barking dog as a generous thumb piece on the cover (you have to put your thumb in the dog's mouth to get the leverage to open the cover). Three examples are known (only two survive with their basins), and among them they were owned by Madame de Pompadour, Madame du Barry, the duchesse de Mazarin and Queen Marie-Antoinette. Madame de Pompadour's was sold on 13 December 1764 and later may have entered the collection of Louis XV's subsequent mistress, Madame du Barry.

Rock crystal and gold; ewer: h 18.9 cm;
basin: h 5.3 cm, l 23 cm, w 19.9 cm
Acquired by the 4th Marquess of Hertford
or Sir Richard Wallace at an unknown date
IA27

Head of a Young Girl, early 18th century
Robert Le Lorrain (1666–1743)

▶ Robert Le Lorrain worked at Versailles, but most of his sculpture was probably for private clients, for whom he produced both marbles and bronzes. This bust is one of several idealised heads of figures in various collections that can be attributed to him.

Marble; h 44.5 cm
Probably acquired by the 4th Marquess of Hertford at an unknown date
S34

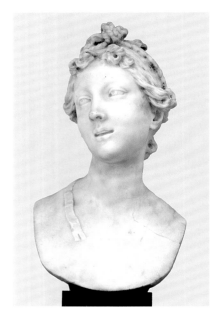

The Vivandières of Brest, 1720s
Jean-Baptiste Pater (1695–1736)

▼ The title derives from the print made after the composition by Jacques Philippe Le Bas in 1760. It refers to the French repulse of the British forces at Brest in June 1694. The verses by Charles Moraine, which accompany the print, exhort the *belles vivandières*, female camp followers, to feed the needy soldiers. The theme recalls the encampment scenes of Watteau and the military pictures of seventeenth-century Dutch artists such as Wouwermans, which were highly prized by eighteenth-century collectors. Pater, however, invests the scene with his own particular brand of Gallic gallantry executed with a delicate touch and decorative palette.

Oil on canvas; 46.7 x 59.5 cm
Acquired by Sir Richard Wallace in 1872
P452

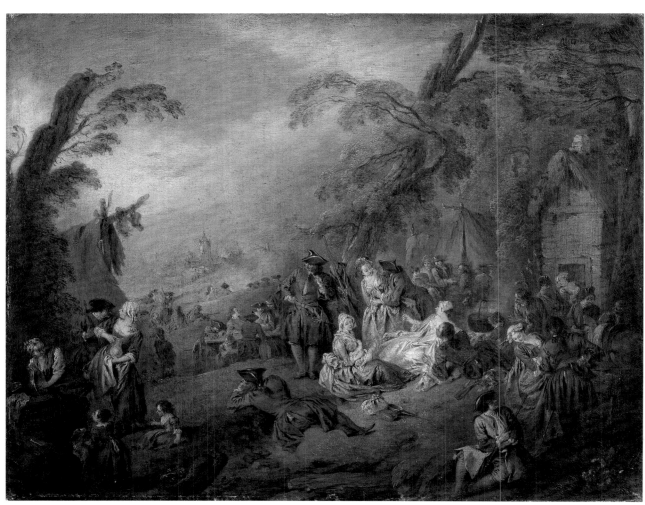

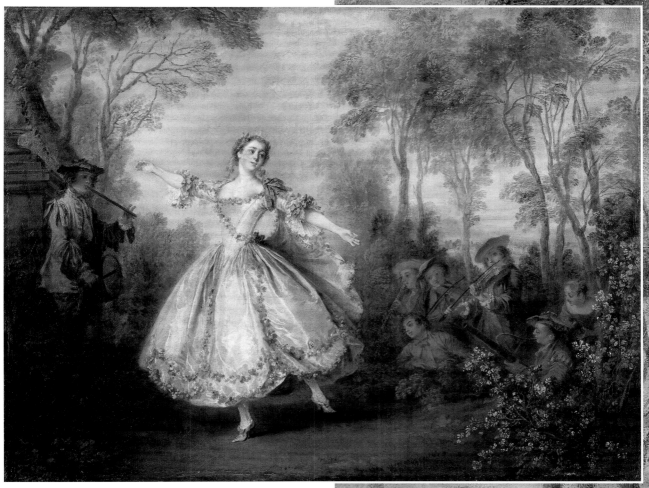

Mademoiselle de Camargo Dancing, 1730
Nicolas Lancret (1690–1743)

▲ One of Lancret's most original creations, the picture marks a new departure in his art as well as in portraiture and the depiction of dance. Marie-Anne de Cupis de Camargo (1710–70) was the first great virtuoso ballerina of the Paris Opéra. Lancret convinces the viewer of the theatrical veracity of the image through the observation of details such as the dress and ballet position *à demi-pointe*. The scene is set in the sylvan park landscape of a *fête galante*. More than a theatrical backdrop, this setting lends the subject a poetic quality, that evokes the ephemeral charm of Mademoiselle de Camargo's talent.

Oil on canvas; 41.7 x 54.5 cm made up to 43.2 x 55 cm
Acquired by Sir Richard Wallace in 1872
P393

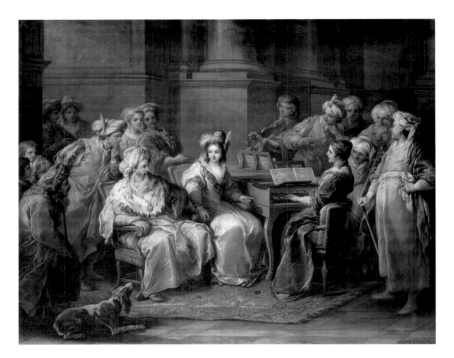

The Grand Turk giving a Concert to his Mistress, 1727
Carle van Loo (1705–65)

◀ The scene combines the eighteenth-century French taste for the exotic and the amorous, to which a piquant resonance has been added by the artist's depiction of his wife, the opera singer Cristina Antonia Somis, known to contemporaries as the 'Philomel of Turin'. She sings a fashionable aria of the day, 'Si caro, si', from Handel's opera *Admeto*. The picture was exhibited at the Salon of 1737, together with its pendant, *The Grand Turk having his Mistress Painted* (Museum of Fine Arts, Richmond, Virginia), in which Van Loo portrayed himself as the artist. The two pictures thus celebrate the complementary talents of Van Loo and his wife.

Oil on canvas; 72.5 x 91 cm
Acquired by the 4th Marquess of Hertford in 1867
P451

A Hunt Breakfast, 1737
Jean-François de Troy (1679–1752)

▶ A preparatory oil sketch for a picture commissioned to decorate Louis XV's dining room at Fontainebleau. The sketch was probably submitted to the King for approval before de Troy proceeded with the commission. *A Hunt Breakfast* depicts the aristocratic pleasures of the chase, under-lining the essentially gallant nature of the scene through the conversational attitudes of the male and female figures. It is remark-able for its fluid, rapid handling and vivid colouring, recalling the influence of Rubens and Venetian art on French painting at the beginning of the eighteenth century.

Oil on canvas; 54.7 x 44.8 cm
Acquired by Sir Richard Wallace in 1872
P463

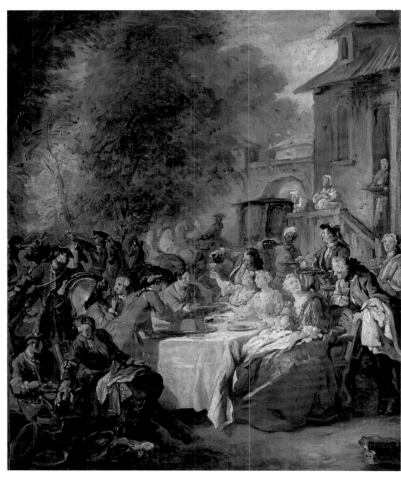

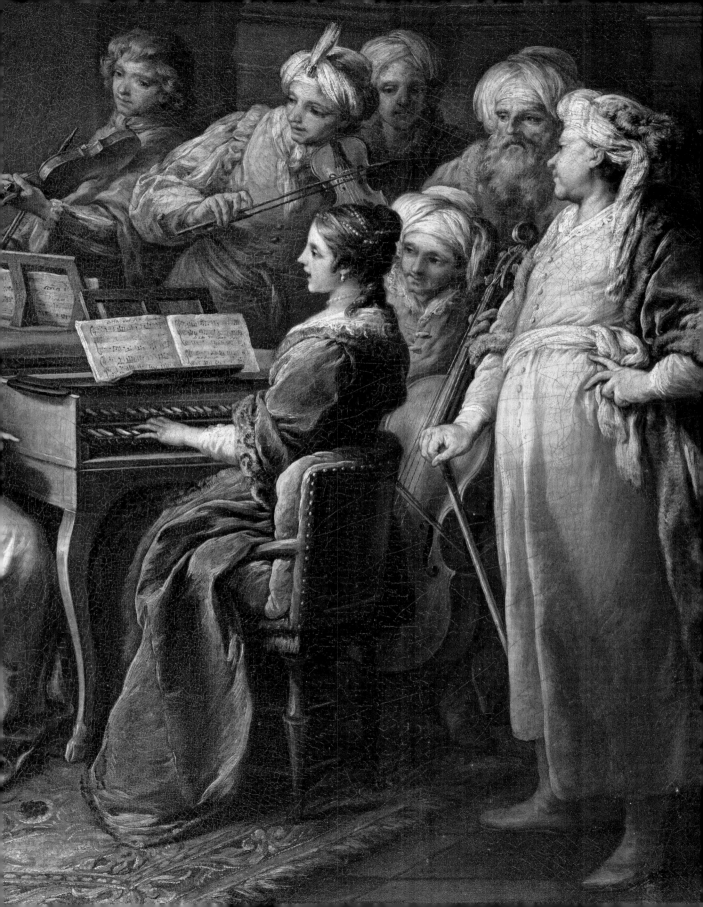

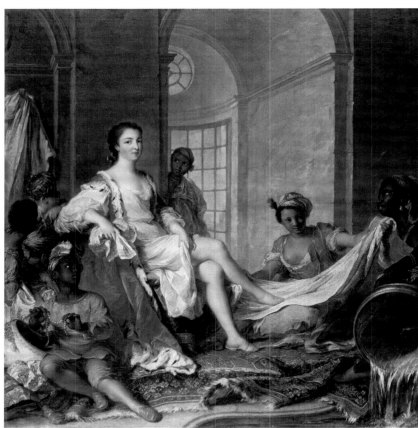

Mademoiselle de Clermont en sultane,
1733
Jean-Marc Nattier (1685–1766)

▲ Marie-Anne de Bourbon (1697–1741), called Mademoiselle de Clermont, was the youngest child of Louis III, duc de Bourbon, and Mademoiselle de Nantes. The formal grandeur of the present picture places it in the tradition of the leading portrait painters of the previous generation but updates the image by reference to the contemporary fashion for *turquerie*. Nattier depicts Mademoiselle de Clermont as a Sultana, justifying her chic state of undress, while lavish costumes, textiles, jewellery and a sumptuous Turkish carpet help to reinforce a mood of exotic excess.

Oil on canvas; 109 x 104.5 cm
Acquired by the 4th Marquess of Hertford in 1858
P456

Time saving Truth from Falsehood and Envy,
1737
François Lemoyne (1688–1737)

▶ The naked figure of Truth is held aloft by her father, Time, who with his scythe subdues Falsehood, in her fine apparel and dissembling mask, while the baleful figure of Discord and Envy recedes, protesting. The subject may have held a personal significance for the artist: the day after he completed it he committed suicide. Yet, as the collector Anne Claude Philippe, comte de Caylus recalled, 'there is no sense of his alienation of spirit in the work, it is even one of his most beautiful cabinet pictures'. It demonstrates Lemoyne's ability to combine the compositional models of the Grand Siècle with a more sensual eighteenth-century tonality.

Oil on canvas; 180.5 x 148 cm
Acquired by the 4th Marquess of Hertford in 1851
P392

The Rape of Europa, *c.*1732–4
François Boucher (1703–70)

▲ Ovid's *Metamorphoses* (II, 835–75) tells of the abduction of
Europa by Jupiter, disguised as a bull. Charmed by the bull's good
nature, Europa climbed on his back, whereupon he bore her off into
the waves, only stopping on Crete to ravish her. Boucher typically
concentrates on the gallant aspects of the scene, eschewing any
reference to the story's violent dénouement. The picture, with its
profusion of flowers, represented Smell in a series of five monu-
mental canvases symbolising the Senses. Painted without fee for the
lawyer Derbais, the canvases greatly impressed contemporaries,
establishing the young artist's reputation as one of the leading
decorative painters of eighteenth-century Paris.

Oil on canvas; 230.8 x 273.5 cm
Acquired by the 4th Marquess of Hertford in 1843
P484

See details on pages 126–7

An Autumn Pastoral, 1749
François Boucher (1703–70)

▶ One of Boucher's most ambitious works in
the pastoral mode, this painting was inspired
by the theatrical characters of the immensely
popular *pantomimes* of his friend, Charles-
Simon Favart. At the Opéra-Comique, where
Boucher was both set designer and a keen
member of the audience, Favart's piquant
musical dramas combined the Arcadian
idealism and aristocratic sensibilities of
pastoral poetry with the rustic, sentimental
characters of popular theatre. Here we see a
recreation of scene VI of Favart's *pantomime
Les Vendanges de Tempé* (*The Harvest in the
Vale of Tempé*), where the amorous Little
Shepherd feeds grapes to the heroine, Lisette.

Oil on canvas; 259.5 x 198.6 cm
Acquired by the 4th Marquess of Hertford in 1852
P482

French Royal Furniture

The Wallace Collection owns some of the most important pieces of French royal furniture anywhere in the world. Furniture history is still a relatively new subject. The pioneer in the field of French royal furniture was Pierre Verlet (1909–87). Working from the 1930s onwards, he discovered a correlation between the numbers and marks painted on pieces of furniture with the list of furnishings recorded in the *Journal du Garde-Meuble*, the daybook of the depot for movable furnishings for the royal palaces. He was thus able to identify when items had been delivered and, in most cases, the precise location for which they had been made. French cabinet-makers often stamped their furniture, a practice that started in the 1740s (according to a law of 1745 that was only enforced in 1749). The marks on eighteenth-century French furniture are crucial to our understanding of the history of these works of art. ↻

Below:
Chest of Drawers for Louis XV's Bedchamber, 1739
Antoine-Robert Gaudreaus (*c*.1682–1746)
Oak veneered with kingwood and *satiné*; serpentine marble top; gilt-bronze mounts; h 93.3 cm, w 179.3 cm, d 81.5 cm
Acquired by the 4th Marquess of Hertford at an unknown date
F86

A Chest of Drawers made for Louis XV

This superb rococo chest of drawers, or commode, was made by the cabinet-maker Antoine-Robert Gaudreaus. Gaudreaus qualified as a master in his profession in 1708. Between 1726 and 1746 his workshop produced over 800 pieces of furniture for the royal palaces, nearly half of which were commodes, a relatively new form of furniture at this time. This commode, based on a design perhaps by S.-A Slodtz, was delivered in April 1739 for Louis XV's bedchamber at Versailles, and it bears the stamp of the château (crossed 'V's) on the top rail on the back. The carcase is made from oak, veneered with the exotic woods kingwood and *satiné*, or bloodwood, imported from South America. The veneers have faded but once formed a strong pattern in vibrant purple-brown and deep pink. An early design for the commode reveals that the mounts were originally intended to be very symmetrical. As executed by the *bronzier* Jacques Caffiéri (1678–1755), however, the mounts twist and turn wildly in the form of leaves and rock formations all over the front and sides of the commode. Such mounts would have helped to light a room in the evenings by reflecting candlelight. Caffiéri was obviously so pleased with his work for this important piece that he stamped one of the mounts with his name.

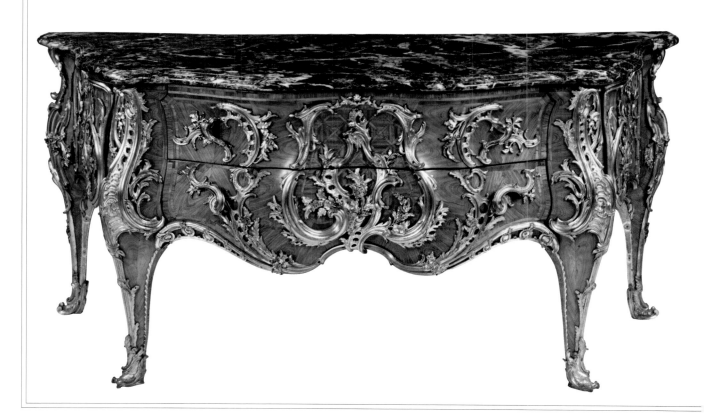

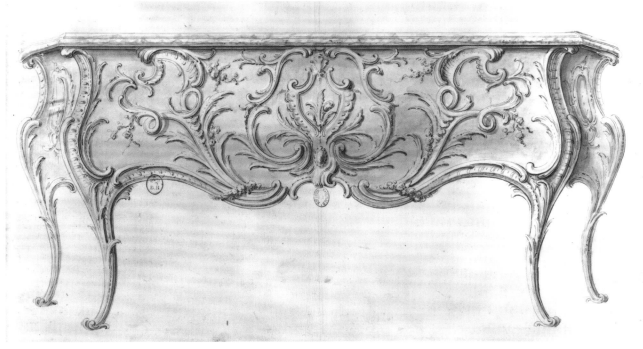

Above:
Design attributed to Sébastien-Antoine Slodtz (1695–1754)
Paris, Bibliothèque Nationale

Branded Versailles mark on top rail of back

Detail of Caffiéri stamp

Detail of central cartouche

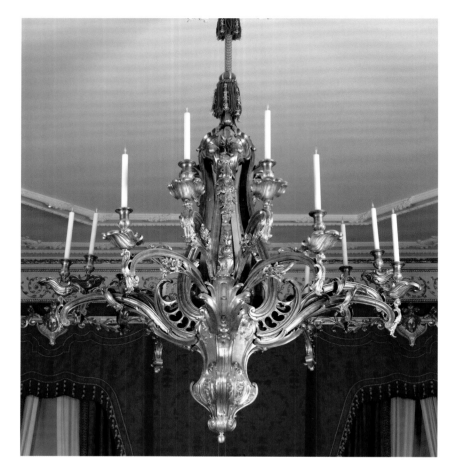

Chandelier (*lustre*), 1751
Jacques Caffiéri (1678–1755)

◀ This magnificent twelve-light chandelier, like a smaller nine-light chandelier also in the Wallace Collection (F84), was made by Caffiéri, probably assisted by his elder son, Philippe Caffiéri (1714–74). It was almost certainly given by Louis XV to his eldest daughter, Louise-Elisabeth, Duchess of Parma, during one of her visits to Paris in the 1750s. In 1803 it was hanging in the *Gran Salone* of the Duchess's former palace of Colorno. With its flowing S-curved arms, the chandelier is a prime example of the rococo style in gilt bronze. The platform at the bottom of the cage bears the engraved mark of Caffiéri and the date 1751.

Iron and gilt bronze; h 179 cm, w 190 cm
Acquired by Sir Richard Wallace in 1871
F83

Potpourri Vase (*pot-pourri*), 1725–45
(porcelain) and *c*.1745 (mounts)
Chinese (porcelain) and French (mounts)

▼ Chinese porcelain was admired enormously in eighteenth-century Europe and was imitated frequently. This potpourri vase, one of a pair, comprises a Chinese porcelain bowl mounted in French gilt-bronze mounts. The prestige of Chinese porcelain is suggested by the fact that, although the porcelain of these bowls is actually rather crude in detail (there are granular impurities in the glaze), the bowls were still considered worthy of being given gilt-bronze mounts.

Porcelain painted in enamel colours; gilt-bronze mounts; h 31.5 cm, w 36 cm
Acquired by Sir Richard Wallace in 1872
F116

Ewer (*buire*), 1725–35 (porcelain)
and 1745–9 (mounts)
Chinese (porcelain) and French (mounts)

▶ The *marchands-merciers*, or dealers in luxury goods, in eighteenth-century Paris often imported Chinese porcelain, which they had fitted with extravagant gilt-bronze mounts. These exotic oriental goods represented the height of fashion and complemented the taste for lacquer furniture at this time. The mounts on this piece have been struck with the crowned C mark imposed

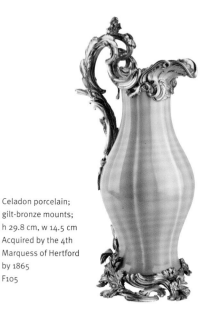

Celadon porcelain; gilt-bronze mounts; h 29.8 cm, w 14.5 cm
Acquired by the 4th Marquess of Hertford by 1865
F105

on gilt bronze sold in France 1745–9. The style of the mounts, cast and chased with naturalistically detailed flowers, buds, bulrushes, shells and weed, is entirely consistent with the date suggested by their marks. The ewer was illustrated on the cover of Isadore Strauss's waltz, *L'Idéal*, commemorating the 4th Marquess's loans to the Musée Rétrospectif exhibition in Paris in 1865.

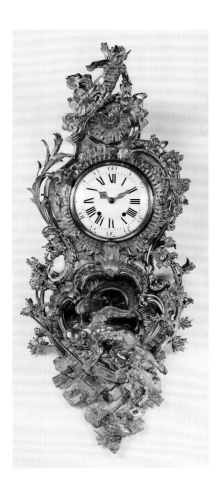

Cartel Clock (*cartel*), *c.*1747
Charles Cressent (1685–1768)

◀ The cabinet-maker Charles Cressent was frequently fined by the guild authorities on suspicion of casting furnishing bronzes (such as clock cases and firedogs), thereby transgressing his limits as an *ébéniste* (cabinet-maker). This clock was probably among works sold in 1749 to pay off his debts. The superb gilt-bronze case, with figures of Love triumphing over Time, is certainly closer to sculpture than furniture, to which Cressent made a small concession with the oak carcase and Boulle marquetry on the sides.

Oak and pine veneered with
première-partie Boulle marquetry
of brass and turtleshell;
enamel dial; gilt-bronze case;
h 135.9 cm, w 52.7 cm, d 35.6 cm
Probably acquired by the
4th Marquess of Hertford
by 1870
F92

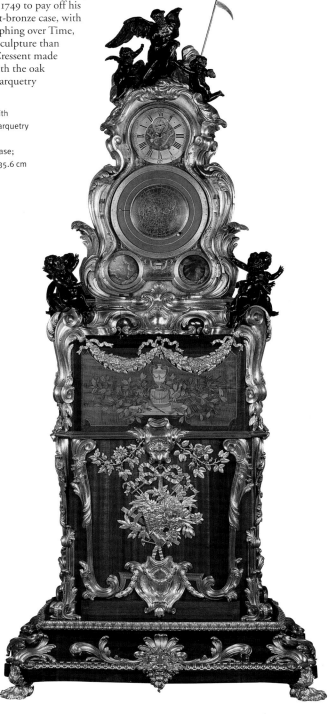

Astronomical Clock (*pendule astronomique* or *pendule à planisphère*), *c.*1750
Movement designed by Alexandre Fortier and made by Michael Stollewerck (died 1768)

▶ Probably made for Jean Paris de Monmartel (1690–1766), banker to the French court (and godfather of Madame de Pompadour), this extraordinary clock was shown in a portrait engraving of Monmartel in his *grand cabinet* at the Hôtel Mazarin in Paris, published in 1772. The principal clock face now shows Greenwich mean time and apparent solar time. From the central dial can be read the age, longitude and phases of the moon, the passage of the sun across the zodiac and the time anywhere in the northern hemisphere (a map of which is engraved on the revolving circular plate); the two lowest dials show the rising and setting of the sun (left) and the moon cycle (right). The clock case is constructed in three sections, supported on a base. Only the upper section, with the patinated figures of two putti stealing Father Time's scythe on top and four putti at the bottom, between which there would once have been floral garlands, forms the original clock.

Top: oak veneered with purple heart and satiné; gilt-bronze mounts;
patinated bronze figures; plinth: mahogany and pine veneered with purple heart
and tulipwood; gilt-bronze mounts; h 294.5 cm, w 133.5 cm, d 91 cm
Acquired by the 4th Marquess of Hertford in 1848
F98

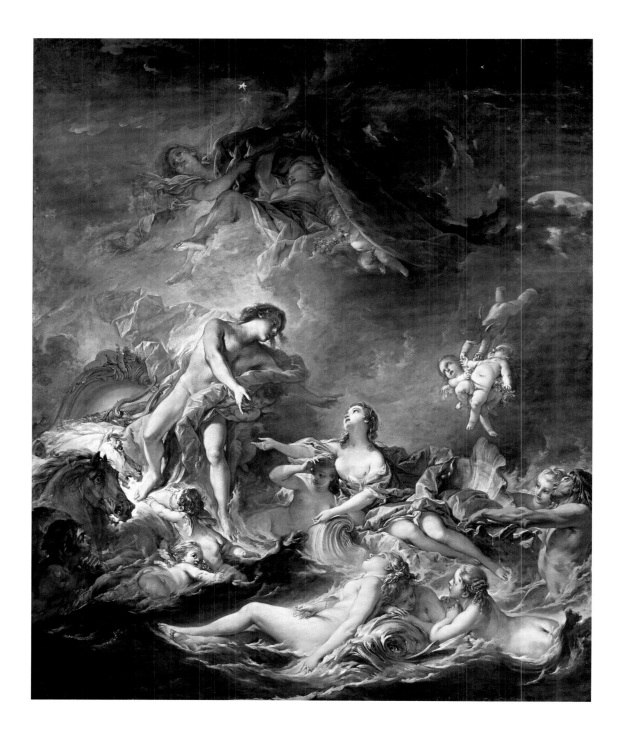

The Setting of the Sun (above), 1752
The Rising of the Sun (opposite), 1753
François Boucher (1703–70)

▲ ▶ According to Ovid's *Metamorphoses*, the sun god Apollo rose every day in his chariot from the river Oceanus, which surrounded the earth. During the day, he drove his chariot across the heavens, bringing light to the world and sinking beneath the waves in the evening. In the waters, Oceanus's wife, Tethys, and her children,

the Tritons and Oceanides, attended him. An amorous dimension was added to the story in the seventeenth century at the court of the Sun King, Louis XIV, when the character of Tethys was conflated with that of the nymph Thetis, Apollo's lover. Boucher's monumental canvases are grand reworkings of the same theme, where the subject

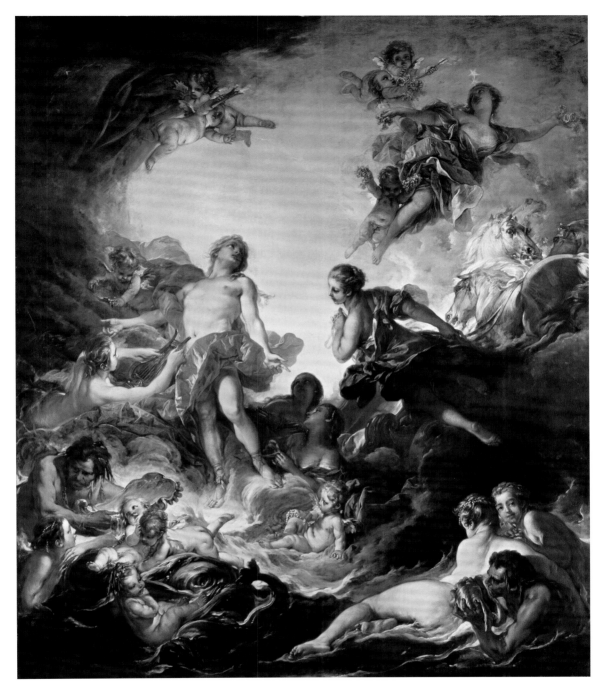

Oil on canvas; 318 x 261 cm
Acquired by the 4th Marquess of Hertford in 1855
P486 and P485

of Apollo returning to his beloved in the waves is now associated with Louis XV relaxing with his mistress, Madame de Pompadour. The Marquise commissioned Boucher to paint the canvases to serve as cartoons for lavish Gobelins tapestries, which decorated the King's bedchamber at her château of Bellevue. They represent the apogee of

Boucher's achievement as a history painter, being praised as such by the artist, Cochin, when shown at the Salon of 1753. Their exuberant sensuality, however, shocked some commentators, who felt their display of nudity was excessive and immoral.

✎ Madame de Pompadour ✎

Jeanne-Antoinette Poisson (1721–64) was a sparkling patron of the arts. From the moment she became Louis XV's mistress in 1745 (when she was created marquise de Pompadour) she invested in contemporary design and manufacture of the highest quality to furnish her many properties in Paris, Versailles, Bellevue, Ménars and elsewhere. This gave her obvious pleasure, but she also wanted to prove herself as a woman of style and taste. Perhaps, above all, she wanted to make her residences attractive and welcoming to Louis XV, so, as her role changed from that of mistress to friend and mentor, she could still entice him into a world of beauty and comfort that would relieve the burden of his royal duties. She succeeded brilliantly in these aspirations.

When she died in 1764 her inventory revealed what a remarkable patron and collector she had been. The Wallace Collection owns a range of paintings and works of art once in her possession, and these give us a glimpse of her day-to-day life, of the colours and subjects that inspired her, of items for her bedroom or boudoir, of her pet dog (in Boucher's portrait), of her passion for music (on the top of a snuffbox) and of the devotion she inspired in her advisors. These objects are intimately personal and luxuriously useful, both qualities that she would engage to delight Louis XV for almost twenty years. ✎

Snuffbox, 1757–8
Noël Hardivilliers (1704–79)

The scenes on this box are from the set of overdoors representing the Arts, which were painted by Carle van Loo for Madame de Pompadour's château at Bellevue and engraved in 1756. Each subject was personal to Madame de Pompadour, with her daughter Alexandrine as the model in Painting, Louis XV as the model in Sculpture, an elevation drawing of Bellevue in Architecture and, on the top of the box, a child-like rendering of herself as Music. The enameller has extended the original scenes, in the case of Sculpture in a personal way with a bust of Alexandrine on the floor. This suggests that the box may have had a closer connection with Madame de Pompadour than if the scenes had just been copied from the engravings. It probably belonged to her brother, the marquis de Marigny, who may have inherited it on her death in 1764.

Gold and enamel;
h 3.5 cm, l 7 cm, w 5.1 cm
Acquired by the
4th Marquess of Hertford
or Sir Richard Wallace by 1872
G24

Tea Service (*plateau 'Courteille'* and *déjeuner 'Courteille'*), 1758–9
Sèvres porcelain manufactory

The service comprises a tray, four cups and saucers and a sugar bowl. A teapot and milk jug could be missing, or household examples of silver could have been used in conjunction with the porcelain. This would have been a sensible solution to the porcelain not being able to withstand very hot temperatures. The children engaged in rustic pursuits were painted, after Boucher, by André-Vincent Vielliard. This service was probably bought by Madame de Pompadour in December 1759.

Soft-paste porcelain decorated with an underglaze blue and an overglaze green ground, painted and gilded; tray: 36.2 x 26.4 cm; cups: h 6.4 and 6.5 cm; saucers: diam. 13.3 to 13.5 cm
Acquired by the 4th Marquess of Hertford in 1849
C401–6

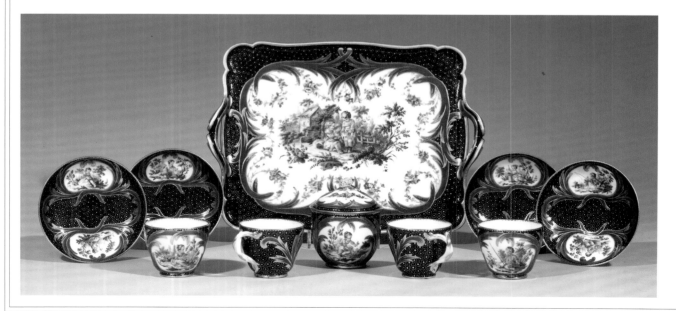

Madame de Pompadour, 1759
François Boucher (1703–70)

After her relationship with Louis XV became platonic in about 1750, Madame de Pompadour commissioned a series of works of art with friendship and fidelity as their central theme. The Wallace Collection's portrait, probably the last Boucher painted of his patron, evokes these ideals through its inclusion of the sculpture of *Friendship consoling Love* (recalling Pigalle) and the presence of Madame de Pompadour's pet spaniel, Inès.

Oil on canvas; 91 x 68 cm
Acquired by the 4th Marquess of Hertford in 1869
P418

Basket (*panier*), 1753
Vincennes porcelain manufactory

◀ Baskets of this kind are rare and probably provided the centrepiece for the dessert course at an intimate supper table, filled with fruits or artificial flowers. The dessert was the final course of a meal, in which fruit compotes, jellies, purées and jams, ice creams and sorbets, glacé or fresh fruit and confectionery were served in elaborate arrangements with dry foods, either in baskets or piled in pyramids. This basket was probably bought in 1755 by the *marchand-mercier* Lazare Duvaux and sold by him in the same year to the duchesse de Mirepoix.

Soft-paste porcelain decorated with a turquoise-blue ground and gilded; h 29.4 cm, w 25 cm, diam. 23 cm
Acquired by the 4th Marquess of Hertford by 1865
C472

Sugar Bowl and Cover (*pot à sucre 'Bouret'*), *c.*1753
Vincennes porcelain manufactory

▶ Vincennes was the precursor of Sèvres and is best known for its first ground colour, the rich *bleu lapis*, which was applied under the glaze. It is at its best when combined with gilded birds and trellis work, and often the gilding was used to conceal runs in the blue beneath. Small bowls like this one were used to serve refined white sugar with tea, whereas larger bowls with plateaux were used at the dinner table.

Soft-paste porcelain decorated with an underglaze blue ground and gilded; h 12 cm
Acquired by the 4th Marquess of Hertford or Sir Richard Wallace by 1872
C377

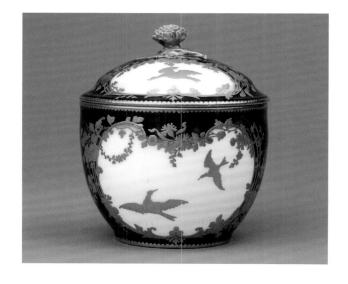

Casket (*coffre*), 1754–5
Vincennes porcelain manufactory

◀ Caskets or coffers of this kind were probably intended for jewels or toilet articles, and this one is lined in red-silk velvet mounted on pages from old account books. It is made of six plaques, which were probably bought from the factory by the dealer Aulagnier in 1754. He seems to have already commissioned the exceptional silver-gilt mounts from Louis Leroy, since these and the decorative painting and gilding on the porcelain echo each other so well. Aulagnier was particularly involved in the Turkish market, and this casket was probably intended for Turkey as part of a large and elaborate toilet service. The service was, however, never completed, and there is no evidence that this casket ever reached Constantinople, probably because relations between France and Turkey broke down at the beginning of the Seven Years War (1756–63).

Soft-paste porcelain decorated with a turquoise-blue ground, painted and gilded; silver-gilt mounts; h 18.8 cm, l 39.5 cm, w 24.6 cm
Acquired by Sir Richard Wallace in 1872
C495

Casket (*coffre de toilette*), c.1755–60
French

▼ One of a pair of caskets bearing the initials L. P. R. in brass on the lids. These stand for Louis, prince de Rohan (1734–1803), and identify him as the original owner. He was ambassador to the court of Vienna, but later became a cardinal and for more than

twenty years was bishop of Strasbourg. This casket was for items of the *toilette*, but others of this design were more often for musical movements beneath clocks supported by bronze animals.

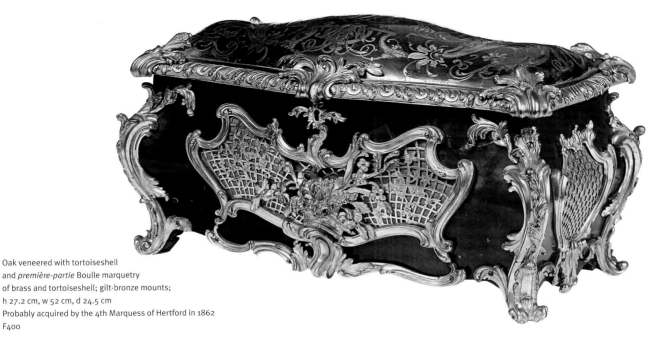

Oak veneered with tortoiseshell
and *première-partie* Boulle marquetry
of brass and tortoiseshell; gilt-bronze mounts;
h 27.2 cm, w 52 cm, d 24.5 cm
Probably acquired by the 4th Marquess of Hertford in 1862
F400

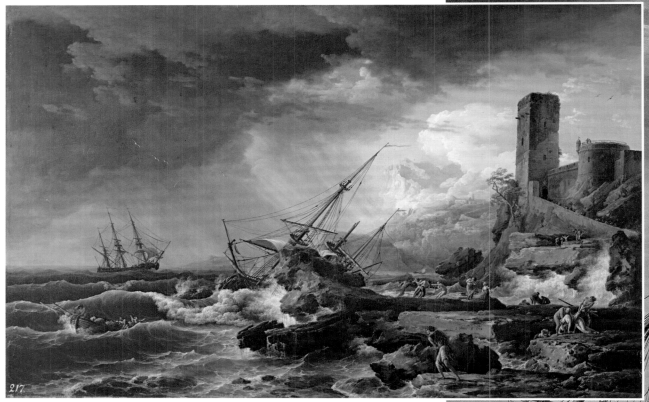

A Storm with a Shipwreck, 1754
Claude-Joseph Vernet (1714–89)

▲ The picture was commissioned by Madame de Pompadour's
brother, the marquis de Marigny, after he had become Minister for
the Arts under Louis XV, and was painted in Marseilles, where
Vernet lived between October 1753 and September 1754. Shipwrecks
were a favourite subject of the artist, allowing him to invest his
seascapes with dramatic emotional content. The present scene
demonstrates man's helplessness in the face of nature. According to
some contemporary critics, including Denis Diderot, the excellence
of Vernet's figure drawing and his mastery of gesture and expression
brought such works close to the admired genre of history painting.

Oil on canvas; 87 x 137 cm
Acquired by the 4th Marquess of Hertford in 1869
P135

Vase (*vase 'à tête d'éléphant'*), 1756–7
Sèvres porcelain manufactory

◀ This vase, one of a pair in the Wallace Collection, is characteristic of the elegance and extravagance – as well as the occasional *bizarrerie* – of the finest products of the Sèvres porcelain factory in the 1750s, when the rococo style was at its height. It was designed by the factory's chief designer Jean-Claude Duplessis *père*, and the cherubs were painted, after Boucher, by Charles-Nicolas Dodin. A similar pair of vases appears in Madame de Pompadour's inventory of 1764.

Soft-paste porcelain decorated with a green ground, painted and gilded; h 37.6 cm, w 27.6 cm
Acquired by the 4th Marquess of Hertford by 1865
C246

Perfume Burner? (*pot pourri 'à l'esprit de vin'* or *veilleuse*?), 1758–9
Sèvres porcelain manufactory

▶ The painted decoration of cherubs and trophies, allegorical of the Sense of Smell and connected specifically with burning liquid perfume to emit a sweet-scented vapour, is a clue to the complex function of this strange piece. Missing metal fittings would have allowed the liquid perfume to be heated over oil and a wick in the little dish. Alternatively, as suggested by the hen and her chicks on the top, the fittings would have been filled with water, over which the egg would have perched inside the faceted section, and as the rising steam enveloped it, the egg would have lightly cooked. This would have been both ingeniously useful and a luxurious toy in the bedroom or boudoir of someone who was chronically sick like Madame de Pompadour.

Soft-paste porcelain, decorated with a green ground, painted and gilded; h 22.6 cm, w 10.7 cm
Acquired by the 4th Marquess of Hertford or Sir Richard Wallace by 1872
C466

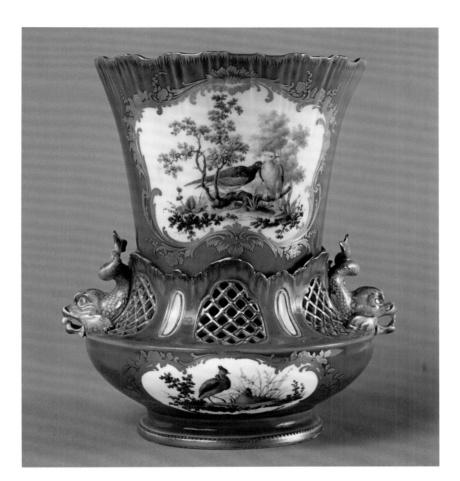

Flowerpot (*vase 'à dauphin'*), 1756–7
Sèvres porcelain manufactory

◀ One of a pair of flowerpots with birds
painted by Louis-Denis Armand (identified
as the painter by his crescent mark). The
design was intended for growing plants in
earth, the lower section being the water
reservoir. The dolphins were associated with
the dauphin of France and mark the birth of
the dauphin's second son (the duc de Berry,
the future Louis XVI) in August 1754. The
pair was presented, as a garniture together
with a third vase, by Louis XV to Adam
Gottlob Moltke, count of Copenhagen in
June 1757.

Soft-paste porcelain decorated with a turquoise-blue
ground, painted and gilded; h 21.4 cm, w 18.4 cm
Probably acquired by the 4th Marquess of Hertford
by 1868
C215

Flowerpot (*vase 'hollandois'*), 1757–8
Sèvres porcelain manufactory

▶ Dutch, tin-glazed, earthenware flower-
pots were used in a similar manner to this
type of vase, hence perhaps the term *vase
'hollandais'*. It was intended for growing
plants in earth, the lower section being the
water reservoir. This vase left the factory as
the largest in a set of three, but was imme-
diately separated by the dealer Madame
Duvaux and sold to Louise-Jeanne de
Durfort, duchesse de Mazarin (died 1781).
The children were probably painted by
André-Vincent Vielliard.

Soft-paste porcelain decorated with a rose-trellis
ground, painted and gilded; h 21.6 cm, w29 cm
Acquired by the 4th Marquess of Hertford in 1859
C217

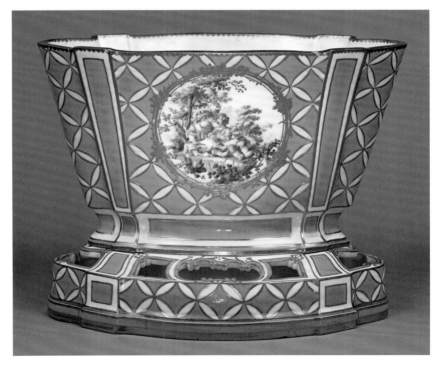

Flower Vase (*cuvette à fleurs 'à masques'*), 1757–58
Sèvres porcelain manufactory

▶ This is the first in a sequence of three ship-shaped vases, designed by Jean-Claude Duplessis *père*, that were produced at Sèvres in the 1750s. Here the form and the interlaced Ls on the front recall a gold and jewelled *nef* (table ornament in the shape of a boat) once in the collection of Louis XIV. These interlaced Ls are extremely unusual and suggest a royal patron.

Soft-paste porcelain decorated with a rose ground, painted and gilded;
h 22.8 cm, w 33.4 cm
Acquired by the 4th Marquess of Hertford
or Sir Richard Wallace by 1872
C225

Potpourri Vase and Cover (*vase 'pot pourri gondole'*), 1757–8
Sèvres porcelain manufactory

◀ As with all Sèvres designs of the 1750s, this vase was designed by Jean-Claude Duplessis *père* and is the second of his three ship-shaped vases of the 1750s. It recalls a gold and jewelled *nef* (table ornament in the shape of a boat) once in the collection of Louis XIV. With a pair of elephant vases, this vase forms a garniture of three, which may have belonged to Madame de Pompadour.

Soft-paste porcelain decorated with a green ground, painted and gilded; h 38.1 cm, w 36.1 cm
Acquired by the 4th Marquess of Hertford
at an unknown date
C248

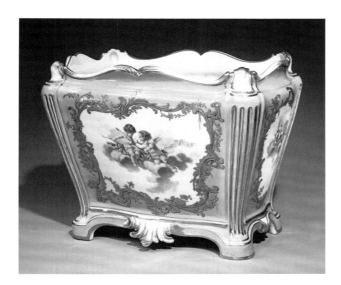

Flower Vase (*cuvette à fleurs 'à tombeau'*), 1757–8
Sèvres porcelain manufactory

◀ The cherubs on clouds, in the manner of Boucher, were painted by Jean-Louis Morin, who later specialised in harbour and military scenes. This model was intended to be filled with naturalistically coloured porcelain flowers set on painted metal stems, and may also have been used for cut flowers.

Soft-paste porcelain decorated with a rose ground, painted and gilded; h 23.5 cm, w 30.2 cm
Acquired by the 4th Marquess of Hertford or Sir Richard Wallace by 1872
C204

Tray (*'grand plateau carré'*), 1757–8
Sèvres porcelain manufactory

▼ The scene of children fishing is taken from an engraving by Jean-Baptiste Le Prince after one of eight decorative panels (now in the Frick Collection, New York) painted by or after Boucher for Madame de Pompadour. It was probably painted by André-Vincent Vielliard. This, the largest model of tray in the 1750s, would have supported up to four matching cups and saucers, a milk jug, sugar bowl and a teapot to form a tea service (*déjeuner*).

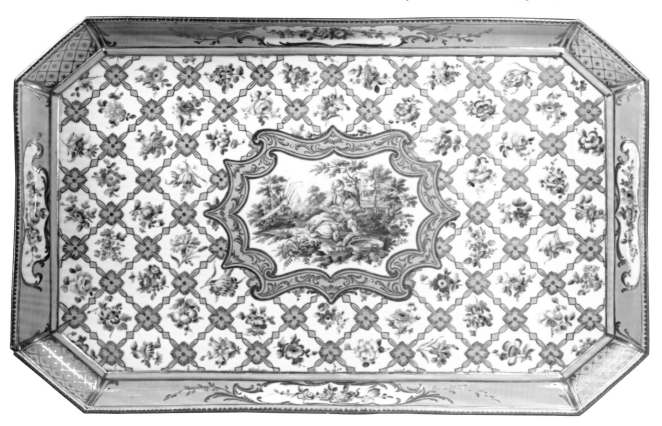

Soft-paste porcelain decorated with a rose ground, painted and gilded; 45.4 x 30 cm
Acquired by Sir Richard Wallace in or after 1875
C390

Snuffbox, 1743–4
Jean Ducrollay (*c*.1708–after 1776)

◀ This superb box, made in Paris by perhaps the finest snuffbox maker of eighteenth-century France, resembles a scallop shell and is enamelled as a white peacock's fan-tail, in full display on the cover. Anyone standing opposite the owner of this box would therefore have the impression of the peacock displaying his tail when the owner lifted the lid. The box was owned by the duc d'Aumont, first gentleman of Louis XV's bedchamber, until his death in 1782.

Gold and enamel; h 3.2 cm, l 7.6 cm, d 5.8 cm
Acquired by the 4th Marquess of Hertford or Sir Richard Wallace by 1872
G4

Snuffbox, 1749–50
Hubert Cheval (active 1716–51)

▶ The plain, translucent (*basse taille*) blue enamel laid over a gold ground engraved with figurative scenes is very unusual when it is the only form of decoration on a box. The chinoiserie designs are from Boucher's *Scènes de la vie Chinoise*, engraved by Gabriel Huquier, and *La Pêche aux Cormorans* (*Fishing with Cormorants*) on the cover is similar to a Chinese earthenware model Boucher had in his own collection. His fashionable Chinese scenes were very influential and appeared on other decorative art objects, including Sèvres porcelain and tapestries.

Gold and translucent enamel; h 3.2 cm, l 7 cm, d 5.1 cm
Acquired by the 4th Marquess of Hertford or Sir Richard Wallace by 1872
G8

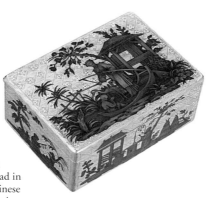

Snuffbox, 1757–8
Jean Frémin (1714–86)

▼ This box in four-colour gold shows popular hunting scenes, several after paintings by Oudry and Alexandre-François Desportes. On the top three hounds attack a fox, and on the front two hounds attack a boar, which stands at bay. To increase the three-dimensional effect, the animals are made in different coloured golds made of alloys, whereby silver is added to make a white or green gold, copper to make a pink or red gold and iron to make a yellow gold.

Gold and enamel; h 4.2 cm, l 8.9 cm, d 6.2 cm
Acquired by the 4th Marquess of Hertford or Sir Richard Wallace by 1872
G25

Snuffbox, 1752–54
Jean Moynat (active 1745–61)

◀ The cover of this box possibly shows Apollo as a shepherd playing his pipe while guarding the herds of Admetus (the same subject depicted by Claude Lorrain in his painting in the Wallace Collection, see page 101). The classical buildings and splashing fountains in the garden landscape, and the thumbpiece, are highlighted in diamonds. The maker, Jean Moynat, was received as a master goldsmith in Paris in 1745.

Gold and diamonds; h 3.5 cm, l 7 cm, d 5.1 cm
Acquired by the 4th Marquess of Hertford or Sir Richard Wallace by 1872
G16

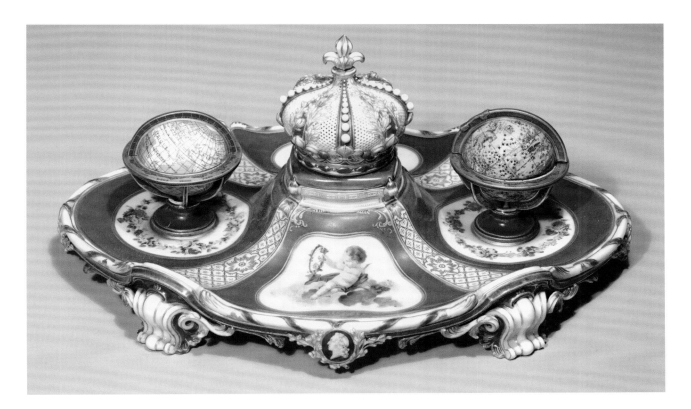

Inkstand (*écritoire 'à globes'*),
1758–9
Sèvres porcelain manufactory

▲ Designed by Jean-Claude Duplessis *père*, this is perhaps the most important object in Sèvres porcelain in the Wallace Collection. Only two other examples of this design are recorded, but this one has particular prestige because it was given by Louis XV to his favourite daughter, Madame Adélaïde. Two medallions reveal this: one in the centre of the tray shows the grisaille head of Louis XV, and another at one end bears the gilded monogram M. A. (for Marie Adélaïde). The terrestrial globe on the left contained an inkwell, and the celestial globe on the right (with the signs of the zodiac and piercings for stars) contained a globular, silver-gilt sand shaker. Inside the cushion was a sponge for Madame Adélaïde to wipe her pen, and inside the crown of France, resting on the cushion, was a bell for her to ring when she wanted her maid to collect the letter she had written.

Soft-paste porcelain decorated with a green ground, painted and gilded; silver-gilt fittings; h 17 cm, l 38 cm, w 27.1 cm
Acquired by the 4th Marquess of Hertford in 1843
C488

Chestnut Basket and Cover (*marronnière 'tenant au plateau'*), 1759–60
Sèvres porcelain manufactory

▼ In the dessert service, *marronnières* were for serving *marrons glacés*. Presumably the baskets were pierced to allow air to circulate round the chestnuts so they did not become too moist, and excess sugar or syrup could drip into the shallow well of the plateau.

Soft-paste porcelain decorated with a turquoise-blue ground and gilded; l 26.8 cm, w 20.8 cm
Probably acquired by the 4th Marquess of Hertford or Sir Richard Wallace by 1872
C473

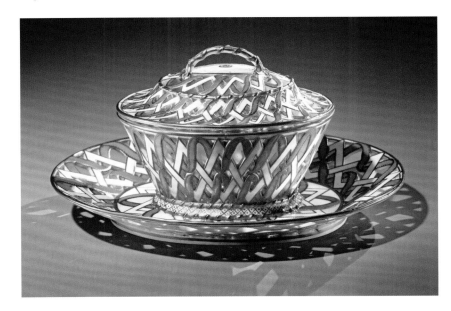

Vase and Cover (*vase 'Boileau'*), 1758–9
Sèvres porcelain manufactory

▶ This vase, part of a garniture of three vases, has painted scenes showing military encampments, a reminder that France was currently involved in the Seven Years War (1756–63). The garniture was probably bought by Louis XV in December 1759, this vase costing 960 *livres* while the other two, *vases 'à oreilles'* ('with ears'), cost 600 *livres* each.

Soft-paste porcelain decorated with an underglaze blue and an overglaze green ground, painted and gilded; h 48.9 cm, w 29.3 cm
Acquired by the 4th Marquess of Hertford by 1865
C251

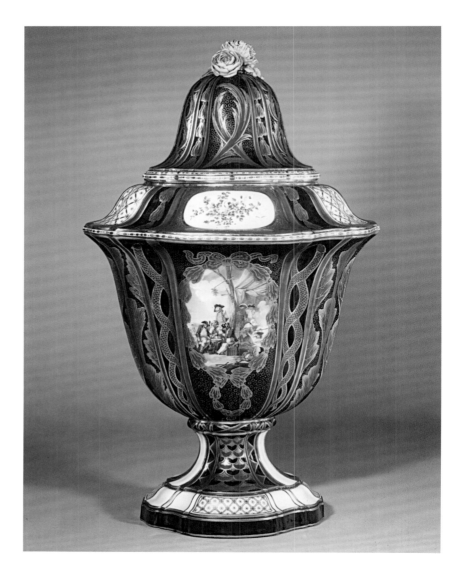

Bulb Pot, 1757–8
Sèvres porcelain manufactory

◀ One of a pair, this pot is decorated with a simplified Greek-key pattern – one of the earliest neoclassical motifs to be found on Sèvres porcelain. The baluster section was for water, and the round fitting at the top encased the bulb, probably a hyacinth. Bulb pots, flower vases and flowerpots were all ways of bringing the garden indoors, and were at their most popular at Sèvres in the 1750s.

Soft-paste porcelain decorated with green-ground scrolls, painted and gilded; h 14.9; w 9.2 cm
Acquired by the 4th Marquess of Hertford by 1865
C230

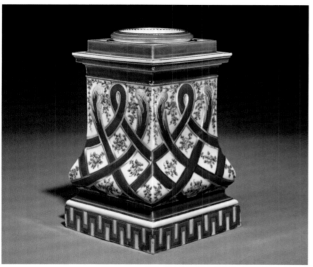

Potpourri Vase and Cover
(**vase 'pot pourri feuilles de mirte'**), *c.*1761
Sèvres porcelain manufactory

▶ One of a pair of vases in this last rococo design to be created by
Jean-Claude Duplessis *père*; the Greek-key pattern on the foot hints
at the emerging neoclassical style. The myrtle branches entwined in
the shoulder are a reminder that an infusion of myrtle leaves was
used to revive old potpourri.

Soft-paste porcelain decorated with a green ground,
painted and gilded; h 27.6 cm
Acquired by the 4th Marquess of Hertford by 1865
C257

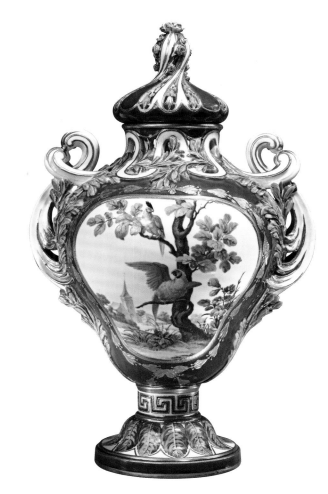

**Potpourri Vase and Cover (vase 'pot pourri
à vaisseau' or 'pot pourri en navire'),** *c.*1761
Sèvres porcelain manufactory

◀ This is the third of the ship-shaped vases
designed by Jean-Claude Duplessis *père* in
the 1750s (see also page 166). The naval
theme is emphasised by the faceted bowsprits
in the mouths of the marine masks, and is a
reminder that at this time the French navy
was involved in the Seven Years War
(1756–63). The popularity of Sèvres porcelain
with English collectors in the eighteenth and
nineteenth centuries is demonstrated by the
presence of all ten known examples of this
shape of vase in English collections by the
mid-nineteenth century.

Soft-paste porcelain decorated with an underglaze
blue and an overglaze green ground, painted and
gilded; h 44.1 cm, w 36.9 cm
Acquired by the 4th Marquess of Hertford by 1865
C256

 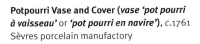

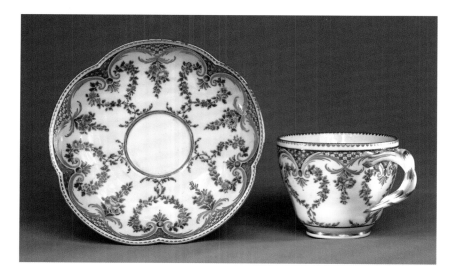

Cup and Saucer (*gobelet 'Hébert'*), 1760
Sèvres porcelain manufactory

◀ This form of cup has the characteristic pear shape of models named after M. Hébert; it was used for tea drinking and often occurs in sets with matching tea wares. Though the painter's mark (the symbol for iron) is still unidentified, the delicacy of the pattern is very distinctive, with flower trails entwining to form heart shapes and with trellis borders at the edge.

Soft-paste porcelain painted and gilded; cup: h 6.4 cm; saucer: diam. 13.6 cm
Probably acquired by the 3rd Marquess of Hertford at an unknown date
C344

Covered Bowl and Plateau, 1760
Sèvres porcelain manufactory

▼ Bowls and plateaux of this kind were used for broths or soups. They were not used at the dinner table, where plate-like soup bowls were favoured, but in the bedroom or boudoir during the lengthy *toilette*. The plateaux could contain croutons or bread, and the cover kept the contents warm and free of hair powder. This example, of a model of the 1750s intended for the Turkish market, was painted by Jean-Baptiste Tandart with trophies, including a trumpet with a banner, an oboe and tambourine, a plumed straw hat, an astrolabe, a telescope, a furled map and a pair of dividers.

Soft-paste porcelain decorated with green-ground scrolling cartouches, painted and gilded; bowl: h 15.3 cm, w 21.5 cm; plateau: h 6.2 cm, l 31.5 cm, w 23 cm
Acquired by the 4th Marquess of Hertford by 1865
C426–27

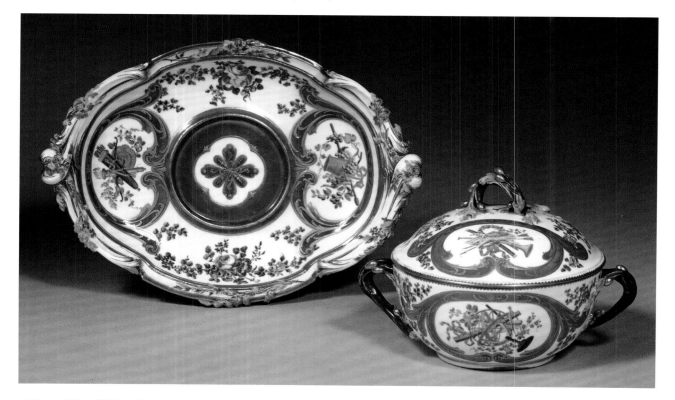

Psyche on a Pedestal, 1762–63
Sèvres porcelain manufactory

▼ Biscuit wares (in porcelain that has been fired but not glazed) were introduced at Vincennes in 1751, and may have been invented by the designer Jean-Jacques Bachelier. Like its companion piece, *Cupid*, this design was devised by Étienne-Maurice Falconet. In fact it was created by Falconet especially as a pendant to *Cupid* in 1761. The turn of her head engages with her partner who should be placed to her right. This piece has a pendant *Cupid* in the Wallace Collection (c493), and both, unlike the other version illustrated here, are seated on pedestals intended for Falconet's *The Bather* (they were muddled up in a Paris sale in 1847).

Soft-paste biscuit porcelain and soft-paste porcelain decorated with an underglaze blue ground, painted and gilded; h 34.3 cm
Acquired by the 4th Marquess of Hertford by 1865
C494

Cupid on a Pedestal, c.1761–3
Sèvres porcelain manufactory

▼ This design, a favourite at Sèvres, was based on a famous sculpture by Étienne-Maurice Falconet, and was actually known as *L'Amour Falconet*. Falconet's original plaster was exhibited at the Paris Salon of 1755, and a marble version, made for Madame de Pompadour, was exhibited in 1757, the year before it was produced in biscuit at Sèvres. Frequently, biscuit figures of Cupid were paired with similar figures of Psyche. The pedestal was specifically designed for this model by 1761 and bears the famous inscription OMNIA VINCIT AMOR (LOVE CONQUERS ALL) from the Roman poet Virgil's *Eclogues*.

Soft-paste biscuit porcelain and soft-paste porcelain decorated with an underglaze blue ground, painted and gilded; h 30.4 cm
Acquired by the 4th Marquess of Hertford or Sir Richard Wallace by 1872
C492

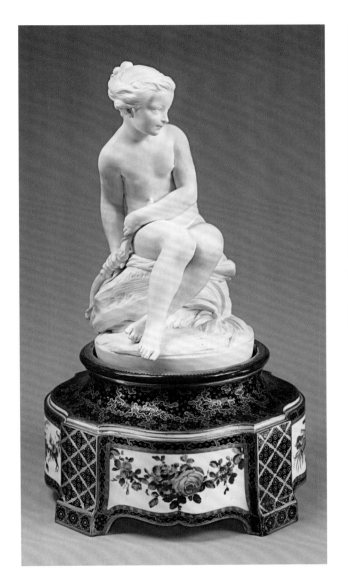

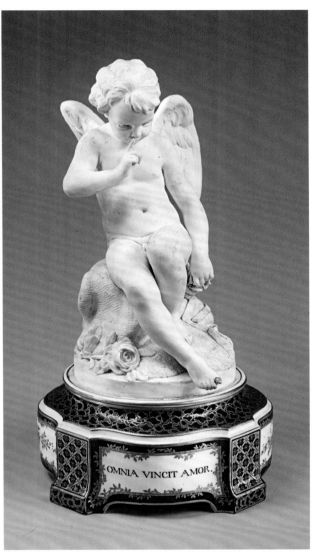

The Broken Mirror, c.1762–3
Jean-Baptiste Greuze (1725–1805)

◀ A fine example of Greuze's modern, moral genre subjects, *The Broken Mirror* is a parable of carelessness, where the disarray of the interior and the girl's dress reflects the disarray of her morals. The fact that the girl laments the loss of her virginity before marriage is emphasised by the yapping dog, a common symbol of carnal desire in eighteenth-century French painting, and the ringless hand that draws our attention in the centre of the picture. The picture belonged to Boucher's friend, Paul Randon de Boisset, who refused to lend it to the Salon of 1763.

Oil on canvas; 56 x 45.6 cm
Acquired by the 4th Marquess of Hertford in 1845
P442

Le petit parc, c.1762–3
Jean-Honoré Fragonard (1732–1806)

▶ The finest of a group of related works inspired by Fragonard's summer spent sketching in the gardens of the Villa d'Este in 1760. The garden belonged to the Duke of Modena who let it grow wild, and it was precisely this proto-romantic charm that seems to have appealed to visitors. The picture may have been based upon the appearance of the Dragon Fountain, although characteristically it has been transformed by Fragonard's imagination. It was probably painted in Paris, soon after Fragonard's return, as an imaginative *souvenir d'Italie*, in which the artist attempted to recall the faded grandeur and dream-like atmosphere of the Villa d'Este.

Oil on canvas; 36.6 x 45 cm
Acquired by the 4th Marquess of Hertford in 1867
P379

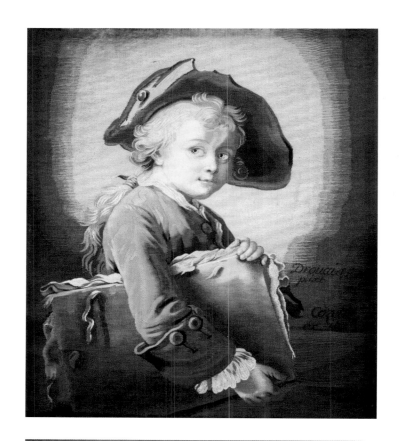

Boy with a Portfolio (opposite top)
Girl playing with a Cat (opposite below)
Gobelins tapestry manufactory, c.1763–4

◀ This pair of tapestries was woven at the Gobelins by Pierre-François Cozette after François-Hubert Drouais. They were apparently given by Madame de Pompadour to her faithful steward Jacques-Charles Collin. As she lay dying she called him to make adjustments to her will and his tears, shed as he copied her final wishes, still stain her will to this day.

Wool and silk tapestry; Boy: 66.5 x 57.8 cm;
Girl: 69 x 50.3 cm
Acquired by Sir Richard Wallace in 1871
F340–41

Toilet and Writing-table (table de toilette),
c.1763–4
Workshop of Jean-François Oeben (1721–63)

▼ The style and quality of this piece indicate that it must have been made in Oeben's workshop. The ram's-head mounts, the floral marquetry on the top of the table and the complex mechanical devices used to open the desk are all characteristic of Oeben. The table was, however, probably finished by Jean-François Leleu (1729–1807), one of Oeben's apprentices, since his mark is incised beneath the lower front drawer. A single lock opens all four drawers, an upper and lower drawer at the front and one on either side. To use the table as a desk, a panel on the top of the upper front drawer can be pulled forwards to serve as a writing surface, with silvered-metal inkwells and a writing compartment. When used as a toilet table, this surface is lifted to reveal a mirror and compartment in the top drawer for cosmetics and other toilet items.

The two side drawers are fully extendable, and each contains a lidded box that can be pulled forwards to surround the user, seated in front of the table.

Oak veneered with tulipwood and with marquetry of sycamore, walnut, pear wood and tulipwood and stringings of ebony and box; gilt-bronze mounts;
h 70.8 cm, w 57 cm, d 43.7 cm
Acquired by the 4th Marquess of Hertford in 1864
F110

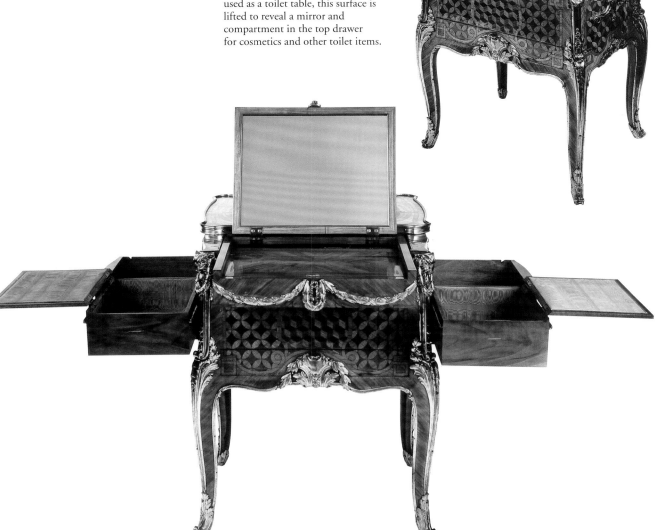

Venus and Cupid Asleep, 1760s–70s
Jacques Charlier (1720–90)

▶ One lesser known aspect of the Wallace Collection is its large
holding of Boucher-related miniatures. Charlier, who spent a period
working in Boucher's studio, specialised in such miniatures, which
enjoyed great popularity in eighteenth-century France. Many of his
works, painted for the open market, reveal a taste for the erotic
female nude, paralleled by that seen in the print trade at the same
period. Here the pose of the figure of Venus recalls that of the
sleeping Nereid in the foreground of Boucher's *The Setting of the
Sun* (see page 156).

Gouache on ivory; 5.5 x 7.8 cm (sight)
Probably acquired by the 4th Marquess of Hertford at an unknown date
M63

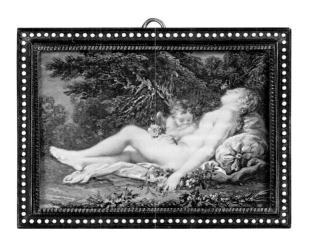

Snuffbox, 1764–5
Louis-Philippe Demay (died 1772)

▶ This box shows miniatures of two paintings by
Boucher that Madame de Pompadour commissioned
for herself. On the top is *L'Amour désarmé*, where
Cupid implores Venus to return his bow and arrow,
and on the bottom *La Toilette de Vénus*, which
Madame de Pompadour hung in her bathroom.
The latter was not even available in engraved form when
this box was made, suggesting that either she, before her
death in 1764, or her brother, on inheriting the two paintings,
commissioned this box from Demay.

Gold and enamel; h 3.9 cm, l 8.9 cm, d 6.3 cm
Acquired by the 4th Marquess of Hertford
or Sir Richard Wallace by 1872
G39

Toilet Service (*service de toilette*), 1763
Sèvres porcelain manufactory

◀ Vincennes and Sèvres toilet wares were
for the cosmetics and hair preparations used
during the ritual of the *toilette*. In royal
circles this was undertaken before courtiers,
friends and tradesmen. This service
(probably incomplete) comprises two
powder boxes, two pomade pots, two patch
boxes, a small brush (*vergette*) for brushing
away wig powder and a clothes brush. The
flowers are probably painted by Dominique
Joffroy. The service may have been intended
for Madame de Pompadour, but was left
incomplete on her death in 1764, subse-
quently being sold in 1767 to the dealer
Rouveau, who in turn sold it to Queen
Lovisa Ulrika of Sweden (1720–82).

Soft-paste porcelain decorated with a green ground,
painted and gilded; gold mounts; brush back:
l 16.8 cm, w 7.6 cm; brush handle: l (without brush)
7.6 cm; patch boxes: h 5.8 cm, w 7.6 cm; pomade
pots: h 10.8 cm, w 8.3 cm; powder boxes: h 10.2 cm,
w 13.3 cm
Acquired by Sir Richard Wallace in 1872
C458–65

Chest of Drawers (*commode en console*), *c.*1765
Stamped IDubois, probably René Dubois
(1737–98)

▼ In the past this chest of drawers has
wrongly been associated with both Madame
de Pompadour and Marie-Antoinette.
Intended to stand below a pier glass, it is
veneered with three separate panels of
highest-quality Japanese lacquer overlaid in
part by a matted, gilt-bronze, Chinese-style
fret. By contrast, the gilt-bronze sirens
supporting tasselled cushions on their heads
are a much more European feature. This
combination of elements is typical of the
more avant-garde, luxury French furniture
of this period. Similar mounts of sirens
appear on a worktable by René Dubois,
also in the Wallace Collection (F330).
The cabinet-maker continued to use the
stamp of his father, Jacques Dubois
(1694–1763), long after the latter's death.

Oak veneered with purple heart and with Japanese
lacquer; brecciated Sarrancolin marble top;
gilt-bronze mounts; h 92 cm, w 157.5 cm, d 57 cm
Acquired by Sir Richard Wallace in 1872
F245

**Child supporting a Candle Socket (*enfant
bougeoir*),** 1773
Sèvres porcelain manufactory

▶ This piece and its pair are early examples
of hard-paste figures, probably made at an
experimental stage, using much earlier
forms to try out the new material (they
seem to derive from Jean-Jacques Bachelier's
figures for Louis XV's first dinner service in
the 1750s). The fact that they are gilded
suggests that there was a problem obtaining
the whiteness of the soft-paste figures and
gilding concealed the imperfection. Gilding
directly onto the biscuitware was also an
experimental process at this date and may
have been influenced by works by
Wedgwood, advertised in Paris in 1771.

Hard-paste unglazed porcelain, gilded; h 22.1 cm
Acquired by the 4th Marquess of Hertford
or Sir Richard Wallace by 1872
C482

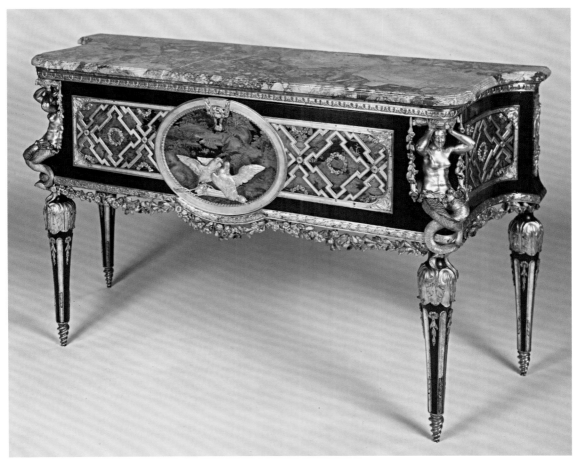

Vase and Cover (*vase 'grec à rosettes'*), 1765
Sèvres porcelain manufactory

▶ This is one of a pair of vases and covers probably designed by Jean-Claude Duplessis *père*. The swags and the Greek-key pattern at the neck are characteristic of the neo-classical style that became fashionable in the 1760s. These vases were acquired by Horace Walpole, who displayed them in his Gallery at Strawberry Hill.

Soft-paste porcelain decorated with an overglaze blue ground and gilded; h 48.5 cm, w 26.7 cm
Acquired by the 4th Marquess of Hertford by 1870
C272

Cup and Saucer (*gobelet 'Calabre'*), 1765
Sèvres porcelain manufactory

▼ The extraordinary decoration of this cup and saucer led to their being placed in store at the Wallace Collection for much of the twentieth century as Art-Nouveau fakes. They are, however, perfectly genuine eighteenth-century pieces, characteristic of the splendidly imaginative design that the Sèvres factory was capable of producing during its heyday. A teapot with similar decoration is in a private English collection.

Soft-paste porcelain decorated with scallop shells in turquoise blue, highlighted with dark blue and gilded; cup: h 8.3 cm; saucer: diam. 15.3 cm
Acquired by the 4th Marquess of Hertford or Sir Richard Wallace by 1872
C362

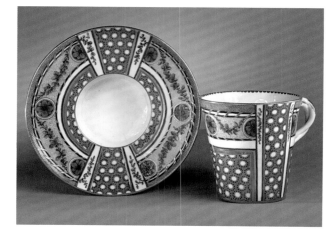

Vase and Cover (*vase 'à bâtons rompus'*),
*c.*1765–70
Sèvres porcelain manufactory

▶ The shape of this vase was probably
designed by the sculptor Étienne-Maurice
Falconet, who worked at the Sèvres factory
from 1757 until 1766. The painted scene
of Savoyard children with a magic lantern
is based on a biscuit-porcelain group by
Falconet, though ultimately based on
designs by Boucher. Savoyard peasants from
the Savoy Alps were common figures at
Parisian fairs in the eighteenth century.

Soft-paste porcelain decorated with an
overglaze blue ground, painted and gilded;
h 37.6 cm, w 23.6 cm
Acquired by the 4th Marquess of Hertford
by 1865
C270

Cup and Socketed Saucer, 1766
Sèvres porcelain manufactory

◀ It used to be thought that socketed
saucers, which steadied the cup to prevent
hot contents from spilling, were intended
for the elderly, but Marie-Antoinette had
not reached her eighteenth birthday when
she purchased one in October 1773. In fact
this model appears to have been devised for
Madame de Pompadour in 1759, and was
intended for use while she was ill in bed
during her many bouts of bronchitis.
It contained those nourishing milk drinks
prescribed for an invalid diet, which
included mixing milk with meat broths,
cereals, wine or beer. Socketed saucers were
often decorated with frieze patterns, and
this example, perhaps imitating textiles, was
painted by Charles-Louis Méraud.

Soft-paste porcelain, painted and gilded;
cup: h 8.7 cm; saucer: h 4.5 cm, diam. 15.1 cm
Acquired by the 3rd Marquess of Hertford
at an unknown date
C443

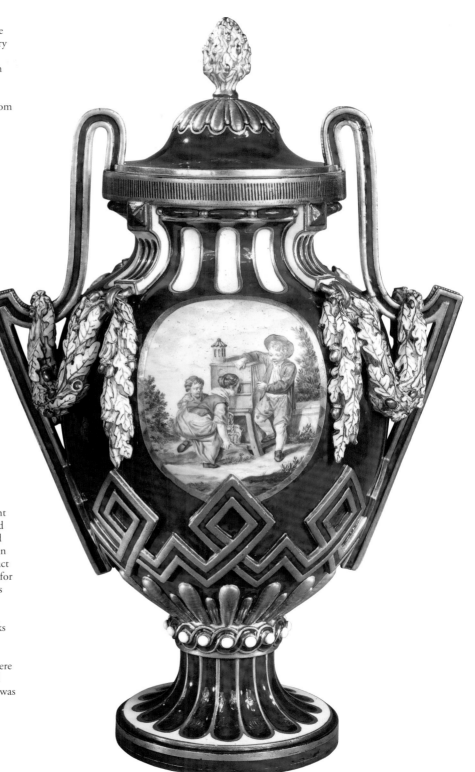

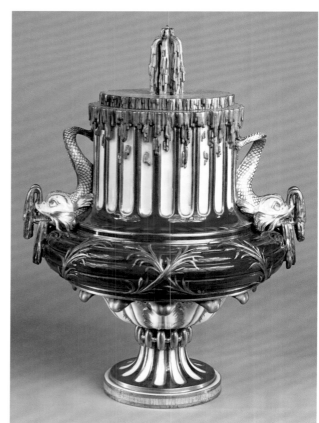

Vase and Cover (*vase 'à jet d'eau'*), *c.*1766
Sèvres porcelain manufactory

▲ This is one of a pair of vases and covers possibly designed by Jean-Claude Duplessis *père*. This shape commemorates the future Louis XVI becoming dauphin ('dolphin', direct heir to the French throne) in 1765 on the death of his father (Louis XV's only son).

Soft-paste porcelain decorated with an overglaze blue ground and gilded; h 35.3 cm, w 26 cm
Acquired by the 4th Marquess of Hertford by 1865
C284

Potpourri Vase and Cover (*vase 'pot pourri ovale uni'?*), 1766
Sèvres porcelain manufactory

▶ The design of this model, attributed to Jean-Claude Duplessis *père*, shows the growing confidence in the neoclassical style. The minimal colour, just the blue ground and gilding, reflects this new austerity.

Soft-paste porcelain decorated with an overglaze blue ground and gilded; h 21.9 cm, w 32.3 cm
Acquired by the 3rd Marquess of Hertford by 1842
C278

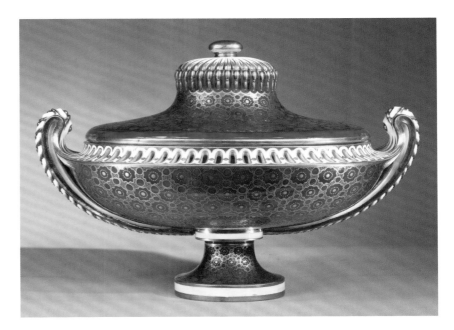

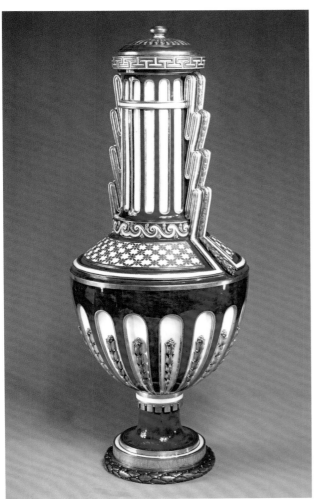

Vase and Cover (*vase 'à colonnes cannelées'*), 1768
Sèvres porcelain manufactory

◀ This vase was possibly part of a garniture of three vases bought by Lord Lincoln from Sèvres in October 1768, when he was in Paris beginning his Grand Tour of Europe.

Soft-paste porcelain decorated with an overglaze blue ground and gilded; h 54.4 cm, w 21.5 cm
Acquired by the 4th Marquess of Hertford by 1865
C306

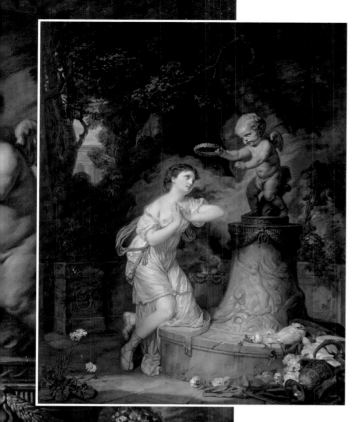

Votive Offering to Cupid, 1767
Jean-Baptiste Greuze (1725–1805)

◀ One of a number of classical subjects Greuze exhibited at the 1769 Salon that demonstrate his growing ambition to become a history rather than a genre painter. Greuze researched his subject carefully: the statue of Cupid derives from an engraving in P.-J. Mariette's *Traité des pierres gravées* of 1750, and the architecture, altar and ewer indicate an attentive study of Grecian motifs then in fashion. The ambitious canvas was, however, criticised at the Salon for its spatial inconsistencies and clumsy figures. The picture was nevertheless acquired by the duc de Choiseul, who hung it in his peacock-blue bedroom.

Above:
Oil on canvas;
145.4 x 113 cm
Acquired by the 4th
Marquess of Hertford
in 1845
P441

The Swing, 1767
Jean-Honoré Fragonard (1732–1806)

▼ *The Swing* is Fragonard's best-known painting, encapsulating for many the finesse, humour and *joie de vivre* of the rococo. No other work better demonstrates his ability to combine erotic licence with a visionary feeling for nature. According to the poet Charles Collé, the history painter Gabriel-François Doyen was commissioned by an unnamed 'gentleman of the Court' to paint his young mistress on a swing, pushed by a bishop, with himself admiring her legs from below. Fragonard, who became well known for his erotic genre pictures, proved better suited to paint the work, in which the impudent reference to the Church has been omitted, leaving the girl as the main focus, delicious in her froth of pink silk, poised mid-air, tantalisingly beyond the reach of both her elderly seated admirer and her excited young lover.

Right:
Oil on canvas;
81 x 64.2 cm
Acquired by the 4th
Marquess of Hertford
in 1865
P430

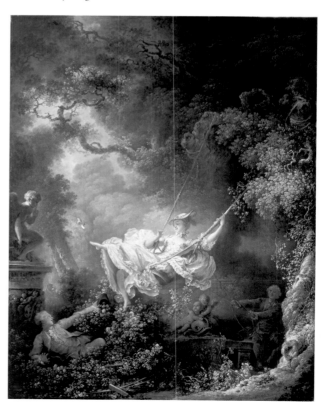

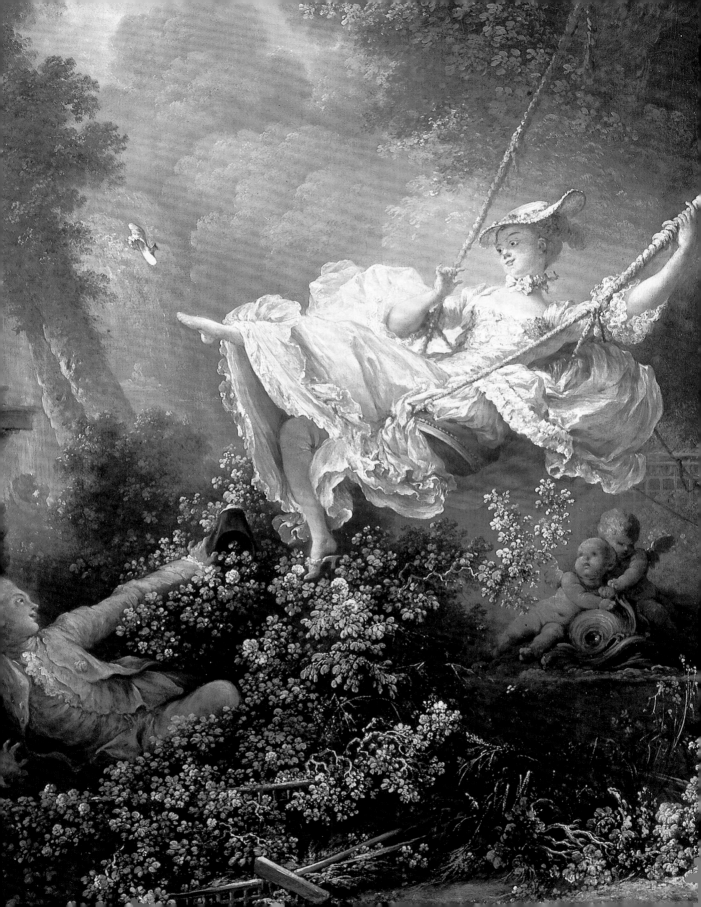

Covered Jug and Basin, 1767
Sèvres porcelain manufactory

▶ The scenes of Savoyard children are painted by Charles-Eloi Asselin after works by Greuze and Boucher. The combination of a green ground with figure scenes is unusual for a jug and basin of the 1760s, and there is only one entry in the factory's sales records, referring to a purchase by Louis XV's daughters mesdames Adélaïde and Louise in December 1767, that could refer to this set.

Soft-paste porcelain decorated with a dark green ground, painted and gilded; silver-gilt mount on jug; jug: h (with mount) 16.2 cm; basin: h 9 cm, diam. 21.5 cm
Acquired by the 4th Marquess of Hertford by 1865
C454–55

Vase and Cover (*vase 'à médaillon du roi'*), *c.*1768
Sèvres porcelain manufactory

◀ This vase may have been given by Louis XV to King Christian VII of Denmark. The oval biscuit medallion showing the French King is after a model of 1738, when he was considerably younger and more handsome than when this vase was made. Christian VII also received a dinner service, and his visit to France in 1768 was marked by a state reception at Versailles and a visit to the Sèvres factory.

Soft-paste porcelain decorated with a dark-green ground and gilded; h 37.5 cm, w 21.7 cm
Acquired by the 4th Marquess of Hertford in 1870
C305

Queen Marie-Antoinette, *c.*1774
French

▶ With its companion medallion of her husband Louis XVI, this medallion of Queen Marie-Antoinette (1755–93) has been attributed to André-Jean Lebrun (1737–1811). The medallion of Louis XVI (also in the Wallace Collection, S392) is signed F. P. LEBRUN, which may mean *fait par* (made by) *Lebrun*, but there were several goldsmiths with this surname, and it is not certain that both medallions are by the same hand. A similar pair, a gift in 1775 from Louis XVI to Haidar Ali (the father of Tipu Sultan) on the occasion of his coronation, is in the India Office Collection (The British Library, London).

Gilt bronze; h 13.3 cm, w 9.5 cm
Probably acquired by the 4th Marquess of Hertford at an unknown date
S393

Snuffbox, 1766–7
Louis Roucel (died 1787)

◀ All the scenes on this box are after paintings by Greuze, with *The Village Wedding* (now in the Louvre, Paris) of 1761, engraved by Jean-Charles Flipart, on the cover. Greuze's contemporary moral scenes enjoyed an enormous vogue in the 1760s. Unlike earlier rococo boxes, where the painted scenes and goldsmith's work provide a riot of decoration, this box shows the new austerity of neoclassicism, which was more in keeping with Greuze's subject matter. Here the enamels fill the flat areas and are simply edged with gold, rather like being miniature paintings in their gilded frames.

Gold and enamel; h 3.9 cm, l 7.9 cm, d 5.7 cm
Acquired by the 4th Marquess of Hertford
or Sir Richard Wallace by 1872
G44

Snuffbox, *c*.1775
German, Dresden, possibly Christian Gottlieb Stiehl (1708–92)

▶ This splendid snuffbox is formed by panels of the hardstone cornelian set in gold cartouches, the largest on the top carved with the story of Leda and the Swan, and lined with panels of gold. The presence of the two miniatures in their secret slide was unknown at the Wallace Collection until their exciting discovery in 1976. Attributed to Hubert Drouais (1699–1767), they show the famous philosopher Voltaire (1694–1778) and his lover, the mathematician Émilie, marquise du Châtelet (1706–49). Both images may have been taken from the life rather than from existing painted portraits. Thanks to their concealment, they are still as alive and vibrant today as when they were painted. The box was formerly in the collections of the duc de Morny (1811–65), half-brother of the Emperor Napoleon III, and of the Empress Eugénie (1826–1920), Napoleon III's consort.

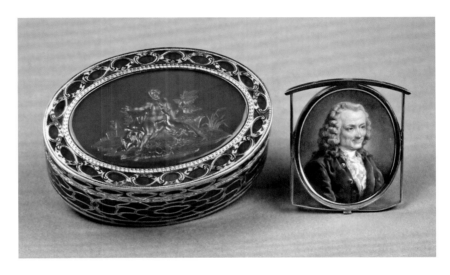

Gold and cornelian with miniatures in gouache on ivory; h 3.8 cm, l 8.4 cm, d 6 cm
Acquired by Sir Richard Wallace in 1872
G80

Snuffbox, 1775–6
René-Jean Lemoyne (active *c*.1765–93)

▶ Abalone-shell boxes are occasionally seen engraved and decorated with gold pins or cartouches, but this lacquered example is more unusual. The chinoiserie scenes are created from a mixture of resins, varnish and gold powder, showing, on the top, a winsome Chinese man sitting under a tree with his broomstick and gaggle of geese.

Gold and japanned abalone shell (mother-of-pearl); h 3.2 cm, l 7.3 cm, d 5.3 cm
Acquired by the 4th Marquess of Hertford
or Sir Richard Wallace by 1872
G55

Drop-front Desk (*secrétaire à abattant*), *c.*1772
Jean-François Leleu (1729–1807)

▶ The original owner of this splendid secretaire is unknown. It is probably close in date to a chest of drawers with similar designs supplied by Leleu for the bedchamber of the prince de Condé at the Palais-Bourbon in November 1772 (now in the Louvre, Paris). The quality of the execution, particularly in the construction of the upper compartment, with the use of solid *satiné* for all the drawers and the subtle profiles of the drawer fronts, suggests that this piece was intended for a similarly prestigious patron. The marquetry baskets of flowers on the bottom doors of the desk reveal the influence of Jean-François Oeben, to whom Leleu had been apprenticed until Oeben's death in 1763. The gilt-bronze, lion-paw feet are often found on furniture by Leleu.

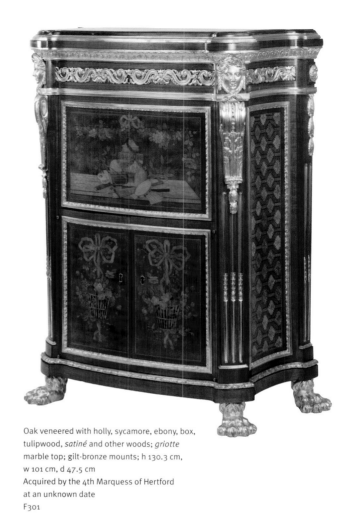

Oak veneered with holly, sycamore, ebony, box, tulipwood, *satiné* and other woods; *griotte* marble top; gilt-bronze mounts; h 130.3 cm, w 101 cm, d 47.5 cm
Acquired by the 4th Marquess of Hertford at an unknown date
F301

Covered Vase and Pedestal (*vase et son couvercle* and *colonne*), *c.*1764
Marble carved by Jacques Adam (master 1746)
Mounts by Robert-Joseph Auguste (1723–1805, master 1757) after models by Augustin Pajou (1730–1809)

◀ Designed by the architect Charles de Wailly (1730–98) for Marc-René d'Argenson, marquis de Voyer (1722–82), a distinguished soldier who had also been director of the royal stud farms, this vase and its associated pedestal were displayed in the sumptuous Hôtel de Voyer in Paris, which was remodelled in an advanced neoclassical style by de Wailly in early 1760s. Tremendous skill was required to carve porphyry, a very hard rock first used in ancient Egypt and later under the Roman Empire. De Wailly had studied at the French Academy in Rome and would have seen many porphyry objects in collections there.

Vase: porphyry; gilt-bronze mounts; pedestal: porphyry, stucco and marble; gilt-bronze mounts; vase: h 55 cm, w 76 cm; pedestal: h 168.2 cm, w 70.3 cm, d 58 cm
Acquired by the 4th Marquess of Hertford in 1853
F354 and F291

Roll-top Desk (*bureau à cylindre*), *c.*1770
Jean-Henri Riesener (1734–1806)

▼ A slightly simplified version of the roll-top desk made for Louis
XV by Jean-François Oeben (1721–63) and Jean-Henri Riesener and
delivered in 1769 (see page 251). It was supplied by Riesener to Pierre-
Gaspard-Marie Grimod (1748–1809), comte d'Orsay, a member of
a leading family of financiers and tax-farmers, only about a year after
the King's desk was delivered. On each side the marquetry includes
the monogram ORS in a medallion (see right). Other elements may
also refer to d'Orsay himself: for example, the dove carrying a letter
on the roll top may refer to his marriage in 1770, and the military
trophies on the sides may refer to his commission as a captain of
dragoons.

Oak veneered with holly, walnut, ebony and box on grounds of sycamore
and purple heart; gilt-bronze mounts; h 139 cm, w 195.5 cm, d 102.5 cm
Acquired by the 4th Marquess of Hertford at an unknown date
F102

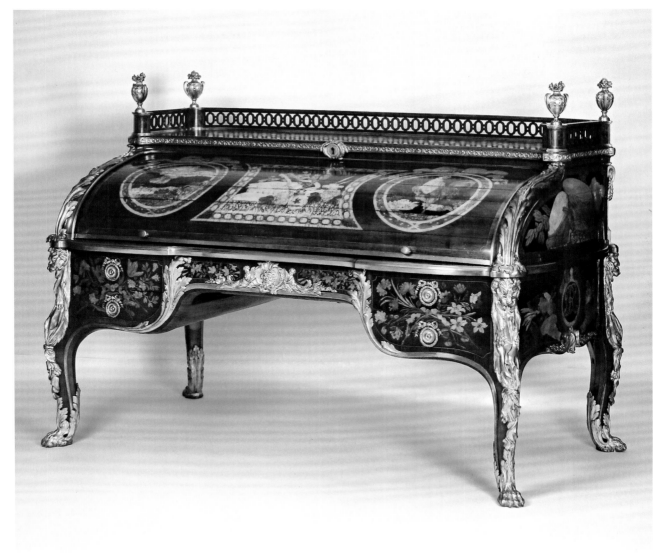

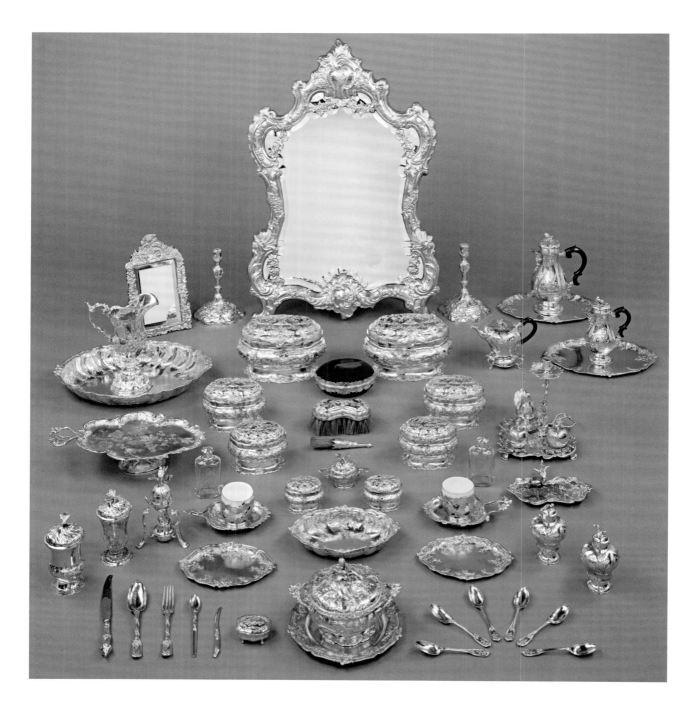

The Augsburg Service, 1757–73
German

▲ Toilet services were an integral part of the *levée* (French) or *lever* (German), the elaborate morning ritual at which wealthy members of society received favoured guests. The German city of Augsburg became the leading centre of their production in the eighteenth century. Although the original owner of this service is unknown, it is one of the finest to survive, decorated in the full-blown German *rokoko* style. It contains fifty-five pieces for both the toilet and the breakfast meal, but would have had some additional porcelain items, now missing. Among the toilet items are the mirror, candlesticks and snuffers as well as various boxes and bottles. The breakfast items include coffee and tea pots, a hot-milk jug and an individual setting with knife, fork and spoon.

Silver-gilt and porcelain; various dimensions
Acquired by the 4th Marquess of Hertford or Sir Richard Wallace
at an unknown date

Mantel Clock (*pendule de cheminée*), *c.*1768
Movement by Ferdinand Berthoud (1727–1807)

▶ A model of clock originally known as 'l'Emploi du Temps', it was first made for Madame Geoffrin (1699–1777), a society hostess famed for holding artistic and literary soirées. According to her will she kept the clock in her bedroom. She admired it so much that she commissioned another version for Diderot. The reading figure symbolises the employment of time but may also reflect a contemporary portrait of Madame Geoffrin. The plinth was made by Joseph Baumhauer (died 1772), and the bronze figure and clock case were probably cast by the founder Edme Roy (master 1745) from a model by Laurent Guiard (1723–88).

Gilt-bronze case; patinated-bronze figure; gilt-bronze base; oak plinth veneered with ebony and mounted with gilt-bronze;
h 47.5 cm, w 69.7 cm, d 27.8 cm
Acquired by the 3rd Marquess of Hertford in 1802
F267

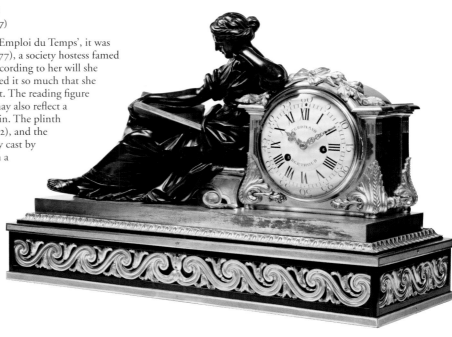

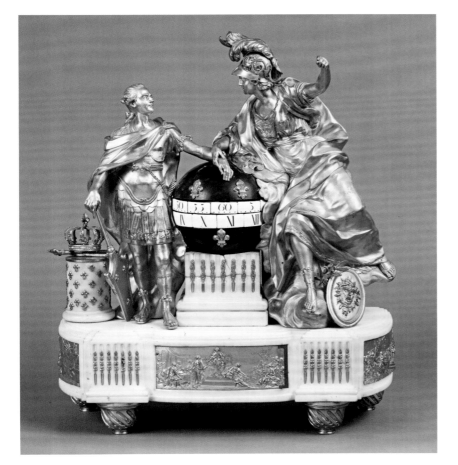

Mantel Clock (*pendule de cheminée*), *c.*1774
French

◀ The design of this clock is tentatively attributed to the sculptor Louis-Simon Boizot (1743–1809). It shows Louis XVI dressed as a Roman general and receiving counsel from Minerva, the Roman goddess of wisdom – a poignant conceit in view of his later fate during the French Revolution. The gilt-bronze reliefs on the base depict, from left to right, the King dining with his brothers, the King in Roman military dress dictating laws to France from a book held by Justice, and the King enthroned on a dais, surrounded by allegorical figures including Trust banishing Falsehood. The clock itself is in the form of a globe. Around the circumference of the globe are two rotating dials with numbers on enamel plaques indicating the hours (in Roman numerals) and the minutes. The lowest of three fleurs-de-lis on the globe indicates the time.

Marble and gilt and enamelled bronze; gilt-bronze mounts; white marble; h 60.5 cm, w 51.8 cm, d 22 cm
Acquired by the 4th Marquess of Hertford by 1865
F259

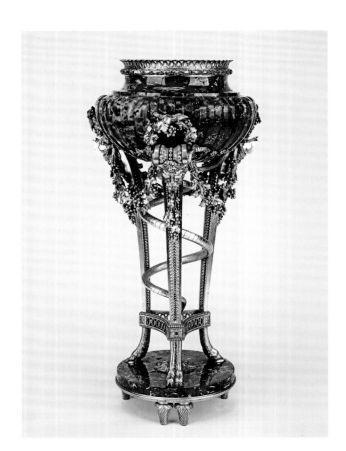

Perfume Burner (*cassolette*), 1774–5
Pierre Gouthière (1732–c.1812)

◀ The gilt-bronze mounts of this perfume burner represent the finest work of Gouthière, the leading maker of gilt bronzes in France before the Revolution. It was made for the duc d'Aumont, first gentleman of the king's bedchamber, and was acquired at the sale of his collection in 1782 by Marie-Antoinette. Perfume burners of this kind were modelled on the bronze tripods featured in wall paintings at Pompeii and Herculaneum. The bowl of this example is made of red jasper, probably cut in the workshop set up by the duc d'Aumont in the Hôtel des Menus-Plaisirs. The mounts feature swags of leaves and berries, satyrs' masks, a twisted serpent and, at the bottom of the legs, goats' hooves.

Red jasper and gilt bronze; h 48.3 cm,
diam. (bowl) 21.7 cm
Acquired by the 4th Marquess of Hertford in 1865
F292

Cabinet (*bas d'armoire*), c.1775
Étienne Levasseur (1721–98)

▶ The demand for Boulle furniture in the eighteenth century far exceeded the availability of existing pieces by André-Charles Boulle (1642–1732) and his contemporaries. Levasseur restored original Boulle furniture as well as producing furniture such as this cabinet, which may derive from a model by Boulle. The keyhole escutcheons and hinge plates are direct copies of original Boulle mounts. Such cabinets were often used to store books, including, perhaps, copies of Homer's *Iliad* or Virgil's *Aeneid*, from which the subject of the Rape of Helen, depicted in the oval mount on the front of the cabinet, was taken.

Oak and pine veneered with Macassar ebony,
African ebony and *contre-partie* Boulle marquetry of
turtleshell and brass; gilt-bronze mounts; h 105 cm,
w 162.1 cm, d 46 cm
Probably acquired by the 4th Marquess of Hertford
at an unknown date
F388

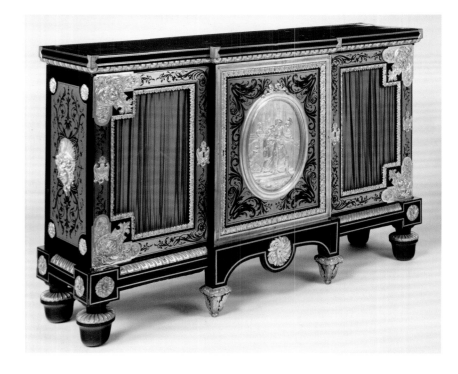

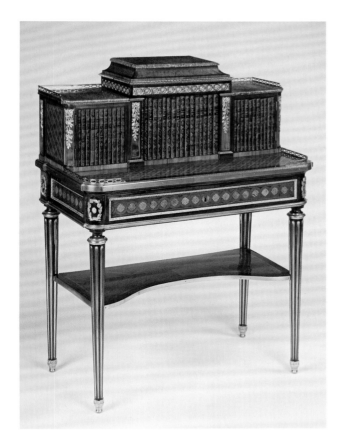

Writing-table (*bonheur-du-jour*), 1774–6
Jean-François Leleu (1729–1807)

◀ With its dummy book spines, this writing table was probably also intended for reading. It once also had a wire trellis from the main frame to the shelf below, surrounding the shelf on three sides and probably serving to prevent books from falling off. The book spines have been placed on three doors; the titles on the left comprise histories of towns and cities, those on the central door are literary, including the *Letters* of the Roman writer Horace, and those on the right are general histories. There is a secret drawer behind the gilt-bronze frieze above the central section with the tambour front, opened by pressing on the fourth gilt-bronze flower head from the left.

Oak veneered with *satiné*, sycamore, box, purple heart, holly, amboyna and tulipwood; Spanish *brocatello* marble tops; gilt-bronze mounts; h 106.7 cm, w 83 cm, d 45.2 cm
Acquired by the 4th Marquess of Hertford by 1865
F323

Drop-front desk (*secrétaire à abattant*), *c*.1776
Martin Carlin (*c*.1730–85)

▶ Sèvres porcelain plaques were first made for use on furniture in the 1760s. The cabinet-maker Carlin specialised in this kind of furniture, decorated with delicate floral panels ideally suited to feminine interiors. This desk was probably commissioned by the prominent dealers Simon-Philippe Poirier and Dominique Daguerre. The floral swag mounts along the frieze of the desk and the elegant tapering legs are typical of the neoclassical style. The rich pink and purple colours of the wood veneers, now faded, would once have matched some of the bright colours on the porcelain plaques. The drawer front on the stand is mounted with a central apron-shaped plaque in a gilt-bronze surround, imitating a fringed drape, a form harking back to furniture of the late seventeenth century.

Oak veneered with tulipwood, purple heart and kingwood; soft-paste Sèvres porcelain plaques; Carrara marble top; gilt-bronze mounts; h 118.6 cm, w 100.5 cm, d 38.5 cm
Acquired by the 4th Marquess of Hertford in 1851
F304

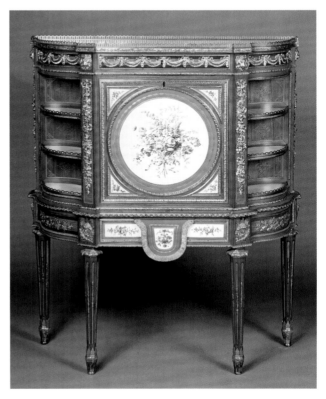

Eighteenth-century France ❧ 193

A Fête in the Colisée, 1772
Gabriel-Jacques de Saint-Aubin (1724–80)

▲ Saint-Aubin was an idiosyncratic and often inspired recorder of late eighteenth-century Paris. Here he depicts the Colisée, which opened as a setting for *fêtes payantes* (paying entertainments) near the Rond-Point in the Champs-Elysées in 1771. Saint-Aubin's drawing of the central ballroom, which is one of many he made of the Colisée in the year following its opening, conveys something of its fashionable, illusionary appeal, made all the more fantastical via the artist's imagination.

Black chalk, ink, watercolour and bodycolour on paper; 16.8 x 22.6 cm
Acquired by the 4th Marquess of Hertford at an unknown date
P780

The Painter's Family, 1776
Peter Adolf Hall (1739–93)

▶ Born in Sweden, Hall trained with the pastellist Gustav Lundberg before moving to Paris and becoming the leading miniaturist of his day. Generally regarded as his masterpiece, this miniature reveals how much of his appeal lay in his scintillating, painterly technique, decorative palette and idealising approach. It depicts his wife, Adélaïde, her sister, the comtesse de Serre, and his eldest daughter, Adélaïde-Victorine, then four years old. The charming family group, with the young mother embracing both her child and sister, reflects the new mood of *sensibilité* made fashionable in the French capital by the writings of Rousseau and the paintings of Greuze.

Gouache on ivory; 9 x 11 cm (sight)
Acquired by Sir Richard Wallace in 1872
M186

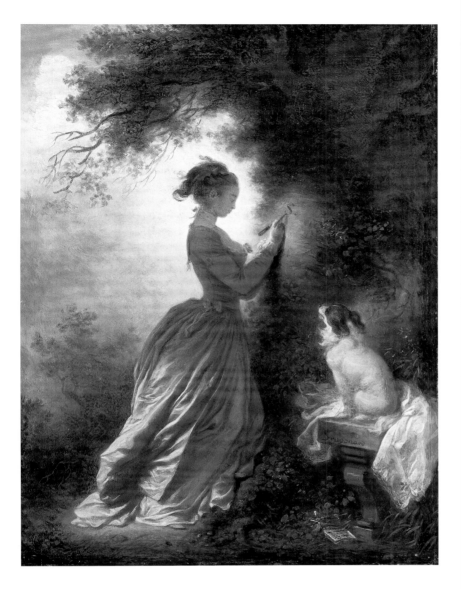

The Souvenir, *c.*1776–8
Jean-Honoré Fragonard (1732–1806)

▲ A young girl, identified as Rousseau's heroine, Julie, in a sale
catalogue of 1792, carves the initial of her lover on the bark of a
tree, while observed by her pet spaniel, the symbol of her fidelity.
The theme reflects the increasing *sensibilité* of the second half of
the eighteenth century. Its scale and careful technique also show
Fragonard varying his style to echo the contemporary taste for the
'little masters' of seventeenth-century Holland, although he con-
tinued to animate such stylistic references with his own inimitable
theatrical lighting, delicate draughtsmanship and calligraphic
traceries of hair and foliage.

Oil on walnut panel; 25.2 x 19 cm made up with oak strips
at each edge to 26.5 x 20.5 cm
Acquired by the 4th Marquess of Hertford in 1865
P382

Tea Service (*plateau 'losange'* and *déjeuner 'losange'*), *c.*1775–80
Sèvres porcelain manufactory

▶ The service was probably decorated by
the husband-and-wife team, Vincent and
Geneviève Taillandier, and may be similar
to one bought by Louis XVI's aunt,
Madame Adélaïde, in 1775.

Soft-paste porcelain decorated with a pale-blue
pointillé ground, painted and gilded; cups: h 6
and 6.1 cm; milk jug: h 9.8 cm; saucers: diam. 13.5
and 13.6 cm; sugar bowl and cover: h 9.9 cm;
tray: 37.4 x 27.5 cm
Acquired by the 4th Marquess of Hertford by 1865
C396–400

Vase (*vase 'sirènes'*), *c.*1776
Sèvres porcelain manufactory

▲ This vase was possibly designed by Josse-François-Joseph Le
Riche, who worked at the Sèvres factory for almost fifty years, and
gilded by Étienne-Henry Le Guay, another long-serving worker at
the factory and its finest gilder, despite having lost the use of his left
hand in a sword fight in 1745.

Soft-paste porcelain decorated with an overglaze blue ground and gilded;
h 49 cm, w 25.5 cm
Acquired by the 4th Marquess of Hertford by 1865
C333

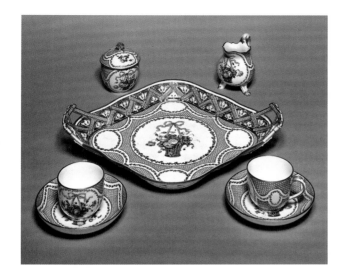

Vase and Cover (*vase 'E de 1780'*), 1781
Sèvres porcelain manufactory

▲ This splendid vase, part of a garniture of three, all decorated with jewelled enamelling, takes the unusual name of its design (possibly by Jacques-François Paris) from a listing made in 1814 of vases *'A de 1780'* to *'E de 1780'*. The scene in the reserve is after Boucher's *Pygmalion and Galatea*, a subject from Ovid's *Metamorphoses*. The garniture was given by Louis XVI to Prince Henry of Prussia, brother of Frederick the Great, when the Prince was on a diplomatic mission to Paris in 1784.

Soft-paste porcelain decorated with an overglaze blue ground, painting, gilding and jewelled enamelling; h 47.5 cm, w 22.9 cm
Acquired by the 4th Marquess of Hertford in 1860
C334

Eighteenth-century France ❧ 197

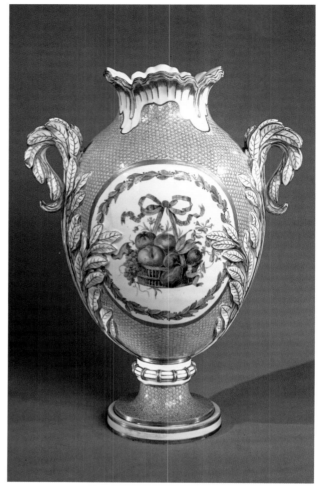

Teapot (*théière 'Calabre'*), 1775
Sèvres porcelain manufactory

▲ The painting is by Louis-Gabriel Chulot, who worked at the
Sèvres factory for an astonishing sixty-three years (1755–1800 and
1805–18), and the gilding is by Jean-Baptiste-Emmanuel Vandé.
A companion cup and saucer and sugar bowl are also in the Wallace
Collection. Teapots were often smaller than one would expect for the
number of cups with which they could be associated, and this was
because a strong brew of tea was diluted in the cup with hot water.

Soft-paste porcelain decorated with a pale-blue *pointillé* ground,
painted and gilded; h 12.1 cm
Acquired by the 4th Marquess of Hertford by 1865
C416

**Covered Mustard Pot and Salt-cellar
(*moutardier* and *salière 'simple'*)**, 1781–3
Sèvres porcelain manufactory

◀ The porcelain components of these
unusual pieces were commissioned from the
Sèvres factory by the goldsmith Jean-Nicolas
Bastin. He specialised in mounting rock
crystal and other materials in cage work of
silver gilt, and he presumably devised these
forms to suit his own overall designs. The
forms are quite different from the factory's
usual mustard pots and salt-cellars for
dinner services, which do not require metal
mounts.

Soft-paste porcelain decorated with a turquoise-blue
ground and gilded; silver-gilt mounts;
mustard pot: h 13.6 cm, w 8.8 cm; salt-cellar: h 5.1 cm,
d 7.9 cm, w 6.5 cm
Acquired by the 4th Marquess of Hertford in 1863
C469-70

Vase (vase 'à feuille de mirte'), 1777
Sèvres porcelain manufactory

◄ This vase was probably painted by Vincent Taillandier and his wife, Geneviève, he being responsible for the flowers and she for the *pointillé* ground. Husband-and-wife partnerships of this kind were not uncommon at Sèvres and in other decorative arts manufactories.

Soft-paste porcelain decorated with a pale-blue *pointillé* ground, painted and gilded; h 31.5 cm, w 23.3 cm
Acquired by the 4th Marquess of Hertford or Sir Richard Wallace by 1872
C296

Ice-cream Cooler (seau 'à glaces'), 1778
Sèvres porcelain manufactory

▼ This piece comes from the great service made for Catherine II of Russia, containing 797 pieces and despatched to Russia in June 1779. It comprised a dinner and dessert service, a tea and coffee service and a biscuit centrepiece for sixty settings, and was one of the most extravagant commissions received by the Sèvres factory in the eighteenth century. The Wallace Collection has four ice-cream coolers and two wine-bottle coolers from the service. They were acquired by the 4th Marquess of Hertford from Lord Lonsdale together with many other pieces after they had been looted from the Winter Palace in St Petersburg during a fire in 1837. The other pieces were returned to Russia by Lord Hertford through the dealer John Webb in 1857. Sorbets and ice creams were a popular feature in the dessert course and they were served in small cups with handles.

Soft-paste porcelain decorated with a turquoise-blue ground, painted and gilded; hard-paste cameo heads on the cover; h 23.7 cm, w 26.2 cm
Acquired by the 4th Marquess of Hertford c.1856–7
C478

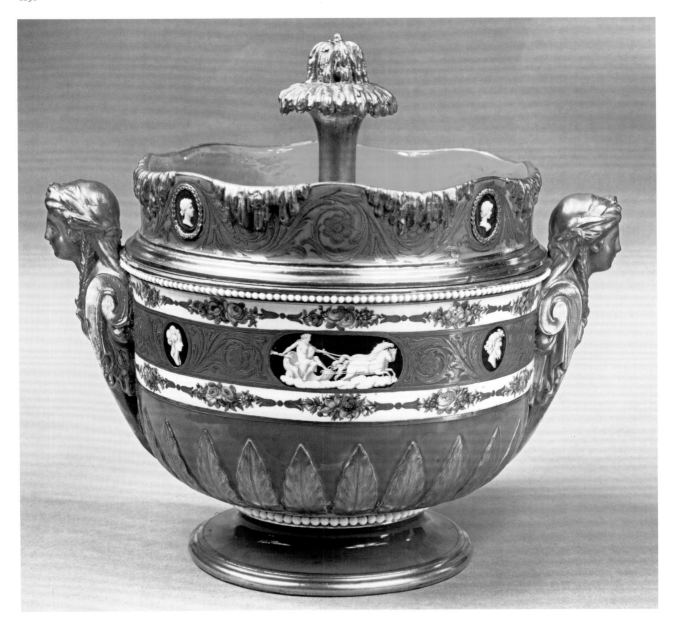

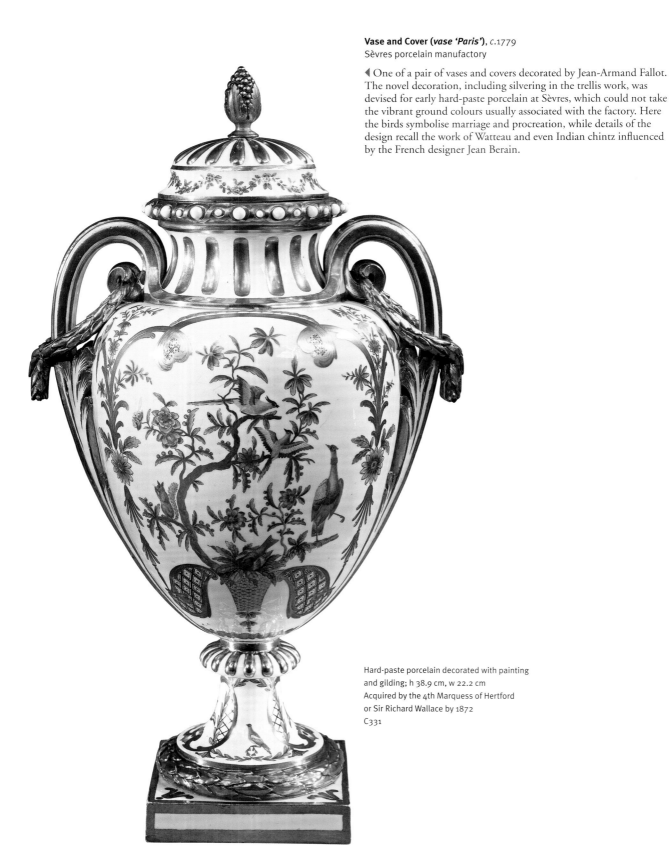

Vase and Cover (*vase 'Paris'*), *c.*1779
Sèvres porcelain manufactory

◀ One of a pair of vases and covers decorated by Jean-Armand Fallot. The novel decoration, including silvering in the trellis work, was devised for early hard-paste porcelain at Sèvres, which could not take the vibrant ground colours usually associated with the factory. Here the birds symbolise marriage and procreation, while details of the design recall the work of Watteau and even Indian chintz influenced by the French designer Jean Berain.

Hard-paste porcelain decorated with painting and gilding; h 38.9 cm, w 22.2 cm
Acquired by the 4th Marquess of Hertford or Sir Richard Wallace by 1872
C331

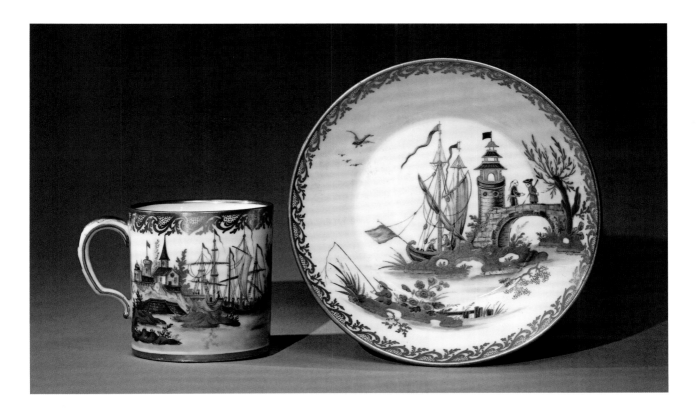

Cup and Saucer, 1779
Sèvres porcelain manufactory

▲ The novel decoration, including gilded outlines to the painted
areas in imitation of Oriental cloisonné work, was devised for early
hard-paste porcelain at Sèvres. Here the decoration by Louis-
François Lécot shows chinoiserie scenes of ships in harbour and the
occasional fisherman or monk in a rocky hermitage. Lécot was a
specialist painter of chinoiseries on hard paste. The cup and saucer
are part of a tea service.

Hard-paste porcelain decorated with painting and gilding;
cup: d 5.8 cm; saucer: diam. 12.4 cm
Probably acquired by the 2nd Marquess of Hertford in 1802
C408–9

Saucer (*soucoupe* for a *gobelet 'litron'*), *c*.1779
Sèvres porcelain manufactory

▶ This remarkable saucer has a very unusual painting in its
reserve. The still life is taken from an engraving of a portrait of
Oliver Cromwell, Lord Protector of England from 1653 until
1658. The matching cup (now lost) had a portrait of Cromwell.
As a regicide and anti-Catholic he was an exceptional choice of
subject for a royal manufactory like Sèvres, and the reason for his
inclusion is unknown. Both cup and saucer were bought from the
factory by Louise-Jeanne de Durfort, duchesse de Mazarin, in
December 1779. The painting is by Nicolas-Pierre Pithou *jeune* and
the gilding by Étienne-Henry Le Guay.

Soft-paste porcelain decorated with an overglaze blue ground,
painted and gilded; diam. 14.8 cm
Probably acquired by the 3rd Marquess of Hertford by 1842
C351

Eighteenth-century France ❧ 201

Armchair (*fauteuil*), *c.*1755 (tapestries) and *c.*1780 (frames)
Tapestries designed by Jean-Baptiste Oudry (1686–1755)
Frames made by Georges Jacob (1739–1814)

◀ This armchair is one of a set of six chairs and two sofas. The chairs were made by the workshop of Jacob, which produced a wide range of furniture in the neoclassical style. The Beauvais tapestries now on all the pieces are not the original covers and date from about twenty-five years earlier than the armchair frames, to which they were probably applied around 1850. Their designs are by Jean-Baptiste Oudry, who, in addition to being the leading animal painter of his time, was director of the Beauvais manufactory. The back of this chair shows a dog raising a pheasant, and the seat shows a parrot and perhaps a guinea pig. The two sofas were made to match the chairs in the nineteenth century, probably in order to display the large Oudry tapestries.

Above:
Walnut and beech; wool and silk tapestries; h 100 cm, w 71 cm, d 59.5 cm
Probably acquired by the 4th Marquess of Hertford by 1870
F185

Below:
Oak, pine and chestnut veneered with hazelwood and rosewood; gilt-bronze mounts; h 85 cm, w 244 cm, d 115 cm
Acquired by the 4th Marquess of Hertford in 1853
F320

Writing-table (*bureau plat*), 1777–8
Southern Netherlandish

▼ One of the most important pieces of furniture to have been produced in Brussels in the latter part of the eighteenth century, this great table was made for Charles-Alexandre, prince of Lorraine (1712–80), governor-general of the Austrian Netherlands from 1744 until his death, for his *salle d'audience* in his palace at Brussels. It was probably executed by Godtfried Weber, one of the *menuisiers*, or skilled wood workers, who also made inlaid floors and marquetry panelling for the palace. The extravagant gilt-bronze mounts, in the form of an interlacing design and large swags, characteristic of early French neoclassicism, may have been produced by Michel Dewez (1742–1804). The table was sketched by the dealer William King in a letter to the 4th Marquess of Hertford and later purchased by the 4th Marquess.

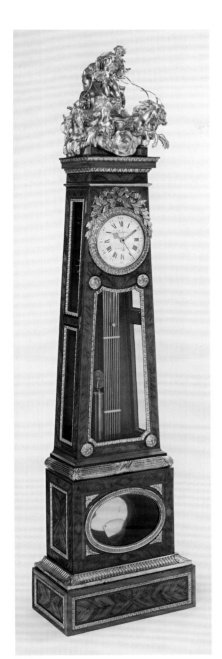

Longcase Clock (*régulateur*), c.1780
Case made by Nicolas Petit (1732–91)
Movement made by Jacques-Joseph Lepaute (master 1775)
Dial enamelled by Elie Barbezat

◀ The gilt-bronze group on the top of this clock shows Apollo in his chariot, whipping his horses into action to gallop across the sky, an illustration of a scene from Ovid's *Metamorphoses*. This motif is a particularly appropriate embellishment for a clock as Apollo was the sun god who rose every morning to bring the day (see also paintings by Poussin and Boucher, pages 100 and 156–7). The clock has a pendulum made up of five steel and four brass rods, which allows it to compensate for changes in atmospheric conditions.

Oak and pine veneered with tulipwood, *satiné*, ebony and box; glass panels; gilt-bronze mounts; h 221.2 cm, w 56.8 cm, d 34.5 cm
Probably acquired by the 4th Marquess of Hertford by 1870
F270

Drop-front Desk (*secrétaire à abattant*), 1780
Jean-Henri Riesener (1734–1806)

▼ Delivered by Riesener on 8 July 1780 for Marie-Antoinette at Versailles, this drop-front writing desk is one of several similar pieces, some stamped by Jean-François Oeben and some by Riesener (who took over Oeben's workshop after his death), all produced between the early 1760s and 1780. The transitional style of the desk, with its elaborate acanthus mounts and iconographical marquetry including the cockerel of France on the drop-front contrasting with the neoclassical male mounts on either side and marquetry urns on the lower doors, indicates that it would have been largely out of date as soon as it was delivered in 1780. Indeed, Marie-Antoinette only kept the piece in her *cabinet intérieur*, or private study, for three years before replacing it with another, more feminine desk (now also in the Wallace Collection, F303).

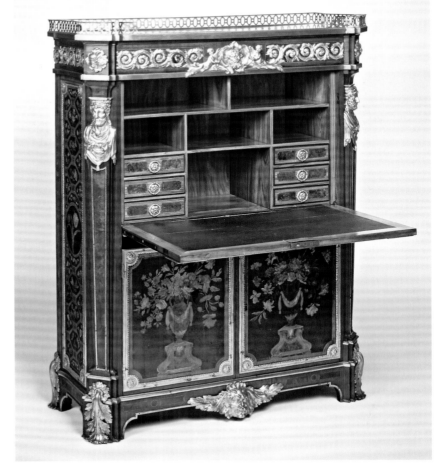

Right:
Oak veneered with sycamore, holly, fruitwood, purple heart and other woods; Carrara marble top; gilt-bronze mounts; h 144 cm, w 112 cm, d 45.5 cm
Acquired by the 4th Marquess of Hertford at an unknown date
F300

Eighteenth-century France ✐ 203

Snuffbox, 1779–80
Adrien-Jean-Maximilien Vachette (1753–1839)

▶ Seventeenth-century Japanese screens and boxes were often cut up in France and mounted on furniture such as secretaires, cabinets and chests of drawers. The small remaining offcuts were considered precious enough to be collected up and sold for setting in goldsmiths' work. This box is one of Vachette's earliest works; he was only registered as a goldsmith in 1779, and became a specialist in mounting lacquer, turtleshell piqué work and hard stone in gold snuffboxes.

Gold and Japanese lacquer;
h 2.6 cm, l 8.6 cm, d 5.4 cm
Acquired by the 4th Marquess of Hertford
or Sir Richard Wallace by 1872
G60

Morning Conversation, c.1780
Niclas Lafrensen (1737–1807)

▼ Miniatures accorded perfectly with the eighteenth-century French love of the intimate, the gallant and the bijou, leading to an expansion of the type of subjects treated. Lafrensen specialised in exquisitely painted miniature gallant and erotic scenes like this vision of two semi-clad beauties chatting during their morning ablutions. The artist pays great attention to the fashionable paraphernalia of dress and interior, adding a frisson of voyeuristic excitement with the vision of the girl using a chamber pot. Intended for the delectation of the connoisseur, such images were often popularised to a wider audience through prints.

Gouache on ivory; diam. 6.8 cm
Acquired at an unknown date
M260

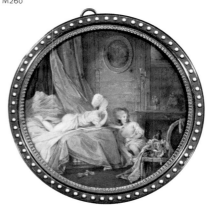

An Unknown Girl, 1780s
Marie-Anne Fragonard, née Gérard (1745–1823)

◀ Long considered to be Fragonard, the painter of this miniature is named as Madame Fragonard on a stipple engraving by Delanaux. In fact many well-known painters' wives appear to have worked as miniaturists, draughtsmen or printmakers in eighteenth-century France. Madame Fragonard specialised in painting sentimental depictions of children, in keeping with the fashions of the time, and her miniatures appeared regularly in sale catalogues from the late 1770s until the 1790s. Her tender evocations of childhood appear to have influenced her husband's art on at least one occasion: Fragonard's *Pierrot* (in the Wallace Collection, P412) follows closely the composition, fluid handling and pastel shades of miniatures by his wife.

Gouache on ivory; 7.1 x 5.3 cm
Acquired at an unknown date
M110

Snuffbox, 1781–3
Paris

▶ Although the goldsmith for this box is unknown, it features six glorious miniatures by Louis-Nicolas van Blarenberghe (1716–94) with views of the château de Romainville, near Paris, and its surrounding park. The miniature on the cover shows Philippe-Henri, marquis de Ségur, the owner of the château, welcoming a young peasant woman who has been chosen to receive a marriage dowry. The other scenes show some of the principal features of the park, where he created a fashionable *anglo-chinois* garden, including a Roman temple (or Rotunda), a Chinese pavilion and bridge, a version of the Medici vase and the tomb of the Marquis's favourite dog, Zizi.

Gold with miniatures in gouache on vellum; h 3.2 cm, l 8.1 cm, d 6.4 cm
Acquired by the 4th Marquess of Hertford in 1863
G62

Mantel Clock (*pendule de cheminée*), 1781
French

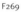 This clock, which has a movement by Jean-Baptiste Lepaute (1727–1801), is based on a design by François-Joseph Bélanger (1744–1818), architect to Louis XV and Louis XVI, who particularly favoured the neo-classical style. The design for the sphinxes on this clock was probably influenced by the antique sculptures of sphinxes in the private collections of Rome, for example at the Villa Albani. Even before Napoleon's Egyptian campaign (1798–1801) there was considerable interest in France in ancient Egyptian art and artefacts. The mounts also feature, at the top, billing doves against a background of swirling clouds and, on the base, six medallions showing the signs of the zodiac.

Gilt bronze on stone base painted to resemble marble; gilt-bronze mounts; h 53 cm, w 56 cm, d 18 cm
Probably acquired by the 4th Marquess of Hertford by 1870
F269

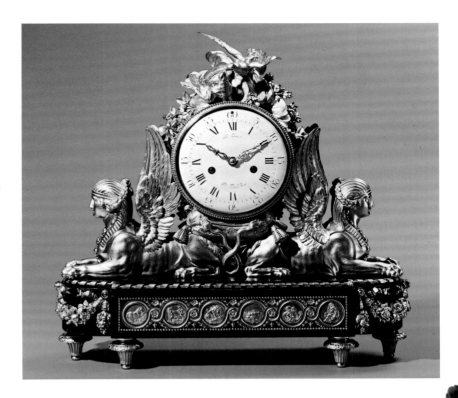

Candlestick (*flambeau*), *c.*1781
Claude-Jean Pitoin (master 1778)

◀ This candlestick, one of a pair of the highest quality, was delivered, together with another matching pair, in 1781 by Pitoin for the Cabinet de la Méridienne of Marie-Antoinette at Versailles. The present location of the other pair is unknown. Both pairs were part of the redecoration and refurbishing of the Cabinet de la Méridienne that was carried out in 1781 during Marie-Antoinette's second pregnancy. The birth of the first dauphin of the reign, Louis (1781–9), is commemorated by the dolphins on this and the matching pair of candlesticks.

Gilt bronze and blue enamel; h 25.4 cm, diam. (base) 12.2 cm
Acquired by the 4th Marquess of Hertford by 1865
F164

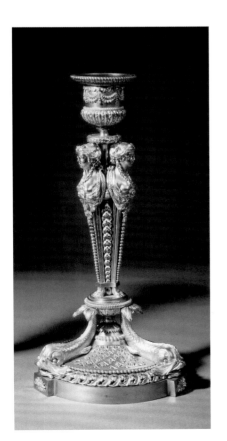

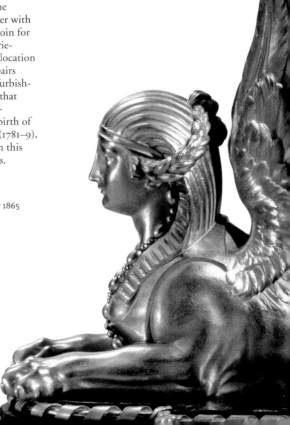

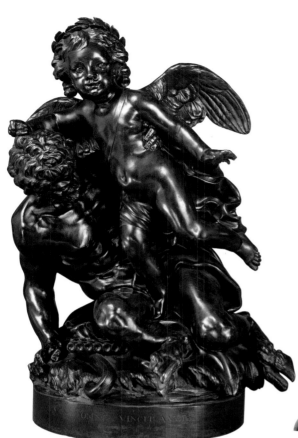

Cupid vanquishing Pan, 1777
Jean-Jacques Caffiéri (1725–92)

◀ Caffiéri was a member of a celebrated family of bronze casters and chasers (see pages 152–3). He also executed marbles and small bronzes for private clients. This bronze, with its pendant *Friendship surprised by Love* (Toledo Museum of Art, Ohio), was commissioned by the abbé Terray, a former finance minister to Louis XV and a lavish patron of the arts. A closely related terracotta had been exhibited by Caffiéri at the Paris Salon of 1771. In the catalogue Caffiéri explained that the subject (*Love conquers All*) is represented by Pan as the god of shepherds and nature.

Bronze; h 42.5 cm
Acquired by the 4th Marquess of Hertford in 1851
S219

Vase: *The Followers of Thetis*, 18th century
French

▶ With another vase in the Wallace Collection (s167), this forms a pair depicting the Triumph of Thetis, a sea nymph who was the mother of Achilles. She is shown accompanied by her followers, fellow sea nymphs (Nereids), Tritons, marine centaurs, a marine goat (capricorn), dolphins and little children. The vases have similarities in composition to two much larger marble vases completed by François Girardon (1628–1715) in 1683 for the gardens at Versailles. Probably cast after the sculptor's death, they may well preserve the compositions of Girardon's original wax models for the marble vases. They are notable for the freshness and vivacity of their handling, which contrasts with the heavy formality of much French sculpture of this period.

Bronze; h 44.4 cm, diam. (maximum) 35.3 cm
Acquired by the 4th Marquess of Hertford in 1860
S168

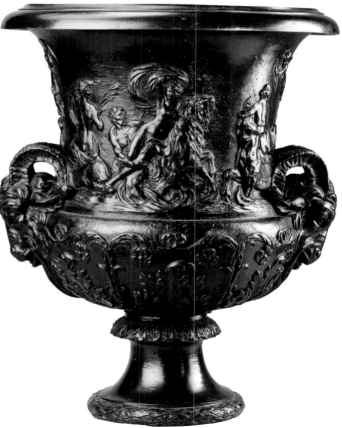

Madame de Sérilly, 1782
Jean-Antoine Houdon (1741–1828)

▶ Anne-Marie-Louise de Pange (1762–99) was married to Antoine Mégret de Sérilly, treasurer-general in the war ministry, and bore him four children. At the time this bust was sculpted they lived in a splendid house in the fashionable Marais district of Paris. In 1794, during the height of the Revolution, the couple were accused of plotting to assist Madame Elisabeth, a sister of Louis XV. Antoine was executed, and Anne-Marie was spared only because she claimed to be pregnant. After two further marriages she died in 1799 at the age of thirty-six. Houdon, the leading French sculptor of his time, was renowned for his portrait busts. This superb example was exhibited at the Paris Salon of 1783.

Marble; h 62 cm
Acquired by the 4th Marquess of Hertford in 1865
S26

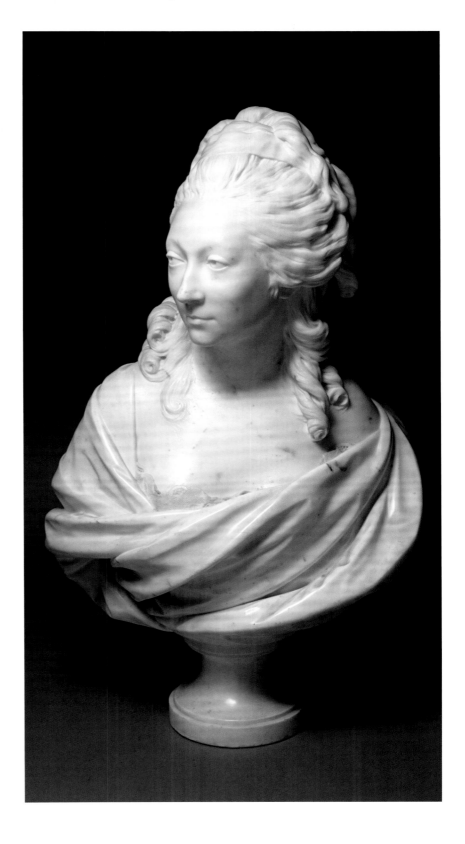

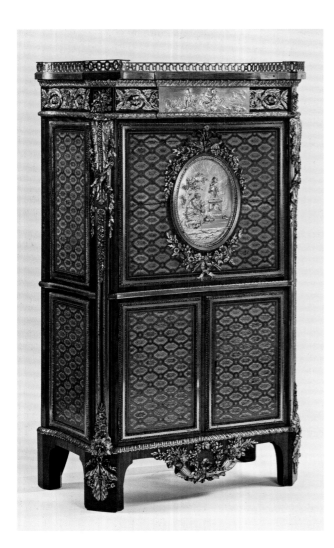

Drop-front Desk (*secrétaire à abattant*), 1783
Jean-Henri Riesener (1734–1806)

◀ This secretaire was supplied by Riesener on 8 March 1783 for Marie-Antoinette's use at the Petit Trianon, Versailles. Most of the archives of the Garde-Meuble de la Reine, one of the organisations that supplied the Queen with furniture for her apartments, were lost during the Revolution, so we do not know for which room at the Petit Trianon this desk was made. The veneer, with a fret-pattern marquetry of satiné enclosing lozenges of holly inlaid with waterlilies of stained sycamore or berberis, is characteristic of Riesener's workshop. This design shows the influence of Japanese lacquer, which was popular at this time. Originally, the marquetry would have been a much richer colour, but this has faded with time. The delicate gilt-bronze mounts, depicting flowers and ribbons, would have echoed the flowers grown by the Queen in her garden at the Petit Trianon.

Oak veneered with *satiné*, holly, sycamore, ebony, box, purple heart and other woods; Carrara marble top; gilt-bronze mounts; h 139.6 cm, w 80.5 cm, d 42 cm
Acquired by the 4th Marquess of Hertford in 1868
F302

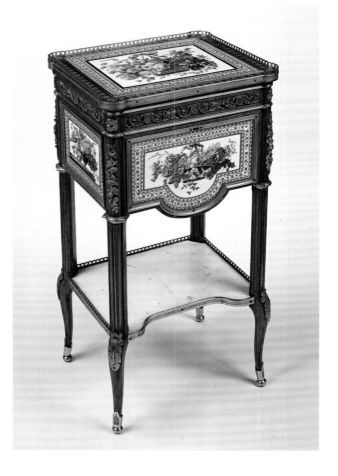

Writing- and Reading-table (*table en secrétaire*), 1783–4
Martin Carlin (*c*.1730–85)

▶ This table, characteristic of the 1780s in its ingenious mechanical fittings, combines a writing and a reading table. Concealed within are two drawers, a candle stand at each side and a mechanism allowing the entire top to be raised and tilted to form a book-rest. It was made by Carlin almost certainly for the dealer Dominique Daguerre. As Carlin died in 1785 this must have been one of his last pieces. The five Sèvres-porcelain plaques bear the date letters for 1783, and have been attributed to Edme-François Bouilliat *père* (1739/40–1810).

Oak veneered with tulipwood; soft-paste Sèvres-porcelain plaques; gilt-bronze mounts; h 79 cm, w 40.7 cm, d 32.8 cm
Acquired by the 4th Marquess of Hertford by 1869
F327

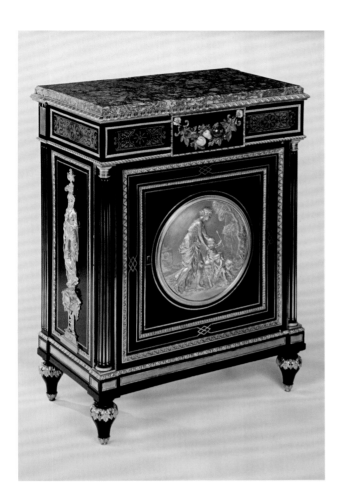

Cabinet (*cabinet* or *meuble à hauteur d'appui*), *c.*1785
Attributed to Adam Weisweiler (1744–1820)

◀ One of a pair, the cabinet is an example of the kind of luxury furniture supplied by Weisweiler through the *marchand-mercier*, or dealer, Dominique Daguerre. It incorporates seventeenth-century Boulle marquetry and exquisite *pietra-dure* panels depicting fruit and flower garlands. *Pietra dura* was particularly highly prized and often reused on furniture. Gilt-bronze mounts of caryatids often appear on such cabinets by Weisweiler, either in the form of flatter mounts, as on the sides of the cabinet here, or as three-dimensional columns on both sides of the front. The circular gilt-bronze plaque depicts a nymph helping an infant, who is carrying a thyrsus, or staff of Bacchus, to ride a satyr – a light-hearted classical scene.

Oak veneered with ebony inlaid with brass stringings and *contre-partie* Boulle marquetry of turtleshell, brass and pewter; marble top; *pietra-dure* plaques; gilt-bronze mounts; h 94.5 cm, w 70 cm, d 40.2 cm
Probably acquired by the 3rd Marquess of Hertford in 1816
F395

Mantel Clock (*pendule de cheminée*), *c.*1785
French

▶ This clock, with its winged infants representing Astronomy and Geometry, is related to another with a similar design (with figures representing the Arts), which was deposited with the clockmaker Robert Robin (1742–99) by Marie-Antoinette after the outbreak of the French Revolution. Robin made the movement of the Wallace Collection's clock. A particularly attractive feature of this clock is the enamelled band painted with four grisaille panels of the Seasons and four profile heads set against panels of simulated lapis lazuli.

Gilt and enamelled bronze; h 60.5 cm, w 39 cm, d 22 cm
Probably acquired by the 4th Marquess of Hertford by 1870
F263

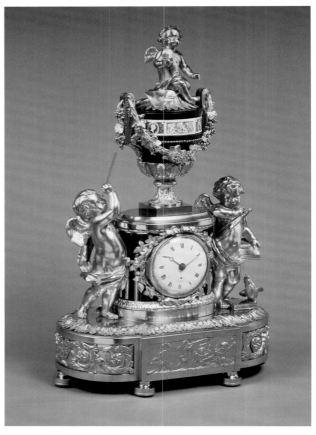

Chair (*chaise à carreau*), *c.*1786
Made by Jean-Baptiste Boulard (*c.*1725–89)
Carved by either Nicolas-François Vallois (1738–88) or Louis Charny (active 1756–86) under the direction of Jean Hauré (active 1774–91)
Gilded by Louis Chatard (active 1773–89)
Upholstered by Claude-François Capin (active 1763–92)

◀ This chair is one of six in the Wallace Collection, ordered on 12 August 1786 as part of a set of thirty-six for the *Salon des Jeux du Roi*, a room used for after-dinner card games at the palace of Fontainebleau. These chairs, with their comparatively short legs and separate cushions, were meant for use by ladies. Reupholstered with Beauvais tapestries in the nineteenth century, the chairs were conserved using archival evidence in 1982. New silk, copying the blue, white and grey lampas, or woven silk fabric, decorated with river gods and sea horses, originally supplied by Louis Reboul, Fontebrune et Cie of Lyons, was manufactured and used to cover the chairs.

Carved and gilt beechwood; silk lampas; h 93.4 cm, w 57.4 cm, d 50.6 cm
Acquired by the 4th Marquess of Hertford at an unknown date
F233

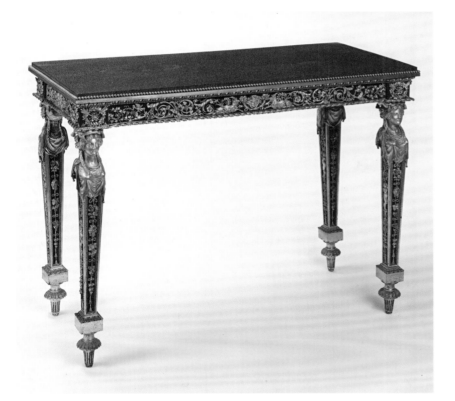

Table (*table sur son pied*), 1785–7
French

◀ One of a pair, this table was almost certainly made under the direction of the dealer Dominique Daguerre. The friezes were probably supplied by the gilder François Rémond (1747–1812), and the piece may have been assembled by Adam Weisweiler (1744–1820). The delicate frieze mounts, featuring masks of Bacchus, cornucopias, recumbent goats and acanthus and vine scrolls, as well as the Grecian female bust caryatids at the top of each table leg, are typical neoclassical motifs. A commode delivered by Daguerre for the *cabinet*, or study, of Louis XVI at Saint-Cloud in October 1788 has similar frieze mounts.

Painted steel and gilt bronze over oak frame; porphyry veneered on to stone; h 82 cm, w 113.2 cm, d 51.7 cm
Acquired by Sir Richard Wallace in 1871
F317

Toilet Table (*table de toilette* or *table à la Pompadour*), 1788–90
Bernard Molitor (1755–1833)

▶ This elegant table and a similar one (now in the Huntington Museum, California), which is stamped by Molitor, form a pair. The table top can be slid back to reveal three compartments. The central compartment is now missing its hinged lid, which would have had a toilet mirror on the back. The Wallace Collection and Huntington tables were described in 1796 as *tables à la Pompadour*, which implies that, with their beautiful but elaborate marquetry, they were already thought old-fashioned. The *trompe-l'œil* marquetry on the top shows a box, its lid removed slightly to reveal a shell and some sprigs of foliage. Inside the desk, the unfaded, satinwood, lozenge-shaped veneer of the side lids of the drawer has retained its pearly-yellow colour. Such veneer was popular at this time and probably imitated the mother-of-pearl furniture made by Riesener for Marie-Antoinette at the palace of Fontainebleau.

Oak veneered with satinwood, purple heart, ebony, sycamore, holly and box; gilt-bronze mounts; h 70 cm, w 81 cm, d 43.5 cm
Acquired by the 4th Marquess of Hertford by 1867
F321

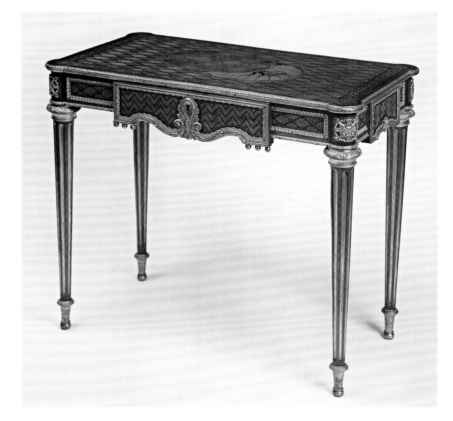

Bacchante with Tambourine (left), and
Bacchante with Panpipes (right), probably 1790s
French

▼ Bacchantes were the female followers of Bacchus, the god of wine. These bronzes, on their green Genoa, or *verde antico*, marble pedestals, are mirrored pairs that combine similar poses with different attributes and facial expressions. They were no doubt intended to be placed on corner cupboards or chimneypieces; the same models are usually found as elements of three- to six-light candelabra. They have been attributed to Joseph-Charles Marin (1759–1834), a pupil of the more famous Claude Michel, called Clodion (1738–1814).

Bronze and gilt bronze; h (excluding pedestal) 46 cm
Acquired by the 4th Marquess of Hertford or Sir Richard Wallace
at an unknown date
S215 and S216

The Fountain of Love, *c*.1785
Jean-Honoré Fragonard (1732–1806)

▶ A new mood of gravity and romantic passion enters Fragonard's art in *The Fountain of Love*. Two lovers are shown hastening to the fountain; 'both aflame, eyes shining, they direct their thirst and the desire of their lips towards the enchanted cup', as the Goncourts memorably described. While referring to contemporary fashions for classicism in the severe profiles of the protagonists, and to the fine technique of certain seventeenth-century Dutch masters, Fragonard sets the scene in a dream-like setting of dark shadows and monochrome colouring, which prefigures the melancholy storm of full-blown Romanticism.

Oil on canvas; 63.5 x 50.7 cm
Acquired by the 4th Marquess of Hertford in 1870
P394

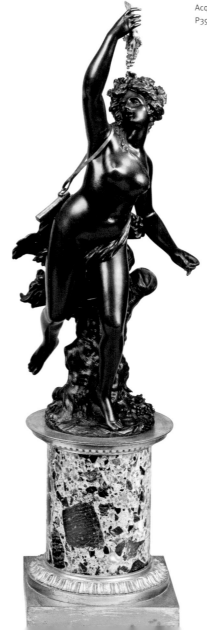

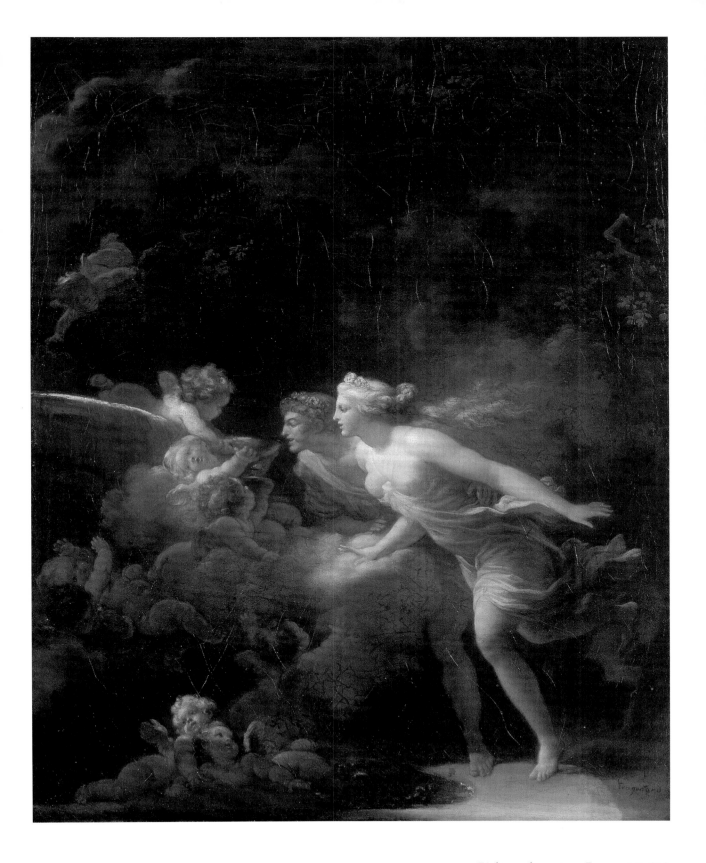

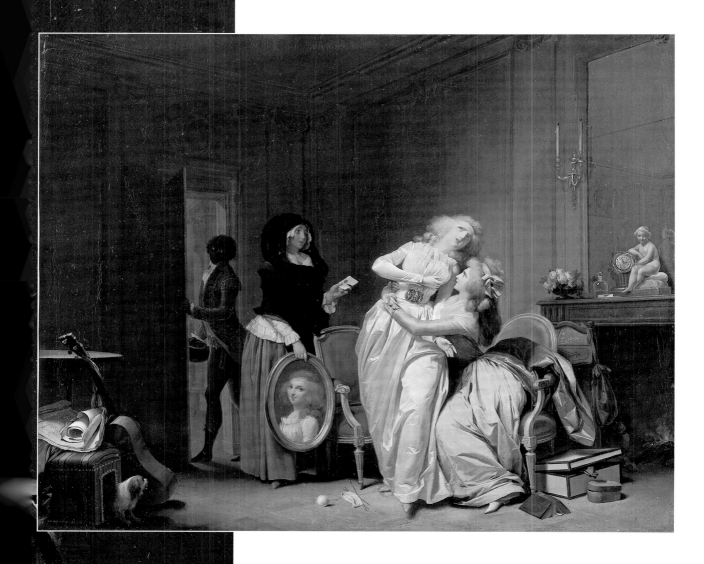

The Sorrows of Love, 1790
Louis-Léopold Boilly (1761–1845)

🔺 A lady, supported by her confidante, mourns the end of an affair, as a servant returns her portrait and unopened love letter. The subject is typical of the sentimental, bourgeois genre scenes with which the artist first made his reputation. A label attached to its stretcher reveals that it formed part of an important early commission of gallant-genre scenes painted for the Avignon collector, Antoine de Calvet de Lapalun. Boilly was noted for his meticulous technique, and *The Sorrows of Love*, in particular, is remarkable for the artist's masterly use of colour in the rendering of the shot silks of the costumes.

Oil on canvas; 45 x 55 cm
Acquired by the 4th Marquess of Hertford in 1863
P479

Madame Perregaux, 1789
Élisabeth-Louise Vigée Le Brun (1755–1842)

▶ Adélaïde de Praël (1758–94) married the banker Jean-Frédéric Perregaux in 1779. Madame Perregaux's husband was both a notable art collector and banker to the Le Bruns, later numbering the 3rd Marquess of Hertford among his clients. Madame Perregaux's portrait, painted on the eve of the French Revolution, is typical of the glamorous, flattering portrayals of female sitters on which Vigée Le Brun's reputation chiefly rests. The artist seems to have been particularly pleased with the work as she wrote to the sitter: 'The portrait of Madame Perregaux is the most charming of all because of its likeness.'

Oil on oak panel; 99.6 x 78.5 cm
Acquired by the 4th Marquess of Hertford
in or after 1862
P457

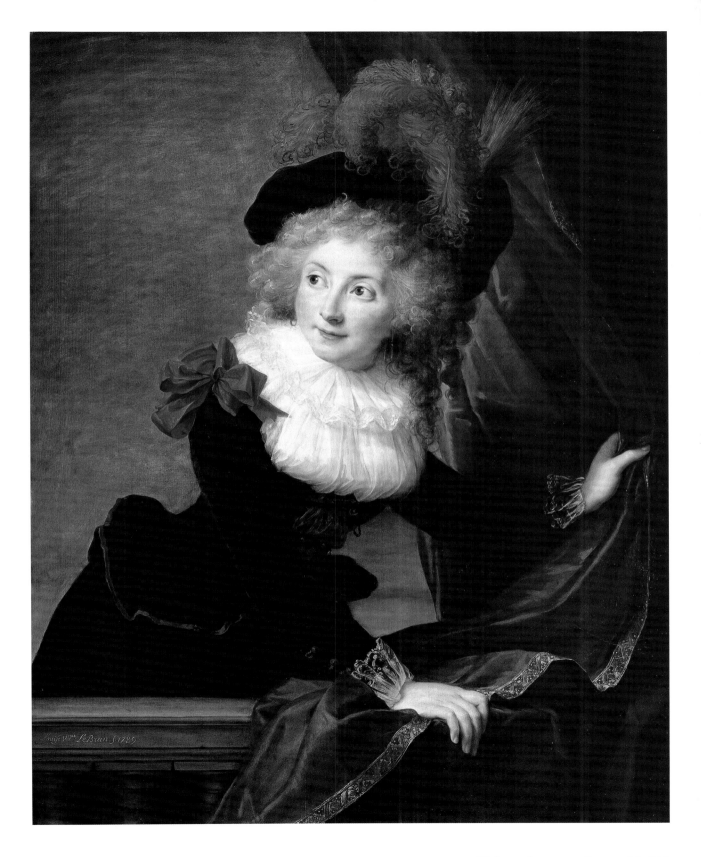

Louise Vigée LeBrun f. 1789

Innocence, early 1790s
Jean-Baptiste Greuze (1725–1805)

▲ In addition to its religious connotations, the lamb in Western art is seen as a symbol of innocence, gentleness, patience and humility. By including a lamb in this picture, Greuze thus invests his beautiful young subject with these attributes. Such depictions of young women cuddling pets, implying their ability to feel emotion, relate to the eighteenth-century cult of *sensibilité* fostered by Rousseau and others. Greuze's heroine thus appears possessed of the heady combination of sexual innocence and emotional depth. The painting later attained notoriety because of the high price (100,200 francs, about £4,008) paid for it by the 4th Marquess of Hertford.

Oil on mahogany panel; 63 x 53 cm (oval)
Acquired by the 4th Marquess of Hertford in 1865
P384

Georgiana, Duchess of Devonshire, with Lady Elizabeth Foster, 1791
Jean-Urbain Guérin (1761–1836)

▶ Guérin moved to Paris in 1785, making his reputation painting miniatures in an austere, classical style much influenced by the recently excavated fresco paintings of Herculaneum and Pompeii. Here he depicts his sitters, etched in profile against a dark ground, wearing classically inspired dress in contrast to their fashionably curled hair. Guérin recorded the sitting at Passy for the Duchess of Devonshire (1757–1806, right) and her close friend, Lady Elizabeth Foster (1758–1824), in his journal on 12 November 1791. Soon afterwards he fled the Revolution, returning to Paris at the beginning of the Consulate, when he became a member of Isabey's studio.

Gouache on ivory; 9.4 x 7 cm (oval)
Acquired at an unknown date
M177

Marguerite Gérard, 1793
François Dumont (1751–1831)

◀ Dumont, who became an associate member of the Royal Academy in 1788 and a regular exhibitor at the Paris Salon from 1789 until 1827, was the most successful miniaturist in Paris following the death of Peter Adolf Hall. This miniature, typical of Dumont's most brilliant period, depicts the painter Marguerite Gérard (1761–1837), sister of painter Marie-Anne Fragonard and pupil of Fragonard himself. The restricted palette and relaxed pose of the sitter in front of a scumbled background reflect recent developments in contemporary portraiture by Jacques-Louis David and Vigée Le Brun.

Gouache on ivory; 16.2 x 11.8 cm
Acquired at an unknown date
M101

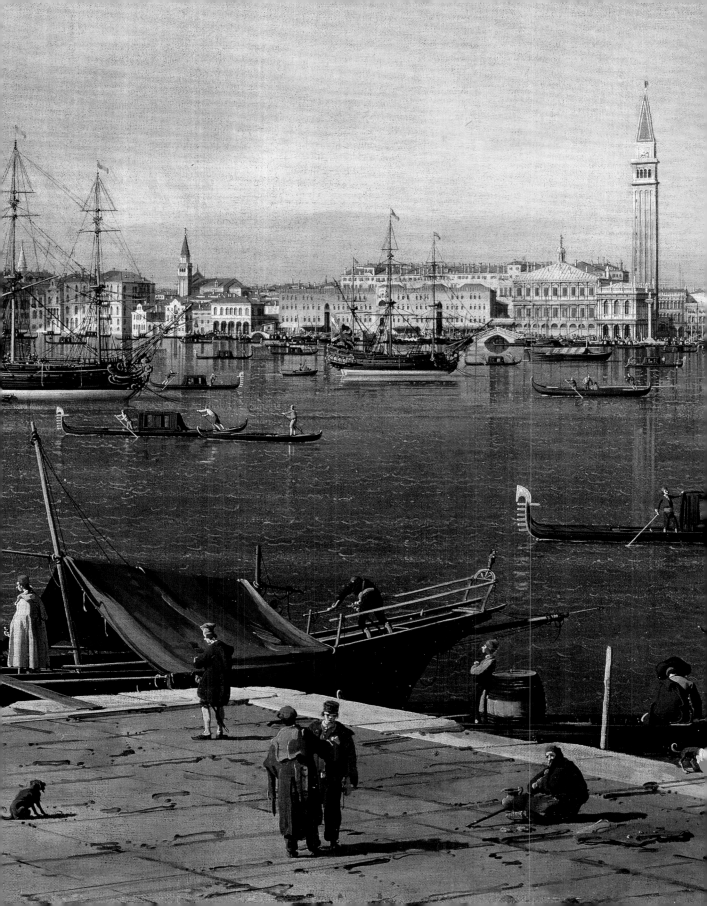

Eighteenth-century Italy and England

Although by far the greatest contributions to the Wallace Collection were made by the 3rd and 4th Marquesses of Hertford and Sir Richard Wallace, some very fine works of art were also acquired by their ancestors, the 1st and 2nd Marquesses. These mainly consist of eighteenth-century Italian and English paintings. Both men acquired paintings by Sir Joshua Reynolds (including two portraits of his daughters, commissioned from the artist by the 1st Marquess), and from the Prince of Wales the 2nd Marquess received an outstanding portrait of his friend Mrs Mary Robinson ('Perdita') by Reynolds's great rival, Thomas Gainsborough. It was also the 1st Marquess who began the collection of eighteenth-century Venetian pictures with his purchase of six works by Canaletto and his studio. The 1st Marquess had been on the Grand Tour between 1738 and 1739, and no doubt he bought these as souvenirs of his time in Italy, like so many others of his class and generation.

The 4th Marquess, for whom the artist was an Old Master rather than a contemporary, added ten more paintings attributed to Canaletto to those he inherited from his forebear, and he displayed them together in a Canaletto Room at Hertford House in a manner much favoured by English collectors. Perhaps more characteristic of Continental taste, however, was his purchase of nine Venetian views by Francesco Guardi, whose light and capricious style was perhaps more admired in mid-nineteenth-century Paris than in London. (It is clear that the 4th Marquess was in Rome in 1845, but very little is known about this or any other possible visits to Italy; although it is probable he took the opportunity to visit the city, there is no evidence that he ever went to Venice.) It was also the 4th Marquess who added such outstanding eighteenth-century English portraits as Reynolds's *Miss Jane Bowles* and Gainsborough's *Miss Haverfield*. In the mid-nineteenth century, paintings by these artists remained highly fashionable, although prices had not yet reached the astronomical levels of fifty years later. ✇

Opposite (detail):
***Venice: the Bacino di San Marco from San Giorgio Maggiore**, c.1735–44
Canaletto (1697–1768)
See page 220

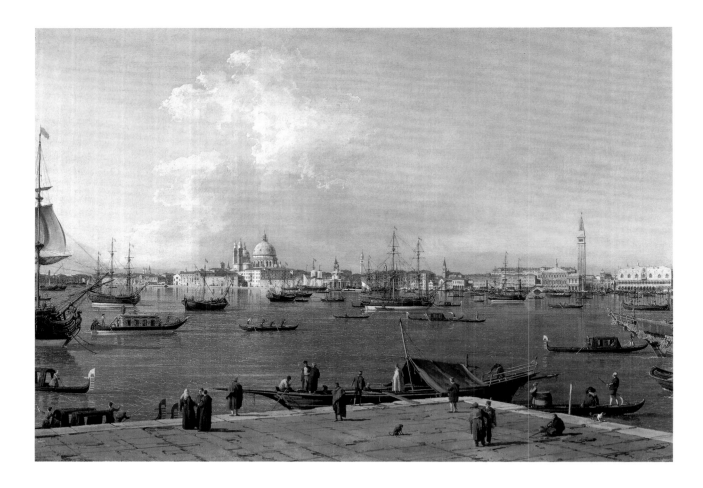

**Venice: the Bacino di San Marco from San
Giorgio Maggiore**, c.1735–44
Canaletto (1697–1768)

▲ One of a pair of unusually large views
which depict the Bacino di San Marco from
opposing vantage points. In this painting the
viewer is placed on the steps of the church
of San Giorgio Maggiore looking across the
Bacino di San Marco towards the Canale
della Giudecca on the left, with the opening
of the Grand Canal in the centre of the
canvas, and the Campanile (bell tower), the
Piazzetta and the Doge's Palace on the right.
It is an attractive, clearly identifiable view
of a type calculated to appeal to the Grand
Tourist, with picturesque elements of local
colour reinforcing the idea of Venice as an
exciting cosmopolitan centre.

Oil on canvas; 129.7 x 188.9 cm
Acquired by the 1st Marquess of Hertford
at an unknown date
P497

See details on pages 218–9

**Capriccio with the Courtyard of the Doge's
Palace**, probably 1770s
Francesco Guardi (1712–93)

▶ A typical Guardi capriccio, whose appeal
lies in its scintillating brushwork and its
combination of recognisable elements of a
real view and imaginative additions or
distortions calculated to surprise and charm
the viewer. Probably painted in the 1770s,
the view includes the courtyard of the
Doge's Palace with the Giant's Staircase on
the right and the Foscari Arch on the left.
The courtyard has been distorted, appearing
much shallower than in reality, and includes
a fanciful façade beyond the staircase and a
statue of Minerva in place of Sansovino's
Neptune and Mars on the staircase.

Oil on canvas; 38.6 x 28.9 cm
Acquired for the 4th Marquess of Hertford in 1859
P647

Venice: the Dogana with the Giudecca, *c.*1770
Francesco Guardi (1712–93)

▶ The view looks across the mouth of the Grand Canal to the Dogana (custom house) on the right, with the island of the Giudecca beyond. Painted over an abandoned sketch copying a view by Canaletto, Guardi seems to have decided to distance his work from that of his predecessor by painting a more generalised view with more scope for invention. With its palette of intense turquoise blues, dashes of reds and yellows, tremulous lines and taut, detailed brushwork, the picture clearly demonstrates how Guardi imparted a new sense of excitement, movement and atmosphere to the Venetian view.

Oil on canvas; 68.2 x 91.3 cm made up to
70.5 x 93.5 cm
Acquired by the 4th Marquess of Hertford in 1865
P494

Cupid and Psyche, 1732
Filippo della Valle (1697–1768)

▶ This sculpture bears a false signature of the French sculptor Claude-Augustin Cayot (1677–1722) and the date 1706, but was recently identified as being in fact an important work by the Florentine sculptor Filippo della Valle. In 1732 della Valle dedicated an engraving to Francesco Gaburri, identifying the sculpture as his own work. Why and when it acquired Cayot's 'signature' is unknown, but a French identity probably would have assisted its sale in Paris to either the 4th Marquess of Hertford or Sir Richard Wallace. Terracotta and porcelain versions of the sculpture are known. Although adult lovers in the original tale, in art Cupid and Psyche are frequently depicted as children.

Marble; h 83.8 cm
Acquired by the 4th Marquess of Hertford or Sir Richard Wallace
at an unknown date
S22

Pier Table, c.1770
Italian

▼ This table, one of a pair, was almost certainly made in Rome, probably not long before being bought by the 1st Marquess of Buckingham for Stowe House in 1774. Although with their ceremonial ox skulls (bucrania) and classical reliefs they are self-consciously neoclassical, the arched mouldings near the tops of their legs and the acanthus leaves near the bottom are reminiscent of Roman Baroque art. They were bought in Rome by the 1st Marquess of Buckingham and may well be products of a workshop specialising in furniture for wealthy 'milordi' on the Grand Tour.

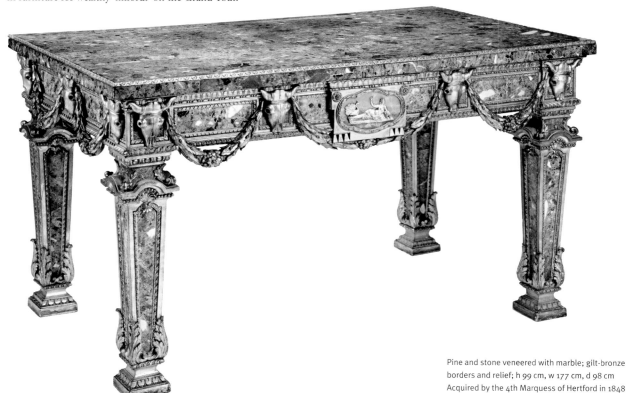

Pine and stone veneered with marble; gilt-bronze borders and relief; h 99 cm, w 177 cm, d 98 cm
Acquired by the 4th Marquess of Hertford in 1848
F514

Inkstand, mid-18th century
Gennaro Sarao (active *c*.1730–72)

▼ This inkstand, with accompanying pots, bell and saucer or sand pot, was made in Naples in a technique known as piqué work. Involving inlaying tortoiseshell with gold or silver, it was first developed in Naples at the end of the sixteenth century, and was later adopted in Paris and London, although Naples long remained the centre of its production. This inkstand is signed (*Sarao Fecit Neapoli*) by Sarao, one of the leading craftsmen in the technique, who worked for Carlo III of Naples and his wife, Maria Amalia. Notable collections of piqué work were assembled in the nineteenth century by the Rothschild family.

Tortoiseshell inlaid with gold; h 10.1 cm,
w 24.8 cm, d 22.9 cm
Acquired at an unknown date
XXIIIA35

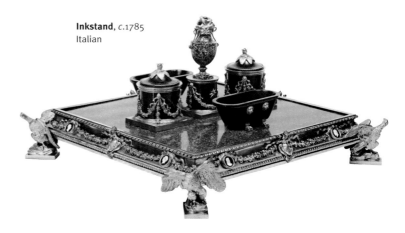

Inkstand, *c*.1785
Italian

▲ This splendid inkstand was almost certainly made in the Valadier workshop in the Via del Babuino, Rome, for Pope Pius VI, who had visited the workshop in 1779. The five containers consist of a central pen holder in the shape of a vase of serpentine marble supported on a pedestal, a sand shaker and inkwell, both in the form of cylindrical pedestals, and two sarcophagus-shaped containers supported on lion-paw feet. The gilt-bronze frame of the stand is decorated with eagles and glass-paste cameos of classical male heads, including Homer, Socrates and Julius Caesar. The accomplished neoclassical style suggests that it was probably made after the death of Luigi Valadier (1726–85), and it has been attributed to the period when the workshop was being directed by Valadier's son, the architect Giuseppe Valadier (1762–1839).

Gilt bronze and porphyry with containers of serpentine; parcel-gilt silver mounts with the arms of Pius VI; glass-paste cameos; h 26.5 cm, w 48.5 cm, d 46.8 cm
Probably acquired by Sir Richard Wallace in 1872
F288

Charles I of England, 1759
Louis-François Roubiliac (1702–62)

▶ This is a free interpretation by Roubiliac of the famous sculpted bust of Charles I (1600–49) by the great Italian sculptor Bernini, destroyed during the fire at Whitehall Palace in 1697. Roubiliac's bust was commissioned by George Selwyn for his house at Matson, Gloucestershire, and formed part of a group of historical portraits probably given by him to his adopted daughter the 3rd Marchioness of Hertford (from whom it passed to her husband). It once had a pedestal inscribed 'King Charles came to Matson with his two sons, 10 August 1643', which presumably explains the commission.

Marble; h 71 cm
Acquired by the 3rd Marquess of Hertford at an unknown date
S23

Miss Nelly O'Brien, c.1762–4
Joshua Reynolds (1723–92)

◀ Nelly O'Brien (died 1768), well-known beauty and courtesan, was a friend of Reynolds, who used her as a model for his 'fancy pictures' and painted her portrait on several occasions. The present picture was painted during the period when Miss O'Brien was enjoying the protection of the 3rd Viscount Bolingbroke, to whom she bore a son in 1764. The artist demonstrates great ability in depicting the different textures and delicate colour harmonies of the sitter's costume, as well as the luminous effects of shadow and reflected light on her face and bosom. The painting was much admired by contemporaries and frequently engraved.

Oil on canvas; 126.3 x 101 cm
Acquired by the 2nd Marquess of Hertford in 1810
P38

Miss Jane Bowles, 1775–6
Joshua Reynolds (1723–92)

▶ Jane Bowles (1772–1812) was the eldest child of Oldfield Bowles of North Aston, an amateur painter of some distinction. When deciding which painter to employ to paint his daughter, Bowles invited Reynolds to dinner to see how he got on with his potential subject. According to Reynolds's nineteenth-century biographer, C. R. Leslie, 'The little girl was placed next to Sir Joshua at the dessert, where he amused her so much with stories and tricks that she thought him the most charming man in the world … The next day she was delighted to be taken to his house, where she sat down with a face full of glee, the expression of which he caught at once and never lost.'

Oil on canvas; 91 x 70.9 cm
Acquired by the 4th Marquess of Hertford in 1850
P36

Miss Haverfield, early 1780s
Thomas Gainsborough (1727–88)

◀ Elizabeth Anne Haverfield (1776–1817) was the daughter of the superintendent gardener of Kew, John Haverfield of Haverfield Lodge. Her portrait is a fine example of Gainsborough's late style. The attention of the viewer is attracted by the spontaneous, twisting pose of the sitter set against an evocative, fluid landscape. Gainsborough's lively but objective portrayal of Miss Haverfield may be contrasted with Reynolds's more overtly sentimental portraits of children, as seen in *Miss Jane Bowles* (above). The picture remained at Haverfield Lodge until 1850.

Oil on canvas; 126.2 x 101 cm
Acquired by the 4th Marquess of Hertford in 1859
P44

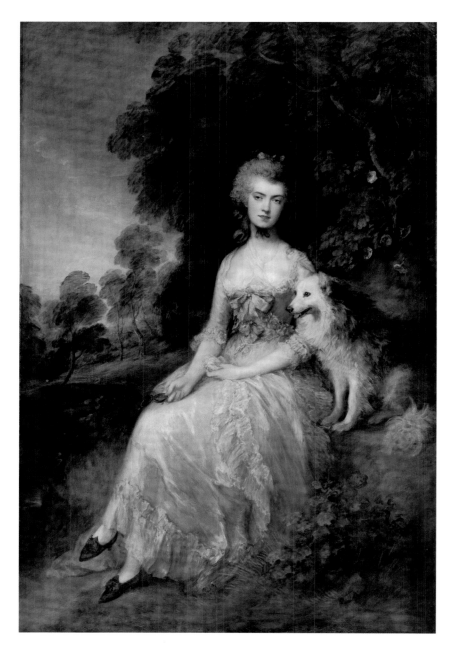

Mrs Mary Robinson ('Perdita'), 1781
Thomas Gainsborough (1727–88)

◀ The seventeen-year-old Prince of Wales (later George IV) became infatuated with Mrs Robinson (1758–1800) in 1779 on seeing her as Perdita in *The Winter's Tale* by Shakespeare at the Drury Lane Theatre. 'Perdita', as she was thereafter nicknamed, became his first mistress. Towards the end of 1780 the Prince abandoned her for a rival, and she spent the following eight months struggling to persuade him to honour his obligations. Following a financial settlement, relations between the former lovers again became cordial and the Prince commissioned the present portrait. Gainsborough's bravura handling and the marriage of pose and landscape impart a characteristic poetic dimension to the picture.

Oil on canvas; 233.7 x 153 cm
Presented to the 2nd Marquess of Hertford by the Prince Regent in 1818
P42

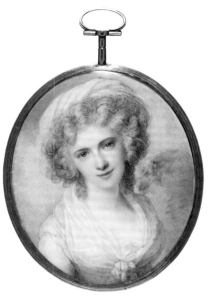

Mrs Fitzherbert, c.1790
Richard Cosway (1742–1821)

▶ Cosway was the most fashionable miniaturist of late eighteenth-century London. Styling himself First Painter to His Highness the Prince of Wales from about 1786, Cosway gained royal favour by painting a miniature of Mrs Fitzherbert. Born Maria Smythe (1756–1837), Mrs Fitzherbert married the Prince in secret in 1785, but the marriage was illegal on the grounds of her Roman Catholic faith. The couple separated in 1803, but the Prince continued to wear a miniature of his lover by Cosway, which he insisted on taking to the grave. The Wallace Collection's miniature demonstrates how Cosway aimed to invest his portraits with great luminosity and vivacity through a light palette and the fluid use of gouache on ivory.

Gouache on ivory; 7.2 x 5.9 cm (oval)
Acquired at an unknown date
M87

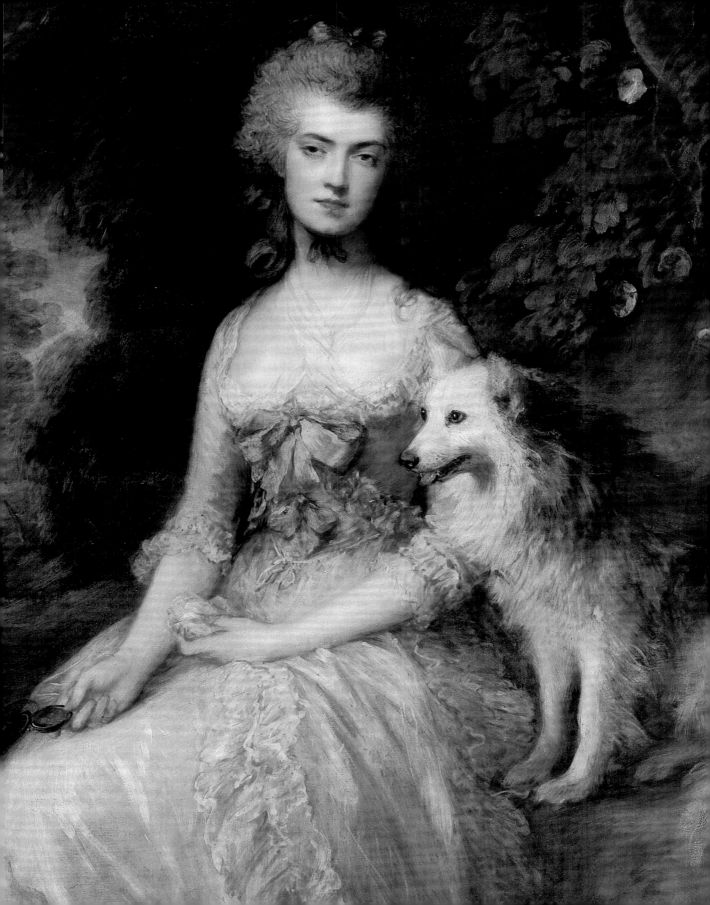

The Nineteenth Century

Both the 4th Marquess of Hertford and Sir Richard Wallace largely confined their collecting of nineteenth-century works of art to paintings and miniatures. Nevertheless, the 4th Marquess also acquired some important nineteenth-century sculptures, such as the busts by Cordier, and some fine European and Oriental guns and edged weapons (see pages 88–93). His copies after major eighteenth-century pieces of furniture are also outstanding works of craftsmanship in their own right (see page 251).

His taste in nineteenth-century pictures was essentially that of other wealthy collectors in the Second Empire Paris of Napoleon III (1852–70). Deeply marked by the Romanticism of his youth, he favoured richly coloured scenes from history and literature, and landscapes featuring pleasant, rather than sublime, countryside. Although he bought works by Lawrence, Landseer and Turner, it was Bonington, another Englishman domiciled in France, who was his favourite among English artists. The paintings of the most fashionable French artists he collected, such as Delaroche, Scheffer and Meissonier, were just as expensive as many of his greatest Old Masters. For example, he paid 80,200 francs (about £3,208) for Delaroche's pendants showing the last days of cardinals Richelieu and Mazarin at the same sale in 1865 at which he bought *The Laughing Cavalier* for 51,000 francs. In 1870 he paid even more, 100,000 francs (about £4,000), one of the largest sums he ever spent, for Ary Scheffer's *Francesca da Rimini*, a celebrated picture in the nineteenth century. Always rather aloof, he seldom commissioned paintings, preferring to buy at auction even works by living artists.

Because paintings by many of the artists admired by the 4th Marquess became unfashionable shortly after his death, other collections of his time have been dispersed. In recent decades interest in these artists has grown substantially, so their pictures have again become expensive and their works in the Wallace Collection are increasingly studied and appreciated. ❧

Opposite (detail):
The Last Sickness of Cardinal Mazarin, 1830
Paul Delaroche (1797–1863)
See pages 244–5

Lady Hamilton as a Bacchante, 1803
Henry Bone (1755–1834)

▲ Henry Bone was appointed Enamel
Painter to George III, George IV and
William IV, and achieved extraordinary
financial success with his copies in enamel
after Old Master paintings. This enamel is
after an oil painting by the French artist
Élisabeth Vigée Le Brun. It shows Emma,
Lady Hamilton (1765–1815), the famous
wife of Sir William Hamilton, British
envoy to Naples, and mistress of the great
naval hero Lord Nelson. The original (now
in a private collection) was painted in 1790.
Bone's copy was commissioned by Sir
William Hamilton and bequeathed by him
to Nelson in the year it was painted.

Enamel on copper; 22.2 x 28 cm
Acquired by the 4th Marquess of Hertford in 1859
M21

Handle of a Walking or Riding Stick, *c.*1800
Russian(?)

▶ This intriguing object is an ivory walking- or riding-stick handle, carved to represent a lion. It holds between its forepaws a gold escutcheon (possibly a later addition) engraved with the arms of the Seymour–Conway family surmounted by a marquess's coronet (the handle therefore dates from 1793 or later). The 3rd Marquess of Hertford went to Russia in 1827, as an envoy to Tsar Nicholas I, when the handle may have been acquired for the Collection.

Ivory and gold; l 11.5 cm
Possibly acquired by the 3rd Marquess of Hertford at an unknown date
S271

The Sleep of Venus and Cupid, 1806
Constance Mayer (1775–1821)

▼ Pierre-Paul Prud'hon (1758–1823) provided the initial ideas for the composition and then left the execution to his pupil and mistress, Mayer. Mayer's manner deliberately imitated that of her lover, while her use of atmospheric *sfumato* and profusion of putti is inspired by Prud'hon's favourite models, Correggio and Francesco Albani. The subject of awakening love was complemented by a pendant, *The Torch of Venus* (1808; now in the Musée Napoléon, Arenenberg), symbolising constancy in love. Both pictures were acquired by the Empress Joséphine, and hung at Malmaison until her death in 1814.

Oil on canvas; 96.5 x 144.5 cm
Acquired by the 4th Marquess of Hertford in 1866
P348

Napoleonica

I n 1802 the future 4th Marquess of Hertford was taken to Paris by his parents and, after they separated, he was brought up in the city by his mother, the 3rd Marchioness. He therefore spent his earliest years in Paris at one of the most exciting times in its history, when Napoleon Bonaparte (1769–1821), born in modest circumstances in Corsica, became emperor of the French and his armies marched from Madrid to Moscow until finally being defeated in 1815 at the Battle of Waterloo. His mother was also on friendly terms with a few officers, including General Junot and Marshal Duroc, so gorgeously uniformed soldiers would have been a familiar sight in the young and impressionable Marquess's Paris home. Much later the Marquess also became a friend of Napoleon's nephew, Napoleon III, who ruled France from 1852 until 1870.

As a collector of Napoleonica, the 4th Marquess concentrated on paintings, watercolours and miniatures, though he also acquired a considerable library of books on military themes and owned some other outstanding objects, such as a magnificent rifle and pistols made by Nicolas Noël Boutet, gunmaker to the Imperial court (A1219-22; A1131). Given his preference for 'pleasing pictures' it is unsurprising that most of the Marquess's Napoleonic paintings are anecdotal treatments of the domestic and ceremonial activities of the Emperor and his soldiers, rather than representations of war.

Napoleon on a Chestnut Horse, 1836
Hippolyte Bellangé (1800–66)
Pencil, watercolour and bodycolour on paper;
41.8 x 33.7 cm

Acquired by the 4th Marquess
of Hertford at an unknown date
P671

The Divorce of the Empress Joséphine, 1846
Henri-Frédéric Schopin (1804–80)
Oil on canvas; 55.8 x 80.5 cm
Acquired by the 4th Marquess
of Hertford in 1865
P568

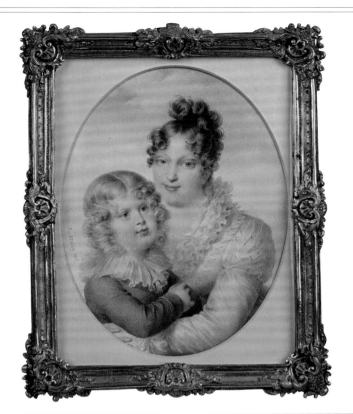

Even after Napoleon's death in 1821, Bonapartism remained a powerful political force in France, and nostalgic images of the Napoleonic era continued to be produced in huge numbers. Admiration for the Emperor, in his lifetime and later, was by no means confined to France, and even in countries that had been his bitter enemy he still exerted a compulsive fascination because of the magnitude of his military and administrative achievements. The 4th Marquess's enthusiasm for the Napoleonic legend was therefore by no means unique among collectors of his time, even those with English connections. ✑

Left:
The Empress Marie-Louise and her Son, the King of Rome, 1815
Jean-Baptise Isabey (1767–1855)
Gouache on paper; 17 x 13 cm
Acquired by the 4th Marquess of Hertford at an unknown date
M210

Below:
Napoleon's Tomb, 1821
Horace Vernet (1789–1863)
Oil on canvas; 54 x 80.5 cm
Acquired by the 4th Marquess of Hertford at an unknown date
P575

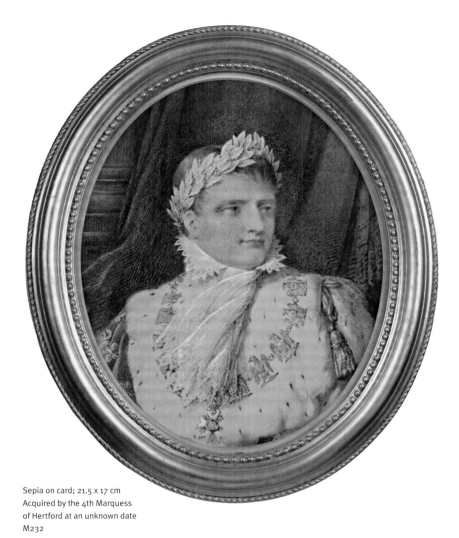

Sepia on card; 21.5 x 17 cm
Acquired by the 4th Marquess
of Hertford at an unknown date
M232

Napoleon I, 1810
Jean-Baptiste Isabey (1767–1855)

◀ Isabey, who first worked in Paris for Marie-Antoinette, was adept at securing patronage from the varied political systems in power during his long life. Under Napoleon he rose to become court painter, providing, with the help of a large studio, countless miniatures of the Emperor and his extensive family. This is actually a sepia drawing rather than a miniature, but it shows the high quality of draughtsmanship of which Isabey was capable. Napoleon wears robes of state as well as a laurel wreath and the collar of the Legion of Honour (see below left). One of Isabey's duties had been to design the costumes for Napoleon's coronation in 1804.

Prince August of Prussia, 1814
Jean-Baptiste Isabey (1767–1855)

▼ Prince August of Prussia (1779–1843), a nephew of Frederick the Great, fought against Napoleon in several battles, including Jena, before being captured at Prenzlau in 1806 (together with his *aide-de-camp* Carl von Clausewitz, the great military theoretician). Later he became a notable figure in French society. He is shown here as a splendidly dashing soldier, wearing the uniform of the Prussian Guards and the stars and badges of five orders, including the Iron Cross of Prussia. The frame is in the form of two laurel branches. The ribbon at the bottom is inscribed *1813*, *1814* and *1815*, in reference to the campaigns against Napoleon that culminated at the Battle of Waterloo.

Gouache on paper; 11.3 x 9.8 cm (sight)
Acquired by the 4th Marquess of Hertford
at an unknown date
M219

Link from a Collar of the Legion of Honour,
1806–15
Martin-Guillaume Biennais (1764–1843)

◀ The Legion of Honour was established by Napoleon in 1802 as an 'honour to recognise military bravery and civilian merit'. It remains to this day France's most prestigious national order. This link is from a collar that would have contained sixteen such links and been worn by its recipient on formal occasions. It is in the form of an eagle with the thunderbolts of Jupiter. Napoleon chose the spread-winged eagle, inspired by the Roman eagle of antiquity, as the emblem of his empire.

Gold; wt 19.4 g
Acquired by the 4th Marquess of Hertford
or Sir Richard Wallace at an unknown date
XIIA66

Box of Game Counters, *c.*1804–15
French

▶ This box contains sixty-six games counters. They are part of a set that probably would have originally comprised eighty-eight pieces and been used for card games. Each counter bears the Imperial device of the bee either singly (in the case of the round counters) or in groups of three (in the case of the rectangular counters). In the time of Sir Richard Wallace the set was thought to have belonged to the Emperor Napoleon, although there is no historical evidence to support this.

Mother-of-pearl, tortoiseshell and gold; l (rectangular) 8.2 cm, diam. (circular) 3.3 cm
Acquired by the 4th Marquess of Hertford or Sir Richard Wallace at an unknown date
XXA56

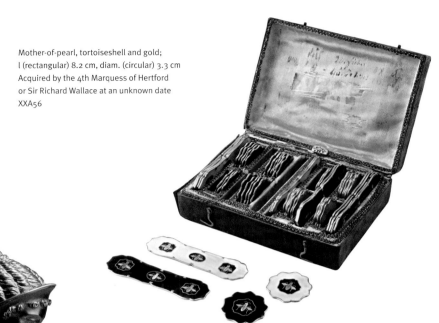

The Empress Marie-Louise, 1812
French

◀ The Empress Marie-Louise (1791–1847) was the second wife of the Emperor Napoleon, whom she married in 1810 (see page 233). She is shown in this statuette with attributes of the Art of Painting. A companion statuette of Napoleon, also in the Wallace Collection (S228), shows Napoleon with attributes of the Arts and Sciences. They are one of five pairs cast in 1812 for Napoleon's palaces. The poses of both figures derive from Roman antique bronzes in the collection of Dominique-Vivant Denon, Napoleon's minister of fine arts, on whose initiative they were probably made. The casting is by an obscure gold-smith named Lacour and the chasing, of high quality, by François-Aimé Damerat (active 1781–1819).

Bronze; h 20.3 cm
Probably acquired by the 4th Marquess of Hertford at an unknown date
S229

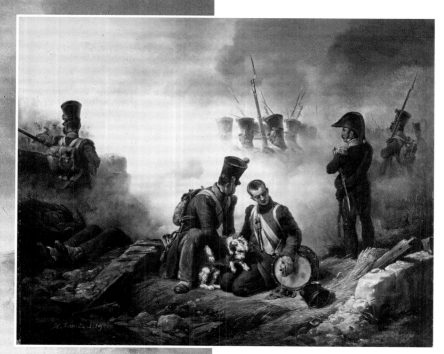

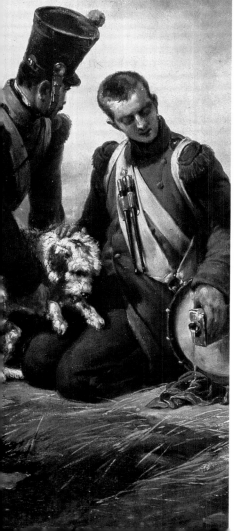

The Dog of the Regiment Wounded
and *The Wounded Trumpeter*, 1819
Horace Vernet (1789–1863)

◀ ▾ These two pendant pictures, combining sentiment toward animals with a touch of military glamour, were among Vernet's most popular works. When they were auctioned in 1865 the catalogue described them as 'paintings of a European reputation'. In the first picture (left) two soldiers attend a wounded dog on the battlefield, whereas in the companion work (below) animals show concern for a soldier, in this case a trumpeter (traditionally the most dashing figure in the cavalry). The paintings were exhibited, without their titles, at the Paris Salon of 1819.

Oil on canvas; *Dog*: 53.1 x 64.4 cm;
Trumpeter: 53.1 x 64.4 cm
Acquired by the 4th Marquess of Hertford
in or after 1865
P607 and P613

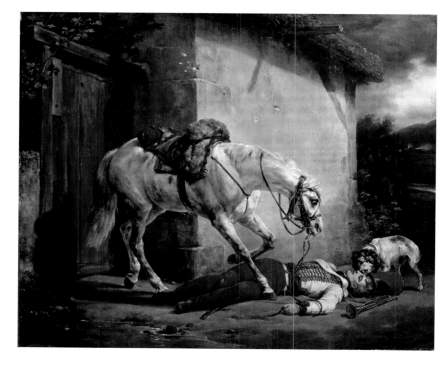

Napoleon and his Staff, 1868
Ernest Meissonier (1815–91)

▶ Napoleon, wearing the green coat of the *chasseurs à cheval*, which
he often wore on campaign, is shown here with his staff officers.
It is difficult to identify the foremost officers, but it is known from
a surviving account book of Meisonnier's, that they include marshals
Berthier, Duroc, Caulaincourt, Ney and Drouot. In the background,
above and behind the elbow of the officer immediately to the left of
Napoleon, is the red and white headdress of Roustam Raza,
Napoleon's faithful Mameluke servant. This detail is said to have been
added by Meissonier at the request of the 4th Marquess of Hertford.

Oil on mahogany and sycamore panel; 16.8 x 18 cm
Acquired by the 4th Marquess of Hertford in 1868
P290

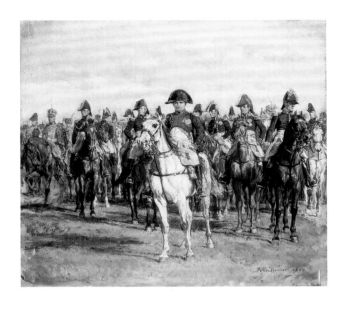

Woodcock Shooting on Otley Chevin, 1813
Joseph Mallord William Turner (1775–1851)

▼ Despite his enthusiasm for the works of Bonington, the 4th
Marquess of Hertford, living in Paris, took only a limited interest in
English painting of his own century. He did, however, acquire a large
number of English pictures at the Elhanan Bicknell sale in London in
1863, including four watercolours by Turner, the only works by this
artist he was ever to own. This is a scene at Otley Chevin, a hill in
West Yorkshire. The sportsman is Sir William Pilkington (1775–1850),
brother-in-law of Turner's friend and great patron Walter Fawkes.
Turner frequently went shooting with the Fawkes family.

Watercolour with touches of gum varnish on paper; 28 x 39.8 cm
Acquired by the 4th Marquess of Hertford in 1863
P651

Coffer, c.1815
English

▶ One of a pair of coffers made for the collector and author William Beckford's famous but short-lived Gothic folly, Fonthill Abbey, which was built between 1798 and 1823. Made in London, they were recorded in the Sanctuary at Fonthill in 1823. A description of the room, which had a carved and partly gilt ceiling 'covered with a reticulation of lozenge work', and walls covered in crimson damask, indicates how well they would have suited it. The general form of the coffers resembles that of Florentine *cassoni*, with neo-Gothic ornament superimposed.

Pine, sandalwood, oak and mahogany, decorated with painting and gilding; gilt-bronze handles; gilt-brass hinges; h 71.5 cm, w 113 cm, d 58.5 cm
Acquired by the 4th Marquess of Hertford in 1848
F472

Margaret, Countess of Blessington, c.1821–2
Thomas Lawrence (1769–1830)

◀ Margaret ('Marguerite') Power (1789–1849) was a famous beauty who married Charles, 2nd Viscount Mountjoy, created Earl of Blessington in 1822. This portrait was exhibited in the same year at the Royal Academy, when according to Byron it 'set all London raving'. Later, Lady Blessington became a renowned novelist and literary editor. Together with her companion Alfred, comte d'Orsay, she established a famous salon at Gore House, Kensington. This was attended by the 4th Marquess of Hertford, who is said to have met the future Napoleon III there.

Oil on canvas; 91.5 x 67 cm
Acquired by the 4th Marquess of Hertford in 1849
P558

George IV, 1822
Thomas Lawrence (1769–1830)

▶ George IV (1762–1830) was an important figure in the history of the Wallace Collection. An avid art collector, before he became king in 1820 he was an intimate friend of the 2nd Marchioness of Hertford and on good terms with her son, the future 3rd Marquess, who advised him on his purchases and on occasions acted as his saleroom agent. Lawrence, the foremost portraitist of his time and President of the Royal Academy (1820–30), painted several portraits of the King, though he regarded this as his most successful. A remarkably informal image, it epitomises the elegance and refinement for which George IV was renowned. It was given by the King to his mistress, Lady Conyngham.

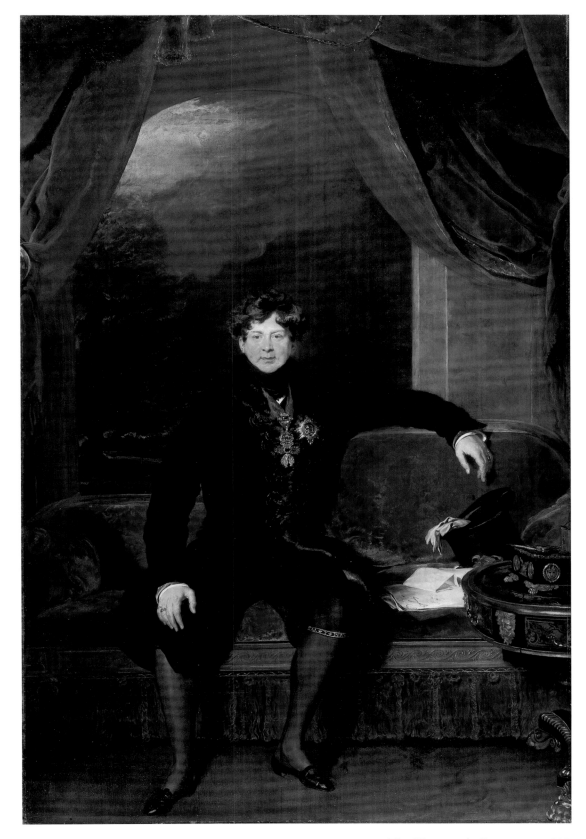

Oil on canvas;
270.5 x 179 cm
Acquired by Sir
Richard Wallace
in 1883
P559

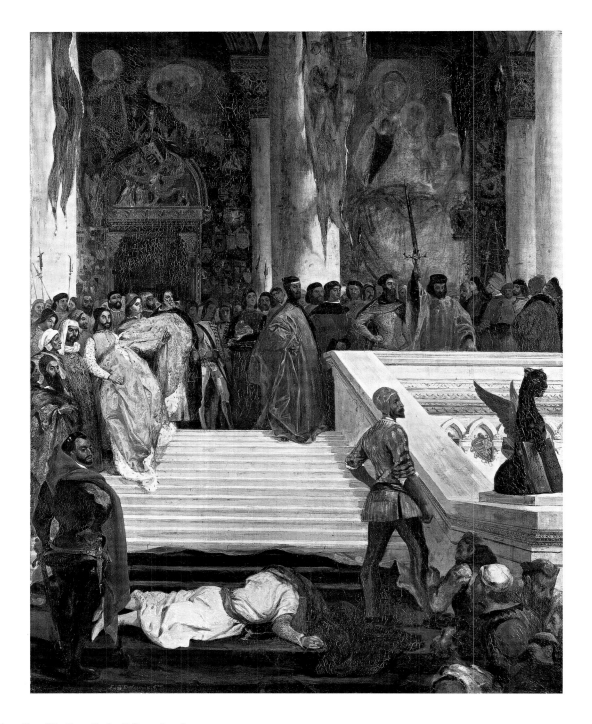

The Execution of the Doge Marino Faliero, 1825–6
Eugène Delacroix (1798–1863)

▲ When Delacroix painted this picture, one of his own favourite works, he was briefly sharing a studio with Richard Parkes Bonington. The influence of his English friend can be seen in the colouring and the bold execution of the figures. The subject is taken from Byron's *Marino Faliero, Doge of Venice* (1820). Faliero (1274–1355) was elected doge in 1354, but was executed the following year after conspiring against the Venetian state. The setting recalls the Giant's Staircase in the Doge's Palace, and the costumes, some of the heads of the dignitaries and the rich colouring are derived from Venetian Renaissance painting, which Delacroix greatly admired.

Oil on canvas; 145.6 x 113.8 cm
Possibly acquired by Sir Richard Wallace c.1871–2
P282

A Lady dressing her Hair, 1827
Richard Parkes Bonington (1802–28)

▶ This quintessentially Romantic image may have a literary source, but if so it has not been identified. From the woman's costume, the scene appears to be set in the seventeenth century. The mirror suggests that it is in part a traditional *vanitas* picture, a condemnation of pride and self-deceit. If there are any moralistic undertones, however, they are overwhelmed by the drama of a gorgeously clad woman in a richly furnished interior calmly dressing her hair while the wind and waves crash outside her window. The emerald-green pigment, so beautifully used here, was introduced in the 1820s.

Pencil, watercolour and bodycolour with gum varnish on paper; 15.2 x 10.2 cm
Acquired by the 4th Marquess of Hertford in 1860
P679

Henri III, 1828
Richard Parkes Bonington (1802–28)

◀ Bonington, like many of his contemporaries, was attracted to history painting because it was more prestigious than landscapes or domestic scenes. His career was too short for his talents to be fully developed, but he completed and exhibited several major history pictures. This work, shown at the Royal Academy in London shortly before his death, shows Henri III (1551–89), the notoriously indolent and effeminate king of France, receiving Don John of Austria, the illegitimate son of the Emperor Charles V. The louche King and his minions are contrasted with the manly vigour of Don John.

Oil on canvas; 54 x 64.4 cm
Acquired by the 4th Marquess of Hertford in 1860
P323

'On the Coast of Picardy', 1826
Richard Parkes Bonington (1802–28)

▼ Bonington was trained as a painter in watercolour, but around late 1823 he also took up oil painting. His instinctive talent is demonstrated by this wonderfully accomplished scene on the coast of northern France, painted within only three years of his taking up the medium. Based on a drawing made during one of his sketching trips, it beautifully suggests a fresh and cloudy morning by a sea that is subject to storms: note the fallen crow's-nest in the foreground. The title derives from a reproductive engraving of 1829 after the painting, but the site may actually be on the coast of Normandy.

Oil on canvas; 36.8 x 50.7 cm
Acquired by the 4th Marquess of Hertford in 1853
P341

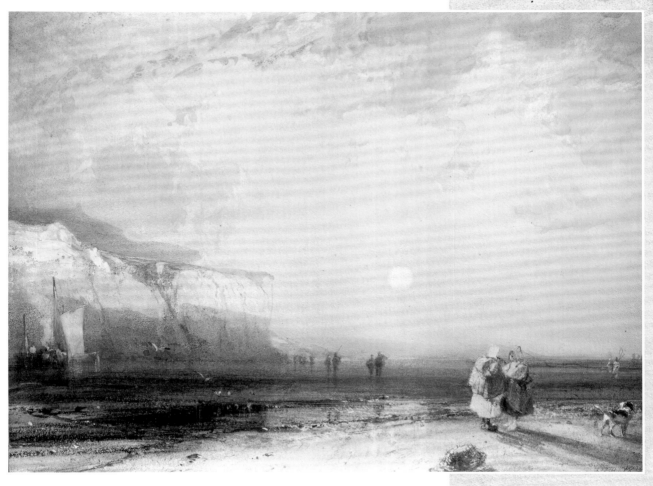

Sunset in the Pays de Caux, 1828
Richard Parkes Bonington (1802–28)

▲ This is one of Bonington's last watercolours, painted shortly
before his death, one month short of his twenty-sixth birthday. It is
a sombre work, seemingly elegiac in mood, but its predominantly
yellow tone and direct engagement with the setting sun are in fact
more the outcome of his admiration for Turner than an awareness of
his own coming death. Such features can be found in his earlier works,
and in oils and watercolours by Turner. The Pays de Caux, the area
north of the lower reaches of the Seine in Normandy, had been visited
frequently by Bonington during his sketching trips.

Pencil, watercolour and bodycolour with gum varnish
on paper; 19.8 x 26.3 cm
Acquired by the 4th Marquess of Hertford in 1863
P708

The State Barge of Cardinal Richelieu on the Rhône, 1829
Paul Delaroche (1797–1863)

▶ Paul Delaroche was the most successful historical painter of his time. Many of his historical scenes, including this, had a contemporary relevance. It was believed by some historians that the roots of the French Revolution lay in the French Crown's policy of expanding its power at the expense of its natural supporters, the aristocracy. Two of the main instigators of this policy had been the great seventeenth-century ministers Cardinal Richelieu and Cardinal Mazarin. Here Richelieu (1585–1642) is shown taking his prisoners, two aristocratic conspirators, Cinq-Mars and de Thou, up the river Rhône to be executed. The composition is indebted to Alfred de Vigny's description of the scene in his novel *Cinq-Mars*, published in 1826.

Oil on canvas; 57.2 x 97.3 cm
Acquired by the 4th Marquess of Hertford in 1865
P320

The Last Sickness of Cardinal Mazarin, 1830
Paul Delaroche (1797–1863)

▶ With its pendant *The State Barge of Cardinal Richelieu on the Rhône*, this painting was exhibited at the Paris Salon of 1831. Here it is 1661, and the dying Mazarin is shown surrounded by aristocrats who have been forced by his policies to abandon their lands and become his sycophantic followers. The man bowing in the centre is the Spanish ambassador, and the young woman on the right looking back towards him wistfully is one of Mazarin's nieces, Marie Mancini, who had a love affair with Louis XIV. One of Mazarin's last acts had been to arrange a marriage between Louis and Maria Theresa of Spain, thus thwarting the ambitions of his own niece to become queen.

Oil on canvas; 56.4 x 97.5 cm
Acquired by the 4th Marquess of Hertford in 1865
P314

See details on pages 228–9

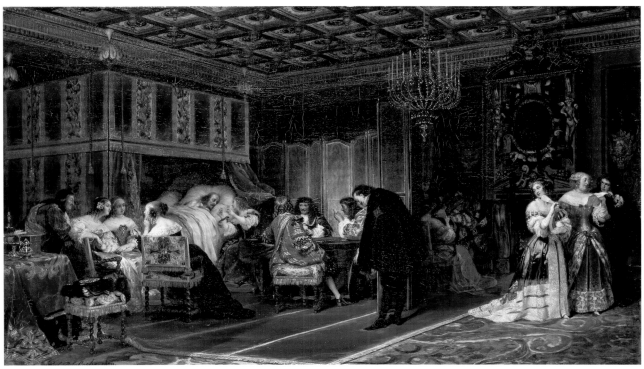

The Turkish Patrol, c.1830–31
Alexandre-Gabriel Decamps (1803–60)

▲ Decamps was one of the leading artists of Orientalist scenes,
although he only visited the Middle East once, in 1828. Although his
ambitions to be a history painter on a grand scale were never realised,
many contemporary critics ranked him with Ingres and Delacroix
among the foremost painters of his time. This painting, exhibited at
the Paris Salon of 1831, was Decamps's first important painting with
an oriental subject. Nine men of a foot patrol are shown accompany-
ing Cadji-Bey, the chief of police, on his round at the port of Smyrna
(now Izmir). There is an element of caricature in Decamps's treat-
ment of some of the figures, particularly the pompous Cadji-Bey.

Oil on canvas; 114.5 x 179 cm
Acquired by the 4th Marquess of Hertford by 1855
P307

An Odalisque, c.1830–32
Alexandre-Gabriel Decamps (1803–60)

▶ Odalisques, slave girls in an Eastern harem, became a popular
subject with French painters in the 1820s. Their rich costumes, the
mystery of their lives and their sexual allure made them enormously
attractive to the European imagination, and Delacroix, Bonington
and Decamps were just three of many artists who included them in
their paintings. In this watercolour the freedom of the bird is
contrasted with the captivity of the woman and the monkey.

Watercolour and bodycolour with some gum varnish on paper; 44.6 x 36.3 cm
Acquired by the 4th Marquess of Hertford in 1863
P666

The Arab Tale-teller, 1833
Horace Vernet (1789–1863)

▶ This picture was painted in Rome by
Vernet immediately after the first of five
visits he was to make to Algeria. It was the
first of many Orientalist paintings he
exhibited at the Paris Salon and elsewhere.
It was painted for the 12th Earl of Pembroke,
who at the time lived in Paris, like the 4th
Marquess of Hertford. The tale-teller in the
right foreground wears a grey and white
striped burnouse; the classically posed girl
on the left (her pose is derived from the
Venus de Milo) recalls the nobility that
Vernet and other European artists in the
nineteenth century discerned in the people
of North Africa and the Middle East.

Oil on canvas; 99 x 136.5 cm
Acquired by the 4th Marquess of Hertford in 1847
P280

Francesca da Rimini, 1835
Ary Scheffer (1795–1858)

▼ Scheffer enjoyed enormous success with
sentimental and religious scenes, many of
which became the subject of popular
engravings. *Francesca da Rimini* was one of
his most admired works; this is the first
version, but he produced many others.
A subject from Dante's *Inferno*, it shows
Dante and his guide, the Roman poet
Virgil, during their passage through hell.
They look on the tragic figures of Paolo and
Francesca, condemned with the souls of the
lustful to the stormy darkness of hell's
second circle. Francesca had been forced to
marry the hideous Gianciotto da Rimini,
but had fallen in love with his handsome
younger brother, Paolo. In 1285 they were
murdered by Gianciotto. He had seen Paolo
kiss Francesca while they were reading
together an account of the love of Sir
Lancelot for Queen Guinevere.

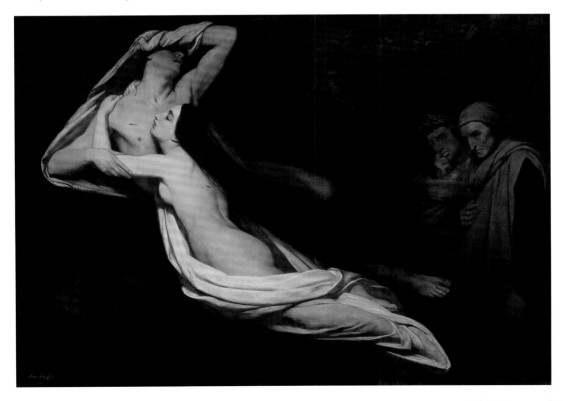

Oil on canvas;
166.5 x 234 cm
Acquired by the 4th
Marquess of Hertford
in 1870
P316

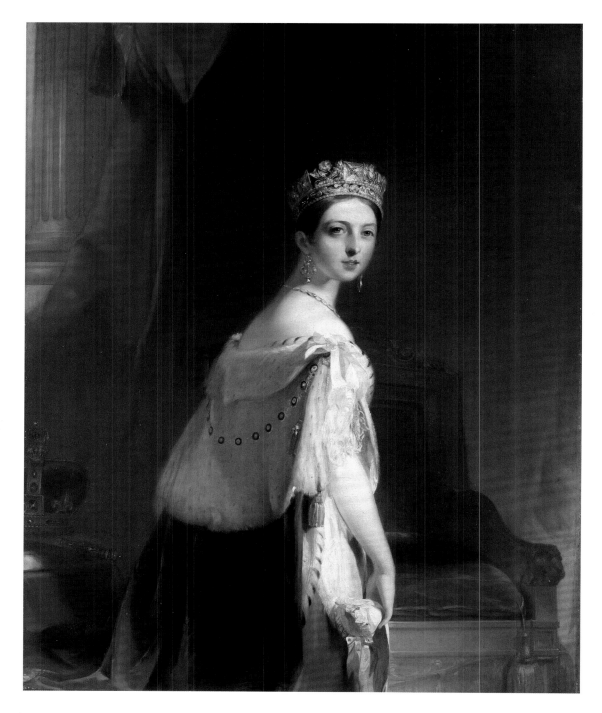

Queen Victoria, 1838
Thomas Sully (1783–1872)

▲ In 1837 the English-born American artist Thomas Sully visited London, bringing with him a commission from the American Society of the Sons of Saint George to paint a portrait of the new queen, Victoria (1819–1901). During five sittings at Buckingham Palace, Sully painted a bust-length study, and from this he derived the full-length version (now in a private collection) for the Sons of Saint George. The Wallace Collection's picture, also based on the life study, was commissioned for an engraving by Charles Edward Wagstaff. Principally through this engraving, it became one of the best-known images of the young Queen Victoria.

Oil on canvas; 142.5 x 112.5 cm
Acquired by the 4th Marquess of Hertford in or after 1855
P564

Left:
Silver and gold;
l 25.8 cm, wt 340 g
Acquired by the 4th
Marquess of Hertford
perhaps in 1829
OA1653

Combined Inkwell and Pen Case (*kalam dan*), early 19th century
Turkish

⌃ Such a pen case would have been held under the arm while the
inkwell was being used. The inscriptions engraved upon it in Arabic
include the names of the maker (*Mahomed*) and the owner (*Richard
Seymour Conway comte de Yarmouth*). The title 'Lord Yarmouth' was
only used by the eldest son and heir of each Marquess of Hertford;
in the case of Richard Seymour-Conway, 4th Marquess of Hertford,
it was a title only used by him between 1822 and 1842. In 1829 he is
known to have visited the British Embassy in Constantinople (now
Istanbul, Turkey), and seems to have stayed in the city for some
months, so he may well have acquired this item then. In this case it
may constitute his earliest-known acquisition.

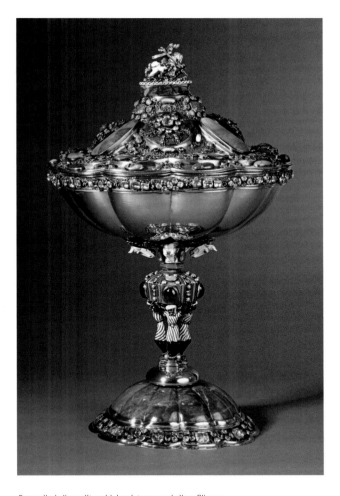

Cup and Cover, mid-19th century
French or Belgian

▶ This elaborate cup and cover is one of the many horse-racing
trophies won by Lord Henry Seymour (1805–59). Lord Henry was
the half-brother of the 4th Marquess of Hertford, being the son of
the 3rd Marchioness by (probably) comte Casimir de Montrond.
He also lived in Paris and collected works of art, but was a much
more out-going character than the 4th Marquess. He was one of the
founders of the French Jockey Club, and helped establish the prestige
and social cachet of horse racing in France. This cup presumably
passed by inheritance to the 4th Marquess or Sir Richard Wallace,
of whom Lord Henry was particularly fond.

Enamelled silver gilt, gold, hardstones and silver filigree;
h 35.5 cm, w 22.5 cm
Acquired, by the 4th Marquess of Hertford or Sir Richard Wallace,
at an unknown date
XIIA103

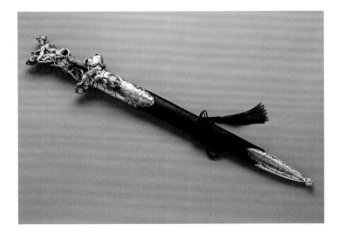

Presentation Hunting Knife, *c*.1860
French, Paris

◀ Cast and chased in solid silver, the hilt shows a Native American
struggling with two mountain lions; the group is signed at the base
by the designer–maker Jeanisset. Relatively few of the works of art in
Hertford House have a direct connection with the Hertford family,
but this splendid hunting knife is one of the few notable exceptions.
It bears an inscription on the reverse of the scabbard locket, indicat-
ing that it was a gift to the 4th Marquess of Hertford from the
Emperor Napoleon III, whose own passion for collecting arms and
armour is said to have been inspired by the impressive Oriental arms
collection of his friend.

Steel, silver, wood and leather; l 69.7 cm, wt 432 g
Acquired by the 4th Marquess of Hertford between 1860 and 1870
A707

Circassian Slave, early 1850s
Raffaele Monti (1818–81)

▶ Monti, born at Iseo in Italian Switzerland, came to England in the late 1840s, and exhibited at the Great Exhibition of 1851 and at the Royal Academy between 1853 and 1860. His *Veiled Vestal* (now at Compton Place, Eastbourne), sculpted for the Duke of Devonshire, gained him immediate fame, and thereafter he was best known for his remarkably illusionistic veiled figures. This sculpture is a reduced version of his *Circassian Slave in the Market-place at Constantinople* (present location unknown), which was shown at the Great Exhibition. Circassia is a region north-east of modern Turkey.

Marble; h 34.9 cm
Probably acquired by the 4th Marquess of Hertford at an unknown date
S43

Bust of a Nymph, 1860
Charles-Henri-Joseph Cordier (1827–1905)

◀ Cordier is perhaps best known for his polychrome sculptures and busts of North African men and women, which were much admired in the mid-nineteenth century. Queen Victoria bought two of his African busts at the Great Exhibition in London in 1851, and Cordier's patrons in France included Napoleon III and the Empress Eugénie. This bust, one of a pair in the Wallace Collection, may have been included in a sale of Cordier's works at Foster's in Pall Mall, London, in May 1861.

Marble; h 53.3 cm
Acquired by the 4th Marquess of Hertford or Sir Richard Wallace at an unknown date
S41

Copy of the Roll-top Desk (*bureau à cylindre*) of Louis XV, *c*.1855–60
French

▶ Probably the most celebrated piece of eighteenth-century French furniture is the roll-top desk (now at Versailles), the first of its kind, which was made for Louis XV by Jean-François Oeben and Jean-Henri Riesener and delivered in 1769. This copy was made for the 4th Marquess of Hertford in Paris, perhaps by a cabinet-maker called Drexler or Dreschler. In the 1850s the 4th Marquess of Hertford was on friendly terms with Napoleon III and the Empress Eugénie. He is likely to have seen the original desk, then in the royal apartments at the palace of Saint-Cloud. His copy repeats the desk as altered in 1794, when the original gilt-bronze interlaced Ls of Louis XV on each side of the desk were replaced with Sèvres biscuit porcelain plaques.

Oak veneered with sycamore, ebony, purple heart and other woods; gilt-bronze mounts and plaques of Sèvres biscuit porcelain; h 143 cm, w 183 cm, d 97.5 cm
Acquired by the 4th Marquess of Hertford *c*.1855–60
F460

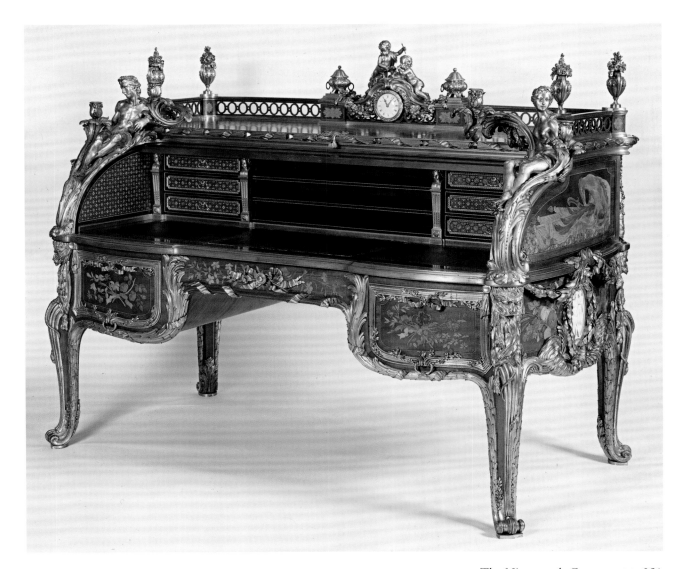

The Arab Tent, *c.*1865–6
Edwin Landseer (1802–73)

▲ Landseer was the most fashionable and successful painter of the early Victorian period, much admired by the Queen herself. This painting was shown at the Royal Academy in 1866 (as *Mare and Foal – Indian Tent etc.*, although the tent appears to be Arab rather than Indian in origin).

It is a rare instance of Landseer's response to fashionable Orientalist themes. As well as the Arab mare and her foal, there are two Persian greyhounds and two monkeys, one wearing an earring. Their owner's presence is suggested by the two pipes in the jar on the right.

Oil on canvas; 153.6 x 226.4 cm
Acquired by Sir Richard Wallace
in 1878 or 1879
P376

The Marble Staircase, 1866
Eugène Lami (1800–90)

◀ Lami was a specialist in military scenes and watercolours of elegant society subjects set in England and France. He received much patronage from the Rothschild family, for whom he was an artistic adviser. This gorgeous watercolour is characteristic of his richly coloured aristocratic scenes. The figures wear late seventeenth-century costume, and the setting recalls (but does not depict) the Staircase of the Ambassadors at Versailles built in the 1670s; the scene does not seem to represent a particular historical event.

Pencil, watercolour and bodycolour with some gum varnish on paper; 31.6 x 50.3 cm
Acquired by the 4th Marquess of Hertford at an unknown date
P653

Index